BILL REID AND BEYOND

BILL REID AND BEYOND

EXPANDING ON MODERN NATIVE ART

edited by KAREN DUFFEK
and CHARLOTTE TOWNSEND-GAULT

Douglas & McIntyre
VANCOUVER/TORONTO

University of Washington Press
SEATTLE

Published simultaneously in the United States and Canada
Originated in Canada by Douglas & McIntyre

Douglas & McIntyre Ltd.
2323 Quebec Street, Suite 201
Vancouver, British Columbia v5T 4S7
www.douglas-mcintyre.com

NATIONAL LIBRARY OF CANADA CATALOGUING IN PUBLICATION DATA
Bill Reid and beyond : expanding on modern native art / edited by Karen Duffek and Charlotte Townsend-Gault.
Includes bibliographical references.
ISBN 1-55365-006-9
1. Reid, Bill, 1920– —Criticism and interpretation.
1 . Duffek, Karen, 1956– II. Townsend-Gault, Charlotte
NB249.R44B54 2004 730'.92 C2003-907234-7

University of Washington Press
PO Box 50096
Seattle, WA 98145-5096, U.S.A.
www.washington.edu/uwpress

LIBRARY OF CONGRESS CATALOGING-IN-PUBLICATION DATA
Bill Reid and beyond : expanding on modern Native art / edited by Karen Duffek and Charlotte Townsend-Gault.
p. cm.
Includes bibliographical references.
ISBN 0-295-98376-0 (hardback : alk. paper)
1. Haida art. 2. Haida artists. 3. Reid, William, 1920– I. Duffek, Karen, 1956– II. Townsend-Gault, Charlotte.
E999.H2B55 2004
730'.92—dc22 2003026884

Design by Ingrid Paulson
Jacket photos (top to bottom, left to right): detail of Bear silver brooch by Bill Reid c. 1970, diameter 4.5 cm, private collection, photo B. McLennan; X̱esu'gwilakw Gave Birth to a Girl by Marianne Nicolson 1999, acrylic on wood, H 147.3 × W 167.6 × D 7.6 cm, private collection, photo M. Nicolson; Bear by Bill Reid c. 1962, cedar, H 1.6 × W 1.3 × D 2.1 m, UBCMOA, photo B. McLennan; detail of untitled, by Robert Davidson 1999, acrylic on canvas, H 74.2 × W 101.6 cm, collection of the artist, photo by Robert Davidson; detail of Dogfish by Bill Reid c. 1959, pencil on paper, H 10.1 cm × W 15.0 cm (mounted), UBCMOA Nb1.547, photo B. McLennan; three silver bracelets by Charles Edenshaw (Beaver, c. 1880, 2.3 × 17.3 cm, UBCMOA Nb1.742, ; Thunderbird, c. 1885, 3.6 × 17.5 cm, UBCMOA Nb1.761; Cormorant, n.d., 4.0 × 18.0 cm, UBCMOA A8093), computer scans by B. McLennan; detail of rattle, Haida, c. 1850, British Museum 5930, photo by Bill Reid at UBCMOA, reproduction courtesy Trustees of the British Museum; detail of The Raven Discovering Mankind in a Clamshell by Bill Reid 1970, boxwood, H 7.0 × 16.9 × D 5.5 cm, UBCMOA Nb1.488, photo B. McLennan; Ttsam aws (Snag) silver brooch by Bill Reid c. 1960, 5.0 × 5.0 cm, UBCMOA Nb1.744; detail of Red Man Watching White Man Trying to Fix Hole in Sky by Yuxweluptun 1990, acrylic on canvas, H 142.2 × L 226.1 cm, collection of Jack and Maryon Adelaar, photo by Yuxweluptun.

Printed and bound in Canada by Friesens
The paper used in this publication is acid-free and recycled from 10 percent post-consumer and at least 50 percent pre-consumer waste. It meets the minimum requirements of American National Standard for Information Sciences—Permanence of Paper for Printed Library Materials, ANSI Z39.48-1984.

We gratefully acknowledge the financial support of the Canada Council for the Arts, the British Columbia Arts Council, and the Government of Canada through the Book Publishing Industry Development Program (BPIDP) for our publishing activities.

Contents

Part III Revisiting the Revival

Part IV Reconciling Aboriginality and Modernity

List of Illustrations

19. Doug Cranmer uses a chainsaw to begin shaping the Wasgo (Sea Wolf) sculpture.
20. Painted paper model poles by Bill Reid.

Between pages 232 and 233
21. *Bear* by Bill Reid.
22. Plush bear designed by Bill Reid.
23. Silkscreen reproduction of a Killer Whale on a Kwakwaka'wakw drum.
24. Children's artwork from Alert Bay Indian Day School.
25. Children's artwork from Alberni Indian Residential School.
26. Ellen Neel presents a "Totemland" pole to Maria Tallchief.
27. Charlies James, c. 1928.
28. Drawing by architect Ross Lort, based on an oolichan box.
29. Chief Henry Speck's artwork on the cover of a pamphlet.
30. Cover art by David Neel (Gla-Gla-Kla-Wis), son of Ellen Neel, for the *Native Voice*.
31. Copper by Marianne Nicolson, painted on a cliff face near Gwa'yi, Kingcome Inlet.
32. *Double-Headed Serpent* by Yuxweluptun.
33. Mural installation by Brian Jungen at the Charles H. Scott Gallery
34. Untitled painting by Robert Davidson.

Foreword

by NIKA COLLISON

A s ONE OF Bill Reid's grandchildren, I never thought too much or too hard about Bill as an artist, storyteller, jeweller, carver, philosopher, or even as a Haida. I knew him as one of my grandfathers—as my "Chinai Bill." I admired him, rolled my eyes at him, laughed with him, learned from him, argued with him, and all the while, loved him.

When Chinai passed away, there were two memorials: one in Vancouver and later one in Skidegate. As I listened to the tributes shared by friends, family, colleagues and even strangers, I was taken by how many "Bills" there seem to have been. And just like the speeches at his memorial, in this book there are people who know Bill and his work in ways that are different from how his family knew him.

Since my chinai's death, I've started to get to know him in different ways, too. Partly from other people's experiences, but more from looking at what Bill did in his lifetime and then contemplating the era in which it all took place. I'm getting to know "Bill the artist" or, as he called himself, a "maker of things." He did some pretty spectacular things in his life and raised the bar for many people. I understand how lucky I was to be a part of his antics over the years.

I realize that Bill truly had an *impact* on the lives of people who knew him personally and the people who know him through the legacy he's left behind. He affected people from many cultures and parts of the world, people with different histories, experiences and educations. Bill reached people in multiple ways and continues to do so.

You can like or dislike Bill, or find yourself somewhere in between. Bill's complexities will be analysed; his talents extolled by one person, his approach questioned by another. As happens with much great art, some folks will weave new intent into an old piece of Bill's. Others might consider a piece for the past, present and future that it represents. Then, too, many a Haida will lay it out straight, acknowledge Bill for what he was, thank him for what he did, make a joke and wonder what the fuss is about. And all the while, some tricky and perhaps even prophetic message in Bill's work could be missed completely.

There is one gift that Chinai has given to all of us, no matter which Bill it is that we know, or what part of him we decide to analyse: Bill Reid has given us "things" to do.

Howa, Chinai, for this, more than anything.

Howa to the contributors of this book for sharing your Bill with us.

Preface

by RUTH B. PHILLIPS

THIS VOLUME owes its origin to the symposium "The Legacy of Bill Reid: A Critical Enquiry," organized in 1999 by the University of British Columbia Museum of Anthropology, of which I was at that time the director. I felt that the long and intimate relationship between Bill Reid and the museum gave us a responsibility to create an occasion on which to reflect critically and in depth on his remarkable legacy. The idea for a symposium grew out of conversations with a number of people, including primarily Charlotte Townsend-Gault, Martine Reid and Karen Duffek. The process of remembrance and assessment had begun a year earlier at the memorial service for Reid, who died on March 18, 1998. Held in the museum's Great Hall, the service was an extraordinarily moving event that will long be remembered by the more than one thousand people in attendance. Over a period of six and a half hours, each of the friends, relatives, colleagues and admirers who spoke added a new layer of anecdote, tribute and remembrance. This volume adds to and thickens these layers.

Michael Scott had written a few days earlier in the *Vancouver Sun* that, for Vancouver, Reid was a "genius loci"—a "spirit of the place." As was evident that evening, the sense of Reid's presence is particularly strong within the Museum of Anthropology's walls. On a platform of the Great Hall stand fragments of Haida totem poles which he, together with Harry Hawthorn and Wilson Duff, had collected and preserved. These poles remained reference points for Reid's artistic work. The windows of the Great Hall frame the Haida houses and the totem poles he made at the beginning of his

artistic career, before the museum building existed. Reid's great masterpiece, *The Raven and the First Men*, lies at the very heart of the building, designed into its centre by Reid, Walter Koerner and Arthur Erickson. These spaces and visual forms are inhabited not only by Haida images but also by the philosophical principles that Reid rediscovered in them and about which he wrote and spoke with his fellow artists and writers. The traces of his conversations mark the Great Hall itself, for just as Reid absorbed Western modernism into Haida art to create his monumental sculptures, so Arthur Erickson absorbed Haida architecture into Western modernism to create the museum.

The essays in this volume complement and build on many of the words that were spoken that night in ways that allow us to understand Bill Reid and his achievements from the perspectives of the Haida, Northwest Coast, southern Canadian and international communities in which he participated. They provide important insights not only into Reid's place in the historical development of both traditional Haida art and Western modernism but also into the broader historical processes that enable an artist to have a formative impact on whole artistic and cultural movements. In different ways, each helps us to understand Reid's art in terms of the specific opportunities and challenges that mid-twentieth century Canada afforded to a man of mixed Haida and white parentage, endowed not only with great artistic and intellectual abilities but also with personal charisma, persistence, a capacity for hard work and a strong sense of mission. George Kubler theorized the conjunctions of personal endowments and historical timing that make up the history of art in his 1962 book, *The Shape of Time*:

> Each man's lifework is also a work in a series extending beyond him
> in either or both directions, depending upon his position in the track
> he occupies. To the usual coordinates fixing the individual's position—his temperament and his training—there is also the moment
> of his entrance, this being the moment in the tradition—early,
> middle, or late—with which his biological opportunity coincides.

In Kubler's terms, Bill Reid had a "good entrance." Despite the undoubted barriers and obstacles he encountered, we can see in retrospect that key factors were at work that would support an artist of Reid's particular back-

ground and goals. The heightened awareness of the dangers of racism in the post–World War II world, a political will to begin dismantling some of the oppressive legal machinery of colonial oppression, the growth of nationalism in the lead up to Canada's centennial year and a fifty-year-long modernist tradition of appreciation for "primitive art," all combined to create a space in which not only Reid but also artists like Norval Morrisseau, Daphne Odjig, Doug Cranmer and Alex Janvier could explore the greatness of their indigenous artistic heritages within the media, genres and constructs of Western modernism.

The symposium participants were invited to address Reid's legacy from the critical distance that begins to be possible after an artist's death, when the full extent of the work and the life are known. They were also asked to place his work both within its indigenous and modernist artistic traditions and within generative matrices of history, politics and cultural movements. A few weeks before the symposium, the event had acquired an additional and unanticipated topicality—even a sense of urgency—from the publication of a feature article in *Maclean's*, Canada's national news magazine, that questioned the authenticity of Reid and his work. Inevitably, the symposium became an occasion for impassioned responses to these allegations as well as for more dispassionate reassessment. Despite the romantic stereotypes, the sensationalism and the ignorance of both Haida and non-Haida artistic process that had informed the *Maclean's* article, the episode bore unintended fruits because it prodded many of the invited speakers to address central issues of art, identity, discourse and historical process with even more clarity and directness than might otherwise have been the case.

Both the symposium and this book model the contrapuntal relationships between university-based and community-based students of and authorities on Native culture that have come to characterize contemporary representations of indigenous art. Although the interests of these participants are not always the same, they are increasingly finding ways to collaborate on mutually beneficial projects. The book also displays the more complete and balanced understandings of cultural phenomena that are produced by intercultural dialogue. And just as the essays demonstrate the importance of the historical "conversational community" that gathered around Reid in the 1960s—the anthropologists, curators, musicians,

fellow artists, patrons and community members who collectively created the environment in which the work of Reid and other Northwest Coast artists could thrive—so projects such as the symposium and this book offer hope of continued and productive dialogue.

The work Bill Reid created and inspired ensures that he will remain a "genius loci" not only of Vancouver but also of Ottawa, Skidegate, Washington, D.C., and other places. However, thinking about artists in terms of "genius" in the English sense of the word—talent and achievement so extraordinary as to be beyond normal human capacities—has largely gone out of fashion in art history and other humanistic discourses. Most scholars today are engaged, rather, in trying to understand individual creative achievements as negotiations not only of artistic traditions but also of particular sets of social, economic and political forces. The critique of Reid's work in both of these aspects is an unfinished project, but these essays provide a solid basis for continuing exchanges. The question of how much difference *modernism*, as an artistic movement, can accommodate and contain, is inevitably bound up with the wider question of how much difference *modernity* can accommodate and contain in political, social and cultural terms. This is, of course, the great question of contemporary multicultural societies like Canada, and Reid's work will continue to stimulate us to address it at the site of his art.

Although Bill Reid, like many of his fellow aboriginal artists, initially understood his project to be the reopening of the abandoned mine shaft of Haida tradition (to borrow another of Kubler's images), he came to understand and actively exploit the political implications of these acts of artistic recovery. He saw works of art that had begun in homage to the past become rallying points for the renewal of broad forms of cultural expression and that today contribute not only to the pleasure of individual art lovers but also to the health and viability of contemporary aboriginal communities.

Introduction: Image and Imagination

by CHARLOTTE TOWNSEND-GAULT *and* KAREN DUFFEK

THIS BOOK GROWS out of the ongoing and protean discussion about the complex legacy of the Haida artist Bill Reid. When Reid died in 1998, at the age of seventy-eight, his ashes—in a bent-box painted in a style for which he had found the words to describe the formal dynamic, placed in a Haida canoe and surrounded by the poles which Reid and others had removed from the villages of Haida Gwaii in the 1950s to the modernist space of the University of British Columbia's Museum of Anthropology, where they are commonly described as works of art—were at the centre of a memorial celebration that lasted more than six hours. Later, there was a salmon feast for the hundreds of people who had gathered. Later still, the ashes were paddled in *Loo Taas* (Wave Eater) for burial in his mother's village of T'anuu. The ceremonials of his passing indicated, as had his life, that there were many Bill Reids: CBC broadcaster; provincial society jeweller; successor of Haida carvers and engravers Charles Edenshaw and Charles Gladstone; heir to the eighteenth-century Enlightenment philosopher Jean-Jacques Rousseau, whose legacy includes the romance of the "noble savage," humanity's original state of freedom; colleague of French anthropologist Claude Lévi-Strauss; co-decipherer of the codes of Northwest Coast art with analyst and emulator of the northern Northwest Coast style Bill Holm; co-eval of Ojibwa modernist Norval Morrisseau; teacher of Jim Hart and Robert Davidson, and mentor to a younger generation of carvers; maverick catalyst for the Haida, had come to stand for many things to many people. His sculpture *The Raven and the First Men* is something of a national emblem because it articulates

these many things—contradictory, sentimental, humorous, original. And in the year 2004, it puts them into the widest possible circulation—on Canada's $20 bill.

This volume contributes to the diversity of the discussion—in voices Native and non-Native—of people whose various lives and experiences make them respond differently to Reid as a Haida, an artist, a social phenomenon; those who knew Reid and worked with him, and others for whom he epitomizes important conflicts in Canadian history, in art history and anthropology; those for whom he was, quite simply, an artist to emulate, and some for whom injecting a little irony into the matter does no great harm. The book's diversity lies in this: that Bill Reid is here discussed as implicated in Haida community politics and in the institutional politics of art; in relations with the media, with museums and universities; in the long-running desperate story of Native / non-Native relations in Canada; in personal relations, and so in the huge admiration and great affection, tempered with exasperation, for the man. And if his work is to be taken seriously, it cannot be above criticism. There are interestingly difficult questions to be asked: how it is that works that have become quasi-official symbols for the Haida, British Columbia or Canada seem to be protected from open response by an aura of sanctity; or, conversely, when the large-scale pieces are critiqued as being uncomfortably close to inflated kitsch, why the enlargement of Native imagery may evoke this response. Needless to say, such critiques are strenuously contested, but the question remains as to whether, and how, new hierarchies of value for "Native art" become established in settler societies, and by whom.

The Bill Reid story always held a wide audience captive, intersecting provocatively as it did with the issues of the day. It provided a focus, if not a disguise, for matters that were potentially explosive and required delicate handling: racial conflicts, the public face of Native identity, the idea of "Canada." The social and political context for this story is part of the public telling of Canadian history. After participating in the totem-pole removal and preservation project of the mid-1950s, Reid then carved, in 1978, a house-frontal pole for the new band council office in Skidegate; he made national news, in 1987, as he knew he would, by stopping work on his sculpture—the national symbol intended for Washington—in support of anti-logging

campaigns on Haida Gwaii; later, there was the spectacular canoe journey in *Loo Taas* up the Seine at the time of an exhibition in Paris honouring the work of Claude Lévi-Strauss: matters of symbolic significance that have by now entered the national consciousness. As this book is in production, the Haida have commenced a lawsuit seeking recognition of the Haida Nation's aboriginal title to the lands and waters of Haida Gwaii (Islands of the People) before the Supreme Court of British Columbia (filed in March 2002). And the repatriation of ancestral remains taken by institutions continues to be a rallying point. The project has successfully petitioned both the American Museum of Natural History in New York and the Field Museum in Chicago. The strategy was to suggest a fundamental opposition between the sacredness of what they were doing and the science that got the bones into the museums in the first instance. It offers profound ethical lessons and interrogates the nature of the knowledge on which museums' mandates are based—not that the two positions are polar opposites.

As Reid struggled to understand himself as an artist, he realized that his Haida self gave him other rights and responsibilities as a member of a community. With startling, because unprecedented, clarity, he acted out and spoke out about this conflict, and wrote about it in his mellifluous prose. There are other factors such as the fascination with the enduring link between gold (the material he favoured as a jeweller) and status, the full spectrum of Reid's abilities, the sheer fame. And the dangers: making him a figurehead could also make him a scapegoat—the fate of many a public figure. Bringing Haida myth and oratory to bear on a human universal, Guujaaw has likened the shifting facets of Reid's public persona to the shattered image of the moon on the restless ocean. Marcia Crosby's much-cited essay "The Construction of the Imaginary Indian" drew attention to the ways in which, in ignorance, a picture of the unknown, the feared, the imagined, gets fabricated. All this only complicates the construction, a joint effort of Haida and non-Haida people, of this complicated Indian.

Part of the predicament is that Reid has been caught by successive waves of intellectual fashion that have, in turn, influenced the responses of other artists, of academics and of the art market. These fashions include a belief in a universal aesthetic language; emphasis on the artist as product of a specific time and place with the relativizing of cultures and cultural

identity, almost the polar opposite of the first, and now a renewed reach
for global values, an inclination to listen to whose who promote constants,
not fashions—constants which might, all over again, include beauty and
adherence to tradition. Marcia Crosby points out that Reid is habitually sit-
uated at the end or the beginning of something rather than the middle.
What is certain is that he, and the way his work has been received, are fully
implicated in the long-running twentieth-century exchange between "the
primitive" and "the modern." Does creativity arise *ex nihilo,* or is every
artist a construct of his or her place and time? Is the human/animal rela-
tionship the oldest theme of art—as is suggested by new discoveries that
push back the dates for the cave paintings of Europe, Africa and Australia
to nearly forty thousand years ago? Is the concept of beauty a universal,
even though diverse in its particulars? Reid was part of the twentieth cen-
tury's efforts to batter down the barriers that prevented an exquisite rattle
or carved chest—things that had purposes within a culture—from being
brought in and counted as art, not hyphenated art. Robert Davidson's 2004
solo exhibition originating at the Museum of Anthropology, moving on to
a Native cultural centre and then to Canada's National Gallery, might be
thought of as evidence of the successful transfer from "ethnology" to
"art." However, the desire, by an institution with inclusive policies, to
make this promotion (as some will see it) still cannot guarantee a change
of classification within the art world.

The focus on celebrating the achievement of Native art has tended to
overlook these interesting shifts which are part of the dynamic of contem-
porary indigenous cultures. On one level, *The Raven and the First Men* can
be easily understood. It has become official art, with all the potential for
banality and boredom, not unlike certain iconic images of the Group of
Seven, whose official status seems to insulate them from criticism. But there
are other levels which we hoped to get at when we titled the symposium
"The Legacy of Bill Reid: A Critical Enquiry." Some of the symposium's
participants were uneasy with the idea of criticism as disrespectful or dis-
loyal, thinking of it perhaps in a negative or unhelpful sense as what the
Haida call "dirty talk," which celebrity status attracts when so much is at
stake. One positive consequence of paying thoughtful, historically
informed, critical attention to the contexts in which Reid's work has been

received is that it can counter the highly celebratory discourse that ends up ossifying tradition and limiting open response to work by younger artists of Native ancestry. Image and imagination can fight one another.

"Self-centred," "uninvolved," "bringer of change"—words that Reid used of himself—apply to many modern artists. He was his own sternest critic, and did not spare his critical eye for other art, other times and other people. It might be said of Reid's life that "like Rousseau's, it can bear others' scrutiny as it bore his own," in the words of James Joyce's biographer, Richard Ellman. Joyce spent much of his life in voluntary exile from Ireland the better to draw on his Irishness, about which he was at once learned and scurrilous, obsessed by all aspects of Irish life, culture and language but not afraid to turn them inside out, to scandalize the purists. The result? General agreement that his experimental novel *Ulysses* stands both as a great document of, and inspiration for, Irish culture.

What then does it mean to think critically about the ambivalences that Reid had identified through his writing, words and thoughts, over three or four decades? He was interested in scrutinizing and querying the clichés of revival, and we see this book as contributing to a critical discourse that the artist himself initiated and believed was helpful precisely because of a great wall of ignorance and misunderstanding—that may now be eroding, somewhat. Total candour from all quarters may not yet be possible, but there is some agreement amongst contributors that it is neither helpful nor accurate to think of Reid as a lone or solitary figure, operating in a vacuum. Future work from the Haida and others will only honour Reid in complicating the picture.

We hope, too, to correct some of the imbalances created on the one hand by hagiography and on the other by making the Haida experience stand for that of all the First Nations on the Northwest Coast. The publication of Reid's own writings in *Solitary Raven* (2000), edited by Robert Bringhurst, is a useful revelation of his own ambivalences, while Maria Tippett's *Bill Reid: The Making of an Indian* (2003) is a recent attempt to deal with the mythologizing. Although this is the fate of emblems, there is inevitably unease at the misrepresentation whereby Reid-the-emblem overshadows the achievements of other people and other communities: "Reid's own example helped to restore a feeling of pride to native communities up

and down the Pacific coast. Suddenly, the traditions of the Haida and the Kwakiutl and the Nuu-chah-nulth were not limited to rotting totems and a history of disease and dislocation" (Scott 1998). But the Nuu-chah-nulth had never stopped making canoes. At Musqueam and other Coast Salish communities, spirit dancing has persisted in spite of legal suppression and urban encroachment. The Kwakwa̲ka̲'wakw, Nuxalk and others continued to hold potlatches in secret while they were officially banned.

There is much in this book to contradict misconceptions of Native cultures "dying" or being fatally impoverished. There is much to complicate facile ideas of revival, restoration and renaissance, and much that endorses them, too. But during the span of Reid's life, some of the outward expressions of Native cultures—masked dances, totem poles, robes and regalia—came to play an increasingly active role in the public realm outside Native communities. The house-frontal pole carved by Reid and raised at Skidegate in 1978, like Robert Davidson's pole raised at Old Massett in 1969, focussed attention, as totem poles do. All kinds of people projected all kinds of ideas onto them. Although their insertion into the public imaginary may further what some resent as the dominance of the Haida among Native peoples of the Northwest Coast, these new poles acted as generalized assertions about the presence, and power, of aboriginality. And they countered the absence suggested by the catastrophic human loss which had reduced, for example, the Haida population, by 1915, to about six hundred people.

In the 1980s, power relations were shifting again. The persistence of First Nations made everyone understand something fundamental about Canadian history and Canadian society, which is not to say that everyone welcomed the lesson. The 1982 Constitution, with its acknowledgement of pre-existing aboriginal rights, precipitated an unsettling scrutiny of difference and equality within the liberal democratic state. Up and down the coast, poles were being raised and bighouses constructed and opened with due ceremony. Guests invited to witness have always been a vital part of such occasions. Whether the general public, or the media, are invited today is a decision for the family or community where the ownership and rights originate. Whatever it signified for its participants, Qatuwas (People

Gathering Together), in 1993, where teams from many nations paddled to Bella Bella in their great ocean-going canoes for an assembly of more than three thousand people, allowed technology and cosmology specific to the Native cultures of the Northwest Coast to be widely admired, but not necessarily fully disclosed. At representations to the most recent Royal Commission on Aboriginal Peoples (which presented its report in 1996) and at court hearings, however, the display of crest-bearing button blankets made cultural ownership public, spectacular and unavoidable. (Whether or not these treasures and crests should be called "art," and many would say that calling them art only expands on an external set of values and significance, they remain closely associated with power, and politics.) In June 2001, six poles, the work of six carving teams, were raised at Skidegate and the Qay'llnagaay Heritage Centre was established, with plans to encompass an expanded museum, cultural interpretative centre, 250-seat performing arts centre and the Bill Reid School of Art. Reid's name is thus imbricated into a conjunction of ancient culture and modern exposure.

Scholars such as Charles Taylor and James Tully have anchored their own philosophical and sociological analyses to Reid's formulations. For them, *The Spirit of Haida Gwaii* is the perfect emblem of the imperfect, squabbling tensions that keep the multifarious Canadian state contained and afloat. The wanderings—the symbolic journey up the Seine, the metaphoric journey in the black canoe, Reid's ashes in the canoe at the centre of the memorial ceremony at the museum, their final journey in *Loo Taas* to T'anuu—all depend on the idea of the canoe as the epitome of value and the transporter of wealth, and, in many of the old stories, of journeying between realms. Perhaps this is a version of the journey in search of some, perhaps unattainable, goal, as found in Homer's *Odyssey*, the quest for the Holy Grail or in the road movie.

And yet the diversity of Canada, the diversity of this volume, lies in more than the expression of good old liberal freedoms and their compelling new metaphors. This book can be read also for some absolutes: that there are proper ways of doing certain things, not open to experiment; that there are things that some people must do and that others should not; that there are times and places appropriate for certain activities and

others that are not; and that experimentation with or negotiation of these rules is, finally, limited. And so Reid's career does not just chart diversity and irresolution, it points to some social and artistic boundaries. He came up against them himself and made them clearer to others.

The four thematic divisions of this book are nevertheless loosely bordered, as each writer's contribution touches in some way on a number of entangled inquiries: how Reid constructed his own understanding of Haida art and shaped that of others; how his understanding inevitably extended beyond the studio toward interaction with the communities of which he was a part; how the idea of a Northwest Coast "renaissance," and Reid's iconic position within it, may now be revisited; and how Reid's complex and wide-ranging legacy may be differently viewed from local and global perspectives at this particular, not-yet-post-colonial moment. Alert to the political, economic and social events of Reid's lifetime, which have radically changed the way in which Native art is produced and received, the writers in this book contribute to the ongoing exchange of ideas about aboriginality and modern art—a debate that Reid's life work helped bring to world attention.

Inspired by the myths and imagery of his maternal heritage, Reid ultimately invented new forms for Haida oral traditions and philosophies, fusing them with the conventions of Western modernism. In Part 1, *Expanding the Understanding of Haida Art*, four writers examine Reid's process of learning the visual language of his inherited tradition and his desire to restore the aesthetic integrity of Haida art in order to bring his ancestors' legacy to wide public attention. Miles Richardson addresses the tension he witnessed in Reid between his Haida and Canadian identities, and how this played out not only in the artist's sense of responsibility for standards but also in accepting his place within a continuous Haida history. Doris Shadbolt and Bill McLennan reflect further on the choices Reid made. Shadbolt, in tracing Reid's conscious quest towards "becoming Haida," describes his study and practice of the art of a bygone era as the means he chose to bring "Haidaness" into his own awareness and belief. McLennan looks specifically at Reid's encounters with the historically changing nature of nineteenth- and twentieth-century Haida art, and how Reid selected from these sources the formal and conceptual criteria that would inspire his personal aesthetic. From the studio position, George

Rammell reflects on Reid's methodology—his relationship to tools and indigenous techniques—as elements of the process by which he distilled opposing cultural ideals and gave Haida iconography a new currency in the larger world.

Ironically, Reid's passionate urging for recognition of the universal value of Haida art helped to set in motion a transformation in the discourse about artistic standards and criteria as universal, toward one encompassing aesthetics as social practice—acknowledging that when objects are "empowered in a space of use," their social functions may be valued more highly than their aesthetic qualities.[1] In Part II, *Locating Community*, five contributors address the social and political spaces within which Reid and his art circulated, and within which he was differently positioned through ancestry, through patronage, and through narratives both experienced and externally constructed. Guujaaw and Gwaganad represent two of several important First Nations voices in this book who speak directly from their own complicated experiences of Reid and who contextualize their subject within local histories that encompass kinship relations, honour his less well-known peers and predecessors, acknowledge the critiques and difficulties between Reid and the Haida community, and unquestioningly affirm him as Haida. Karen Duffek focuses on Reid's ties to the Museum of Anthropology, and how he used the institutional space not only as a conduit to his material heritage but also to engage in public debates about the positioning of Haida art within shifting regimes of value. Reid's relationships with prominent individual and institutional patrons is examined further by Alan Hoover, who offers a critical assessment of the interplay between patronage and Reid's public reputation as the pre-eminent Northwest Coast artist of the twentieth century. How Reid "became Haida," and came to be considered a cultural hero, are explored by Marcia Crosby as elements of a salvage narrative that denies the varied experiences of Haida people in the last century; she argues that Reid belongs not at the beginning or ending of this story but in the middle of contemporary Haida history.

At once a symbol of and a skeptic about the Native artistic "renaissance," Reid has been at the fulcrum of most celebratory as well as critical discussions of late twentieth-century Northwest Coast art. In Part III,

Revisiting the Revival, five essayists query the premises on which the idea of "revival" is based. David Summers investigates multiple interpretations of the historically complex Western term "Renaissance" and how its characteristics may apply to the circumstances of Haida art and Reid's role in its renewal. Taking a close look at the decades preceding Reid's career, Aldona Jonaitis analyses how rebirth has been conceptualized as an event that followed the decay and death of a more perfect, more canonical version of indigenous art. With his metaphorical chainsaw in hand, Doug Cranmer, who worked as Reid's "other-side man" in constructing UBC's Haida village, takes a slice out of Reid's reputed role as the artist who revived the practice of monumental carving. Ki-ke-in reflects on his own personal experiences of the artist, as well as the often contradictory elements of Reid's public persona as both the creator of a renaissance and "a most unlikely Indian." And Aaron Glass suggests that Reid's role was that of a culture broker who, in mediating between histories of indigenous production and global reception, helped "Northwest Coast art" to emerge as a publicly recognized category.

The idea of expansion—of rules, of audiences, of references—is evident in Reid's work and in the diverse approaches of contemporary Native artists toward aboriginality and modernity. Yet much contemporary Northwest Coast art remains at the periphery of current critical discourse. In Part IV, *Reconciling Aboriginality and Modernity*, four writers look at the local, national and international contexts within which Reid's work came to be understood, and in which Native artists continue to define conflicts and convergences today. Scott Watson examines the tensions between demands for restoration and for modernization of traditional art practices through several decades of social and political change. Charlotte Townsend-Gault looks at Reid's complicated relationship with the terms of modernity, and how his struggles paved the way for succeeding generations of artists to, in their turn, struggle with the contemporary significance of aboriginality. Examining her own responses to Northwest Coast works located in museums—Reid's sculptures as well as historical objects from her own community—Marianne Nicolson reflects on questions of cultural ownership and the possibility of creating contemporary works of cross-cultural significance and intent. Finally, Leslie Dawn reviews how art history and

anthropology have claimed Reid's productions as their proper objects of study, and how Reid engaged with both disciplines in constructing and then challenging the terms on which the idea of "revival" was founded.

WE ARE GRATEFUL to all those who contributed to this project. With generosity, they brought to it their long experience; with their ability to think on their feet, they stimulated the symposium; and with their patient and feisty co-operation, they enlivened the editorial process. All of which helps to get us beyond not tradition itself, but beyond being stuck in immutable, incapacitating awe of it. Our thanks go, first, to the contributors to this volume: some of whom reworked their original presentations given at the 1999 Reid symposium, others whom we invited to add further dimensions and new voices to the discussion. Sadly, Doris Shadbolt, Reid's most important biographer, passed away just prior to the publication of this book, and it is with a sense of honour and respect that we present the essay she prepared for this volume. Martine Reid assisted in the planning of the symposium as well as a publication to arise out of it, and we are grateful for her valuable input. To all other speakers, moderators and commentators at the symposium, we thank you for contributing your ideas and questions, and thereby helping to shape a critical space for ongoing dialogue: Robert Davidson, Lois Sherr Dubin, the late Marjorie Halpin, Stephen Inglis, Gerald McMaster, John O'Brian, Martine Reid, Robin Wright and the many audience participants. Special credit is extended, as well, to the Museum of Anthropology, for its intellectual and financial support of this project; to its former director Ruth Phillips, who during her tenure initiated the idea of the symposium and supported a publication to follow; and to project manager and curator Bill McLennan, who assisted enormously with photography and assembling images. Financial support for the 1999 symposium was provided by the University of British Columbia's Faculty of Arts as well as the Social Sciences and Humanities Research Council of Canada; without that original support, this book would not have come into being.

When we approached Loretta Todd, inviting her to write an afterword, we wanted to give the last word to an acclaimed artist of aboriginal descent whose films and writing have helped to shape the way that appropriation has been thought about, who has questioned the hierarchies of value which

put weaving, basket-making and dancing lower than woodcarving, and pointed out the exclusionary ways in which official history gets written. But Todd was uneasy with "afterword." It suggested, she said, that something had already happened, already been dealt with, was over. "Beyond" was better—cumulative, honouring, a forward momentum, not fully knowable. We are grateful for "beyond." We hope it characterizes this book.

ENDNOTE

1. David Summers, comments made at 1999 Reid symposium. During the symposium, both David Summers and Marjorie Halpin participated in a question-period discussion about the well-made object. Halpin had observed that while the well-made object may be desired and appreciated, it is less easily "theorized." Summers took up the point, responding that in Renaissance terms, skills and virtuosities were not understood as simply aesthetics but as "social practices, as culturally specific practices." Halpin had herself pointed out that in much of the discourse surrounding Native art, the well-made object represents a "moral imperative" for aboriginal societies—a notion she could no longer accept. She suggested that Bill Reid may have shared Summers's definition of the well-made object as "that behaviour into which people are educated," adding: "I think we have Bill Reid to both thank for it and for keeping it in our sights as a very important thing to strive for, but also for complicating it as only a trickster could do" ("The Legacy of Bill Reid " 1999).

I

Expanding the Understanding of Haida Art

On Its Own Terms

by MILES RICHARDSON

Based on the transcript of comments made at the symposium "The Legacy of Bill Reid: A Critical Enquiry," organized by the University of British Columbia Museum of Anthropology and held at the UBC First Nations House of Learning, 13–14 November 1999.

H AIDA LAAS, good people: I am Kilsli Kaaji Sting, and I am of the Eagles of Chaatl of the Haida Nation. First thing I'd like to do is acknowledge the Musqueam Nation and the great Salish Nation in whose territory we are gathered this morning. Before we begin this session of Haida speakers, I'm going to ask Nika Collison, Bill Reid's granddaughter, and Marianne Jones, Haida citizen, to come forward and start off with a spirit song to invoke Bill and some of the spirits of those who have gone on.

Shortly after Bill's passing and the beautiful memorial ceremony we had in the Museum of Anthropology, I was working in my office in downtown Vancouver when I got a call from Doris Shadbolt, Bill's biographer. She was obviously stressed and needed to talk. We agreed to meet for lunch the next day, and when she arrived she was still very disturbed. She had one question on her mind: was Bill Haida? That was a really special moment because, to me, that wasn't even a question.

Bill's mother was Sophie Gladstone, from Skidegate, and in the Haida tradition that's how we trace our identity. Bill came from a very strong Haida family with deep roots and rich traditions, and a mother who cared for her children very much in a difficult world. Much has been made about

the early years of Bill's life with his brother, Bob, and sister, Peggy, and with their parents keeping them from knowing about their Haida heritage. That's not a unique experience amongst Haidas or amongst First Nations people generally. It wasn't until he was in his twenties that Bill really discovered that he was Haida—that his lineage traced back through his mother to this nation of people. It was quite a revelation for him, and it really put some clear and somewhat difficult choices in front of him in coming to terms with that.

You can read his biography for all the details, but he returned to his mother's village and found out about, and met, and got to know, his relatives. His family was clear and without question. He had two aunts who didn't live there—Irene and Ella Gladstone—and he had uncles—Percy, Willy and Ernie Gladstone—who were each rich human beings in their own right and very much a part of Skidegate and the Haida Nation. I know that Bill's Uncle Percy was one of the mentors in my life, and a person whose accomplishments I respect very much. He went off in the Second World War as an air force gunner, and he came back and was one of the first people in our village to get a master's degree in economics at a time when no one really went on to university. I remember Willy: he looked like a big Swede. He had big bushy eyebrows and was a really good carver. In Skidegate, everyone who owned a trolling boat (that's how everyone made their living in those days) had a boathouse, and that's how I remember Willy and Ernie. They had a beautiful boathouse, and it was right where the bighouse is today—where Bill raised the totem pole in Skidegate. Their boathouse was right there, and it was fascinating to be amongst them and spend time with them and see their craft. A boat they built was called the *VTG*, the initials of Ernie Gladstone's wife, Vera Thomas Gladstone. My dad eventually bought it, and he fished his whole career on that boat, which he subsequently named the *Juan Pérez*.

That was a really rich place and a rich time that Bill came back to. You can only imagine him, being amongst his relatives and people, and seeing this rich life and this rich culture that he was just becoming re-exposed to, and coming to terms with and accepting. We, the Haida Nation—and I believe, humankind—are better off because he did accept that part of himself, that important identity that he was an heir to. He put the best he had into living it and bringing it forward. Bill was like that. Above all, he was a

thinker. He really thought about who he was and what he stood for and what was important to him. Once he made up his mind, he had the courage to live it. It was beautiful to watch, and I'm honoured and privileged to have had the opportunity to be his friend and to benefit from his advice and guidance.

Bill took a really fascinating part of his inheritance and made his entry there. This art, this cultural legacy, fascinated him. I remember that when I was involved in politics and he was also involved, it used to awe him how ten thousand people amongst humanity could get so much attention as the Haida Nation. They have such a reputation and such a presence, he'd say, that you'd think they were a far larger population. He took that and he did his best to understand that. It was much more than art to him: it was a way of being; and those manifestations of ways of being represented ways of thinking, every bit as much as they were ways of seeing. You can see that around you. What do those pieces of art mean to you?

He understood that, in order for cultural expression and art to continue to be strong, there had to be standards. You can't represent just anything as Haida art, in his view. He worked to develop high standards, unprecedented in his time, and attempted to infuse that into his work. He took a lot of criticism from Haidas and others for his work and ways. He used to tell me about coming out of Ryerson Polytechnic as a goldsmith: he worked there with this old German, and he'd be on his eighteenth ring, trying to get it right, and he'd think he had it just perfect, and the old guy would take it and pound it back to nothing. It would just break his heart, but he kept on. He developed his standards, and I think that is a really important part of Bill's legacy that the living generation of Haida must continue. That is my understanding of one of the main purposes of the Bill Reid Centre at Qay'llnagaay, at Second Beach: to develop an institution for clarifying and developing standards in Haida art and teaching young artists to carry forward that tradition.

Why do the Haidas have such a reputation in the world? Our forefathers developed a way of living—a culture—that captured the attention and the imagination of other human beings, simply on its own terms. Not because it was Indian art or aboriginal art or anything like that. Simply on its own terms, it was worthy of praise and attention, and that is very much

a part of what interested Bill. Sure, he identified with us—those of us who are living—and he got along with us pretty good. I mean, we'd fight amongst ourselves like anyone else, and we'd have wonderful sharing days, and days when we'd be arguing: just the stuff of life. But Bill really related to the ancients; he related to the old people and the old ways. When he looked at their creations, he felt he had a bond with them, and that in his manifestation, today, he had an opportunity to connect with them. He understood the realities of life, the importance of politics, but he had a very strong connection to the old people. I think it was very appropriate, and I feel grateful to Martine and to his clan, the Raven and Wolf clan of T'anuu, for taking him back and placing his ashes in T'anuu next to Charlie in his old ancestral village. I think that was a fitting final act in Bill's life, because that is where he was comfortable, that is who he was comfortable with and that is who he strived to live with. It was beautiful to watch.

If I was looking at Bill's life work in terms of technique, he developed standards in Haida art and tried to bring it to the best that he could. The ideal to him was the well-made object, as he often said. After the crest of this magnificent (in my view) ancient culture, there was a downturn for the last couple of hundred years, for reasons we're all familiar with and that I'm not going to get into now. Bill picked up this legacy at a very difficult, and some would say dark, time in our nation. He picked it up and he took it out in a new direction in a contemporary world. He sat it up there under his own interpretation, his own creation, and again it was respected and accepted on its own terms. Incidentally, it was Haida art. Canadians were very proud of him as a Canadian artist, and Bill was proud and patriotic as a Canadian. But he brought that rich tradition and he resurrected it in today's world on its own terms. That's an awesome accomplishment and will always be a huge part of his legacy to me.

On days like this, on a Saturday, Bill would always ask me what I did: "What do you do, Buddy? Tell me what you do in politics." So I'd give him a spiel about Haida title and injustice and all these other things, and he'd seem kind of bored with it. Then I'd ask him, "Bill, what's Haida art? What makes Haida art Haida art?" About two hours later, he'd be waking me up. But when we got into a bind in politics, as we often did, Bill was always there. When he was doing *The Spirit of Haida Gwaii,* we were working to protect

an area of Haida Gwaii where the logging was imminent. He was preparing *The Spirit of Haida Gwaii* for the Canadian Embassy in Washington, D.C., and he quit work on it: "I'm not making this for you, Canada, if you are going to do this to my people." It was a gesture he made, and who knows what effect it had. But Bill put his heart and soul into it.

Another time, we had been blockading and stopping the logging companies on Lyell Island from working. After all that happened, there was an IWA strike—the forestry workers' union—and the union made a decision that since this company hadn't been able to work all these months, they would give them an exemption from the strike. Politically, this was not on, in our view. So Bill decided he was going to do something about it. His health wouldn't permit him to be on the blockade, so he was donating art and raising money. But he really wanted to do this, and I know that Marianne Jones was one of the people who packed Bill up this logging road on a really cold winter morning—really rough terrain, and it was raining and blowing. It's still dark out at that time of year: just a desolate logging road seemingly in the middle of nowhere. Bill sits on a chair with his rain gear on, carving on cedar, pitch black outside. Around the corner comes a convoy of logging trucks—there must have been ten of them going to work that morning. The first one pulls up, and Bill is right in its headlights. The boss gets out and walks up to him. Usually, they're quite rude to us, but the boss says, "Good morning, Mr. Reid. What are you doing?" Bill looks up at him and says, "Oh, just whittling." That issue was dealt with, politically, not long after.

Bill had his hands and his full heart in the endeavours of the Haida Nation: he was an ambassador for Haidaness and for the Haida Nation. I'm proud to have known him. I think that Bill and his life have taught us all; his ways and what he did can still teach us a lot. I know that we need to move on, but we should always remember the gifts and insights and ways of living that he shared with us. *Howa.*

The Will To Be Haida

by DORIS SHADBOLT

ONE EVENING in the early 1950s, my husband, Jack, came home from a visit to see his mother in Victoria. He handed me a small package, which, on opening, revealed a silver brooch in the form of a seal. On the back were engraved the words "Haida Art, Bill Reid." Jack had encountered Bill on the ferry and recognized him as the adult of the youngster whom he had known many years before in a Victoria elementary school where he (Jack) was teaching. At the time I had not met Bill nor indeed heard of him, for he was not then the famous iconic person we know today. He was a young jeweller craftsman returning to Vancouver from Toronto where, while he was working as an announcer for CBC Radio, he had completed a course in the European techniques of fine jewellery making at the Ryerson Institute of Technology. He was already committed to a career as a jeweller and believed, as he said to me later, that jewellery was one of the oldest arts and perhaps the most comprehensive of all, requiring an enormous knowledge of materials and all the techniques of manipulation. He himself had started at the age of twenty-eight—much too late, he said: he should have apprenticed at the age of sixteen to have truly mastered the craft. He always seemed to have doubts about his ability as a goldsmith, evidence to the contrary.

The deficiency in our acquaintance was soon remedied, for Jack and I often visited Bill in his house in Kitsilano, where he had a workshop in the basement from which he would make small items such as cufflinks to sell for twenty-five or thirty dollars. And then in 1963 he set up a wonderful spacious

four- or five-room workshop on the second floor of a ramshackle wooden building at the tail end of Dunsmuir Street, where it then petered out between Thurlow and Bute Streets. In several of the rooms there were jeweller's benches and often one or more Native people of a younger generation, about whose future Bill often despaired and to whom he was determined to hand on his knowledge and his skills. I was working as curator at the old Vancouver Art Gallery at the time and could slip out by the back door, cross the alley and walk across the parking lot, and be in his studio in less than five minutes. He could do the same in reverse, and we shared many visits in those years. I learned something about the Native history of this country, of which my education up to that point had left me in ignorance, and I had the privilege of seeing at first hand the evolution of his wonderful pieces, either on one of the benches or as he would take them out of his pocket on one of his visits to my office. There were many conversations and opportunities for taking notes, and, during the course of this essay, any time that I quote Bill, I am referring to things he said to me in conversation.

At the time when I was coming to know him, it seemed that whenever Bill's name came up for discussion it was almost always pointed out that he was only part Indian (as First Nations people were then commonly referred to), having had an American father of German and Scottish descent, and having been brought up in largely white communities by a mother who had pretty thoroughly assimilated anglicized attitudes and values. Even an infamous recent article in *Maclean's* magazine, which had set out to diminish his reputation, wasted no time in pointing out rather disparagingly that he was only part Native, as though from the start he was somehow compromised. So when I first began to think about the book I had undertaken to write about Bill Reid, I knew that one of the questions I must deal with was the question of how it was that this person should end up as our ur-Native artist. And so the first chapter in my book was given the title "Becoming Haida." I admit that at the time of writing I didn't realize the full import of those words "becoming Haida," which I had not heard used before. When someone, I do not remember who, proposed a book of that title, they were shooed off what at the time I thought of as my property.

The facts of Bill's early life are well known, but, as a prelude to addressing my topic, they must be briefly recalled. Bill was born in Victoria on January

12, 1920, where for one year he attended the private school of Alice Carr—a fierce disciplinarian, according to Bill—whose more famous sister, Emily, used to appear in the classroom from time to time, and where he also briefly encountered my husband, who happened to be a young substitute teacher in the elementary school Bill was attending. (What Bill remembered was that Jack, in that role, read the class poetry and had them all painting Picassos.) While Bill was still a young boy, his mother took him north to join his father, who had a hotel in Hyder, a mining town on the American side of the Yukon/Alaska border just across the river from Stewart on the Canadian side. He never lived in Stewart but did go to school there.

When Bill was thirteen, his mother took him again to Victoria, where she set up a successful dressmaking business to support her children and where Bill went to high school and for one year attended Victoria College. Bill remembered visits from his mother's Native relatives, her sisters and brothers, when he was growing up. He remembered the gold bracelets bearing Native designs that his aunts wore, but he never thought of the relatives as being Native. For one thing, he told me, they didn't on the whole look "Indian." There had been a white person in the family tree someplace along the line. And also because his mother, whose life had been formed during a time of intense demoralization for Native people, when it was difficult to take pride in being one, took pains to suppress her origins. Later on, when Bill began to take an interest in the Native side of his heritage, she was less than enchanted when, in his own words, he "began digging up those old bones which she had spent her life trying to bury." So he never thought of his relatives or himself as being Indian.

All this is by way of saying that in his formative years, Bill had no real contact with Native culture. He did not live in a Native village, play on the beach with the other kids, hear the elders telling stories or take part in Haida community events. He spoke excellent, indeed elegant, English and was equipped in all the obvious ways to move into the white mainstream of Canadian society, as his brother and sister did. They had been brought up under the same circumstances as he had, and they moved into successful careers in Ontario and England. As he himself said, he was well into his teens before he even became conscious of the fact that he was anything other than an average North American Caucasian. But then, perhaps simply

stirred by a normal curiosity about his mother's side of the family, since his father was rarely there to talk about his, Bill finally at the age of twenty-three boarded a co-op seiner and went to the Queen Charlotte Islands, as they were then still called, on a voyage of self-discovery. There at last, in Skidegate, he met his grandfather, who had been taken on by his famous uncle Charles Edenshaw, in a pattern of adoption common among the Haida. Edenshaw had taught Bill's grandfather the basic techniques for making engraved gold bracelets, although, according to Bill, his grandfather was never particularly good at it, just adequate. Bill described his grandfather as a white-skinned fair-haired man with whom he found immediate rapport, even though the old man spoke virtually no English. The grandfather had inherited Edenshaw's tools and had carried them on his back the eighty miles from Old Massett to Skidegate. Bill was permitted to handle the tools, some of them with Edenshaw's own ingeniously made handles of bone or ivory.

Through his grandfather, Bill met for the first time a number of the older men and women for whom the old traditional ways of living were still alive in memory and whose presence and bearing bespoke their pride in being who they were. I believe this visit was a critical turning point for Bill. As he himself reflected, he was well into his teens before he even became conscious of the fact that he was anything other than an average North American Caucasian. Whether or not Bill saw a clear fork in the road at that time, one road pointing back to his Native roots, the other to a future in the white world of art and business, and made a conscious decision at this point, I do not know, but certainly there was born then a sense of affinity with his Native ancestors, a recognition of common experience across the years, a belief in their dignity and a respect for their accomplished and responsible art—for it was art in the service of the community. That sense was to remain with him, deepening until it became the firm core of his life.

There were really two reasons for Bill to choose the road back to his ancestors. One was his recognition of the human qualities he admired in the elders he had come to know a little, and then, of course, his admiration for their skills (there were those bracelets in gold and silver with Native designs that his aunts had worn on their visits in the early years). On graduating from the Ryerson Institute of Technology course in jewellery making, the first thing he wanted to make was a bracelet bearing a Haida

design. By the time he set up his first workshop in Vancouver, he was already committed to making jewellery, drawing on the old designs. He was to make several spectacular pieces of contemporary jewellery in the late 1960s and '70s, but he would say that he couldn't be satisfied making pretty baubles for pretty people. The second reason, perhaps just as persuasive as the first, was subjective and very personal. Thanks at least partly to his mother, he was able to move with ease and grace in the white community, but he did not feel at home there. Growing up in non-Native communities had not given him a sense of Canadian identity. He felt adrift as a Canadian and desperately wanted an end to that cultural drifting.

I used to think that the aura of melancholy that surrounded Bill like a cloud was the result of having two cultural heritages to deal with. He spent a lot of time with me, trying to explain his family's relation to each other or to Charles Edenshaw (and he once drew me a heredity chart), but he never did mention the fact that he was actually a Haida by blood, having both a Haida mother and a Haida grandmother. That gift of blood didn't make him feel a Haida, and he desperately wanted the feeling of cultural security he had witnessed in that first encounter with his elders. In the early days Bill often referred to what he (and perhaps others) did as "artifakery," and it only struck me belatedly in thinking of all this that it was a reference to the fact that he did not consider himself authentically Haida. He made things quite clear to me some years later on my first trip to Haida Gwaii. We were on a film shoot, and between episodes at T'anuu, with Bill sitting on a moss-draped rock or stump, everything beaded with tiny luminous pearls of mist, I asked Bill why, when he had approached the fork in the road, he had followed the Native path back to his ancestors rather than pursuing the mainstream route for which he appeared to be well prepared. He replied with absolute clarity and certainty that he had observed that modern Western cultures seemed to be lacking in any viable functioning myths that could affirm life for him and give him the sense of inner conviction, knowledge and community that he longed for. And so he set out on the arduous journey back to claim his Haida identity.

How by a conscious act of will do you gain belief? How do you become Haida? For Bill, the main route was through a meticulous and thorough working through of what we think of as the art of his ancestors:

the totem poles, the wooden boxes and feast dishes, the masks and, of course, the bracelets. His chief role model was always Charles Edenshaw, whom he finally decided was his great-great-uncle. Edenshaw's career started when Haida culture was still intact and ended after it had come close to being destroyed. He went from creating great ceremonial art to working for the curio trade. But, said Bill, he brought great integrity to both. In taking this route, Bill must have known, or intuited, early on, what anthropologists and cultural historians surely know: that a culture is expressed and imbedded in its arts and their close cousins, the rituals, and that it is those arts and rituals that keep a culture alive when it is threatened. His personal journey to self-discovery, inspired by and commencing with those first youthful trips to Haida Gwaii, took on momentum, direction and method when, while announcing for the CBC in Toronto in the 1940s, he discovered the large and magnificent Haida totem pole rising three storeys in the big stairwell of the Royal Ontario Museum—a wonderful installation in which the pole unfolds before you as you mount the stairs. The pole was from T'anuu, the village where his grandmother was born and where he would be buried almost fifty years later. He spent a great deal of time with that pole, studying it and gradually coming to see and feel its characteristic forms and their interrelationships. "Things began to come together in that pole," he said.

I remember a long time ago I came upon a powerful statement by Bill Holm from his classic book, *Northwest Coast Indian Art: An Analysis of Form*. It was repeated by Ted Carpenter in his introduction to another remarkable book, *Form and Freedom: A Dialogue on Northwest Coast Indian Art,* a collaboration between Holm and Reid. Carpenter quotes Holm as saying, "I, myself, have derived a certain physical satisfaction from the muscle activity involved in producing the characteristic line movement of this art, and there can be little doubt that this was also true for the Indian artist." For me personally, that remark tingled with a truth I had long known and I was thrilled to have it confirmed in Holm's own practice as a non-Native American who had steeped himself in Native culture and become himself a skilled carver. In a most interesting speculation, he goes on to suggest that there may be an interrelationship between the characteristic movements of Native dance and the visual art styles of ovoids and linear

patterns, and he found participation inseparable from his understanding. I cherished this remark from the moment I read it because it demonstrated to me how the body has its own form of knowledge and ways of learning the cultural messages encoded in the old forms.

Along with "the well-made object," another of Bill Reid's phrases never long from his lips was "deeply carved"—a phrase that, according to Wilson Duff, also occurs frequently in the early texts. Bill first heard it when he went north for his grandfather's funeral. Someone told him that he should go down into the village and see Mrs. Tulip's bracelets made by Edenshaw: they were "really deeply carved." He went down and saw them and "the world was really not the same after that," Bill said. He went on to say that "deeply carved" only meant well made, but, in the context of other discussions, I knew he really meant that some designs dug the old meanings into the wood or gold, or whatever the surface, more profoundly. He was often critical of the young carvers who came into his studio "not really knowing who they were" in the sense of self-discovery: that is, he said they had never put themselves through the process of bringing their Haidaness into their awareness, but they claimed to be Indian and therefore everything they did was automatically Indian. For himself, he believed that art without belief, but with mere technical ability or skill, was likely to be meaningless.

In Holm's book *Northwest Coast Indian Art,* there is a reproduction of a bracelet by Charles Edenshaw alongside one made by a journeyman copyist of Edenshaw's work. Bill, in pointing to the "deeply carved" quality of the Edenshaw, noted that the Edenshaw design "didn't slip around on the surface" but "echoes consistently in the rectangulated corners and the ovoids." And so he set out to put himself inside that bubble of "belief," and his way was primarily through an intense and prolonged study of the old art, making copies from Charles Edenshaw or from other masters, always acknowledging his debt to the past. Naturally, he was impatient with young carvers who wanted immediate results and success. They weren't prepared to go through his slow process of study and practice, and, in so doing, allow themselves to be "deeply carved" by the culture as he had done. He often spoke of his disappointment and again in 1978 when he undertook to make and raise a totem pole for his mother's village of Skidegate. It was intended

as a return to his Haida ancestors for all he had gained from them and in recognition of his gratitude. He had erected a plastic-covered shed in which to work, and he put up a sign inviting assistant workers to come and help him on the pole, thinking of it naturally and as always as a learning opportunity for the next generation. Several would come, he said, and stay perhaps for half an hour and then disappear, never to be seen again. They wondered why he was bothering with drawings and plans, and if they were carving a pole, why not just get at it with the tools. His disappointment was intense. He himself continued to refresh and hone his knowledge of past art throughout his life while acquainting himself thoroughly with the Haida style of design and, of course, the cultural language it spoke. But it wasn't just Haida form he had to learn. He had to understand what the old art was about in terms of its content: the relationship between animals and man and the universe and how order is maintained—all that had been given to Northwest Coast artists like a shaping, conditioning cloud, which their ceremonies and rituals didn't let them forget. Bill, of course, knew that all that collective cloud of the past had gone and that literal belief was impossible; but there was poetic, metaphoric belief, and he succeeded in putting himself in that space. As he said, the "whole business of doing and re-creating form from a period requires a mind set" that is in tune with that other period. So he had also to get to know the stories and myths and the characters that animated them.

Bill had first heard some of the old stories from Henry Young, his grandfather's great friend, a man in his eighties when Bill first met him, but over the years he became familiar with all the creatures in the Haida bestiary: the Raven, of course, and the Bear, Wolf and all the others who became his familiars. So he was able in his familiarity to invent his own stories or to introduce variations on the old ones, and finally he was ready to free the creatures from their static positions on poles, crowded on top of one another and imbedded firmly in the wooden matrix, and permit them to step out into real space and enact their dramas and tell their new stories. He said he had always thought of the creatures in the traditional art as actors waiting for a curtain to go up so that they could perform their roles. He said he wanted to let them loose before the curtain goes up. This he began to do for the first time, perhaps, in the boxwood version of the

Raven discovering mankind in the clamshell, and he was at his freest (or his creatures were) in *The Spirit of Haida Gwaii*. The creatures are known, established personae in the stories, but they are taking part in a drama of his invention. This break from the formal and schematized conceptualism of the traditional art was Reid's most innovative artistic move, if we think in terms of conventional art history—off the totem pole into the theatre without breaking the connection with the past—and it has been one that made him accessible to non-Native audiences. And so Bill, at the end of his journey, had found his way home. A part of his inner being was Haida. There was no more talk of "artifakery" and when, on returning from one of his trips to Haida Gwaii around 1986, he announced that "the ghosts had left T'anuu," I took it to mean that he had made his peace with his ancestors and was now sharing their spiritual space.

There still remained for Bill the task of connecting with that spiritual space through the rituals, that other form in which cultural meanings are embedded and carried through time. When a younger generation of Native people, including Robert Davidson, began to revive and perform the old dance rituals, Bill, I am sure, understood and appreciated what was going on, but dancing was not his way. He had a natural aptitude as a storyteller, and for him this became another way that he could give life to the tradition. He was very aware of the connection he was making whenever a group was gathered together to hear him tell about the Raven bringing light to the world or something else from the repertoire of stories he carried around in his head.

Over the years people have tried variously to fit Reid into the mainstream of modern Western art, thinking that this, in typical Eurocentric fashion, would be a validation of his art. Their effort was mistaken, as Bill does not belong in that tradition with its rigorous search for its own self-defining truth. I remember the sternness with which he once said to me, with self-mocking emphasis and deliberation, and at a time when he was already starting to receive a lot of critical attention, that he "never intended to become an artist" (as commonly understood in the context of Western art history). Ironically, he did become an artist, and a very great one, though of a different and much more rare order, and one denied to most of his contemporaries. And it came about as the result of what, after so many years of knowing him and talking to him, and recently thinking about him,

now seems so clear to me: that the central driving passion in his life was to be Haida: not just a Haida by the incident of birth that, according to Haida rules of succession, a Haida mother and grandmother automatically made him, and not just a Haida by blood, but an aware and conscious Haida with the inner assurance of identity and knowledge and the sense of community that that meant.

Becoming Haida, however, involved more than the inner conversion for which he had largely drawn on the material culture of his ancestors. There was also the outer being, the "Haida in the world of social and political action": the being and being seen in the world as a reacting, responsible Haida, and action in a time of reawakened Native consciousness and increasing problems with land claims, Native rights and ecological threats. He never wanted a weighty role, never wanted to revive culture or be involved in all those social problems, and he sometimes wished that he had been able to be successful as a contemporary jeweller and so have been free from the whole "Indian problem." Certainly, if in achieving his success in the urban world he had leaned heavily on his ancestors, as he constantly reminded himself, he knew that the reverse was equally true: the ancestors could lean heavily on him once he took up the burden of Native causes. He knew that the art was not separable from the culture, and his prolonged immersion in the art led him to a profound respect and feeling for their makers' larger accomplishment as human beings. And so he became the silver-tongued spokesman for his ancestors, exerting constant effort to compel the world to recognize his forebears' essential qualities, through his eloquent writing, frequent interviews and appearances as guest speaker at conferences, openings and other events. And occasionally there was overt political action, such as stopping all work on *The Spirit of Haida Gwaii* while he joined in a protest against the British Columbia government's approval of logging on the southern half of Haida Gwaii.

The closing words should be Bill's, I think: "I've spent most of my life with a feeling of identity with the Haida people, always, of course, at a distance in some urban location. Recently, however, I've finally had to face up to what it really means to be Haida in the later part of the twentieth century and at last, in fact, may have to become a Haida." This is from a verbal statement he made to the Wilderness Advisory Committee in 1986. He had, of course,

become a Haida quite some time before, and he was acknowledging it here. To complete the story of his evolution into Haidaness: before he died, he potlatched his people and, following Haida practice, adopted a boy into his clan. If there were any doubts about how his Haida peers felt about his status, they were dispelled during the memorial service held in the Great Hall of the Museum of Anthropology, at which he was, over and over again, acknowledged as a great Haida.

A Matter of Choice

by BILL MCLENNAN

B ILL REID'S WORK is clearly identified as Haida by its conceptualization, its
naming and its recognition by the Haida Nation. But is it ethnographic
art, modern art, commercial art—or all three? There seems to be a need to
categorize art before it can take its place in the hallowed halls of a museum
or gallery, and a need to articulate its relation to society before the appro-
priate critics can express their views. How Reid's artworks should be
categorized and where they should fit in the art world parallels the inability
of our society—that is, the greater North American milieu—to recognize
the right of First Nations people to determine their own continuing tradi-
tions and legacies. It reflects our possessive overuse of the word "art" to
reflect our society's visual expression current at any particular time. But it
fails to recognize the rights of other societies, particularly indigenous ones,
to change and adapt. More clearly, it shows our society's lack of knowledge
about or interest in understanding another's art on its own terms.

Questions of ethnic authenticity—Is it Haida? Is it Reid?—stem from
the Euro-American requirement of intellectual and artistic continuity.
Such questions continue to reflect the criteria of nineteenth-century
ethnographic collectors who scorned Haida argillite as non-traditional.
The basis for their reasoning was that the only legitimately traditional
works were those made of materials and forms belonging to pre-contact
times. Art created for sale to European and American traders, or even
works made for artists' own communities using materials traded into the
community, were looked upon as inferior. Argillite, which may not have been

carved prior to contact, became a "new medium" used to present images of
Haida histories and Euro-American contact. Because argillite did not have a
traditional or functional past use, artists appear to have had greater freedom
in their conceptualization and portrayal of images when working in this
medium. The category of "art" would encompass the works they created.
Just as the ethnographers wanted only the unadulterated, the missionaries
and government wanted the "pure," with the heathen removed and relegated
to the past. These contradictory values from our society, the judgement
society, denied the rights of the Northwest Coast people, who were drawn
or forced into a socio-economic dependent, government-imposed struc-
ture rather than being allowed to continue to grow from the roots of a ten
thousand-year-old history and to benefit from the encroaching Euro-
American societies.

The choices that Reid made early in his artistic career drove the process
which culminated in works such as *The Raven and the First Men* (1980) and
The Spirit of Haida Gwaii (1991). These choices also bring forward questions
of our society's responsibility to understand and appreciate cultures other
than our own, in particular those of First Nations, whose histories and
relation to the land are inevitably deeper and more complex than those of
recent arrivals.

Reid's process of acquiring traditional knowledge, aesthetic insight and
carving skills was by no means "traditional." When he decided to pursue a
career in creating Haida art, he did so without cultural constraint, unbur-
dened by any social obligations associated with what he might produce.
He would not have known of these intricacies, since he did not grow up in
the Haida community. Reid's contact with Haida people was through family
members residing mainly in Victoria and Vancouver. His initial attachment
to the art was perhaps a counter to his mother's distancing herself from
her Haida identity. In addition, Reid's art was for the market; it was a means
of economic support. As he began to understand Haida aesthetics, he
found inspiration in the artworks of nineteenth-century Haida artists, par-
ticularly Charles Edenshaw. Edenshaw was an artist bridging two worlds:
one now past, in which visual representation was owned and controlled by
family rights, and in which the identity of the artist/craftsperson was less

important than that of the object's owner or commissioner; and another, now prevailing world in which the artist sets the boundaries of the art and his or her name is the prominent one.

At the start of his career, Reid did not feel obligated to connect his work to the continuum of Haida art still present in the late 1940s—a carving practice carried forward by a twentieth-century Haida society whose cultural loss was shaped by imposed potlatch laws and the changes that government, church and industry had brought to Haida Gwaii. Haida art was still produced in modest amounts, primarily for the tourist and collector market, but little was made for cultural use within the community. An aesthetic value for the art remained in place, though diminished from the refinement and complexity characterizing works from the nineteenth century. The loss of aesthetic or visual sophistication in Haida art parallelled the people's forced loss in cultural determination. The works still being produced by Haida carvers in the 1940s did, however, carry forward a cultural component that has fuelled the fires of enthusiasm since the early 1960s. As Wilson Duff (1972:5) pointed out, "Raven remains Raven no matter how well or poorly it is depicted . . . Visually, it has only to meet the minimum requirement, recognition, to accomplish its entire job." The object embedded in community culture supersedes the question of aesthetic value. Its importance is carried not only in its artistic composition but in its relationships to physical involvement and human interaction: oration, song, dance, symbolic representation and continuity. In this way, objects become culturally significant by keeping memory alive. Reid's primary focus, however, was on the visual qualities of the classic nineteenth-century Haida style, and in retrieving, restoring and representing them to the community beyond Haida Gwaii:

> 1920–1939: Instructed in lore, history and tradition of the Haida by his grandfather, Charles Gladstone, nephew of Charles Edenshaw, the greatest of the 19th century Indian artists (Reid 1969).

> My grandfather was carving slate at that time and making bracelets, both reasonably competently, but certainly they wouldn't be called great works of art. That was in the 40's—when I first

really became acquainted with jewelry. There was still enough
vitality to interest me. But there was really nothing much going
on and very few young people, if any, were interested (Reid in
Maranda and Watt 1976:34).

When Reid began his study of Haida jewellery, he emulated the
engraved silver work of his grandfather, Charles Gladstone (1877–1954).
One of Reid's earliest bracelets, now in the University of British Columbia
Museum of Anthropology collection, shows a use of space and an engrav-
ing style similar to his grandfather's (figure 1). Gladstone's bracelet is
engraved with a fairly straightforward depiction of a bear, while Reid's
depicts a beaver. Their shared style of composition is also representative of
bracelets created by other Haida carvers between the 1940s and 1950s. In
1954, when Reid attended his grandfather's funeral in Skidegate, he saw, for
the first time, bracelets made by his great-uncle, Charles Edenshaw
(Shadbolt 1986:29). That exposure led Reid to redefine his goals in the cre-
ation of Haida art. Edenshaw's compositional style developed and changed
over his lifetime (figure 2), but no matter which of Edenshaw's bracelets
Reid encountered in Skidegate, their size, detail and elements of abstrac-
tion would have represented a very different aesthetic than was typical of
mid-twentieth-century Haida work. It was an aesthetic that Reid came to
extol as the epitome of nineteenth-century Northwest Coast art (figure 3).

Charles Edenshaw (c. 1839–1920) had created a style of Haida art which
embodied aesthetic refinements from the past but also effectively incorpo-
rated Euro-American aesthetics, images and forms. Some of the work he
produced, such as model houses and totem poles, reflected the historical
past, and these were generally commissioned by the ethnographic collec-
tors of the day. At the same time, he produced innovative artworks, which
he more often seems to have sold to private collectors. Edenshaw's work
was as contemporary and possibly more contemporary than much of the
work being produced in the Euro-American romantic tradition in North
America at the time, which included such genres as painted landscapes of
the rugged frontier, portraits on canvas of the last "Redskins," and bronze
sculptures of the cowboy and his horse in the subduing of America. (In other
words, when Edenshaw was sculpting myths and histories into remarkable

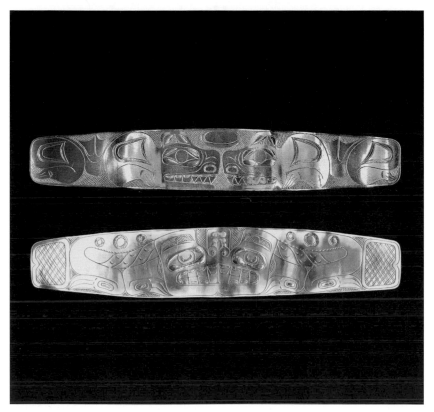

FIGURE 1

Figure 1: Two silver bracelets: (*top*) Two Bears by Charles Gladstone 1951, 3.0 × 6.0 cm, UBCMOA Nb1.749; (*bottom*) Beaver by Bill Reid c. 1955, 3.5 × 7.5 cm, UBCMOA Nb1.743. Computer scans by B. McLennan

Figure 2: Four silver bracelets by Charles Edenshaw, in suggested chronological order, oldest at the top: a) Beaver c. 1880, UBCMOA Nb1.742, 2.3 × 17.3 cm; b) Thunderbird c. 1885, UBCMOA Nb1.761, 3.6 × 17.5 cm; c) Cormorant n.d., 4.0 × 18.0 cm, UBCMOA A8093; d) Dragonfly n.d., UBCMOA Nb1.365, 4.0 × 16.5 cm, Haida Gwaii Museum, Qay'llnagaay. Computer scans by B. McLennan

Figure 3: Two pieces by Bill Reid c. 1960, styled after the work of Charles Edenshaw: (*top*) Ttsam aws (Snag) silver brooch 5.0 × 5.0 cm, UBCMOA Nb1.744; (*bottom*) Shark/Dogfish silver bracelet 3.8 × 16.8 cm, UBCMOA Nb1.707. Computer scans by B. McLennan

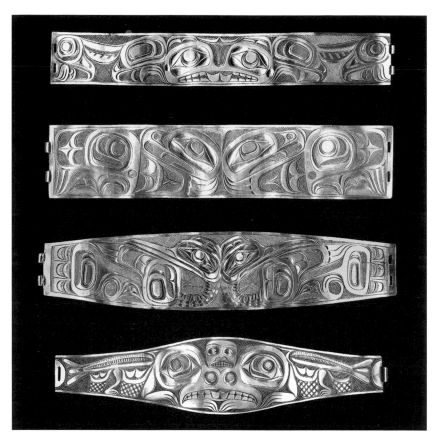

FIGURE 2

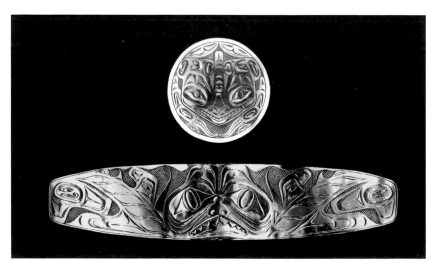

FIGURE 3

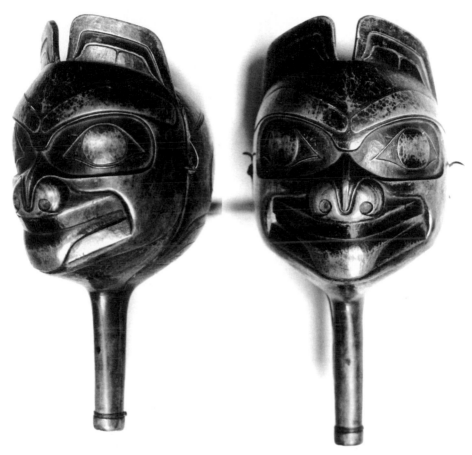

FIGURE 4

Two views of a rattle, Haida c. 1850, British Museum 5930, reproduction courtesy of the Trustees of the British Museum. Photographed by Bill Reid in 1968, photos in UBCMOA collection

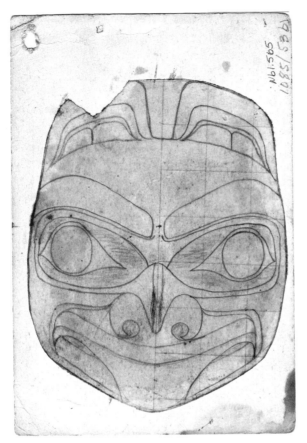

FIGURE 5

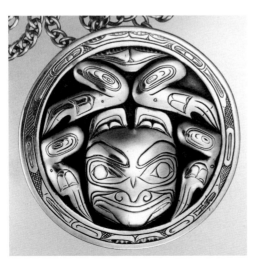

FIGURE 6

Figure 5: pencil sketch by Bill Reid c. 1970 of the rattle in figure 4, 15.0 × 10.0 cm, UBCMOA, Nb1.565. Figure 6: silver brooch by Bill Reid c. 1970, depicting the rattle in figure 4, diameter 4.5 cm, private collection. Photos by B. McLennan

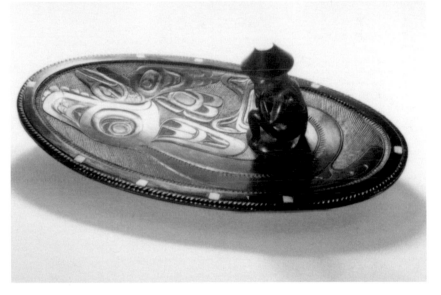

FIGURE 7

Argillite dish and details of figure by Charles Edenshaw c. 1904,
H 10.7 × L 26.6 × W 16.5 cm, UBCMOA A7048. Photo by B. McLennan

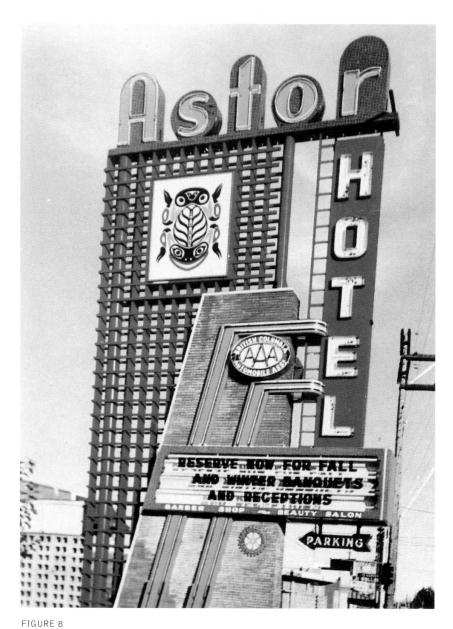

FIGURE 8

Frog painted by Bill Reid and Wilson Duff, Astor Hotel, Vancouver, British Columbia, from a postcard dated 1955. Courtesy Jim Wolf, Heritage Planning Assistant, City of Burnaby

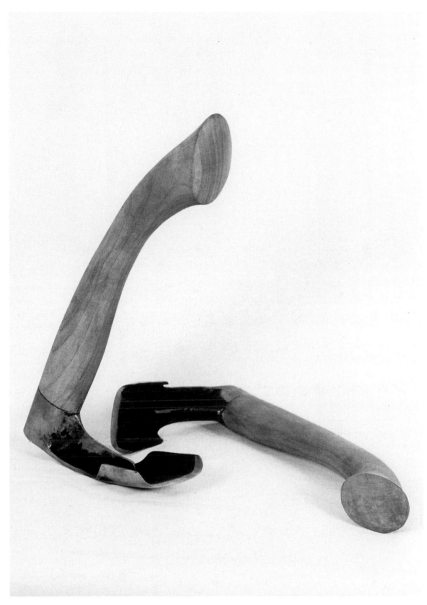

Lipped elbow adzes made by George Rammell in Bill Reid's style, 2002. Photo by George Rammell

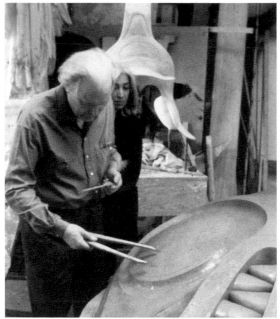

FIGURE 10

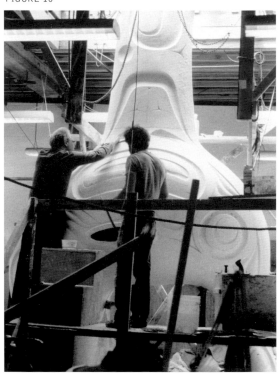

FIGURE 11

Bill Reid's *Chief of the Undersea World* in process, Granville Island studio in Vancouver, May to July 1983. Figure 10: Reid calibrates the clay version of the sculpture. Figure 11: Working on a scaffold, George Rammell assists Bill Reid to revise the formlines on the vertical plaster whale. Photos courtesy George Rammell

semi-abstract stone sculptures, the newcomers were documenting their ever increasing presence on the land. Edenshaw's work is not in art galleries, whereas that of the newcomers is.) Working in new mediums of argillite and silver, Edenshaw drew from the history and concepts of the Haida and from the new Euro-American influences that affected his life. He created a range of works that, without lengthy explanatory labels, give a sense of unique artistic vision. Edenshaw made his living as a carver and painter: he was an artist, and he produced work that was simultaneously ethnographic, contemporary and commercially viable.

Reid's choice to study and use primarily the work of Edenshaw, along with that of other nineteenth-century Haida artists, as models from which to begin constructing his own definition of Haida art was based on aesthetics. Yet the parallel between his work and Edenshaw's, in terms of being ethnographic, contemporary and commercial, is clear:

> I find it rather easy to live in both worlds: one that is the world of today, the world of the archeologist and anthropologist who give us a scientific, rational framework for examining the past and present of the Northwest Coast; but also this other world that I largely invented for myself, based on such slight knowledge as we have of myth and legend.[1]

Reid pursued his study of classical nineteenth-century Northwest Coast art by travelling to North American and European museums, looking for and photographing pieces that caught his eye. Between 1966 and 1968, for instance, when he served as a special consultant for the Vancouver Art Gallery's *Arts of the Raven* exhibition, Reid surveyed what he considered to be "all major and public and private collections in Canada and the United States east of the Rockies," building up an important photographic resource: "I have photographed most of the significant items in the British Museum and Liverpool collections of North West Coast Indian art objects, and recorded the pertinent information" (Reid 1969). In an effort to record sculptural volume, he photographed each three-dimensional object from several points of view to create a series of images. Reid's photographs of a museum artifact, a carved rattle (figure 4), display his attention to such

detail. His subsequent drawing and interpretation in silver of the rattle (figures 5 and 6) show how he was gaining a sense of proportion and movement of line through the surface of the sculpture.

One of the many features that stand out in Edenshaw's work is the animation or life-like movement he instilled in the Haida characters he created. Reid took this animation to a large scale in his monumental works *The Raven and the First Men* and *The Spirit of Haida Gwaii*. Argillite gave the earlier Haida artists a new but rather brittle medium in which to work. Possibly because of the fragile nature of this material, many of the figures are necessarily blocky or only partially exposed from the main section of stone. Edenshaw's carving of the Raven as the Master Fisherman, however, in which the humanoid figure was carved separately and added to the argillite plate (figure 7), is one of the earliest freely animated Haida sculptures to emerge from the mythic past, though it was still tied to a background and story structure bigger than itself. By contrast, Reid's figures in the two above-mentioned monumental sculptures become the composition itself.

Controversies about whether Reid's jewellery and monumental sculptures are truly the work of his hand are based on the selective definition that writers use to categorize them (O'Hara 1999). A parallel struck me while viewing Alexander Calder's massive mobile at the National Gallery in Washington, D.C., produced in 1976 when Calder was seventy-eight years old. He did not cut, shape or paint the work, but it was his vision which he directed to a final outcome. The label in the gallery gives only Calder's name and does not list the steel cutters, the painters or the engineers who brought the work to reality. When Reid, however, is viewed in terms of "Haida," making him an ethnographic artist and therefore primarily a craftsman, there seems to be a requirement to list and acknowledge all participating hands. The handcrafted quality of ethnographic art is considered to be of more importance than the concept or vision. This is because our society lacks the knowledge required to interpret the work within its larger historical context and the willingness to recognize it as valid contemporary art. We seem to have no difficulty in recognizing as art the paintings that depict Northwest Coast sculptures, such as those by Emily Carr.

Did Bill Reid start a renaissance? I don't think so. I do believe he is one of the founding members of a group of people who will be acknowledged

as instigators: individuals who, often from a distance, were and are able to see the power of art forms that echo the environment from which they grew. Reid was such a person, able to decipher the complexity inherent in Haida art. As his career developed, he took advantage of public recognition of his artwork as a hook with which he could draw wider attention to the pressing issues of Haida Gwaii and the Haida people. The renaissance will come when the art combines with the songs and histories, new and old, and settles back to the land of Haida Gwaii.

In his lifetime, Reid did very little to clarify the art-or-ethnography issues which his art often raised and which continue to be debated by critics and scholars. Such issues did not seem to bother him. In fact, he rather enjoyed any controversy that his art could instigate. In my twenty years of conversations with Reid, one of the concerns he consistently expressed was the way in which his jewellery should be displayed. When the Museum of Anthropology had the opportunity to install four new cases in the Raven Rotunda to house his smaller works from its collection, Reid insisted that the cases be as elegant as any you would find on Fifth Avenue, New York's prestigious jewellers' street. He wanted his work to be displayed as fine art and, more specifically, that the cases position each object at eye level, well lit and visible at close range. He was equally serious about the need to access, appreciate and study the work of past Haida masters such as Edenshaw, as he was about voicing his concerns for the future of the Haida people and the land of Haida Gwaii.

In every way, Reid left the argument over his artworks unresolved: no choice and every choice. "No choice" but to return to the masters of nineteenth-century Haida art and apprentice with them through copying and studying their works, now distributed in museum and private collections around the world. "Every choice" in terms of broadening the selective criteria by which indigenous art and humanity can take their place in contemporary society.

ENDNOTE

1 Bill Reid, in a 1986 brochure advertising the Equinox Gallery in Vancouver, UBC Museum of Anthropology archives.

Goldsmith / Culturesmith

by GEORGE RAMMELL

IN THE SUMMER of 1958, as a tired and cranky six year old, I experienced my first artistic epiphany. Like hearing a voice speaking down to me from above a burning bush, I was struck by an image that transformed my everyday experience of the urban sprawl. I lived with my mother and sister in a rental house on Randolf Street, a gravel road in south Burnaby. My all-day babysitter was Florence. She insisted on taking a neighbourhood kid and me for relentless walks west along Kingsway, past Sears (now Metrotown), while she pushed her baby in its comfortable sedan buggy. These five-mile sidewalk treks were pure hell—child abuse in my memory. If I protested by sitting down or throwing a tantrum, Florence responded by walking ahead until my fear of abandonment was greater than the pain of marching on. One day she made us hike so far west I saw the modern Astor Hotel on the north side of the street. On its two-storey sign was a painting of a highly stylized frog (figure 8), but it was much more than a frog. Its sinister body affected me like an occult manifestation penetrating the traffic and signage. It possessed a presence bigger than the Bowmac sign on Broadway and more awesome than the W on the Woodward's tower, because it held a truth that was a complete anachronism in its surroundings. Anyone capable of making this image must have been in touch with an exotic world. But how could something so old, so otherworldly, simultaneously feel so new? And how did this come to Burnaby? Answers to these thoughts were completely inaccessible to me. Ironically, it was Florence who had taken me on this journey.

More than twenty years later, the answers jumped into my lap. While helping Bill Reid to carve his red cedar *Phyllidula, the Shape of Frogs To Come,* we were exchanging frog stories when it became apparent that the Astor Hotel mural was an early collaboration of his with Wilson Duff. It all made sense now: the ancient icon felt so modern due to its shocking recontextualization, a device that was instrumental to Bill's accomplishments in later life.

In 1973 Bill was invited to speak about his career at the Vancouver School of Art (now the Emily Carr Institute of Art and Design) on Dunsmuir Street. As a student, I felt as though I were seeing Bill's slide seminar through new prescription glasses; after several years of art history, my innocent childhood viewing of art was long extinguished. I thought Bill was like a European agnostic, re-creating religious icons from the cathedrals for the contemporary art establishment there. It appeared as though his intellectual task of giving tribal iconography a new currency in the larger world would be provocative, even a violation, to the Haida. Throughout his talk, I withheld a burning question about his personal responsibility to the tribe. It was obvious he was struggling under a weight and anxiety that shielded him from the student debates encouraged in art school at the time, regarding craft vs. art, appropriation vs. originality.

Three years later he came to my studio to ask me if I would carve for him on *The Raven and the First Men.* I thought I would help him for a few months; I had no idea this was the beginning of an ongoing dialogue that would span eleven years and fourteen sculpture projects. On my first day with Bill, his trust in my abilities was a surprise. I was accustomed to the technical conventions of sculptors and art foundries where a strict hierarchy of disciplines is maintained. Each technician is a specialized cog in the production. Scale-ups are faithful to scale models, three-dimensional reference points are established carefully to avoid any artistic interpretation, and even shrinkage rates of cast materials are predetermined.

As I studied the one-third scale plaster model of the sculpture, Bill said, "Don't look at that, it will only perpetuate mistakes." His goal was to achieve the tension he had in the tiny boxwood original, and my role was to interpret his oral instructions—"Make it feel like a clam!"—into three dimensions. So I started chopping. I valued the opportunity to be on his team, to immerse myself in his practice and to determine an answer for

myself to the "How Native is he?" question that echoed around him from curious onlookers. My idealization of Bill's art was like the dreams I had of the beasts on his gold bracelets floating over Vancouver like holograms in the night sky. But this was an opportunity to dispel the myths and adulation. I wanted to see what the differences really were between the indigenous practices that he employed and the non-Native studio activities with which I was familiar. With which cosmologies was he aligned? Undoubtedly, structural differences in his thinking were bound to be manifest in techniques on the shop floor.

I would like to share the obvious aspects of Bill's methodology that operated outside of Euro-Canadian sensibilities and of the contradictions he mediated while distilling opposing cultural ideals.

THE HANDMADE TOOL

Bill possessed a small box of heirlooms that he cherished in privacy. These were engraving tools that Charles Edenshaw had made and used. Their worn zoomorphic handles conveyed the beliefs of their maker. By extension, the most striking trait that Bill exhibited in the studio was his fervent identification with the handmade carving tool. The overall form of these tools maximizes the carver's ability to match the positive blade shape to the negative of the ovoid being carved. Beyond their function, however, Bill's hook knives and adzes had to possess an internal aesthetic in order to function as progenitors for new work, passing, as genes do, from parent to offspring. The subtle angles of the blade-handle relationship were an active talisman, a collaborator in the creative process. Bill could replace the blade of his knife as often as necessary throughout his life, and he could change the handle if it split—it still remained the same knife. But he could never change the blade and handle at the same time without losing what the tool knows, which is its potential to work forward while possessing its accumulated past.

A visiting artist once carved the tail-rest off Bill's favourite hickory D-adze, assuming he was doing him a favour. This tool was similar to the ones that master adzers such as Doug Cranmer used to provide the "woven" pattern of surface cuts across broad cedar surfaces, a texture that, according to Bill, is "considered to be very classy in certain circles." To Bill, this amputation robbed the tool of all its accumulated history since his

early "replication" period at the University of British Columbia. It was one of the few times I saw Bill furious. He stormed around the studio and accused me of the violation, of which I was innocent. I would never have done that, as I knew the tool's value. Damaged adze firmly in hand, Bill's ultimately unsuccessful hunt for the vandal was on.

Newly made tools, regardless of their maker, were thoroughly scrutinized by Bill and mercilessly ridiculed if not formed properly. Great tools that passed the bilateral symmetry test and embodied the right parabolic curves for the proposed task, tools that tapped into the realm of the magic maker, were given an initiation ritual through the "First Chip Ceremony," performed in the company of comrades in the shop. Toolmaking and goldsmithing were paramount in Bill's priorities, the standards by which he measured other things. Not only were toolmaking and the ability to maintain a sharp cutting edge prerequisites for carving, they were directly correlated to intelligence and self-esteem. Bill's carvers, the young Jim Hart and Don Yeomans, reinforced these values: the sharpest minds kept the sharpest tools. Dull tools, like dull people, were considered a dangerous waste of time.

European tools are generally pushed or punched away from the carver, but Northwest Coast tools (other than the skew chisel) are characteristic of Pacific Rim peoples, who put the emphasis on the back stroke and pulling towards themselves. According to Bill, this is a motion (untypical of Europeans) that provides a better response and intimacy not only while carving but also while making love. After painstakingly repairing Bill's tools, I was finally getting the inside scoop on information that applied directly to my quality of life.

This relationship to the tool was very different from that of my non-Native mentors, who often employed a wide range of technology in their work. For them, art was a separate phenomenon from tools, which are things you buy or rent: a transparent means to achieve one's goals.

Bill's favourite tool was his "all-purpose" lipped elbow adze (figure 9). It was a versatile tool due to the raised lips on the sides of the blade, which allowed for deep cross-grain adzing. Bill idealistically attributed this blade design to the important Kwakwaka'wakw artist Chief Willie Seaweed (1873–1967) of Alert Bay. But Bill was actually exposed to this tool through Kwakwaka'wakw artist Chief Mungo Martin in the late 1950s. Mungo's

innovative son Dave Martin modelled the blade after the large two-handed Euro-American shipwright's adze that the Native carvers used for preparing logs. The young Martin then attached his newly forged blades onto traditional one-handed wood elbow handles, which provided flexibility for rhythmic adzing.

In the early 1960s Bill worked with a metallurgist at UBC to adapt this adze design for his own needs. They welded a rigid, steel-jointed, hatchet-like adze that was excellent for three-dimensional work involving constant end-grain carving. Bill would rough-adze his forms, then switch to his electric sanders, skew chisels, hook knives and straight knives to tightly define his surfaces and provide clarity to his sensitive curvilinear style. Bill's unpainted totem for Skidegate (1978) and *Loo Taas*, his large canoe (1986), are examples of monumental cedars that appear to reject the undulating, adzed surfaces of the Haida art he was quoting. But Bill's works are the result of his strong-willed logic to create a hybrid between two distinct cultural practices. Western sculptural ideologies of pure form and space were a major influence. One only has to look at the work of Bill's closest friends—Bill Koochin, George Norris, Frank Perry and Tony Cavelti—to see how the Western sculptural values of Bauhaus, formal humanism and minimalism were shared amongst this circle of artists.

Bill's tools also proved to be indispensable when we were carving the monumental plaster patterns for his bronzes in the 1980s. Plaster is the same density as alder, and we could add on layers easily to carve multiple revisions. Bill continued to use his "all-purpose adze" near the close of the twentieth century. I see this beautiful tool as a symbol of his determination to work parallel to Haida conventions while fusing them with Western values to achieve a dynamic personal expression.

ORIENTATION OF THE SUBJECT

Another condition I found intriguing in Bill's studio was the irrelevance of the vertical-axis logic that is engrained in the history of Western art. Bill often drew his creatures on a table rather than on a vertical easel, and he continuously spun these images 360 degrees to connect ovoids, as though the creatures were moving like a Raven that folds its wings and tumbles, three-dimensionally, through space. I encountered a similar juxtaposing of the

components in his sculpture when, working as a contractor to scale up his *Chief of the Undersea World,* I was planning the steel frame for the monumental clay version in its breaching, vertical pose (figures 10 and 11). The conventions of Western sculpture necessitated that the clay be modelled on the vertical axis and aligned precisely as the completed bronze would be seen by the viewer. This way, the public sees what the artist animates; the anatomical weight distribution and modelling of the clay surface is like a painting of light and shadow, or as the Renaissance masters called it, "chiaroscuro."

I discontinued this approach when Bill said he wanted his whale made horizontal, split in half. His method, though much more labour intensive for me and my friend and co-worker Jack Carson, was consistent with totem carving and provided ground-level access for Bill to work on the clay—a growing issue due to his advancing symptoms of Parkinson's disease. Once the plaster pattern was cast from the clay, I took the initiative to erect it on a metal armature. Now we were working in the Western tradition on scaffolding surrounding the vertical sculpture. Bill studied the piece in a new light and responded by reorienting the axis of the main ovoid at the base of the dorsal fin, which altered all the intersecting lines radiating out across the whale's body.

THE AMBIGUITY OF SCALE

> *"My people were hunters but I am a silversmith* (ladzzola). *Silvercraft is my trade."* —Charles Edenshaw (quoted in Barbeau 1957)

Like Michelangelo asserting that he was a sculptor and not a painter when the pope assigned him to paint the ceiling of the Sistine Chapel, Bill identified himself as a goldsmith, and he applied goldsmithing strategies to any discipline in which he was immersed. He saw his monumental bronze whale as gold jewellery and treated it as such: it was just bigger. Critics who express disdain for Bill's quantum leap from miniature to monumental often misunderstand the tenets of Northwest Coast aboriginal scale.

In 1989, the Tallix Foundry north of New York had assembled the cast bronze sections of Bill's whale and chased over the weld seams; the technicians then assumed it was ready for the final patina and waxing. To Bill, however, the work was about to begin, as the cast bronze is the best stage

at which to refine the reflective surfaces that expose distortions from the thermal stresses of casting and welding. The consecutively deepening layers of linear relief, revealing the corporeal animal, had to be precise to achieve the tension Bill sought.

The Tallix Foundry specializes in casting the work of east-coast Expressionists (such as Nancy Graves and de Kooning) who celebrate atmospheric textures; imperfections or weld seams are integral to the aesthetic of their process. To the directors of the foundry, Bill's requests to recarve his massive bronze to a jewellery tolerance appeared obstinate, because the viewer would never detect these imperfections from a distance. Furthermore, that degree of refinishing is as labour intensive as the sand casting itself and would require additional funding. To Bill, it simply meant "doing a good job," the way a goldsmith engraves a bracelet after the repoussé stage. While Bill's patrons back home scrambled to finance this unexpected twist, he was in the metal-finishing wing of the foundry, training his new crew of "Haida slaves"—a team of young New York metal chasers— to decipher the complexity of the ovoid. To defend his position, he shared his favourite Longfellow passage with them over their loud rap music:

> In the elder days of Art,
> Builders wrought with greatest care
> Each minute and unseen part;
> For the gods see everywhere.

Pointing out the different layers of his ovoids with emery sticks, Bill lectured his new crew about Haida design theory. At the same time, the American artist Frank Stella was working behind him with his crew, flinging ladles of molten aluminum into his large abstract assemblages. These two artists, both giants in their own circles, were working back to back, apparently indifferent to each other's aesthetic.

During the 1970s, the tenets of modern sculpture defined our sensory experience and physical relationship to the "site" as integral to the work. One idea could not shift across a range of scale without losing its integrity. Artists of this era were attempting to embrace anthropology and the prehistoric art of their respective regions in order to shed the baggage of previous

modern art movements, but the body as performer or interactive participant was still the essential scale reference. Ironically, this doctrine partially sustained Renaissance logic of the human body as central to the universe.

A seventeenth-century Renaissance sculptor, in the process of translating a small maquette into a monument, would proportion the form to adapt to the viewer's vantage at the predestined site, and the larger volumes would also increase the anatomical complexity of the surface. A direct scale-up would appear doll-like, and in Renaissance culture that was the precinct of the naïve. In the world of the Haida mannerist, ideas naturally shifted across a huge range of scale without changing their internal relationships, as it was the viewer's task to adapt to this shift. The supernatural inhabitants of the ocean and rain forest were omnipresent across the realities of scale and location: little humans could hide in a bear's ears or a clamshell; seawolves could eat three whales a day; a beaver could dwarf its outdoor audience, or exist in miniature engravings on the jewellery bench.

"CHARLIE WOULD HAVE WANTED IT THAT WAY"

> *Maturity is the ability to live in ambiguity and uncertainty.*
>
> —Abraham Maslow

If Bill Reid's challenges were comparable to those of another artist's, it would have to be his maternal great-uncle, Charles Edenshaw (c. 1839–1920)—not because they are related but rather because they both carried their personal interpretation of Haida art into uncharted destinations in times of unprecedented change. In his youth, Edenshaw participated in the wealth of potlatch culture in which a robust exchange with European traders contributed to the diversity and dynamics of the Haida. Then, within his lifetime, he witnessed both the decline of the fur trade and the smallpox epidemics that killed 75 per cent of the Haida population within three years. In the wake of this holocaust era, huge gaps in the social order of the Haida appeared: individuals of low social rank could raise their social status through the production of art. The genres of argillite carving and silversmithing were well suited for artists of Edenshaw's generation to portray their first-hand memory of the breadth of Haida culture prior to the plagues of 1864–1886.

Following Bill's jewellery-making studies at Ryerson Polytechnical Institute in Toronto, he began working unpatronized at his jewellery bench and without the momentum of the "Northwest Coast Renaissance." His earliest works were still considered craft curios, and, like Edenshaw before him, he sold them for little more than the value of the materials of which they were made. But Bill made his jewellery bench an extraordinary site of cultural alchemy by applying his newly learned technology of classical European goldsmithing to Haida iconography. The resulting works possessed the authority of crown jewels but embodied a duality of cultural practices that complimented the high standards of both. This was the most original sculptural manifestation of Haida cosmology since Edenshaw's. Bill's supporters in mainstream society began to recognize the cultural and monetary value of these pieces. His body of work set a new precedent for contemporary aboriginal art on the coast in the following decades and a new genre for its practitioners in a multitude of disciplines.

Bill's avocation to celebrate the art of his mother's tribe and thereby improve his own social status had the altruistic impact of creating a new model for Northwest Coast aboriginal artists in the larger world. This new paradigm that Bill constructed between communities launched a contemporary renaissance. Bill's jewellery bench was the source of an ever-expanding demand for contemporary First Nations art. This accomplishment could be compared to important Afro-American musicians whose art fostered a racial tolerance that contributed to the emancipation and civil rights movements. Bill's work was that of a humanist addressing a century of colonization. He was the son of a seamstress who denied her Native heritage due to the pressures of systemic racism, but he came to be regarded as a Haida of "national treasure" status within his lifetime.

In his formative years, Reid took on challenging reconstruction projects that allowed him to construct his own identity. During this period, he formed a foundation for his mature years when he made pieces that functioned as personal interpretations of Haida culture. His development synchronized with the liberal infrastructure boom in the 1970s when institutions were focussing on First Nations art, exhibiting it in the halls of mainstream society. Barnett Newman's advocacy to recognize Northwest Coast Indians as individual artists represented in the New York exhibitions

that he curated in the 1940s was now standard practice in museums and galleries. The attempts of government programs to promote "Indian art" as a financial resource through tourism were eclipsed by Native authors with a self-motivated aesthetic who proclaimed inherent rights. The original role of Haida art, to record lineage and ownership of land and resources, broadened to become an iconography of resistance for the continued struggle toward a recognition of nationhood.

Bill's example of working within a relationship to a museum and a university encouraged a new generation of First Nations artists and writers to engage in post-secondary curricula, enabling a new interpretation of the culture from within a deconstructive discourse. Bill encouraged this investigation. He would never produce a slick product and was always pulling the skin off to investigate the nature of the beast. He often said, "You can't break the rules effectively unless you understand them thoroughly." The university anthropologists aided him in comprehending the complexity of Haida art; without their help, he could never have been capable of responding to his times with such innovation. This academic mentoring for Bill's chosen role was a surrogate for the traditional apprenticeship he never received.

If Bill's suspicions were true—that his ancestors were watching and judging him as he worked—then Charlie was the posthumous guide who wielded authority over the others. Whenever Bill had carved all the compromise out of a project and felt it was completely resolved, he would proudly say, "Charlie would have wanted it that way."

COLLABORATION AND AUTHORSHIP

Bill did not potlatch in the old way, but he regularly visited the accomplishments of his Haida forbears. Wherever he travelled around the world, the glass boxes were opened and the white-gloved conservators aided him in his sojourn with the artifacts he admired. I remember watching him hold the Tsimshian twin stone mask in Ottawa, running his fingers over its subtle contours; and another time he invited me to indulge in marvelling with him at the ingenuity of a little argillite spirit canoe. The inventiveness that is harboured in these precious artifacts by unknown artists from his past was the same inventiveness he demanded of himself. As with the monumental art of any culture, collective energy was greater than any individual's capabilities to

create single-handedly, and Bill saw the potential in those around him to help in various disciplines. Sandburg's "Ancient Reluctant Conscript," to whom he often referred, was the teamwork he had the confidence to employ.

Bill's physical imperatives and limited studio time throughout the 1980s were balanced by strong patronage that enabled him to produce an amazing amount of new monumental work, and he moved through a range of projects like a maestro conducting an orchestra. This shift from the hands-on control of his earlier years toward the role of artist as director-creator is confusing for a public that values the romance of the solitary genius, especially within the popular construct of the aboriginal carver, so it is important to understand how his pieces were produced. He invented concepts that carried his pieces into the enigmatic realm of the previously unaccomplished—but what did he ask of his associates? And who defined the surfaces of his works with the micro-precision cuts that he valued so highly, who stretched the drum-tight skin of Haida embroidery over his forms? It is essential to know the culture and commitment of each participant to understand how Bill's art came to be.

Bill's commitment to the reconstruction of aesthetic values was the antithesis of Duchampian philosophy that distances itself from aesthetic conventions. But Bill used "readymades" of his own, not in the form of found objects but rather in the culturally specific skills of active Haida and Euro-Canadian practitioners. The expertise that he required to achieve the highly authoritative contexts for his work also included architects, most importantly Arthur Erickson. Bill deeply appreciated Arthur's sensitive, site-specific preparation for his sculpture. Bill's associations exhibit his interest in the dynamics and development of other artists and the active cultures and sub-cultures to which they belong. Like his contemporaries, he worked from an informed universal vision with his mind on, and hands in, the work he directed.

English literature provided Bill with inspiration to relocate the grand narratives of the Haida in a linguistic sea of puns and metaphors. His satirical titles, statements and antics poked fun at our vanity and failed attempts to understand each other. One such performance was his humorous stroll around Granville Island, pulling the wheeled *Phyllidula*, his sardonic cedar raven in a frog's body, behind him on a leash like an obedient Haida pet.

Bill believed that an artist who could master an art (such as goldsmithing) also had the ability to quickly attain the same high degree of proficiency in a new chosen field. He was most intrigued by the intersections of his various pursuits—anthropology, literature, printmaking, sculpture, etc.—and the labyrinth of relationships encouraged his curiosity and intellectual growth. He also saw art-making as a social activity rather than a solitary pursuit. He often made Leonardo da Vinci–like measuring gauges and templates that fascinated him more than their sculptural results, for they exhibited the principles of his logic and steered the team process toward his goal.

My contribution to Bill's work changed as I became familiar with his goals. While working on *The Spirit of Haida Gwaii,* he encouraged me to contribute my whole ideation to the composition of the scale models and to the sculpting of the formal anatomy on the full-size pieces. If he liked what he saw, he used it; if he did not, we would try an alternative approach until he was satisfied. But Bill's authorship of the results was unequivocal, as it was in the many other disciplines in which he worked. Bill's animated curvilinear style and his contextual shift to contemporary art values were his alone; they required a lifetime to develop, and he potlatched us all with these gifts.

The literature on Bill is peppered with misleading stories that avoid complexity and attempt to support his work with unnecessary props. In one such article in Ryerson's alumni magazine in 1985, Pat Lush quoted Dr. Michael Ames, then director of the Museum of Anthropology at UBC: "Reid has a flock of today's budding native artists and would-be artists hanging around and this is one of the reasons he is not very wealthy—a lot of the work on his commissions goes to these younger people." But no one was paid to hang around his commissions; I was scaling up Bill's whale at a low contract price, and I absorbed the losses when Bill's inevitable changes demanded much reworking of the forms.

Following Jane O'Hara's exposé "Trade Secrets," published in *Maclean's* in October 1999, I was concerned that the great admiration for Bill that I had expressed in hours of interviews was not conveyed in her story. Then the *Globe and Mail* published an article by Sarah Milroy, the daughter of Bill's Vancouver dealer, accusing me of provoking the *Maclean's* argument. In an attempt to stifle discussion and lay blame, she attacked my credibility

and my own work in the worst art scandal I have seen. It felt like a panic at the stock market. Individuals who had vested interests in Bill's career were publicly discrediting those of us who had aided him in the studio. Subsequently, a spokesman for the Museum of Anthropology told the media that even though Bill's assistants were artists, by agreeing to work for him they were accepting the role of artisan and should therefore not claim authorship. This response only added to the confusion and was inconsistent with the goals of a university, as it was Jane O'Hara who wrote the *Maclean's* article, not Bill's associates who were interviewed.

Regardless of the scandals and misrepresentation, I and many others feel fortunate to have contributed to Bill's legacy. As a contemporary elder, his work posed important questions rather than providing static definitions. Furthermore, he redressed the effects of church and state colonialism by encouraging initiatives that contribute toward the prosperity of First Nations, and he helped non-Natives to understand unfamiliar social values. His work unveiled a new stream of cultural-conceptualism that affected his communities far beyond his expectations.

THE TRICKSTER BUILDS A NEST

In 1980, Bill and I were working on his yellow cedar piece, *The Raven and the First Men,* at the carving shed at UBC, when a letter arrived from MacMillan Bloedel stating that they were pleased to donate their "yellow cedar product" for his current sculpture. Bill was infuriated that this company defined yellow cedar, an indigenous tree cut from aboriginal land, as their own "product" like some kind of extruded synthetic. While he was reeling from this letter, a squad of RCMP security officials arrived to plan the unveiling of his sculpture by Prince Charles, the Prince of Wales, at the Museum of Anthropology. They quietly stood around us watching us as we carved; then Bill-the-Trickster announced he had invited a delegation from the American Indian Movement to the unveiling. No one was amused. The circle of stone-faced stares around us meant the officers were assessing the risk: Was this serious? Would Bill use this event to create an international embarrassment to expose colonial injustices and Canada's current violation of its own laws toward First Nations? Bill stared back long enough to make everyone anxious; then he had a good chuckle to himself as he got back to work.

Like a raven arranging stolen silver in its nest, Bill would transform gifts of patronage into art that worked for his causes. His art also criticized the impact his benefactors often had on aboriginal communities and the environment. The lumbermen who clear-cut on Haida land may have been looking for redemption by financing Bill, the ambassador of Haida art, to create a sculpture depicting the raven discovering man in a clamshell, a pivotal work that is a jewel in the crown of the urban power centre of western Canada. But what if the Good Liberal Indian Artist suddenly became the Dangerous Native Activist sitting on a logging road and telling the world of the current destruction of Haida Gwaii by Big Business? What if the man with all the honorary doctorates and bank awards shook the confidence of investors by stopping his work on *The Spirit of Haida Gwaii* for the Canadian Embassy in Washington to flag the damage caused by international logging companies? Or what if he removed the Canadian flag from his canoe, on its journey up the river Seine, in favour of the Haida Nation flag because of Canada's refusal to recognize the legitimacy of Haida land title?

Bill knew the power brokers would eventually distance themselves from his politically charged pieces and donate them back to his causes. Unlike modernist sculpture that embellishes bank building lobbies, Bill's work carried an urgent political message. It contributed to the impetus of current aboriginal nations who are affecting the balance of power in British Columbia.

In retrospect, I'm glad that, as a student at the Vancouver School of Art, I withheld my brazen questions regarding Bill's personal responsibility to the tribe from which he drew his contemporary work. The internal contradictions and stresses of Bill's position between conflicting world views often appeared like a curse that induced the symptoms of his Parkinson's disease. I came to realize that the answers to my questions about him were harboured in his life's work. I also saw how Bill, from his autonomous position, accepted the responsibility of pursuing the art of his mother's tribe.

THE BILL REID MEMORIAL GROVE

At the east side of Gate 7 at Marine Drive and Agronomy Road on the UBC campus, there is a stand of evergreen trees surrounding an open glade: it is the former site of Totem Park, a reconstructed section of a Haida village.

I feel that this parcel of land should be dedicated to Bill Reid to signify the accomplishments he realized on this site over a span of twenty years.

In 1979 I was at this site, near the adjacent carving shed, pruning a branch from a tree for a tool handle, when Bill exclaimed that I was violating the future Bill Reid Memorial Grove. There was always a wry and prophetic edge to his humour, but little did I know then that I would be carrying this idea forward. It is a reasonable proposal, however, considering that this land was precious to Bill and that his greatest period of artistic growth took place there. Many of the stories he told while carving *The Raven and the First Men* described the discoveries he made while working there seventeen years earlier. As the squirrels performed antics around the shed, Bill would reflect on his own accomplishments when he and Doug Cranmer produced so much work. He had a bond with this place like no other: he needed and appreciated the academic support of the university and the forested refuge it provided for his quest to understand Haida art. Since the big Haida houses and carvings were moved to the Museum of Anthropology in 1978, there is now an open glade; it is framed by coniferous trees creating a camouflage light on the ground where he once carved the huge *Sea Wolf* and *Bear* pieces, now in the Museum of Anthropology. Through the trees can be seen the carving shed that Henry Hawthorn designed in 1958. Whenever I go there, I feel a powerful sense of Bill's presence, knowing this is where he launched an investigation instrumental in what became known as the "Northwest Coast Renaissance."

We owe it to ourselves and our descendants to acknowledge the site where this man had the energy to create new models for understanding the cultural evolution of this region. Bill felt a great affinity to this place: it was here that he worked, socialized and picked blackberries. I hope we can dedicate this site to the memory of the man and his most prolific years.

ENDNOTE

I am forever grateful to Bill Reid, who opened the doors of his bighouse to me and shared its contents: his beliefs, determination, discoveries and humour. And I thank Jim Peacock for editing my initial draft. I would also like to thank the following for providing information in personal communications with me: Doug Cranmer, Tony Hunt, William Koochin, John Livingston and Peter Macnair.

II

Locating Community

Man, Myth or Magic?

by GUUJAAW

Based on the transcript of comments made at the symposium "The Legacy of Bill Reid: A Critical Enquiry," organized by the University of British Columbia Museum of Anthropology and held at the UBC First Nations House of Learning, 13–14 November 1999.

GOOD PEOPLE: I think that Bill must be the most dissected thing outside of a laboratory—and when you start chopping things up, the more pieces you put it in, and the smaller it gets, the harder it is to recognize what it originally was.

I knew Bill pretty good from working with him—we had our laughs and fights—but also from a few adventures with him in Gwaii Haanas. I saw something about how he operated and what was in his heart. Every morning when we travelled around in Gwaii Haanas, Bill would be up on deck and fishing before anybody else got up, and whatever he caught, even if it was bullheads, he'd feed it to his friends. We had evenings when we would be passing around deer meat on the bone. He figured that the real problem with the earth is that everyone got so civilized that they are losing their humanity. . . he wanted me to give them a course in de-civilization.

In this symposium, I'm marvelling at how people could puzzle over a statement like "What is 'a well-made object'?" as they analysed Bill. There are still a couple of things that I thought I would add to the discussion, however.

When I worked with Bill, he got excited when he was looking at the old poles and pieces—that's what really turned him on. He had a good way of

explaining and figuring out what somebody had done. With a totem pole, for instance, he would just show you a deeper thing to consider than what meets the eye. In his own way, he explained the profound logic that underlies the arrangements and interrelationships of the lines of Haida art, and the ways to entrap the tensions. This is one of the world's most regulated arts. A totem pole, when done properly, is a complex assemblage of planes where the rule does not have to be understood in order to be received as proper by the mind's eye. Bill's mission simply seemed to be to try to maintain the standard that the old people had set and that amazed him so much.

We had an old canoe blueprinted because we were trying to figure out how to build one ourselves. The shipwright that we retained was astonished to realize not only the beauty of the design but also the accuracy of the craftsmanship, which he said wouldn't be surpassed in any conventional wooden boat. At every scale, from the canoes to the spoons, the workmanship was inspiring. I just wanted to add a couple of stories as you absorb what Bill was or what he wasn't. One time, when we were working on the Skidegate pole,[1] he was already starting to get sick, but he was still working and continued to work for a long time after that. There are two female figures on that pole, and I asked Bill, "How come we're not making breasts on these ladies?" Bill growled and grumbled but gave no audible answer, so we kept going up the pole. A few months later, we're working on the tail of the shark right on top. There's basically room for one guy to work, as it's cold out and there's snow on the ground and it's getting dark, and as I was working, Bill said, "Well, I'm going inside—I feel just about as useless as a tit on a totem pole." So, you see, he always did get around to an answer.

Yesterday, Diane Brown talked about what Bill wanted when he died, and it was a crab feast. We did have the crab feast—and she had some of it, too.

When we brought Bill's remains to T'anuu, his final resting place, some of our people dug a hole, and the dirt that came out of it sat in a pile beside it. It wasn't that big—the box took up most of the hole. After the prayers and goodbyes were said, everyone had a chance to shovel some dirt from the pile beside the grave. I was singing—so I had to keep the song going until the hole was filled. The shovel kept going around until they used up all the dirt that had come out of that hole. Somebody got the coast guard to pack up more dirt from the beach. I kept singing, and Leon Bibb had to

help me out . . . I don't know where all the dirt went. Maybe this wasn't even Bill's last trick.

We don't need to dissect Bill. We don't even need to try to understand him. We should just be happy he came amongst us.

What I'd like to do is sing a song to finalize this part of it. I want to get Bill's granddaughter, Nika Collison, to sing a song with me. Bill always enjoyed the song, enjoyed the dance, and tried to integrate our culture into his life as much as he could.

This song is about the moon as you can see it from Skidegate—the way it looks when it's shimmering across the water. The song first dismisses the singer as being of little importance and turns the attention to the moon: the moon has shattered. This song would be sung by Ravens, who are teasing the Eagle ladies to go pick up the pieces. The concept is too high to be considered an insult.

> *ha way ee ya, ah wa ee ya, hay hay ho, oh*
> *ha wa he yay, ha wa ee ya, hay hay ho*
> *oh ho ah ho*
> *gam giinaaguu, dii 7isgangaa*
> *hay hay ho, oh*
> *ƚungaay 7uu xuusdaayaagaanii*
> *hay hay ho, oh*
> *giid7in jaads 7uu 'll g'ugwaay ƚinst'aagaa*
> *hay hay ho*
> *7o ho, ah ho.*

I was going to say just one more thing about the buzz over whether Bill was Haida. Like me, that was what he was—Haida—and there was nothing he could do about it. Thank you.

ENDNOTE

1 The house-frontal pole, over 17 metres (56 feet) high, was carved for the new Skidegate band council office and raised in 1978.

A Non-Haida Upbringing: Conflicts and Resolutions

by GWAGANAD (DIANE BROWN)

Based on the transcript of comments made at the symposium "The Legacy of Bill Reid: A Critical Enquiry," organized by the University of British Columbia Museum of Anthropology and held at the UBC First Nations House of Learning, 13–14 November 1999.

K ILSLAAY GAANG·NGA. *K'uljad gaang·nga.* All chiefs and chief ladies. I had a great respect for Iljuwas. Since he passed from us, this is the first time we will speak about him. For one year we did not speak about him in respect for his relatives, his wife, his children, his grandchildren. Today is the first time we will talk about him. We are going to show our respect for him now. He was a very skilful Haida, he was a very gifted Haida. He put the Haidas up. Thank you, Iljuwas. Thank you, Bill.

This is my traditional opening, for which I was given help from an elder at home. It is how all people should begin speaking about one who has passed; it is the Haida way to begin to speak about one who has passed. It must be done for a respected and gifted man.

In our hearts, we all accepted Bill for who he was. We get our clan, crests and name from our mother. That is how it is. Iljuwas was of the T'anuu Raven Wolf clan. His chief Cheexail and clan followed his every wish for his last journey. He came from a long history of gifted clan members—Miles Richardson III ("Buddy") mentioned some of them. We believe that you are born with your gift; the supernaturals give you this gift. In Bill's case, he was given the gift of creating beautiful art. It is not up to us mortals to

question that gift—it is to be respected. These supernaturals come in many forms, and out of respect to one of the hereditary chiefs from this area, Kilslaay (Jimmy Hart), I will share with you an amazing story that I was told by Nang Ḵiing·aay 7uwans (James Young). In the beginning of time, the *sgaana gid iids*—the supernatural killer whales—were the first beings to come to Haida Gwaii. There were few humans around then. The killer whales landed on Rose Spit around the Tow Hill area. They were the first supernatural beings, and they brought their wives with them, their killer-whale wives. These supernatural killer whales had special markings. At will, they could come out of their killer-whale skins and become human beings. The killer-whale beings wanted to have children. They could not have children with their wives; their wives had different markings from their husbands, and that is where we get our clan system from. If you're a Haida, you are either an Eagle or a Raven, and this is how far back in the beginning of time that we got our crests. from the Beginning-of-Time people. They could not conceive children, so they went into Massett Inlet and they took six wives from Old Massett and took them back to Rose Spit. They then had children with these ladies from Massett Inlet. These people, Jimmy Hart's people, are therefore what we call *guhlgihljuuwa*, which means "they are more thoughtful than me or you." They were more gifted, they were more in tune with the supernaturals, so it made sense to me that part of Iljuwas's background, if you traced far back enough, would be that he was one of the descendants of the real supernatural beings. It made sense to me, and I accept and I respect that he is a *xaayda*, a descendant of the women in Old Massett and the people in Old Massett who are "more everything," is how the elder put it to me. I didn't plan to tell this at all, but I want you to understand the beginning of time with us, I want you to understand how we became what we became. I've heard about four chapters of this beautiful story, and there's much more to it—it's fascinating.

So again I say, we don't question who gets this gift. We generally know that if it's traced back to the beginning of time, often there's people that'll bring it out, so it's no big surprise to me that my nephews, and Bill's grandchildren, Walker and Tyson, have it in them. We know it will come out at some time. It's not up to us to pull it out or make them do anything. It will come with time.

I first heard of Bill when I was a small child and he was on the radio. The elders would say that this was Sophie Gladstone's boy: Charlie Gladstone's grandson. I can just remember a really deep voice. I can't remember what he said. I'm sure I wouldn't have understood it anyway, but we were proud of him. Before he started producing art, the Haida people were proud of him. I first met and spoke to Bill at the beach on Tow Hill. He was sitting on a log beside the Hailen River. My husband Dull and our two children, Judson and Lauren, who were two and four years old, were walking the beach when I noticed him sitting there. So I walked over to him and I said, "Hello, Bill," and sat beside him. He fiddled in his pocket and said, "Do you want to see a trinket?" He proceeded to unwrap a cloth and show me the most beautiful gold bracelet I'd ever seen. I said, "Some trinket!" We sat in silence for a while and I left. Since then, our paths have crossed many times. I believe he was very interested in the Haida spiritual ways. There's not much written or known about that, and he had many questions about that. And I was willing to share.

I saw the struggle that went on in him. I'm sure he had many conflicts about who he was, being brought up in a white society on the one hand and being able to produce beautiful Haida art on the other. Often I thought that the more the conflict raged within him, the more beautiful the art became. If you deny the gifts that the supernaturals give you, and you try to keep them down, you become ill. And Bill did become ill.

Long before Bill came to Haida Gwaii, there were several Haida artist/carvers. When I was a child I watched Henry Young Sr. carve. He would tell me the legend that went with the carving. This was what happened if you lived in the village. As well as Henry Young, there were Tim Pearson, John Cross, Tom Moody, Arthur Moody, Charlie Gladstone, Luke Watson, Lewis Collinson, Isaac Hans and Rufus Moody, to name a few. Rufus taught many young artists and offered free classes to some of our young men, to teach them some basics. Many of them are still carving. I bring this up as it's been said that Bill brought back Haida art. The Haida art didn't go anywhere. It was always there, as the supernaturals gave this gift to many Haidas. Our art objects are all over the world in museums. However, Bill brought Haida art to the world on a grand scale.

I've often read articles saying that the art is what "being Haida" means. I question that, as where would that put the hundreds of Haidas, myself included? I couldn't draw an ovoid if my life depended on it—but here I am, Haida. Being Haida is a combination of things. It is our relationship to the earth, a relationship to the food that Xaayda Gwaay (Haida Gwaii) provided, and the richness that *gataagaay* (food) from the land and the sea gave our ancestors and that gave them the time to think about and create and produce some of the most beautiful art objects ever.

There's another legend about the son of the god of the wind, and he was a supernatural being. A house was built by the god of the winds for his son: every part of the longhouse was carved. The headboard was so elaborate that they called it "Blinking." They called it Blinking because it was so beautiful and so elaborate that to look at it made you blink. It was called the Blinking House. The son of the god of the wind in the legend— you could only imagine how beautiful it was. Cooking utensils—they elaborately carved every spoon. We had a lot of time to create only because the earth allowed us to. We didn't have to be struggling, gathering food; the food was there, the richness of the land was there, the beautiful trees were there. I often think that the Haida culture was quite advanced thousands and thousands of years ago.

To me, to be Haida is mainly to understand and speak the language; that gets you closer to feeling what Haida means. I saw Bill very troubled about how we operated as a people. He didn't grow up with us and didn't really trust how we operated, how we ran things, how we did things last minute. It's kind of a challenge: we know that two thousand people are coming to Skidegate, but we leave it in the back of our minds what we're going to do. Often Bill would come and say, "There's nothing happening. We're having a big celebration!" And I'd say, "Don't worry about it. It'll happen." This caused him anxiety. During the struggle to save Lyell Island, I saw his anxiety level rise to probably the highest I'd seen. When we chose to represent ourselves in the courts, he wanted us to have lawyers. We said, "No, we've got Guujaaw, we've got Buddy." We were quite happy having Guujaaw. Even though he hadn't won many cases to date, we were confident. We were really, really thrilled having them represent us, but to satisfy Bill, we let some lawyers in to talk to

us. We just said, "We don't need them." I felt that he didn't have the trust that we had, the knowledge that we have that our ancestors are always around to help us and guide us. And you have to have faith in that. Before I do a speech, long before I got asked a year ago to do this, and almost every time I thought of it, I asked the ancestors to come and help. And I believe that it's basically something of what they want you to hear that's coming from me.

Bill would phone me up many times and ask me to come down and visit him on Granville Island. I would see what he was working on at those times. My wish for him and my prayers for him were that he would come to a place of acceptance and peace with being Haida before he went on his journey. I'm happy that I did see this happen during a trip to Gwaii Haanas in August of 1994. There was, as usual, a huge entourage: his doctor, his nurses, his lawyers. They had chartered the *Hi-yu*, which was our boat, and we also took along *Loo Plex*, the fibreglass version of his *Loo Taas* canoe. It was a wonderful time. It was a difficult thing for him to do, to travel in his condition, but I saw in my heart and in my mind that Bill had got there. There would often be times where he would want to phone the helicopter, he felt so unwell, and the whole camp would be still. We'd be on the verge of calling the helicopter and he would burst out of the longhouse, well again. And one of my favourite memories of him is when he was heading down the beach holding his cane, and he stopped and he started playing golf with the spruce cones. It was so like him, he was so like that, he was so like a trickster. He liked to be a trickster, he liked to be referred to, in fact, by one of his honoured names— Yaahl Sgwansung, which means "the Only Raven"—given to him by Florence Davidson. He had many Haida names. She also gave him the name of "Golden Voice." Pretty important how many names you receive.

During that same trip to Gwaii Haanas, Bill was well enough to get on *Loo Plex*. We were based in Windy Bay, and all the people that were with him got on the canoe and they started paddling. Guujaaw hadn't yet arrived. I stayed on the beach and watched. My husband videotaped the whole ten days. Bill said, "Where's the drum?" And there was no drum, and I was on the riverbank watching them and he grabbed a plastic five-gallon fuel tank and he started drumming away on that. That's another one of my favourite memories. I saw him very comfortable and happy and proud of who he was at that time.

So many things about how Bill operated and how we as Haida people operated were different. Whenever we do something, the protocol has to be right: we have set rules. And Bill always managed to just smash all those up and . . . that's the way it was. Even at this conference I feel like he's here—I know he's here. It made me laugh, because just before we started, Buddy came and said, "You're speaking ahead of me, would you cut your speech down?" I said, "Hell, no. Cut my speech down for you?" He said, "Well, could I go ahead of you?" I said, "No." In our way, you know, he can't really do that to me, but I said, "Well, if you're going to jump me, you can jump Doris Shadbolt. Then I'll feel better about it." So he ran around and did that.

When Bill carved his pole, it was the first pole raised in Skidegate in over a hundred years. It got raised in June of 1978. There was a huge celebration, and there was a huge sense of pride. And I must say that we ran around and we researched, we visited all the oldest people and we had to research how you raised a pole traditionally. We had to research what kind of song you sang—we didn't have Haida singers and dancers until the pole-raising. But anyway, the pole got raised in a traditional Haida manner. Bill made us think and he made us research more than we would have if he wasn't there, to make us do things right. A lot of the times we had conflict, and not all conflict is bad. Often I felt he had more faith in what he knew—in what he grew up with. He had more faith in somebody who had the technology, or he had more faith in somebody who had been to school a lot or wrote a lot of books. He never seemed to question that part, but he often questioned what we were doing. In this way he made us more careful and more aware of what we were doing. But with all that, the respect and the love for Bill was there. We accepted who he was, we accepted the wonderful gift that he was given. We accepted it, we respected it, and we loved him.

I remember when I first read in the *Globe and Mail* that he wanted Guujaaw to steal his body from the morgue and drive it up to Haida Gwaii, dump it off at Cumshewa, and let the crabs eat him—and then have a crab feast later. I thought, "My God!" I was so shocked when I read that. I was angry. I couldn't wait to see him next. I went down to the studio and I said, "Bill, what could you be thinking, how could you do that? The *Globe and Mail*! Everybody's reading that and everybody's going to think we're going to be eating you." And he just chuckled. No answer, no explanation, nothing.

Just this chuckle. I'd be scared to open some of the articles. You know, another one that angered me was that we were mere, pitiful remnants of what our ancestors were. I thought, "Oh, my God! Pitiful remnants of our ancestors!" I would get angry and sometimes I'd say to Dull, my husband: "I'm not going to talk to that guy ever again." And Dull would say, "He's great. His antics—that's what makes him great. You have to talk to him." Sure enough, I would see him again, and the anger would go and the respect would return.

I had to see that he just didn't go far enough in understanding that we are our ancestors. Our ancestors are here. We're here because of our ancestors. In my heart, I believe that in the end, Bill had got there. Bill—Iljuwas—is a Haida. Bill—Iljuwas—is a Haida with many names. Bill—Iljuwas—was born and was given the supernatural gift that we all respect. There isn't anyone anywhere who can take that away from him, because nobody on this earth can take away what the supernaturals give.

So again I say, *howa*! I say *howa* to you, Bill—Iljuwas—who gave us so much to think about, so much to be proud of in what you did. I hope that we carry on. I hope that we do raise a pole once a year in Skidegate. I know he wanted his pole to be the first pole, and he wanted a pole to be raised every year thereafter. That was his wish, and that's what we could do for Bill—Iljuwas—we could do that.

IN JUNE 2001, six totem poles were raised at Qay'llnagaay,[1] the site where the new Heritage Centre and the Bill Reid School of Art will be built. It was a glorious week for the Haida people. I am certain Bill was there with us.

ENDNOTE

1. Qay'llnagaay means "Sea Lion Town," which was an ancient Haida town on the present boundary of Skidegate.

On Shifting Ground:
Bill Reid at the Museum of Anthropology

by KAREN DUFFEK

"I HAVEN'T MADE up my mind yet whether Haida culture is extinct," said Bill Reid in 1991. "If it's become more than that, it's only recently" (C. Hume 1991:c2). In his public presentations, writings and interviews with media, Reid often articulated—in a typically provocative way—the contradictions he felt about his dual position as a maker of Haida art and "a product of urban twentieth-century North American culture" (Duffek 1986:3). He not only confounded the beliefs of others, both Native and non-Native, about what "Haida" and "Haida art" had been and were becoming, but simultaneously drew upon and resisted the values of modern Western art. Throughout much of his career, Reid based his artistic approach on a firm belief in the death of Haida culture. With equal conviction, he spoke about the importance of reassessing its material legacy, its art, in universal aesthetic terms. His pronouncements of cultural extinction helped to shape public understanding of the artistic revival that was well underway by the early 1970s and in which he was held to play a pivotal role as instigator. Yet he also disrupted this discourse. Perhaps because of the strong ties to the University of British Columbia (UBC) and to its Museum of Anthropology (MOA) that spanned his entire career, Reid questioned the extent of the "so-called renaissance" beyond its urban manifestation in such institutions (1979a:115). Toward the last two decades of his life, moreover, Reid repeated but also increasingly countered his own statements on cultural death. He began to assert his identity as a member of the living Haida

community, not only through art-making but through campaigning for public recognition of aboriginal rights to ancestral lands and resources.

In 1984, Bill Reid spoke at the Museum of Anthropology in one of a series of public events entitled "Northwest Coast Indian Artists in Dialogue."[1] The series featured prominent artists engaging in conversations with museum anthropologists about what then appeared to be a major shift within an otherwise market-driven revival: the renewed production of "art" for Native use—for personal, spiritual, community and potlatch purposes. Participants were asked: What is the significance of creating pieces for Native use, versus creating art for the marketplace? Most speakers contested the simple duality of this question as they revealed the inevitable overlap of Native and non-Native patronage in their commercial work and ceremonial production. They also affirmed the significance of dancing, of linking art to social relations, of understanding the function of a mask: in short, of discovering the agency of art-bound-to-community in rebuilding cultural knowledge. Reid's turn to talk came in the final session, when he joined Haida artist Robert Davidson in a conversation with Marjorie Halpin, Curator of Ethnology at the Museum of Anthropology.[2] The ensuing dialogue, and the larger debates on which it touched, are the subject of this paper. Included here are excerpts selected from their wide-ranging conversation, moments with particular resonance for the changing ways in which Northwest Coast art—specifically Haida art—was then being valued and assessed.

In the early 1980s, the sense that something important was occurring in the revitalization of Northwest Coast art, that a history of cultural loss and silence was reversing itself, was becoming increasingly palpable for non-Native audiences, particularly through widely publicized events such as totem-pole raisings, dance performances and exhibitions of contemporary Northwest Coast art. The Museum of Anthropology was prominent in staging such events. Its opening in the new Arthur Erickson–designed building, in May 1976, had already made a powerful contribution to reclassifying historical Northwest Coast carvings as masterpieces of fine art. Moreover, its exhibitions of contemporary First Nations art, including a series of one-person shows begun in 1977, were contributing to the recognition of a new kind of expression—an "Indian modern art" (Ames 1992:84)—whose proper place (art gallery or ethnology museum?) and the criteria by which it

would be judged ("aesthetic" or "ethnographic"?) were being hotly debated by artists, anthropologists, critics and others.

At the same time that recognition by institutions of the Northwest Coast art revival was growing, as was their influence in governing its direction, other voices were insisting on renewing the place of art within First Nations communities and on privileging locally specific criteria of value not encompassed by galleries and museums. These voices questioned prevailing notions of cultural death and revival. They replaced the emphasis on "loss" with an awareness of the historical circumstances of colonial "theft," pointing to continuities rather than declines in cultural practices. The tendency of public institutions and the market to give priority to visual art and its formal "quality" over the social functions of such expressive forms was similarly challenged as a criterion of authenticity.

One of these voices belonged to Kwakwa̲ka'wakw artist Tony Hunt, an earlier speaker in the MOA series, who described his carving and painting not only as fine art but as components of a history of ceremonial use, privilege and responsibility. Recalling the potlatch held by his grandfather Mungo Martin in 1953, after the potlatch ban was dropped from federal legislation,[3] Hunt said: "In the early years I never knew I was at a potlatch that was outlawed. And all of a sudden I was at one that was legal." His statement reminded listeners of the survival and evolution of cultural knowledge within his community regardless of the profound social and economic changes its members had experienced, and despite the efforts of church and state toward its eradication. Like his grandfather, Hunt had worked closely with anthropologists in museum carving programs, and he spoke of his desire to teach young carvers and dancers in order to strengthen Kwakwa̲ka'wakw traditions. His words made clear, however, that such strengthening was not a project to be defined by museums alone: "The mask had meaning only after the dancer took the mask and used it." Rebuilding the cultural practices underlying the visual art required "memory accumulated beyond the grasp of the museum" (Hawker 2002:141) among elder teachers and other community members.

At the time of the series of artist dialogues, the political ground underlying the Museum of Anthropology was being shaken up in some significant ways. Throughout British Columbia, First Nations were taking direct action

to claim aboriginal title and control over resources and their development. Demands for recognition of an inherent right to self-government became more forceful, as did assertions of sovereignty over culture and its representations. The criteria by which the museum had collected, classified and assigned value to objects could not easily be separated from the complex history of colonial encounters of which museums are a part. The stage was set for developing new terms by which the relationship between museums and "originating peoples" (those from whom the objects in collections originally came) might also be redefined.

The Museum of Anthropology has, since its founding, taken such shifting ground as a starting point from which to address questions that have become central to our time and place: how cultural identity and cultural boundaries are to be negotiated, and how different histories and visions of culture and community can be articulated in relation to one another. Located as it is in the traditional territory of the Musqueam Nation—a point of land that is not only geologically eroding but also politically contested—the museum has become aware of the risks as well as the potential of being situated on unstable ground, and the importance of being anchored and rooted. Similarly, the postmodern process of deconstruction that, in its celebration of fragmentation and provisionality, has effectively loosened boundaries around such rigid categories as "Indian art," offers both benefits and risks for First Nations artists and communities, whose strategy of reclaiming, rebuilding and reaffirming traditional cultural practices is taking on a new urgency. Because of the massive removal of ethnographic and archaeological objects to distant museums during the late nineteenth and early twentieth centuries, many originating communities were deprived of key components of their heritage. Moreover, the number of fluent speakers of Native languages is rapidly shrinking in most communities. Projects of cultural restoration—whether of languages, songs and dances, or of regional styles of carving and weaving, or of rights to inherited privileges and territories— depend not only on destabilizing the externally imposed ideas by which First Nations practices have been named and understood. They depend, as well, on a process of construction—of creating new understandings—that has as its foundation values and histories that are shared and continuous, even while these must be negotiated and allowed to evolve.

During their dialogue at the Museum of Anthropology, Bill Reid and Robert Davidson took their places in what Marcia Crosby (1994:97) has called the "open-ended continual struggle for meaning of Northwest Coast cultural objects in the public sphere." In often divergent ways, they positioned themselves and their work in the space between sometimes contradictory, sometimes complementary, strategies—between constructing and dismantling, between restoring and inventing. The museum offered more than a backdrop for this conversation. It too was a participant in the process by which the revival of Northwest Coast art had been defined and these artists' positions within it validated. In creating a public space for dialogue, the museum made room for a broadening of the revival discourse, in which the ongoing stories and changing meanings of Haida art could be argued out from different points of view.

The dialogue began with a masked entrance by Davidson, to the drumming of his friend, Nuu-chah-nulth artist Joe David. Davidson wore a mask he had newly carved depicting the spirit creature Gagiit, a fearsome being with grotesquely exaggerated features, unkempt hair and spines protruding from around his mouth. Davidson explained to the audience that representations of this creature are often used to start off the dance program at community feasts at home, in Old Massett. (In a recent recollection about his performance, he added, "The session had to do with masks—with intellectualizing masks, which I didn't know much about— so I thought I'd do this as a bit of a trick on Bill."[4]) The discussion ensued.

HALPIN: *In the early part of the century, Swanton[5] was told by the Haida that people who have not been initiated into the dancing societies—into the mask—were people with "dark faces" and "stopped-up minds." It had something to do with dancing as opening up the person. One of the things that Joe David said at Robert's potlatch[6]: he talked about people shining, their faces shining. And that's what I'm looking for: what dancing does; what difference it makes to dance.*

DAVIDSON: *You have to psych yourself up to be that person that you're impersonating. It's very different from carving. I didn't carve the masks until I started singing and started understanding the songs and just psyching myself up.*

REID: *Well, I haven't got a dark face . . . I can't make a comment about the dancing because I'm not a dancer and never have been. And it's been pointed out to me many times before, I think, by somebody not too far away from us in the audience, that I wasn't a bad carver, considering I couldn't dance. I think there's probably some truth in that. I envy people who can dance in any way, because I think it's one of the great human expressions. But unfortunately my fine Anglo-Saxon upbringing didn't accommodate that. And when I was of an age when I could've learned something of it, it wasn't in practice—it wasn't available to me. I think it probably gives you a wider grasp of the whole culture which underlies the carvings that we do. I don't know what effect it would have had on me had I been able to.*

HALPIN: *How did you find out about the culture?*

REID: *I think it was in a search for some kind of identity that I began to gravitate toward the Haida part of my ancestry. I'd never visited my people and the village until I was an adult. And so the only source I had was books and museums and the odd acquaintance with some people from the villages. From this rather flimsy structure, I built a foundation from which I could start re-creating. It certainly was a business of re-creation to start with, or it could even be called straight copying, that's what it was. I learned the jewellery trade, and that seems to be particularly adaptable to the Northwest Coast designs or vice versa. And I developed an understanding of the structure of the designs in a very mechanical way.*

It was not a commitment to the ceremonial, to the mythical, to any part of it— it was an attraction to the aesthetic of the art forms and the wonderful experience of seeing these things grow as they were applied to the pieces of jewellery. It was a long and interesting process, uncovering this famous set of "rules" that we keep trotting out whenever this kind of discussion comes up. I'm beginning to doubt the rules myself, but they certainly were useful in the early part of the reconstruction of the Northwest Coast aesthetic.

When I started playing around with the Haida designs, I was absolutely convinced that there was nothing new that could be done with them—that all I could do was use these jewellery techniques which I had learned and apply the best of the old designs to this new medium . . . And then one day I just did something that didn't relate to the old designs, and it was quite an amazing experience to look at it

and realize that it was not too bad and that I could begin to create if not new, at least different interpretations of the old forms. It was a series of constant discoveries for a period of a decade or so, and I eventually began to understand something of the complexity and the differences that can be derived from these basic forms out of which Northwest Coast art is constructed.

DAVIDSON: *I feel you have to start by imitating, start by copying. When you apprentice to a master, it's very important to copy, to start understanding the rules or the formula. It's very much like when my children were going to school, they would constantly practise doing their ABCs. They wanted to learn how to draw those letters, and they'd put a few words together, and then eventually they can start creating their own stories. Those stories come from their heart, and I feel creativity comes from your heart. Now what's happening is that the mythology that we were confronted with—my ancestors' mythology—has to be updated: updated in the way that it always was. Generation after generation updated and gave those mythologies a meaning. I feel that stopped three generations ago. Now it's our challenge to give that mythology a meaning for today. I feel once we start creating that meaning, we're no longer imitating.*

Widely regarded as the "über-Haida" artist of the twentieth century, Reid nevertheless thwarted popular expectations of what experiences that position might entail. He often described himself as a "WASP" and an "artifaker" (Duffek 1986:4, 41), emphasizing his distance from traditional Haida cultural practice as well as the living Haida community. Willing to "hybridize" his work by fusing Haida expressive forms with the conventions of Western sculpture and modernist jewellery design, he confronted notions of indigenous cultural purity even as he came to embody a link to Haida master artists of the past. At the same time, Reid's emphasis on craftsmanship and materiality—"the well-made object"—together with his desire to restore a high level of quality to Haida art, ignored the conceptual focus of much contemporary international art. Despite occasionally worrying that his art might be "all form and freedom and very little substance" (Reid 1981:166), moreover, he questioned both the academic, rule-based understanding of Northwest Coast art and the re-emerging criterion of ceremonial function as indicators of its authenticity.

Reid was frank about his approach to learning the visual language of Haida art by copying the work of Charles Edenshaw and other Haida masters of the nineteenth century. Museum collections, he made it clear, were the primary source from which he constructed this understanding. Formal possibilities excited him; moving beyond copying meant discovering the potential of the old forms to be visually reinterpreted.

Davidson also reiterated the necessity of copying older works as an essential element in the learning process. Yet through his words and masked performance, he demonstrated a further conviction that to move beyond copying requires more than formalist innovation. To affirm and create a contemporary conceptual or mythological basis for Haida art, he suggested, an object's place within a current and evolving Haida cultural practice—whether ritual or everyday, whether in the context of the home or the feast house or the urban diaspora—must also be restored.

The parallels and differences between Davidson's and Reid's statements hint at wider debates about the public positioning of Haida art—debates that Reid, in association with his museum and corporate patrons, had already helped to set in motion. Reid's relationship with the Museum of Anthropology, in particular, covered five decades, from the early 1950s until his death in 1998. The Museum of Anthropology continues to exhibit, research, publish and promote his work within a framework of historical and contemporary Northwest Coast and world arts. Some of the main points of conjunction between Reid and the MOA may now, however, be seen as points of contention, because they are inseparable from the cultural and political shifts that began to take shape during the period of the artist's and the museum's shared history. These points, which are elaborated in the discussion that follows, encompass the salvage of totem poles from abandoned Haida villages, the reclassification of Haida art according to universal aesthetic values, and the establishment of Reid and his work as icons in the Northwest Coast art revival.

Much has been written about the premise of cultural death on which the "salvage paradigm" is based and how "those doing the saving . . . become both the owners and interpreters of the artifacts or goods that have survived."[7] In 1954 and 1957, Reid took part in joint expeditions of the British

Columbia Provincial Museum and the University of British Columbia's Department of Anthropology to salvage totem poles from abandoned sites on Haida Gwaii. Poles and pole fragments rescued from among the decaying ruins of T'anuu, K'una (Skedans) and Skung Gwaii (Ninstints) entered the Museum of Anthropology as artifacts of a bygone culture, connected less to the continued existence of the Haida people (then living in Skidegate, Old Massett and urban centres) than to the "ghost villages" at which the relics were found. "But the days of such depredations are over," declared anthropologist and expedition member Wilson Duff (1976:88) in 1976, the same year that the new MOA opened with the poles installed in its dramatic Great Hall. Debates continue today about the expeditions and whether they represented salvage or plunder. For Reid, the trips and the works themselves became part of the raw material that simultaneously reinforced his perception of Haida cultural death and allowed him to rebuild an understanding of nineteenth-century Haida sculptural form.

Situated inside the Museum of Anthropology as singular works of art, the poles and pole fragments were also re-presented as components of national heritage and as human achievements of universal aesthetic value.[8] By emphasizing the visual qualities of the sculptures, the museum sought to further cross-cultural appreciation of Native expressive forms. The visual provided museum visitors with a point of entry into Haida art and culture, a way of transcending their (less accessible) local references. It did the same for Reid. Reid's translation of Haida imagery into gold and silver vessels, cufflinks and earrings depended on isolating motifs that, in the 1940s to the 1960s, no longer seemed a part of functioning Haida narratives and crest ownership but represented an artistic standard that could be given modern application through European goldsmithing techniques. "He was living and working within the white urban culture," notes Doris Shadbolt (1986:181), "at a time when the separability of art from society was a demonstrated fact, and yet he was emulating the art of his ancestors which had, in another time, so clearly spoken of their indivisibility."

The "indivisibility" of Haida art and society proved not, however, to be wholly relegated to the past. As James Clifford (1991:241) has observed, "To portray an object as fine art in an ongoing Northwest Coast tradition down-

plays its role as contested value in a local history of appropriation and reclamation." Today, the exhibit of salvaged poles in the Great Hall has not been substantially altered since its 1976 installation. Yet the poles' status as "mute relics" (Duff 1976:84) is countered as new points of conjunction and contention among First Nations, museums and the public shape the criteria by which these works are read. Physically, the poles are separated from Haida communities and lands. They remain aesthetic accomplishments that may be viewed cross-culturally as art. At the same time, the strengthening of local ceremonial practices, reclaiming of inherited crests and family prerogatives, repatriation of human remains, and assertion of title to lands and resources—all of which speak of cultural survival rather than extinction—are helping to restore a reading of Haida art in which social values take their place beside formalist ones.

HALPIN: *One of my beliefs is that certain exceptional artifacts contain the essence of a culture. Could you comment on that? Because if it were so, I think you would have seen it.*

REID: *I suppose the whole magic secret of art is that it does express the personality or the essence of not only the culture but of the individual who creates it and the people of his own generation and, if it's a long, containing culture, the whole background that led to that stage of its development. It is the wonderful thing about Northwest Coast art particularly that it has these many layers of meaning on a nonverbal level, where you can identify with and empathize with somebody so far removed from you culturally, geographically, in time—but the message comes through strong and clear. I think it is quite evident that whatever the feelings those old people had in the nineteenth century, where most of our old material comes from, has some relevance to people today, because they are attracted to it and respond to it and put out good money to buy it.*

DAVIDSON: *I feel that dancing is very universal in its expression. I feel dancing is something that we all understand. The art form is the same way. I don't like to limit myself in the fact that I do Haida style—it doesn't mean I'm only a Haida artist. I feel my role right now is to give it that universal quality that has already been there and which was lost about four or five generations ago.*

At various points in their dialogue, both Reid and Davidson spoke of the "universal" as a criterion of value—indeed, as an ideal—that carries with it the premise that Haida art of high formal standards can transcend its local context to be appreciated globally. In the 1960s, Reid, along with Wilson Duff and Bill Holm, contributed to what Halpin later described as a "universalist discourse":[9] an academic and formalist way of speaking about Northwest Coast objects that values stylistic and material attributes over social relations and function, and that predominates in many published analyses of the art. Reid was a passionate advocate of that discourse. His emphasis on the transcultural qualities of the well-made object contributed to the success with which he helped bring Haida art to world attention.

Perhaps ironically, as Northwest Coast art gained global recognition and the collector market grew, some artists began to question the criteria of value represented by a universalist ideology. Artists like Davidson, who by the 1980s were successfully making a living creating carvings and prints for non-Native patrons, found increasing personal and spiritual value in simultaneously rebuilding a community-based role for their work—sometimes, as when hosting a potlatch feast, at great financial cost to themselves. Restoring the formal and conceptual standards held by nineteenth-century masters—"the universal quality that has already been there"—remained fundamental to strengthening current art practices. But ideas about local ownership of and boundaries to cultural knowledge were now also being restored. Such assertions, in which local purpose was given priority rather than being transcended, seemed antithetical to Western or modernist notions of universal heritage and accessibility.

Through the windows of the Museum of Anthropology's Great Hall the old poles from Haida Gwaii look out at newer compositions: the mortuary, house-frontal and memorial poles carved by Bill Reid and Doug Cranmer for the University of British Columbia between 1959 and 1962.[10] When Reid developed the plans for this Haida village installation with anthropologist Harry Hawthorn, his goals were to acknowledge and acquire skills in the tradition of monumental carving by creating replicas based on fragile older works and on photographs.[11] The project was the first major, high-profile commission through which Reid, already recognized for his small-scale carvings and jewellery, confirmed his place as the

central contemporary figure in the preservation and revival of Haida art. His patrons were not Haida clans but rather the University of British Columbia and, by association, its museum, as well as governmental and corporate donors.[12]

Reid's UBC poles were "modern" in their autonomy from the social relations that crest figures traditionally symbolized, even as the new works replicated nineteenth-century totemic forms. The choices Reid made in selecting and combining figures were determined not through consultation with Haida authorities but according to his more generalized intention to portray the main mythological and crest images, and the range of totem-pole types, used by southern Haida in the past. His single mortuary pole, for instance, was inspired by fragments salvaged at K'una and T'anuu: Reid adapted their carved figures to represent the Bear Mother story and added a frontal board depicting an Eagle of his own design. With knowledge acquired over the ensuing years, reports Hilary Stewart (1990:62), Reid found "that depicting Eagle was inappropriate, because this crest does not belong with the Bear Mother story." Specific clan histories and other local meanings were subsumed but clearly not erased by the new purpose for which these works were created.

The UBC Haida village project was conceived as a kind of retrieval of carving practices and motifs from the past for the education and enjoyment of a diverse, urban-based public. Ultimately, it also provided an impetus for further totem-pole carving by a new generation of Haida artists. Robert Davidson took up the challenge in 1969 not only to create his first pole but to carve and raise it in his home community of Old Massett. Whereas Reid had deployed the university commission to gain greater recognition of the historical and universal values of Haida sculpture, Davidson set out to shift the context for Haida poles from the reconstructed to the living Haida village. Moreover, he intended his pole to represent all of the Massett Haida and so selected the Bear Mother story as a "neutral" subject equally representative of the Eagle and the Raven clans. Like Reid, Davidson eventually learned that the pole would be read differently from the perspective of still-functioning Haida protocol. Its main figure of the Grizzly Bear is a crest of the Raven clan; Davidson would have had to give equal emphasis to an

Eagle clan crest in order to achieve the neutrality he desired (Davidson and Steltzer 1994:22). He often recalls, however, that because the pole was raised as a component of ceremony, it helped to restore the role of art as a conduit for the transfer of such cultural knowledge within his community (Halpin 1979:4).

HALPIN: *I think of both of you as giants, but I also think of you, Bill, as the man who started it in our time, as sort of an ancestor to people like Robert—that he stands on your shoulders. What is that like for you, to already, as it were, be a legend in your own time?*

REID: *They call me the godfather, I hear. I never started out to do anything but make pretty baubles for pretty people. I wasn't going to carry on a tradition or be responsible for anything at all. It's always been sort of a surprise to me that this thing has grown the way it has. The one thing I feel like doing once in a while, and I'm sure Robert does too, is getting up on a soapbox and saying, "Don't go complaining about this $1500 you got paid for that bracelet made in two days last week, because I made the same thing, only for five dollars, and we developed the market." I know it's kind of a crass footnote to the whole thing, but it was owing to the fact that I was working at another job and was able to sell this stuff for nickels and dimes that the market built up. I realized I was working for about twenty-five or thirty cents an hour, which is the same as Charles Edenshaw was making during his time of greatest affluence.*

I've only had about three people whom I've influenced directly. Robert is the first one, and he was well on his own way. He was pretty phenomenal because he'd come out of what was then a wasteland artistically in Massett and was already making these very nice, efficiently carved items when I first ran into him. He just needed a little introduction to some of the basic forms and he was away.

DAVIDSON: *I had to follow my grandfather's path, and my dad's, and Charles Edenshaw's. And when I came to the city, there was Bill Reid. Seeing all this incredible culture that's accessible to the urban people, and then flying back to Massett and seeing absolutely nothing: that was a challenge, to bring this knowledge back to the village. Bringing that totem pole to the village inspired a little*

spark that was there for ceremony. That ceremony couldn't have happened without the art. The art was the facilitator, the medium. And I feel from the meaning that I'm getting through the ceremony, that the art is enriched.

Two years ago I gave a potlatch to adopt Joe David as a brother, and I used that same time to invite the people in the village to use this occasion to name their children. The idea came from the complaint that I kept hearing in Massett, which was, "There are no more names. We're not handing them down." So I challenged those people, and I feel that experience freed me. It freed me of the cultural restrictions that I kept binding myself with. Everywhere I'd go, I'd hear, "What are you doing? You're not allowed to do that, you're not allowed to do this." And I'd say "Why?" From that challenge of the potlatch, I feel free to do anything.

HALPIN: *When you knocked on doors and invited people to join you in that potlatch, what kind of response did you get?*

DAVIDSON: *There were some people who were very excited: the very old-thinking people, the people who still spoke the language, who were very close to thinking in their grandparents' ways of thinking. Some were very "Let's leave the past behind." The people who had that attitude were people who had had very bad experiences as Natives. It was challenging to have all these different responses. But on the night of the potlatch when the children were being named, these people who refused this occasion to name their children were lining up. I felt that was very exciting to see the transition and accept where we come from.*

Throughout their dialogue, Reid and Davidson demonstrated that the idea and the ideal of "revival" would continue to be differently defined and negotiated within as well as outside First Nations communities. Strategies of cultural and artistic renewal, like the recategorization of Haida art, were not fixed or complete. Instead, they were reaching beyond the purview of museum display to an increasingly complex entanglement of community, artist, public institution and market.

Reid's points of conjunction with the Museum of Anthropology served to reinforce his reputation as the catalyst for the revival, restoring a tradition within new systems of value. Several of his works in wood, ivory and precious metals were shown in the museum's Masterpiece Gallery, a

kind of "connoisseur's selection" of Northwest Coast art that opened as part of the new museum building in 1976.[13] The MOA gradually built up the largest public collection of Reid's works in all media, including the monumental sculpture *The Raven and the First Men* (1980), an installation that placed Reid's work literally at the core of the museum for which it was created and, as a widely reproduced and circulated image, onto the world stage. In 1986, the museum organized a retrospective exhibition, *Bill Reid: Beyond the Essential Form*,[14] and by 1994 the escalating value of Reid's jewellery and small-scale carvings prompted their removal from the Masterpiece Gallery to a new and more secure installation surrounding the *Raven*. The publicity Reid received for these and other commissioned and collectors' pieces strengthened not only his position as a master artist but also the perception that, as Halpin announced (1981:30), the social context of Northwest Coast art had irrevocably "shifted from the level of local consumption to the international art market."

Reid regularly and publicly countered his reputation as legendary ancestor, pointing to the pre-revival, pre-iconic status of his art and describing the challenge of building an international market for commodities rooted in local traditions but not yet accorded universal value. Davidson, who began his career about a decade after Reid and was equally committed to expanding the market, articulated his own overriding challenge as the need to reverse the local / international shift: that is, to repatriate cultural knowledge and its stewardship from urban, non-Native audiences to the Haida people. He expressed his growing realization of creative freedom not as a consequence of assimilating a modernist sense of artistic autonomy, moreover, but rather as the result of helping to restore the place of ceremony within his community. With this came his further understanding that "culture" could be both inherited and newly imagined.

HALPIN: *We normally think that culture somehow is prior to its artistic expression, and Robert's talking about a situation wherein art is bringing forth culture, and taking a rather primary role. I'd like to ask you to comment on that.*

REID: *I think we should stop sparring around and get into some talk about some issues about the whole movement. I parachuted this totem pole into Skidegate six*

years ago now,[15] *and the response was anything but enthusiastic at the start. I was alone on the job. Now there are many reasons for this, and I won't blame the people for it. Anyhow, we finished the pole, finished the house and put the whole thing together. Then all of a sudden the activity started. In about a week's time, it seemed to me, everybody had button blankets and there was a grand celebration organized. It was one of the most exciting experiences I ever had. I was given a very warm round of thanks for my contribution, and I went away feeling wonderful. Well, since then I've been to four or five totem-pole raising celebrations, all the same totem pole. I think it's about time we got on with something else.*

I would like to see sometime a carving program or something similar going on, where the people can begin to develop skills and attitudes which they had before. I have the most profound respect for people of my grandfather's generation, and Bob's grandfather, who was younger. They came out of a terrible disaster which everybody knows about and built a new life for themselves. They established boatyards and built these Victorian houses and so on, with nothing much to go on but their own ingenuity. I would like, through the arts perhaps, to get that appreciation of what is possible.

The art of the Northwest Coast should be relevant not only to the Native societies but to the outside world as well. We are sitting here on a remnant, on the ruins, of a culture which has been compared, and I think justifiably so, with the greatest cultures of the past—Egypt and Mesopotamia and all those places that we revere so highly—and we ignore it. It could be a part of our common heritage here, something we could look back upon, instead of looking back constantly to Europe. We could perhaps not use these old forms in themselves but merely draw inspiration or identity with the land through them. And perhaps some of us could eventually begin to be North Americans, with a real feeling of some cultural roots in this country. But it has to be a two-way street. There are still animosities, suspicions, hatreds even, between the two societies. These have to be overcome, and we have to learn more about each other.

DAVIDSON: *On the totem pole, Bill, the reaction you had in Skidegate was the same I had in Massett. I think that reaction is very common; when someone says, "We're having a party," nobody wants to help organize it but everybody wants to be there. Furthermore, not too many people really understood the impact the totem pole was going to make, until the momentum started happening. That's when all the knowledge*

became public, that's when we all embraced each other: we all saw a common denominator. We arrive at solutions to problems through living. I feel that the totem pole, for example, is a very strong symbol and it is allowing the Natives to regain their identity and also try to find their roots again. I know for myself that it took a long time before I finally accepted being Native and getting over the shyness of putting on a mask or singing the Haida songs. It's a real barrier that we all have to go through.

HALPIN: *But what do these people—the audience—have to do with it all?*

REID: *I still have difficulty with this whole situation. I've been making a really good living for a number of years, making these objects. And yet I can't reconcile myself to feeling comfortable about the lack of progress in alleviating the social situations that are still maintained in the communities. Until some positive steps are taken, you can't feel that the official community as a whole is on your side—in fact, they're still the enemy. It's by neglect if not conscious persecution. What this has to do with making a living selling art objects based on Haida designs is something which I have a hard job convincing myself about. I do it because I like doing it, because I think the objects—when I have to give myself excuses—justify themselves.*

In talking about bridges I constantly recall The Bridge on the River Kwai, *which is, if you remember the movie, about a British engineer who was captured by the Japanese during the war and put to work building a bridge. To simplify the story a lot, he got so enamoured of his own expertise at bridge building and the praise of his captors that he forgot they were the enemy and built this remarkable bridge which was erected for their war effort. Somehow I feel that in building these things that I do, I'm building that kind of a bridge, too. It's a one-way street, in a way. We feed into the general population these objects which bring satisfaction and enjoyment to the non-Native population, and you get money in return individually, but nobody sees beyond the images of the iconography to the people whose ancestors created this kind of thing.*

That's one thing you get with this package, I think. When you start making Northwest Coast art, you have to become involved in some way with the people.

DAVIDSON: *When I first came to Vancouver, it was a culture shock to see all these people, and they knew about Haida culture, they knew about Tsimshian, they knew about Tlingits, they knew about Kwagiulth—they were a lot more aware of what*

my ancestors did than I was. The things I was exposed to were fuzzy photographs that Marius Barbeau had compiled in about five books, one of them being Haida Myths Illustrated in Argillite Carvings. *These people were asking me questions about where I came from, and I didn't know anything about where I came from. It became my responsibility to find out. So that's what these people have to do with it.*

Throughout the dialogue, Reid contested the legitimacy of renewed cultural practice as a meaningful way of defining a contemporary Haida identity and presence. He carved his pole for Skidegate, he once said, "as a memorial to the Haida of the past, not an attempt to turn the clock back" (1981:169). "Turning the clock back" was a critique Reid extended to the revival of Haida dancing and ceremony, even as his own work helped to stimulate such activities, and even as he articulated a necessary connection between his art and the Haida people. In Reid's eyes, the significance of reclaiming and rebuilding skills associated with art-making was not simply the renewal of cultural practices but the social and economic empowerment of those who attained such skills. This was the route through which he envisioned a repositioning of Haida art within a universal system of value and of Haida people within a new global reality. Universal recognition of the art required universal recognition of the people, Reid suggested during the dialogue: a "two-way street" constructed on a more equitable basis than colonial relationships allow.

Both Reid and Davidson recognized that, just as art-making for Native and non-Native audiences overlapped for most Northwest Coast artists, local and global concerns would intersect in most strategies for artistic renewal, whether culturally or economically based. Where Reid's view was oriented outward, Davidson's was becoming increasingly grounded in the local. Recognition of the universal values of Northwest Coast art by museums and the market had already helped to bring the art to the attention of audiences around the world. Now, in the face of treaty negotiations and the threatened loss of Native languages, restoring and assuming control over traditional cultural practices was increasingly becoming a priority for coastal First Nations.

Fundamentally, and perhaps inadvertently, Reid's Skidegate pole project contributed to what Davidson would go on to describe as "going back":

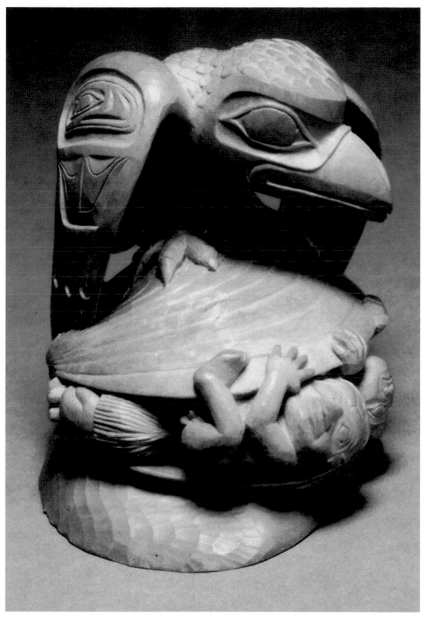

FIGURE 12

The Raven Discovering Mankind in a Clamshell, boxwood carving by Bill Reid
1970, H 7.0 × L 6.9 × D 5.5 cm, UBCMOA NbI.488. Photo by B. McLennan

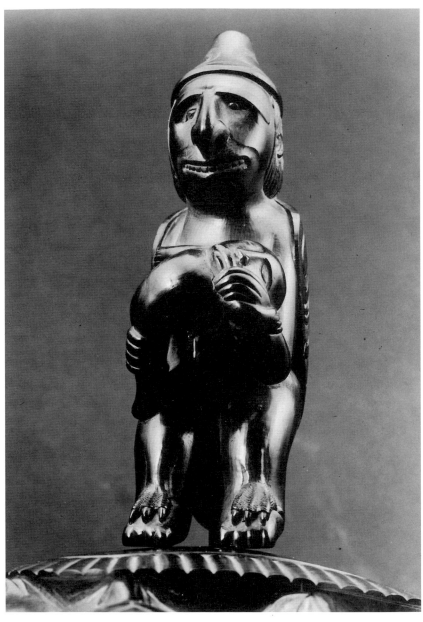

FIGURE 13

Detail from lid of argillite chest, late nineteenth century, attributed to Charles Edenshaw, figure H 16 cm, chest H 37.0 × L 45.5 × D 30.0 cm, Royal British Columbia Museum 10622. Photo by Andrew Niemann, courtesy RBCM, Victoria, B.C., Neg. CPN 10622

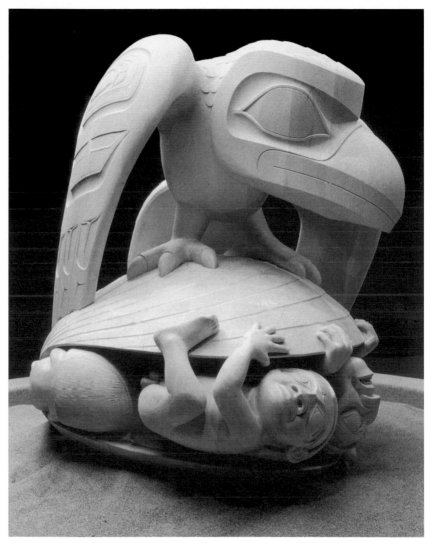

FIGURE 14

The Raven and the First Men, by Bill Reid, 1980, laminated yellow cedar, H 1.9 × D 1.9 m, UBCMOA Nb1.481. Photo by B. McLennan

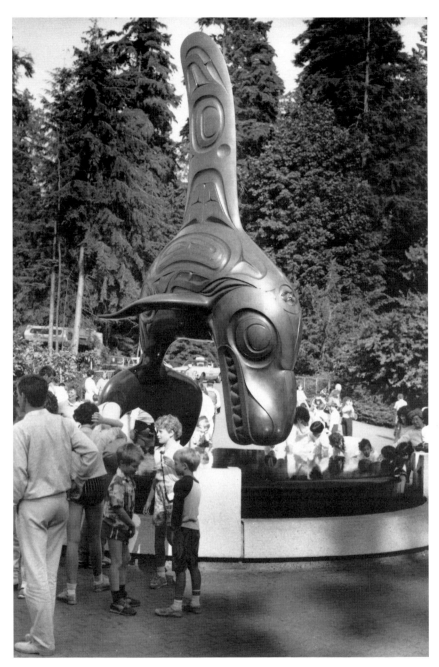

FIGURE 15
Chief of the Undersea World, by Bill Reid, 1984, bronze, H 5.5 m, collection of
Vancouver Aquarium Marine Science Centre. Photo by B. McLennan

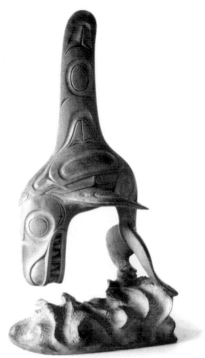

Killer Whale maquette by Bill
Reid 1983, boxwood, H 10 cm,
private collection. Photo by
B. McLennan

FIGURE 16

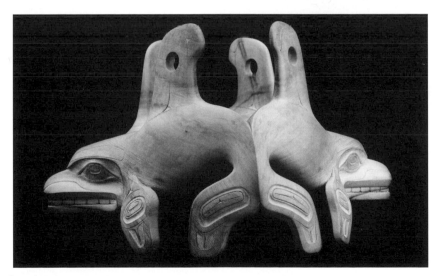

FIGURE 17
Killer Whales maquette by Robert Davidson 1984–85, yellow cedar, H 16.3 ×
L 27.9 × D 25.9 cm, collection of Old Massett Village. Photo by Andrew
Niemann, courtesy Royal British Columbia Museum, Victoria, B.C.

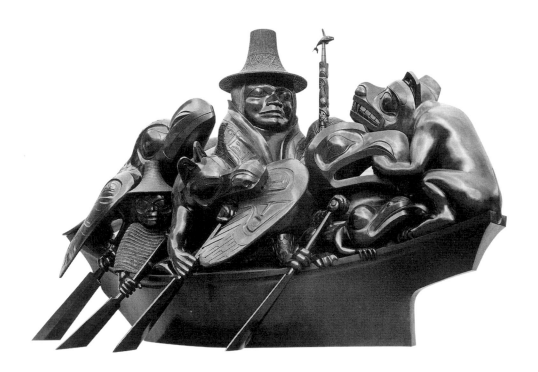

FIGURE 18

The Spirit of Haida Gwaii by Bill Reid 1991, bronze, H 3.89 × L 6.05 × W 3.48 m,
collection of Canadian Embassy, Washington, D.C. Photo by Ulli Steltzer from
The Black Canoe: Bill Reid and the Spirit of Haida Gwaii (156–57), courtesy of the
photographer and Douglas & McIntyre.

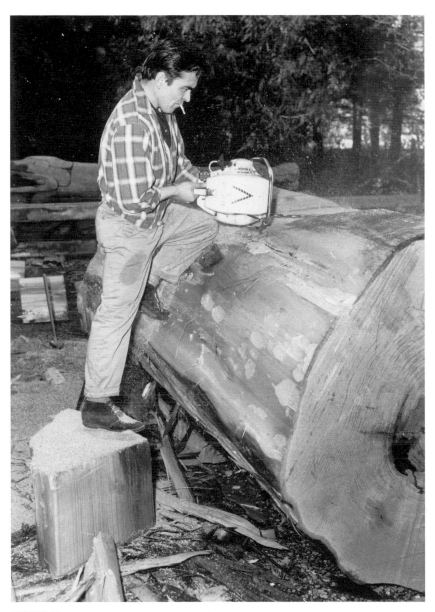

FIGURE 19

Doug Cranmer uses a chainsaw to begin shaping the Wasgo (Sea Wolf) sculpture, University of British Columbia campus, 1962. Photo UBCMOA archives 1.403

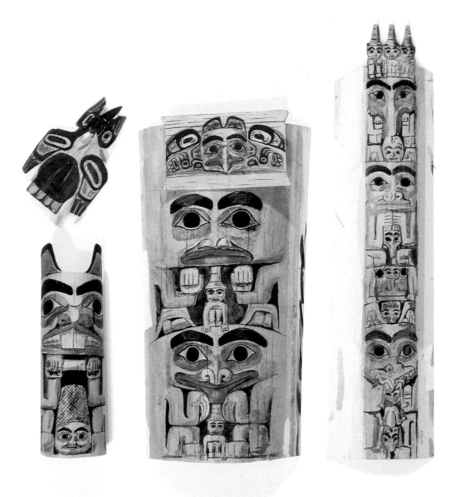

FIGURE 20

Components of three poles from a complete set of painted paper models made by Bill Reid in 1959 for the Haida houses and poles created for the University of British Columbia. Left to right: Beaver (H 19.7 cm) and Raven (H 12.5 cm) from memorial pole, UBCMOA A8254; single mortuary pole, H 31.6 cm, UBCMOA A8253; mortuary house-frontal pole, H 42.9 cm, UBCMOA A8251. Photo by B. McLennan

not a nostalgic return to the past, but an assertion of local practice that might provide a foundation from which to resist and, ultimately, gain support within, the broader society. From Davidson's perspective, rebuilding Haida histories and knowledge bases, as well as re-placing cultural practice into continuing histories (sometimes in the face of community dissent), offered a way of repatriating cultural knowledge and its ownership to originating communities. The masked entrance with which Davidson opened the dialogue was a demonstration of this understanding, performed directly for Reid and for the museum audience. The mask was not to be understood solely as art or museum object. It was created specifically to restore the position of Gagiit masks within Haida ceremony and song—a position left empty for most of the twentieth century when such masks were no longer carved or possessed by the Haida people.[16]

The reconstitution of connections between objects and living cultures—including continuing ownership among originating peoples to the images, narratives and rights represented—is now among the major challenges that the Museum of Anthropology and other Canadian museums, in dialogue with First Nations communities, have determined as a foundation for contemporary practice. "Stories, masks, and ancestors' remains become means for moving publics to urge and support political decisions of significance," anthropologist Michael Kew has observed (1993:92). In the years following the MOA dialogue, Reid chose the canoe, both carved in cedar and cast in bronze, as a vehicle with which to demonstrate his skill at mobilizing public, governmental and corporate support for Haida initiatives. The Museum of Anthropology, the international arena and disputed Haida lands became the sites on which Reid transformed his discourse from creating "baubles" to creating resistance and demonstrating publicly his scepticism about both the significance of the Northwest Coast art revival and his essentialized roles as hero and bridge figure.

Uncomfortable and unfamiliar with Haida dance traditions, Reid choreographed his own "dance" with the form and materiality of objects, positioning himself and his work in relation to the legacy of his ancestors, and before new and disparate audiences. The steps he chose to take on this very public stage helped to shape ongoing convergences and struggles between narratives of

cultural disappearance and continuity; they may yet lead to a more complex understanding of historical and modern expressions of Haida art.

HALPIN: *What's next?*

REID: *I shall continue to "build bridges across the River Kwai" and worry about them, and slowly but inexorably be herded into a carving program in Skidegate. I hope, if this thing works at all, we can do in a small way what I would like to see done eventually in a much larger way, and that is to get people into the village who can assist a return to the old cultures. By that I don't mean ceremonial, I don't mean language, I don't mean any of those things. The one outstanding thing about the old Haidas, Kwagiulth, Tsimshian, Heiltsuk, Haisla, the whole lot, was their amazing competence. They could cope with an environment which was rich but not easy, and on it build a truly amazing culture. I would like to see the skills that are present built upon, and new ones introduced.*

DAVIDSON: *I agree with you. I know the art form has played a very important role in regaining our foundation. I very much support your idea of going back. When you look at the old pieces, they do compare to great masterpieces of the Old World. When I look at one horn spoon that I have, I am in awe of the integrity that person had, and the caring he had, in producing this absolutely beautiful spoon: a very common, very functional, sculptural piece. My challenge as much as yours is to bring that standard back.*

REID: *Often when young carvers come to me and say, "How can I become a great artist?" I tell them to go and read Moby-Dick for a start. It's not really intended seriously because I don't think anybody's going to do it. But it would be one step on the road to a broad understanding of their world that I think is necessary for anybody who presumes to put into his work what the old timers did. That is the universal message which will transcend time and space and culture. Those old people were completely educated in their universe. Our universe is no longer a stretch of beach and a number of genealogies and a body of myth. It extends far beyond that.*

DAVIDSON: *It was only recently that I started getting interested in the songs and dances in Massett. My interest brought me to quite a few different people in the*

village. The survival of any dances was very minimal, and there are very few that are still handed down. I don't want to stop there and say, "Oh, woe is me. We don't have any dances." Some of the songs that our dance group sings, I call them universal songs. They don't belong to any family. And I know we developed a few dances so far to mark different occasions.

When I started getting into ceremony through dancing and singing, when you get into that space, you get into the spirit of the dance and the occasion. I like to think of ceremony as a time to stop. It marks a change in direction.

ENDNOTES

1 The series was co-ordinated by the author and presented by the Museum of Anthropology in co-operation with the University of British Columbia's Centre for Continuing Education. The four evening events included Joe David with Marjorie Halpin (6 March), Beau Dick and Simon Dick with Peter Macnair (13 March), Tony Hunt with Kevin Neary (20 March), and Bill Reid and Robert Davidson with Marjorie Halpin (27 March). Tape recordings of all sessions are in the UBC Museum of Anthropology archives.

2 Dr. Marjorie Halpin, Curator of Ethnology at the Museum of Anthropology and Associate Professor of Anthropology at the University of British Columbia, died on 30 August 2000.

3 Held at the British Columbia Provincial Museum in Victoria in celebration of the opening and naming of the bighouse constructed by Mungo Martin for Thunderbird Park, this three-day event was the first publicly held "legal" potlatch ceremony given since the early 1920s (Webster 1991:227).

4 Personal communication from Robert Davidson, 13 February 2003.

5 Ethnologist John R. Swanton published his research among the Haida in 1905 (see Swanton 1905).

6 In 1981 in Old Massett, Davidson hosted a potlatch, "Children of the Good People," at which he formally adopted Joe David (Steltzer 1984).

7 Crosby 1991:266–91, 274. For a discussion of the "salvage paradigm," see Clifford, Dominguez and Minh-ha 1987.

8 Such positioning of Northwest Coast art is somewhat mitigated at the Museum of Anthropology in its visible storage area, where diverse objects (though not full-sized totem poles) are crowded together, with little institutional interpretation provided.

9 Marjorie Halpin, unpublished commentary presented at the symposium "The Legacy of Bill Reid: A Critical Enquiry," 13 November 1999, Vancouver, British Columbia. Tape recording in UBC Museum of Anthropology archives.

10 The six poles, a mortuary figure and two post-and-beam Haida houses were first installed at Totem Park on the west end of the University of British Columbia campus, and were relocated to the grounds of the Museum of Anthropology in 1978. The mortuary figure was installed inside the Great Hall. In 2002, the house-frontal pole was moved inside the museum building for conservation reasons.

11 Reid to H. Hawthorn 1959.

12 The project was funded by a Canada Council grant and made possible by the contribution and delivery of cedar logs by the MacMillan, Bloedel and Powell River Company, Dr. Walter C. Koerner of Rayonier Canada and the Flavelle Cedar Company (A. Hawthorn 1963).

13 The Masterpiece Gallery was designed to show the finest historical pieces of the Walter and Marianne Koerner Collection, to which were added works by contemporary Northwest Coast artists such as Reid and Henry Hunt. In 2000, it was replaced by the semi-permanent exhibit *Gathering Strength: New Generations in Northwest Coast Art*.

14 Curated by Hindy Ratner and Karen Duffek, with an accompanying publication of same title by Duffek.

15 Between 1976 and 1978, Bill Reid carved a frontal pole at Skidegate for the new band council office; he was assisted in the last five months primarily by Guujaaw, as well as by Robert Davidson. Reid intended his pole as a memorial to the Haida of the past. It was the first pole to be raised in his mother's village in more than a century.

16 Personal communication from Robert Davidson, 9 July 2003.

Bill Reid: Master of Patronage

by ALAN L. HOOVER

He proposed that great art only results from great patronage.
—George Rammell, 1999

A SIGNIFICANT BUT often overlooked factor in the formation of Bill Reid's popular reputation as not only "one of the greatest and most versatile Native artists" (Brown 1998a:39), but also "the finest living Haida artist and one of the greatest artists in Canada" (Godfrey 1992:13) is the patronage he received. An appreciation of the pivotal importance of patronage throughout Reid's career puts into context the claims that his oeuvre was outstanding, his craft astounding. Reid was a strategist of patronage. His public reputation was disproportional to the aesthetic quality of his work and derived in part from the prestige he was accorded through his relationship with powerful individual and institutional patrons.

Patronage is not only a feature of the international "art world" but was also commonplace in Haida culture of the nineteenth century and earlier. Chiefs commissioned works that enhanced their status and the status of their families. The artist added to his or her own reputation by creating works made to be publicly displayed by the commissioning title holders. Robin Wright (1999) points out that by producing commissioned work, Reid similarly enhanced the status of his patrons, whether they were people of power within Canadian society or in cultural institutions; at the same time, he enhanced his own reputation as well as the status of Haida culture. Moreover, Reid's ability to form supportive and long-lasting relationships

with key individuals and institutions allowed him to enjoy both the support and promotion that determined the trajectory of his career. His participation in the so-called revival of northern Northwest Coast art (see Reid 1979:142 and 1981:168; L. Dyck 1983) lent legitimacy to the life work of his patrons, who were often his friends and colleagues, in the museums and universities.[1]

Bill Reid was not aware of his Haida background until he reached his early teens and only became interested in Haida art in his twenties (Reid 1974:87–88). He was inspired by two men to learn to make Haida-style jewellery: his grandfather, Charles Gladstone, a carver and silver engraver; and Charles Edenshaw. He knew Edenshaw as the uncle with whom his grandfather had apprenticed and as the creator of the jeweller's tools that his grandfather had inherited. It was not until 1954, at the time of his grandfather's death, that Reid actually saw Edenshaw's work (Shadbolt 1998:84) and began studying his creations; and, as he stated (1974:89), "It was during this period that I built up an unrepayable debt to the late Charles Edenshaw." Reid began his career in a basement workshop, making gold and silver brooches, earrings, cufflinks and bracelets decorated with Haida motifs, which he sold in shops and directly to friends. Reid's activity attracted friends, admirers and patrons from all the nooks and crannies of British Columbian society, at both private and public levels. In 1974, he was honoured with a retrospective show at the Vancouver Art Gallery—the first aboriginal artist to be so acknowledged (VAG 1974). Although Reid had produced a few significant large-scale objects by this time, his reputation had been built on the production of finely crafted jewellery. The retrospective exhibition was the first step in Reid's canonization as the premier First Nations artist in British Columbia.

BILL REID'S PUBLIC SCULPTURE

In the same year as his retrospective, Reid was diagnosed with Parkinson's disease.[2] He did not allow his personal circumstances to defeat him, but rather found a solution that allowed him to continue and even expand his career with remarkable success: he turned from making jewellery to masterminding large, complex, public sculptures. The physical effects of Parkinson's made it extremely difficult if not impossible for Reid to continue producing the jewellery that had until then been the centre of his work, so he changed his

studio practice to one involving proficient Native and non-Native sculptors and apprentices as assistants (Reid 1976:110 and 1974:92). I will discuss three of his best-known public sculptures in terms of the circumstances of their production and their role in building his public reputation.[3]

The Raven and the First Men (1980)

This period in Reid's career centres on his 1970 carving of a miniature box-wood sculpture (figure 12) which represents the Haida myth of the Raven's discovery of the first humans in a bivalve at Rose Spit, on the northeast corner of Graham Island (see Hoover 1983; Reid and Bringhurst 1984:31–37). Reid's realization of this myth was, in his own words, "a direct outcome of his [Charles Edenshaw's] treatment of the same theme, and I can only hope that it does him credit" (*Artscanada* 1981:33). The piece in question is Edenshaw's argillite chest, now in the collection of the Royal British Columbia Museum (see Hoover 1983; Macnair and Hoover 1984:127, 130–31). It was featured in the 1967 *Arts of the Raven* exhibition at the Vancouver Art Gallery. The three-dimensional sculpture of the Raven on the chest lid (figure 13) directly references the Haida creation story. Its brilliance lies in Edenshaw's portrayal of the Raven in the act of transforming from human to bird as he discovers human beings.[4] What form did the Raven have at that moment? Did he have a bird form, as suggested by Reid, or did he have a human form? Edenshaw left that question open. In the opinion of many, Reid's answer to the question—his own miniature Raven—compares well to this wonderfully complex sculpture by Edenshaw.

The large yellow-cedar sculpture *The Raven and the First Men* (figure 14) derives directly, albeit after a ten-year delay, from Reid's miniature boxwood version of the mythic subject. In one of the most important acts of patronage in Reid's career, Walter Koerner, a long-time benefactor of the University of British Columbia (UBC) and a patron, offered him a commission to produce a "massive version" of the diminutive carving. Koerner wanted Arthur Erickson,[5] the architect for the planned new Museum of Anthropology, to design a space to feature the scaled-up Raven (Shadbolt 1998:53). Erickson, in addition to designing a space for the Reid sculpture, was also determined to move the Haida replica poles and buildings, carved by Reid and Doug Cranmer between 1959 and 1962, from their old location in UBC's

Totem Park to the site of the new museum (Farrow 1973). Reid returned to
Vancouver from Montreal specifically to fulfill the commission but subse-
quently had to refuse because of health problems (Reid 1974:92). Despite
the added difficulty of identifying a suitable material for the work, he con-
tinued to be pushed by Koerner to fulfill the commission (Iglauer 1982:22).
Reid ultimately managed to reinvent himself as the master artist, com-
pleting *The Raven and the First Men* by supervising a team of artists that
included George Norris, Gary Edenshaw (Guujaaw), George Rammell,
Jim Hart, Reg Davidson and Kim Kerrigan (Farrow 1980; Lowndes 1982:25;
White 1980; L. Dyck 1983). The sculpture was dedicated by HRH Prince
Charles in 1980 and celebrated by a Haida delegation from Skidegate and
Old Massett (White 1980).

Reflecting on *The Raven and the First Men*, Reid considered it "a miracle
that the integrity of the original design has been maintained with so many
people involved" (White 1980). Others have compared the sculpture to its
miniature forebear and found the cedar giant to be derivative.[6] In her dis-
cussion of both works, Karen Duffek (1986:45) suggests that the boxwood
carving "exerts an impact far greater than its diminutive size," and that this
impact is delivered "physically in the large version, thus sacrificing some of
the mystery of the miniature." Doris Shadbolt has commended the sense of
mystery achieved in the boxwood Raven through technical virtuosity and
jewellery-like detail (Shadbolt 1998:141). The same cannot be said for the
large-scale work. While the small boxwood Raven balances precariously
atop its clamshell, the outer edge of its right leg fairing delicately back into
its body, the large yellow-cedar Raven is more stolid and upright; it crouches
awkwardly on top of the clamshell, its right leg attached in a peg-like man-
ner to its body. The wings of the boxwood miniature, moreover, appear
more plastic in comparison to the large bird's rather "wooden" appearance.

The successful completion of this project depended both on Reid's
strategic deployment of relationships with the sculpture's patrons,
Koerner and Erickson, and the deft leadership of his first co-operative stu-
dio operation. Equally important, the central placement of the sculpture
in the museum—a result of the patronage relationship that led to its cre-
ation—gave *The Raven and the First Men* a degree of attention that remains
out of proportion to its aesthetic merit.

Chief of the Undersea World (1984)

In 1984, Reid completed a second large public sculpture, *Chief of the Undersea World* (figure 15). This bronze Killer Whale stands 5.5 metres (18 feet) high outside the entrance to the Vancouver Aquarium Marine Science Centre in Stanley Park. Jim and Isabelle Graham, long-term benefactors of the aquarium, initiated the project.[7] Having seen an impressive sculpture at an aquarium in New Zealand, they became interested in funding a large public sculpture that could similarly function as a "signature" piece for the Vancouver institution. Elizabeth Nichol,[8] co-owner of the Equinox Gallery, chaired the selection committee that was subsequently formed (Westman 1984:22). Their first choice of artist was Bill Reid. He initially accepted the commission, offered to him upon his submission of a boxwood maquette (figure 16); he later withdrew, however, citing personal reasons. The committee next approached other artists, including Michael Snow, Wayne Ngan and Robert Davidson, and asked Davidson to submit a proposal.

The committee had already received Davidson's maquette (figure 17) (see Thom 1993:112) when Reid changed his position and stated that he now wished to proceed with the Killer Whale sculpture. This allowed the committee to go back to its first choice of the better-known senior artist. The donors were not as fond of the complex horizontal orientation of Davidson's maquette,[9] which contrasted dramatically with the verticality of Reid's tiny boxwood whale (Shadbolt 1998:146; L. Dyck 1983; Westman 1984:21; Duffek 1986:fig. 36).[10] Revisiting the selection process allows us to see that Reid's project went ahead because of the charisma of his miniature whale, his reputation, and the championing of his cause by the committee.

It is interesting to compare Reid's whale—both the boxwood and the bronze versions—with the maquette that Davidson submitted and that was rejected by the aquarium's search committee. Davidson's model is a single piece of yellow cedar that is carved as two whales with their heads facing in opposite directions. Their bodies are symmetrically divided along their dorsal axes to produce four bodies, each with a dorsal fin and sharing the two heads and two tails. The sculpture, which is diamond-shaped in plan view, balances elegantly on its tail flukes and pectoral fins.

Reid's sculpture, on the other hand, has its origins in the gold Killer Whale that adorns the top of the gold dish commissioned from him in 1971

by Peter Macnair of the British Columbia Provincial Museum (Shadbolt 1998:139; MacDonald 1996:225). Featuring exaggerated snouts and grimacing toothed mouths, Reid's whales are not as naturalistic as Davidson's, which feature foreshortened heads. The latter, like the whale engraved on Edenshaw's argillite dish (A7048) at the Museum of Anthropology, are more supple and round, evoking the taut, elastic physicality and surface tension of the skin of a live whale. Reid's whales, with their thinner, less rounded structures, are not as successful in evoking "whaleness," resulting in objects that are closer to three-dimensional industrial logos than fine art sculptures. Duffek (1986:50) has suggested that "Reid's greatest success lies in merging realism and Haida stylization." Robert Davidson (1986), on the other hand, has provided one of few public critiques of the sculpture: he suggests that when it was scaled up from the original miniature, the proportions of its two-dimensional design units were not adjusted accordingly.

What does the selection of Bill Reid and his *Chief of the Undersea World* reveal about patronage? Reid's strategy was to provide the selection committee with an object that was familiar and easily identified as Haida. Single-figure sculptures abound in Haida art, both as traditional memorial figures and as objects made for sale. Davidson's complex, four-bodied sculpture, with its minimal two-dimensional design, may have challenged such expectations: the patrons and the selection committee probably were unsure of public reaction to it. Perhaps the committee was anxious to make the "right" decision, and choosing a clearly Northwest Coast–style figure by a senior artist was safe.

The Spirit of Haida Gwaii (1991)

Bill Reid's last sculpture, *The Spirit of Haida Gwaii*, was conceived in 1985 when he was asked by his long-time friend and collaborator, Arthur Erickson, to carve welcome figures for the new Canadian chancery building in Washington, D.C. (Scott 1998). Because welcome figures are not part of Haida tradition, Reid proposed, instead, to sculpt a canoe. The result was a large bronze canoe (figure 18), measuring 3.89 metres high × 6.05 metres long × 3.48 metres wide (12 feet 9 inches high × 19 feet 10 inches long × 11 feet 5 inches wide), filled with figures from Haida mythology (see Bringhurst and Steltzer 1991).

This project was interrupted in 1987 when Reid refused to complete the sculpture, using his reputation strategically to achieve international attention for the Haida. He stated that it would be inappropriate to use Haida symbols as "Canadian window dressing in Washington" when provincial and federal governments were denying Haida people the right to preserve the natural heritage of their homelands ("Artist" 1987). Reid had already made public his opposition to clear-cut logging on Lyell Island, and was concerned that his art would be used to represent a government unsupportive of the "very minimal, legitimate requests of Canada's native peoples" (Cernetig 1987). The issue of clear-cut logging on Lyell Island was resolved in 1988, when an agreement establishing Gwaii Haanas National Park Reserve and Haida Heritage Site was signed by the Haida Nation and the governments of Canada and British Columbia.

Now the sculpture project met another obstacle: it was costing substantially more than the corporate sponsor, R.J.R. Nabisco Brands, had originally agreed to pay.[11] In 1988 the Tallix foundry in Beacon, New York, declared it would not release the sculpture until it was paid the $300,000 it was owed. Nabisco refused at first but eventually decided that the project had to proceed and paid the money needed to complete the sculpture. The total cost of the sculpture, estimated at $275,000 at the start, soared to $1.7 million (Godfrey 1992:11) or $1.8 million (MacDonald 1996:228). Reid had apparently also contributed $100,000 of his own money but, in return, had negotiated the right to make a second full-size replica of the original and "up to two hundred copies, in various sizes, of the whole or parts of the sculpture" (Godfrey 1992:13).[12] It is not surprising that such monetary negotiations would take place with corporate commissions on this scale; it does, however, indicate the emblematic status that both Reid and his work had achieved.

The Spirit of Haida Gwaii was unveiled in 1992, two years after the chancery building opened (MacDonald 1996:228). *The Jade Canoe*, a second version of the sculpture dated 1994, was purchased by the Vancouver International Airport.[13] It is a duplicate of the one at the Canadian chancery but is finished with a green rather than a black patina.

Like the Raven and Killer Whale commissions, *The Spirit of Haida Gwaii* has an antecedent. But here, the initial source of inspiration compares less

favourably with Reid's interpretation (see Bringhurst and Steltzer 1991:30–31). *The Spirit of Haida Gwaii* has been extolled as "magnificent" (Boddy 1989:32), "his crowning achievement, the undoubted masterwork of his productive life," his "last and summary masterpiece" (Shadbolt 1998:185), and the "pièce de résistance of Bill Reid's work" (MacDonald 1996:228). There appears to be some consensus that, of Reid's three major sculptures, this one, often called "the black canoe," is the most powerful. Why is this so? Is it the charge of personal and collective meaning that Reid has infused into the iconography of the piece (Reid 1991)? Whereas Reid's other sculptures also find their inspiration in Haida mythology, *The Spirit of Haida Gwaii* was forged in the context of ongoing Haida struggles to regain control of traditional lands and resources. In addition, this piece, unlike the *Raven* and *Killer Whale*, was conceived as a monumental sculpture. Although it was gradually worked up in scale through clay models, it was not created as a miniature only to meta-morphose into a giant at a later date. Neither Charles Edenshaw nor any other Haida artist of his calibre ever produced a figured canoe of the com-plexity and size of *The Spirit of Haida Gwaii*. In contrast to *The Raven and the First Men,* Reid's giant canoe is simply more accomplished than any of its miniature antecedents.

Reid knew when he began that *The Spirit of Haida Gwaii*, situated in Canada's embassy in arguably the most powerful city in the world, offered him a significant artistic challenge. He also must have known that it would be his last major work. The sheer size, complexity and polished finish of the black canoe, augmented by Reid's impressionistic text (1991), give it a charisma that is only enhanced by its "power" location. Both the giant and the miniature have their attractions (see S. Stewart 1993). Bill Reid's last work—a giant in size and cost—certainly expanded his reputation as one of Canada's most prominent sculptors of public art.

UNIVERSITY, MUSEUM AND MEDIA PATRONAGE

The circumstances that led to Bill Reid becoming a highly successful artist, "a superstar from a superior craftsman and artist" (White 1980), included his friendships with, and the patronage he received from and through, aca-demics and curators at the University of British Columbia, the British Columbia Provincial Museum (now the Royal British Columbia Museum),

the University of Washington in Seattle, and the Canadian Museum of Civilization, among others. In the 1950s, Reid's friendship with Wilson Duff led to his participation in salvaging Haida poles from T'anuu, Skedans and Ninstints, and to ten days of working with Mungo Martin (Reid 1956b). As a Haida person, Reid's involvement legitimized the "salvage" activities that seemed crucial then. His friendship with Harry Hawthorn was the key to his three-and-a-half-year contract to carve the poles and build the houses that made up the UBC Totem Park project. Such contacts also helped Reid to sell his work[14] and put him on the radar for further projects.

The academic and museum communities have been almost unanimous in their praise of Reid. Duff (1962) was unreserved in his enthusiasm for his friend's work, describing Reid's jewellery as "the finest Haida silver work being done, and perhaps ever done." In his contribution to the catalogue for Reid's 1974 retrospective, the French anthropologist Claude Lévi-Strauss boldly states, "Thanks to Bill Reid, the art of the Indians of the Pacific coast enters into the world scene: into a dialogue with the whole of mankind." Anthropologist Joan Vastokas (1975:14), writing in *Artscanada*, credits Reid with "one of the largest and most seminal roles in this renewal of the Northwest Coast heritage." George MacDonald, former director of the Canadian Museum of Civilization, suggests that *The Spirit of Haida Gwaii* signals "that Northwest Coast native culture was not extinct but was, shaman-like, rising from the ashes" (1996:228).

This is the kind of praise which has become customary, and it indicates how the attention Bill Reid received arguably had as much to do with his role as a bridge figure and "reviver" as it did with the merits of his art. Indeed, it deflected attention away from the works themselves—and from the serious criticism to which Reid was not averse. As Charlotte Townsend-Gault (1998) argues, the objective of criticism is not to denigrate, it is to consider seriously. Native art does not need to be protected in a criticism-free zone, she says: "Reid was not afraid to make his own austere judgments. It is doing him no favour to protect his cultural stature by an aesthetic *cordon sanitaire.*"

Wilson Duff's assessment of Reid's jewellery was only partly true: Reid's work was, in the 1960s, indeed a breakthrough for artists born in the twentieth century, because it revealed a renewed understanding of the

legacy of Charles Edenshaw. Despite Reid's mastery of more complex goldsmithing techniques, however, I would contest whether Reid's jewellery equalled Edenshaw's in terms of design. Duffek (1986:49–50) has offered some critiques of Reid's two-dimensional work, as has Reid's former student, Robert Davidson (Gustafson 1999). Peter Macnair has noted that "His work is largely copyist, and if you read Bill Reid on Bill Reid, he'll admit to this" ("Revivalist" 1986). Perhaps the harshest critic of Reid was Reid himself. As Duffek (1986:28) reports on what she was able to elicit from Reid, "He divides his prolific output into four loose categories labelled *bad, derivative, playing it safe,* and *mature.* Many of these pieces he regrets having made, and would like nothing more than to *melt them down* or even *dump them into some appropriate part of the ocean!"*

The university and museum communities also played significant roles in Reid's canonization. The Museum of Anthropology further institutionalized his status as the premier contemporary Northwest Coast artist when it chose to put a photograph of his miniature ivory totem pole on the cover of its 1975 publication *Indian Masterpieces from the Walter and Marianne Koerner Collection* and included his work in the gallery devoted to the "finest pieces" in the Koerner collection (A. Hawthorn 1975:14). Although Reid's presence was already hugely visible in UBC's Haida village carvings, his inclusion in the "Masterpiece Gallery" moved Reid from the ethnographic "outside" to the inner sanctum devoted to "high art" (Halpin 1975:42). Reid's installation as an institutional presence at the Canadian Museum of Civilization took place later, from 1987 to 1992, and was due primarily to his promotion by George MacDonald, who assembled plaster "originals" or casts of all of Reid's large bronze sculptures (MacDonald 1996:222, 226).

Another significant force in Bill Reid's success was the role of the media, which largely absorbed and reflected the laudatory stance taken by the museum and university communities (Milroy 1999). The sheer volume of press devoted to Reid's projects is evidence enough of its affections. Media support for Reid throughout his career may have been due to the fact that he was one of their own. Reid's experience as an on-air radio personality made him accessible and perhaps something of a *cause célèbre* of the broadcast and print media. In addition to his media presence from 1951

to 1958, reading the news or hosting music programs on the radio for the Canadian Broadcasting Corporation (CBC), Reid developed a voice specifically associated with First Nations in British Columbia (Bringhurst 2000b:238; Duff 1954b; Reid 1954b), producing radio pieces for the CBC in 1954 and 1956 (Bringhurst 2000a:27; Reid 1954a, 1956a). One of these was developed as the narration for a 29-minute, black-and-white CBC television film associated with the exhibit *People of the Potlatch*[15] (Duffy 1986:156). In 1959,[16] the CBC released a 27-minute, black-and-white film on the Anthony Island totem-pole salvage project, for which Reid developed the screenplay and narrated the text (Duffy 1986:189; Reid 1959a).

The tenor of the one article that goes against the media's largely positive response was, not surprisingly, shocking. In 1999, journalist Jane O'Hara's article in *Maclean's* argued that Reid and his supporters deliberately obscured the fact that much of Reid's later work was fabricated by hired artisans whose contributions were never acknowledged. O'Hara suggested that Reid, and those who have an investment in his reputation, consciously obscured Reid's extreme physical impairment, ignoring or minimizing the extent to which he was no longer able to produce his own creations. The responses to this article defended Reid's character and his work on various grounds, including pointing out that the practice of relying on studio assistants has always been widespread (Milroy 1999; Rammell 1999; Johnston 1998; Wyman 1999). The hyperbole that marked some of the support given Reid's work by his patrons was uncritically repeated by his former colleagues in the media.

MASTER OF PATRONAGE

The success of Bill Reid's career was shaped in no small way by the conjunction of his personal quest to connect with the heritage of his maternal Haida relatives, and the cultural and political agendas of important British Columbia institutions and individuals. As pointed out by a number of writers, settler societies demonstrate a profound need for an identity separate from their Old World origins and specific to the "New" World that their cultures and societies have colonized (Mead 1976:286, 297; Crosby 1991:273, 287; Francis 1992:186–87). First Nations art has become the "choice of decoration for government and public buildings everywhere" (McMartin

1996:D1). Corporate patrons also are attracted to First Nations art because of its traditional focus on "display and prestige-enhancement, communication, virtuosity and visibility"; in contrast to much contemporary non-Native art, moreover, its "meanings" may be relatively transparent, often "explained" in written descriptions of the images portrayed (DeMott 1989:10, 11).

Vancouver International Airport, in its circa 1996 expansion, spent some $6 million on predominantly First Nations art. It did this because, according to Frank O'Neil, president of airport services, First Nations art creates an "authentic sense of place"; it will make the airport a destination in itself, so that travellers will want to fly to Vancouver rather than Seattle—and that has "a great commercial spin-off" (Bell 1996). In the same way that the owners of Reid's gold and silver jewellery display their wealth, good taste and multicultural sophistication through their collections, so do the institutions that feature Reid's sculptures in their public spaces (see Dubin 2001:49–50).

Bill Reid was the ultimate cultural tourist. But he did not travel to exotic places—he travelled, instead, through time back to the lost world of his maternal ancestors. Driven by nostalgia, Reid (1980a:148) the antiquarian, admiring "the elegant line, the subtle curve, the sure precise brushstroke" of a Haida object, wished with a "sudden aching sense of identity" to connect with his "distant cousin who first lovingly made it." The objects that he produced were the souvenirs—the metaphoric post cards—that authenticated his atavistic experience of that lost world (Reid 1956a:45). Yet, for most of his life, he maintained an ambivalent relationship with the Haida. As an antiquarian, he identified largely with the past. The present with all its complications was an inconvenience. In the early part of his career, Reid (1956a:45) repeatedly stated that "what should be remembered about Indian art: it is dead art." Later, he seemed sceptical about the significance of the Haida art that was being created to be used in the villages, the songs that were being composed by younger Haida artists, and the use of objects in new ceremonial activity. Such activity ran against the grain of the aesthetic antiquarianism of which Reid was a part. The pole that he so courageously carved in 1978, despite the complications of illness and no funding, was meant, in his words, for the old Haida (Iglauer

1982:13). It was not for "the Living Haida"—the name of the potlatch that Robert Davidson hosted three years later in Massett.

Reid's attitude toward contemporary First Nations people was certainly conflicted (L. Dyck 1983; Johnston 1998). His mother had denied her Haida background (Reid 1974:87–88; Shadbolt 1998:14–15, 21–22), and Reid could not have been unaffected by the racism to which she was subjected and from which she tried to shield her children. Arguably, Reid's solution to his cultural confusion was to admire the idealized culture of the past and reject the messy dysfunction and struggle of the present. Yet he was, unavoidably, a part of the present, and the patronage discussed here was particular to his time and place. Despite his discomfort with the new vibrancy in cultural practice, Reid (1981:166) came in the last years of his life to recognize that contemporary Haida art was more than just "an artform in search of a reason for its own existence." That Reid's public reputation exceeded the aesthetic importance of much of his work can be demonstrated when comparing his art with that of his mentor, Charles Edenshaw, and his student, Robert Davidson. Reid could not have produced the major public sculptures he did without the championing of Wilson Duff, Harry Hawthorn, Doris Shadbolt, Claude Lévi-Strauss, Edmund Carpenter, Adelaide de Menil, Arthur Erickson, Walter Koerner, Elizabeth Nichol, Jim and Isabelle Graham, and the institutions with which they were associated. Reid's reputation as the pre-eminent Northwest Coast artist of the twentieth century, moreover, derived in part from the prestige he was accorded through his relationships with such prominent individual and institutional patrons. Of course, patronage of one sort or another is the norm for most sculptors working on major public projects. Reid understood this perfectly well, and realized that the shift in scale was crucial to his objective, which was two-fold: continuing to enhance his prestige while moving his art out from individual and institutional collectors to a wider public stage. By producing the largest bronze Northwest Coast-themed sculpture and situating it in the Canadian Embassy's chancery building in Washington, D.C., he accomplished that objective.

Reid was an aesthetic archaeologist. He and Bill Holm made visible the structure of northern Northwest Coast two-dimensional design, and Reid introduced complex techniques to the production of Northwest Coast

jewellery. Perhaps most importantly of all, Reid could communicate in both spoken and written form his passionate love for the glories of Haida art. No other artist working in the Northwest Coast tradition has been able to articulate his or her passion with such skill and power. This ability and the exposure it gave Reid in the wider community, combined with his need to reinvent himself out of the limiting restriction of his own physical frailty, helped him to realize his ambition to become the first Northwest Coast artist to produce large public sculptures that broke the ethnic stricture of the totem pole form.

What is astounding about Reid's patronage relationships is not their existence, but their prominence, magnitude and continuity. It is difficult to think of another twentieth-century Canadian artist who attracted such patronage and whose career has been more productive, successful and popular. As George Rammell (1999) reports, "He [Bill Reid] proposed that great art only results from great patronage." The patronage that Reid cultivated provided him with the alliances needed to ensure his success in the business of producing public sculpture. In the process, he raised the profile and status of his patrons as well as of his art.

ENDNOTES

1 Perhaps this is the answer to Marcia Crosby's observation (1991:282) that those dependent on patronage must offer something in return. It is also clear that Reid offered his friendship and his intelligence.

2 Reid was diagnosed with Parkinson's disease in February 1974 (Iglauer 1982:16). See also Gainor 1982 and Arnason 1985.

3 Not included in this discussion are the 17.4-metre (57-foot) totem pole that Reid carved and raised in the Haida village of Skidegate in 1978 (Lowndes 1982:25); the 8.5-metre (28-foot) bronze frieze *Mythic Messengers* of 1984, or the two cedar canoes carved in 1985 and 1986 (Duffek 1986:24–25; Mohr 1990: 78–79; Herem 1998:48; M. Hume 1989).

4 The transformation that is represented remains open to interpretation.

5 Apparently, Reid had known Erickson since the 1950s (Johnston 1998).

6 Because of their enormous differences in scale, it is difficult to demonstrate visually the relationship between these two pieces, except through photographs; no two photographs, however, are taken from exactly the same angle and with the same lighting.

7 Personal communication from Jim and Isabelle Graham, 2002.

8 Nichol was Reid's agent from 1981 to 1991 (Lewis 1999), but I am not aware that she was his agent at the time she was named to chair the search committee.

9 Personal communicaton from Jim and Isabelle Graham, 2002.

10 Jane O'Hara (1999:26)—see also Gainor 1982—states that Jim Hart carved the boxwood Killer Whale maquette and that Reid carved only the waves on the base of the miniature sculpture. However, John Livingston (personal communication with the author, 2002) is quite certain that Reid created the boxwood miniature.

11 Reid and Nabisco had been brought together by Ken Taylor, the Canadian ex-diplomat and former vice-president of Nabisco. Nabisco had previously committed to support a program of cultural events (subsequently cancelled) associated with the opening of the new chancery building. At the time, the CEO of Nabisco was a good friend of Prime Minister Brian Mulroney's (Godfrey 1992:11–12).

12 Similarly, Reid and his agent Elizabeth Nichol had the right to sell limited editions of smaller versions of the Vancouver Aquarium's bronze Killer Whale sculpture (Johnson 1982).

13 See the website of the Vancouver International Airport Authority: www.yvr.ca/guide/todo/art.

14 For example, three of Reid's argillite poles that Wilson Duff brought to Victoria were purchased by a cabinet minister in Premier W.A.C Bennett's Social Credit government (Kew 1958).

15 This exhibition was organized in the spring of 1956 by the Vancouver Art Gallery in co-operation with the University of British Columbia (VAG 1956).

16 Bringhurst (Reid 2000:56) gives the date as 1963.

Haidas, Human Beings and Other Myths

by MARCIA CROSBY

W HEN I FIRST met Bill Reid at the University of British Columbia's Museum of Anthropology, I only knew that he was a renowned Haida artist. So I introduced myself and told him that some of my family were from Skidegate and Massett, the northern and southern villages in Haida Gwaii. He knew my father's grandmother, and so a number of times in public gatherings and in his studio, he told me a story he knew about my great-grandmother Ada Crosby, who was married to Thomas Crosby, the brother of his maternal grandfather, Charles Gladstone.

He said that when my great-grandmother died, his mother was with the Skidegate women who were getting Nunaay (Grandmother) Crosby ready for burial. Then he'd pause as if remembering how he'd heard the story from his mother. Leaving me, he returned to his mother's memory of one woman rinsing out her washcloth in a basin of water that had come from a creek by the old hall in the middle of the village. And as she smoothed the cloth over the crest tattooed on Ada's chest, the old woman whispered, "She so plitty." Bill would smile right after he spoke the last line. And I'd smile back at the brief sketch of my history in his.

He accurately imitated the slow rise and fall of the Skidegate accent. But he'd tell the story differently than I do now; he'd tell it the way my grandparents and others of their generation did, moving suddenly from narrative into dialogue without introducing the speakers, and using inflection, intonation and gesture to signal the different speakers. He loved

the old Haida people. In his writings, he often spoke about how fortunate he felt to have "gained the friendship of many of the old men and women . . . who still remembered something of the great days of the Haida past and . . . who still had a pride in that past" (2000:88).

Ada Crosby was born in 1857 in the village of Chaatl on Buck Channel, near the western end of Skidegate Narrows. This is where Reid had seen "the oldest pole still standing on the Charlottes." "These people," he said, "managed to lock such tremendous power into their work that even after 150 years or so of assault from the elements, and with most of the carving worn away, the tremendous force of this old pole still comes through. Its power in a sense is undiminished" (2000:127).

> *"My grandmother was a chief. That's why her whole body was tattooed. From her neck all the way to her ankles. Her back. Her chest. Right down to her wrists."*
>
> *"But how did you see them?"*
>
> *"We slept with her every night."*
>
> *"Why?"*
>
> *"We just did, after my grandfather and my dad died of the flu in 1935. Dad died first, then Ts'inaay [Grandfather] the next day."*

Ada Crosby, along with most of the southern Haida, moved into Skidegate Mission around 1897. It was a migration that included Reid's grandfather Charles Gladstone from Naikun; his grandmother Josephine Gladstone and my paternal great-grandfather, Jimmy Jones, both from T'anuu. Although many of the old ones had lived in their own villages as long as possible after the final smallpox epidemic began in 1862, life finally became untenable in the barely populated villages by the turn of the century.[1]

I think of my father the spring he was trying to teach me Haida, and my mother competing with him, trying to teach me Sm'algyax, my maternal Tsimshian grandmother's language. "Don't do that. You'll confuse her," Dad said. Mom laughed at Dad's claim on me. Not much of their teaching stuck anyway, except for the love. One morning, inspired by the feel of old words and the rhythmic sound of the Skidegate dialect, Dad came out to the living room, singing in Haida, a bedcover over his shoulders in

place of a button blanket, wrists at his hips, hands bent back and upwards. He dipped down, first this way, and then that. Mom smiled as he moved around the room.

"What are you doing?"

"Dancing the 'Women's Dance' like Nunaay Crosby."

"Crazy," she said softly.

He burst out laughing like he'd been caught by Nunaay herself. Then laughed and danced as he followed her around the floor. We stood and watched his joy.

I've been gathering flashes of my past in Bill Reid's narratives, watching my grandfather Jimmy Jones on the seiner that took Reid and some anthropologists to the village of T'anuu in 1954 (Reid 2000:38, 39, 43), reading our oral histories in Bill's stories about, and by, other Haida, searching for familiar profiles in the blurred background figures in the photographs illustrating books about him.

I looked for Bill in the tributes to him after his death and wondered if this was how he wanted to be remembered: that he had "become Haida" by finding his way "home" to a place where he was finally buried with his ancestors. I know "becoming Haida" is something Bill talked about himself,[2] but I couldn't help thinking about the way we tell stories about ourselves and how these can sometimes intersect with, and are informed by, the enormous body of academically constructed work about aboriginal peoples. I also knew that since I had last written about Bill, the kind of stories I'd read about him and the Haida in the days following his death hadn't changed much in ten years.

Like most academics, I'd come to "know" Reid through books, art catalogues, essays, archival materials and newspapers, through anecdotes and quotes by and about him. My theories and perceptions of him as "representation" continually shifted over time: he was a vehicle to my traditional past, then the epitome of the West's "civilized barbarian"; sometimes a champion of aboriginal rights, then a Judas.

> They said he was a hero.[3]
> He said, "I never wanted a weighty role . . ."[4]
> They said there was an Indian art renaissance.

He said it was the graphic and plastic arts that were rediscovered.[5]
They insisted there had been a cultural revival.
He said, "I can't quite buy it."[6]

He was other; he was the centre.
He said "they"; he said "we."
He loved "them"; he was deeply disappointed in "them."
Pronoun referent,
often unknown.

Then, a year after his death, in 1999, I was invited to rethink him once again at a symposium, "The Legacy of Bill Reid: A Critical Inquiry," at the University of British Columbia. I joined a fair number of southern and northern Haida who also attended to remember and memorialize Bill's life.[7] What follows is a survey of sorts that represents some of the rethinking I've done since then. However, I raise more questions than I can answer, point to more possible histories than I can unpack and more narratives than can be developed in this paper.

Reid's official history has been formed around a simple storyline, typical of the kinds of narratives that have been written about the "post"-contact aboriginal experience. The plot almost always begins with historic and/or geographic displacement and loss—the various effects of colonization. The main character's history is traced to his or her people's place of origin, to a time and place where culture was intact. This period is followed by the coming of the Europeans, the subsequent disruption and sometimes geographic dislocation. After the death of the old ones and the old ways, the conflict or tension reaches its climax—in the city or on a reserve—with the "Indian's" loss of character, authenticity and sometimes even his humanity. However, a thread of the old ways remains. As a "tragedy," urban aboriginal histories unfold in a kind of backward trajectory toward cultural and social disintegration. As a heroic story, the conflict is resolved by the main character, who must find the thread—the way back to his or her intact beginnings—even if it is one s/he never knew.

Reid's story positioned him as more than the protagonist who finally "becomes Haida" by finding his way "home" to Haida Gwaii.[8] His role was

also a redemptive one in which he heroically redeemed his mother and the family for their lack of Haidaness and loss of humanity[9] by "reviving an almost dead art form" and the culture of his mother's people. By the late 1960s, Bill Reid's role in the "cultural revival" and the shift of Northwest Coast Indian art into the national and international world of fine art was recognized—and famously entrenched—by noted French structural anthropologist, Claude Lévi-Strauss: "He has tended and revived a flame that was so close to dying. . . . thanks to Bill Reid, the art of the Indians of the Pacific coast enters into the world scene."[10] And on that world stage, each time Reid unveiled a work, launched a canoe or raised a pole, whether in Skidegate, Vancouver, Ottawa, Washington or Paris, his work was witnessed by Canadians and the world as a part of *its* artistic legacy. In this part of the story, his "return home" was merely a subplot that contributed to the interests, struggles and complications of an epic (folk) tale. International in its telling, crossing time and space, it blurred the distinctions between Reid's Haida and Euro-Canadian ancestries—as they are—as he became the universal hero. At the same time, his mother's people and his relatives authenticated the work as Haida, and often witnessed his, and their, continued and incremental acts of "becoming."

BEGINNING IN THE MIDDLE OF THINGS

Reid started to speak publicly about Northwest Coast pre- and post-contact history sometime after beginning his art practice in 1948, including his personal story as it figured into his development as an artist. But he actually began speaking in the middle of a much larger narrative. He joined those who had been creating the history of the development of Northwest Coast "Indian" art since about the turn of the century. The tellers of the story have been mostly non-Native academics but have also included some First Nations practitioners.[11] Many of them were involved in various scientific, nationalist and art projects centred on "salvaging" Northwest Coast material and oral culture, which were continually transformed through the years within Western institutions. Franz Boas, John Swanton, Marius Barbeau, Erna Gunther, Ellen Neel, Alice Ravenhill, Claude Lévi-Strauss, Mungo Martin, Wilson Duff, George Clutesi, Bill Holm, Peter Macnair, Robert Davidson and Doris Shadbolt are a few of the many who participated in

this process of collection and/or recategorization. At its core, this is "salvage ethnography" whose purpose is to construct a traditionally intact aboriginal history that existed just before contact, after which the "Indian" began dying. Telling (recording) this story is the first paradoxical act of "salvaging" (saving) the remains of such "authentic" cultures. Each of those involved in this project contributed to the redefinitions in their own way, in varying contexts specific to their historic time, place, profession, discipline and individual impulse. But it was not until the late 1940s that the focus on creating standards for Northwest Coast material culture as fine art, using Western criteria of aesthetic excellence, began to be realized. Reid's story is both informed by these voices and part of this larger history.[12]

Reid made important additions to the already historically entrenched "dying Indian" script. However, any singular hero portrayed as the only one left who can represent some kind of an authentic past, or an entire community or nation, is given such a reductive role that when it is played out it naturally leads to conflict. The story leaves too little room for the paradoxes and complications of Reid's personal history, much less the multiple histories of Haida culture and society. So, even when he self-consciously played this heroic role, from which he benefited greatly, he also contradicted himself. And when the role was foisted upon him, he often railed against the impossible weight of it. "The Haida live their lives," he said, "I live mine."[13]

Reid provided the chorus of voices with his, at times, harmonious difference, wavering unsteadily between his Haida and Canadian identities. He publicly joined in the history of Northwest Coast Indians in a 1954 CBC radio broadcast about a trip he'd taken earlier in the year to Haida Gwaii with anthropologists who were salvaging several house poles from the villages of T'anuu and Skedans. Although he said later that during his radio career he spoke "from the non-Indian viewpoint" (2000:87), he self-identified in the broadcast as someone who had *"some right* to be telling this story" (38, italics mine), since his grandmother had been born in T'anuu and his mother was raised in Skidegate.[14] He continued to exercise that right, based on blood, lineage and ancestry, throughout his career: he spoke about what he knew in text, but not in fact; he referenced the authority of the memories of the old Haida people he'd met, together with academic text, to authenticate his own work and knowledge; he

sometimes called the Haida "my folks" (38) or "my only relatives" (88), stating that he'd spent most of his life with a feeling of identity with the Haida (88, 213). And yet he also confessed, "My relationship to the culture of my people is . . . a very remote one" (193), that he was "to all intents and purposes a good WASP Canadian" (196). Throughout his career, he was candid about the limitations of his lived cultural experience with, or personal understanding of, aboriginal peoples.[15] But he still spoke of them with authority. In fact, he did not say, "I am Haida" or "we Haidas" until 1986.

Solitary Raven, an anthology of thirty of Reid's writings dating from 1954 to 1991, provides a survey of what he had to say about Northwest Coast art and culture and the initial impact of colonization on the social life of Haida people and "Natives" in general.[16] The compilation of narratives reveals that he clearly had extensive venues from which to speak, and an identity that was ambiguous—or ambivalent—enough to appeal to many audiences. While many of the first essays in the text recount the history and effects of colonial oppression on the Northwest Coast, his recounting shifted in 1979 from a broad descriptive "telling" to "showing" the final results of colonialism in emotive and specific terms.[17] It is as if Reid's initial telling of colonial history, which must have been enlightening to a then mostly uninformed public, became a weight. Rather than freeing anyone from Canada's past, "the Indian" gets caught in his continual recounting—dead, dying or living finally in colonialism's inevitable and "tragic" outcome. It could also be said that while the Indian's counterpart, the colonizer / victimizer, recedes into the background in the anthology, this one is also caught in what can only be called a bad script.

The general outline of his story goes something like this:

> Death of the old ways: The old people, ways and languages of the great past (eighteenth and nineteenth centuries) are dead—as is their art[18]—destroyed mostly by disease, alcohol, reserve life, missionization, residential school and other programs for assimilation.
>
> Time of loss: The turn of the twentieth century to post-World War II was a time of stagnation and decline (Reid 2000:139), and things did not get much better after that.[19] Most contemporary Haida do not know and appreciate the past; they only have faded

memories of old memories[20] (though Reid had memories of talking to the few surviving old people who remembered that great past).[21]

Finding the thread: Only academic knowledge of the past and its art is left (Reid 2000:111, 155). Following that, an intellectual analysis of Northwest Coast art is the only logical medium for the recovery of the old art practice.[22] The intrinsic power of their aesthetics, design and form remains, and is so powerful that it revealed to Reid who the original makers were.

Finding "home": Through his intellectual understanding of their art, and his application of that knowledge in his own art practice, Reid became intimate with the old ones—their intellect, genius and creativity.[23] Like other high art forms in the world that are recognized in Western art canons (classical Greek and ancient Egyptian), the northern Northwest Coast style is resignified as having universal human value.[24]

Universal art for the world (note: key detour from usual plot): Reid was one of the few Haida who had an understanding of the art's value, and so he was the one who brought it, as a world art, to the world.[25]

Redemption for the dying Indian: In the meantime, back at the reserve, or any urban skid road, most contemporary Indians have lost their humanity.[26] Reid's message of redemption for "them" was that they should "do something"—something that represented the quality of the old ones' ability to survive the loss of their culture into the twentieth century: their initiative, flexibility and adaptability (2000:169–70). Although he concluded in one of the anthology's last essays that "The Haidas came alive again" (215), he spoke a few years later of their "inevitable descent into oblivion" (223). It's as if the story has come full circle. Back to the dead.

The "dead" part is the most significant element of Reid's telling as it unfolds in *Solitary Raven*. It is difficult to find even a flash of my, or any aboriginal person's, past in it. The text begins with the death of the nineteenth-century Indians in its first essay, "Tanu," written in 1954. By 1979, Reid was describing the dark social conditions (cultural death) he saw

around him: "The plot is so familiar that it scarcely bears repeating" (2000:135). But he had already repeated the death-of-the-Indian part of the plot many times since he began speaking and writing about Natives and newcomers. In 1988, he wrote, still, about the social death of the old Haida's descendants in the essay "Joy is a Well-Made Object." The "well-made object" portion of this lecture was lost. However, if his description of the social conditions in Skidegate was simply his introduction to a longer lecture on "art," he established here that Northwest Coast art could not have been produced from or within contemporary Haida society. In fact, *Solitary Raven* reads like an anthology of short stories with an overarching plot in which Reid, an almost omniscient narrator, suffers some crucial loss that results in utter disillusionment, or loss of faith.[27] If the "Indians" constitute a composite protagonist of sorts, there is not enough change, development or complication in their story to keep me interested as a reader.

Of course, it's important to remember that what Reid was ultimately talking about was his art practice and its place in the so-called cultural revival. He believed that great art of the past came from a highly complex society, and it was clear to him that this context no longer existed. His point was that contemporary Northwest Coast art, which he saw as mostly driven by a market economy, did not necessarily signify a cultural revival (Reid 2000:160–69). A valid point. However, that point was also premised on the common belief that when aboriginal people stopped making cultural objects, it was evidence of their loss of authenticity as distinct peoples. But aboriginal culture is not intrinsically held only in cultural ("art") objects. It is held in political, social and economic dimensions, in our memories, in local knowledge, in new and evolving institutions. Such a culture cannot be reduced to a story about the seamless development of Northwest Coast art that leaves too little room for varied histories of aboriginal peoples.

While those histories did include the actual end for many aboriginal peoples and their ways, we need a new paradigm for examining those endings in closer detail, and recording them with respect and in memorial. We need new ways of looking at those who survived, seeing the old ways and old ones as changing, not just dying. The twentieth century can also be unpacked as a series of many beginnings for generations, rather than an ending or simply as loss. For example, besides Reid there are other contemporary aboriginal

artists, like Mungo Martin and George Clutesi, who produced material culture in the public sphere as forms of resistance.[28] Yet in 1956 Reid saw himself and Martin as "atavists groping behind us toward the great days of the past, out of touch with the impulse and social pattern that produced the art" (2000:45). Not a surprising conclusion, since salvage ethnography leaves no way to see totem poles and other objects, oral histories and ritual, as systems of signs whose meanings *remained*, changed and invested elsewhere—as in contemporary political organizations. Reid does not make the historical link between the decline of cultural objects and ritual, and the emergence of a new kind of aboriginal politics. Early Haida leaders, such as Peter Kelly and Alfred Adams, who were a significant force in the formation of the Allied Tribes and the Native Brotherhood, do not figure in his social history. Northwest Coast "art" history is not about recognizing how poles and oral histories constitute legal documents signifying ownership of land, and that even when the poles and the old ways were gone, aboriginal lands and title have remained a central concern to First Nations leaders into the twentieth and twenty-first centuries. Thus, thirty years later in 1986, when Reid made a political stand with the Haida around the land issue, he said of their resistance: "After a century or more, the Haidas came alive again" (2000:215). He seemed to have no concept that they had never died, no knowledge of the continued resistance by aboriginal peoples (in which the Haida had played a significant role) to British Columbia and Canada's claim to their lands. It has been the continued use, knowledge and love of their own lands, history and community that brought the Haida to the public confrontation with the Canadian and provincial governments, to which Reid referred.

Granted, Reid was not a historian. "Bill did not call himself a writer but rather 'a maker of things,'" says Martine Reid in *Solitary Raven*'s Afterword (Reid 2000:232). "However, when he committed to it, the result was another 'well-made' product." Although Reid began writing in the middle of an ongoing Northwest Coast Indian art history, there was another important aspect of the contribution he made as an individual maker of history. He wrote his own historic beginnings from a place *in medias res*, because, as with most histories, it isn't until one's arbitrary or mutable beginnings become a meaningful sequence to a self-conscious narrator that s/he can tell the story: the beginnings, middles and endings of a person's, object's, event's

or group's narrative. And from this place, Reid reinforced the meaning and value not only of those beginnings, which he located in the nineteenth century (2000:155), as did many other academics, but he used those meanings and values to map out the plot for the rest of the story. It was his personal story, as much as it was the story written by friends and contemporaries such as Wilson Duff, Bill Holm, Robert Bringhurst[29] and others.

In regard to his art practice, Reid contended that he began in the middle of a diminishing stream: "Everything else that was going on was a result of people imitating people who were imitating other people who were imitating the great people of the past. It was sort of the diminishing stream. So we [Reid, Bill Holm and Wilson Duff] skipped all that and went back to the origins—in museums and books—and discovered what we thought were the basic rules governing at least the northern style of the art" (quoted in Duffek 1983b:40).

Reid was referring to his and Bill Holm's intellectual analysis of the "original" old forms, which began in the late 1940s (Duffek 1983b:40) and was central to the discursive interdisciplinary shift of ethnography to art. By the 1960s, Indian art firmly had entered the realm of fine art through Holm's *Northwest Coast Indian Art: An Analysis of Form,* which was used to provide the conceptual framework for the Vancouver Art Gallery's 1967 exhibition, *Arts of the Raven: Masterworks by the Northwest Coast Indian.*[30] The curators were Bill Reid, "Haida craftsman and authority on the Indian arts"[31]; Wilson Duff, curator of anthropology at the then British Columbia Provincial Museum, and Bill Holm, art historian and curator of Northwest Coast Indian art at the Thomas Burke Memorial Washington State Museum. The exhibit focussed on the northern style, including the work of Tlingit, Tsimshian, Kwakwaka'wakw and Nuxalk. But it privileged the material culture of the Haida as the "best" art, displaying the works in terms of Western art practice and its criteria for aesthetic excellence. It was described as an art form made by a few *individual* men of *genius* during the nineteenth century—"the golden age"—and both Reid and Holm asserted that the art was made by artists who were more concerned with aesthetics and design than with the object's socio-political meanings (VAG 1967:n.p.). Thus the necessary shift from ethnography to Western art history. The ovoids, formlines and U forms, codified, described and finally prescribed

by Bill Holm, were used to identify "masterworks" made by an individual depoliticized Indian artist, in a lineage of genius and mastery.

As the exhibition's curators mapped out the beginnings of Reid's art practice, they "skipped" past half a century of Haida history, past most contemporary artists, because, they contended, there weren't many Haidas (or many other Northwest Coast artists) who were "good" artists at the time.[32] Past the early work and memories of his grandfather and other old artists Reid had met, past the lives of their descendants, the ones he said only held "memories of old memories," and toward his Haida relative Charles Edenshaw (c. 1839–1920), who had earlier been identified by Boas and Barbeau as the "best" and the last of the great Haida artists of the nineteenth century. Reid said that Edenshaw mentored him "in absentia." In creating this lineage of mastery in *Arts of the Raven*, which jumps from Edenshaw to Reid and, to a lesser degree, to the younger Haida artist Robert Davidson, the curators also created a huge historical and cultural gap. This "signification gap," says Marvin Cohodas,[33] can then be used to resignify anything, and therefore came to be seen as a period of "decline and loss"—the premise for the recovery of earlier, more "authentic" art forms. Once recovered, the original Northwest Coast material culture that inspired Reid, placed together with his own work, were reinvested with meaning in 1960s modernist terms, situating both as universal "masterworks."

Through Reid's study of academic texts, cultural objects in museums and the application of that knowledge in his art practice, he formed an intimacy with the "vanished men and women" of the past. He believed that he was able to gain "insight into the extremely sophisticated attitudes these people had toward their art" (2000:120–21). For Reid, their "ingenious ways of doing things," their design principles—the formlines, the abstraction, the enormous tension in the ovoid—reflected "in some way the personalities of the people who made them, the individuals as well as the society that produced those individuals" (116). Through the "tremendous power they locked into their work," the old ones of the late eighteenth and nineteenth centuries came alive to him. He knew them (66). Perhaps he even "really loved them," which is what he said of Wilson Duff's relationship with the people he studied (110). It is here, in this place of intimacy, that

Reid makes the link between the past, his art practice and his interest in the contemporary social conditions of the Haida people:

> [The art] has led me . . . to a deeper concern for, and perhaps a deeper knowledge of, the people—the descendants of the people who made these things. I've been able, in my mind at least, to put myself in the place of those old artists and imagine the impulse behind what they did and how they accomplished it. And through an understanding *of them*, I have come to realize what has been taken away from the people, *their descendants* . . . this marvelous facility with their hands, the marvelous facility with words, the *totality of their culture*, in which every one of them participated (Reid 2000:197–98, italics mine).

The genius, personality, and individual and social complexity of the dead became Reid's point of reference for what contemporary Haida life was not. Like many non-Native experts, it's clear he believed he knew more about what it was to be a "real" Haida than did those who lived in the twentieth century. This stemmed from seeing Northwest Coast aboriginal peoples in terms of "what had been taken away from them." But Reid was not comparing two different times in history. Rather, he measured a purely idealized and unlived life against the life into which the Haida and other Northwest Coast peoples were born. Perhaps more significantly, he measured it against the life into which he and his mother were born—he in 1920, and she in 1895.

Reid said of this time, "Between the turn of the century and the Second World War stretched a time of stagnation and decline" (2000:139). On one hand, he admired the flexibility and work ethic of his grandfather's generation, and the way they "enthusiastically" used the knowledge that survived from the old ways to adapt to the new life. He admonished the contemporary Haida to "do something"—something that represented the qualities of their grandparents' and great-grandparents' ability to survive, which he thought was "the only hope for the native people" (169). However, he concluded, "whether willingly or not," the old people embraced the invaders' ways "with unqualified enthusiasm" (137). He saw their inevitable

decline through assimilation, the death of the old ways in the shift from crafting canoes to building fishboats, from singing Haida songs to singing in choirs, from beating on drums to playing in church brass bands, from making plank-and-beam houses for extended families to building single-family dwellings (137, 223). He whitewashed this part of our history with the broad brush of assimilation, stroking out the details of a time of great change and half a century of aboriginal life, including his own.

"My mother had learned the major lesson taught the native peoples of our hemisphere during the first half of this century, that it was somehow sinful and debased to be, in white terms, an 'Indian,' and she certainly saw no reason to pass any pride in that part of her heritage on to her children" (Reid 2000:87–88). In Reid's chronological autobiographies,[34] he traced his mother's displacement to residential school from her place of origin in Skidegate and briefly outlined her subsequent assimilation: she did not return to her ancestral home, married a non-Native and raised her children in silence about their Haida ancestry. There they remained, the offspring of colonialism, covered in her shame and the silence of their Haida past, until Reid's official public history as an artist began to unfold after World War II.

These beginnings, described by Doris Shadbolt (1986:15) in her biography of Reid as "a time of hopeless demoralization for natives," explain Reid's lived cultural experience as a North American Caucasian. But they also give context to Reid's saviour/victim story. His and his mother's beginnings provide anecdotal evidence of a contemporary Northwest Coast Native family, specifically Haida, born in "stagnation and decline." And this beginning, which he told *in medias res,* created a historical context and need for a cultural hero or saviour; it mapped out what aspects of Northwest Coast and Haida history would be included in the narratives he wrote or told. Yet Sophie Reid's role as a victim was not one she expressed for herself. It was her son Bill who gave particular value and meaning to both her history and the time period from which he retrospectively wrote. Given his authority as the maker of this historical representation, he became the contemporary hero who redeemed his mother and helped restore a sense of pride in all the other Haida who supposedly had also lost theirs.

ANOTHER BEGINNING

If we consider Reid's reference to how the "Indian" circulated as a sign at the turn of the twentieth century, he quite rightly recognized that being identified as Indian was an anathema. It was even dangerous at times. In the broader context of being "Indian," however, we could consider Sophie Reid's life in terms of the history of aboriginal women who married white men or who travelled to Victoria to work as domestics. By considering patterns of encul-turation rather than the experience of assimilation—since the issue of race would not have allowed these women to be completely assimilated into Canadian society in Victoria at the time—we can ask different questions: In which social situations would Sophie Reid's specific national Haida identity have been subsumed into the one that was socially and legally defined for her as "Indian"? What were the aspects of being Indian that she could not avoid, given the various laws and policies of public institutions and private estab-lishments that must have mediated how she and other Native women moved about on the coast and in Canadian cities at the turn of the century? How did she and other Native women circulate in private Euro-Canadian spaces? How was the Reid family directly affected by representations of "the Indian" circu-lating in the public sphere (Bill may have looked "white," but Sophie Reid did not), and how did that representation intersect with policies of assimilation, racial discrimination and social acculturation? When we change the field of questions, we shift the focus from constructing Reid and his mother's begin-nings as a time of assimilation and "hopeless demoralization for natives" to its context in the history of *Canada's* "shameful" past.

Saying that Sophie Reid didn't want to be Indian is different from saying she didn't want to be Haida. Such distinctions of self-identity must have existed in varying degrees in her and other aboriginal women's private spaces. If Sophie Reid was not proud to be "Indian," how did she live her life in a way that gave her pride? And did the life she pursued reflect the desire of a woman to have the same rights and respect as other women of her time, perhaps even a likeness of the rights and respect that her Haida mother may have had in her own social and cultural space? How did Sophie Reid self-identify as a Haida in nuances of language, voice and gesture when her relatives came to visit her? Did they speak in Haida of other friends and rela-tives from Haida Gwaii? Since we know that Bill Reid's mother and aunts

wore Haida bracelets made by John Cross, we could also consider how the bracelets on the arms of aboriginal women dressed in Euro-Canadian clothing acted as markers of their aboriginal heritage. Were they signs of wealth or beauty, like Ada Crosby's tattoos? Since the bracelets inspired Bill to become a jeweller (Reid 2000:190), we could situate the beginnings of his art practice here. By doing so, Reid would be more authentically located in his actual lived cultural experience, rather than in an art practice that began in an idealized and illusory past.

Sophie Reid's decision not to speak of her ancestry to her children (Reid 2000:87–88) did not pass away with her. It has been passed on to her children and other Haidas who survived to speak of what she felt she could not. And what Bill Reid would not. When we begin to look at our histories from a different perspective, we see the incredibly diverse ways that aboriginal people were challenged to deal with the impact of colonization. Sophie Reid's history, then, is not about stagnation and decline, but is rich in its complexity.

MIDDLES

In 1986, Reid self-identified for the first time as "being" Haida when he made a public statement to the Wilderness Advisory Committee. International and Canadian national interest in Reid's work and his Haida heritage did provide, in a limited way, a political platform upon which, together with the support of Haida chiefs and representatives of the Haida Nation, he would stand against the Canadian government in regard to aboriginal land. It was here that he said he would have to "finally... face up to what it really means to be Haida ... I am taking a few steps along the road to becoming one" (2000:213). This statement is significantly different from his earlier references to his Haida blood and ancestry, which were relative to other aspects of his life that also determined his identity. However, his interest here, as it had all his life, lay in the Haida past:

> For it is only in such places as South Moresby that the past can be
> found intact and unchanged. Every other aspect of Haida culture
> has been eroded away. The language is almost gone. The songs,
> stories, the very genealogies that were the threads that made up
> the fabric of Haida life, are almost forgotten... So we have left

only the sea, and a few sacred groves unaltered since the great
change that began two centuries ago (Reid 2000:216–17).

This statement reveals his life's gaps and silences, his nostalgia for an
"almost forgotten Haida life," a life he never knew. His "return" to his Haida
identity, this romantic journey home, was a return to a time and place that
he and others made up: the "golden age," the "classical period" of the late
eighteenth and nineteenth centuries (comparable to other great civiliza-
tions), uncontaminated by modernity. For him, all that was left by 1986
were "a few sacred groves." In the midst of this heroic return, he still
mourned what was not there. Yet this "home"—the one he had been con-
structing and defining from the time he first began to tell his story—had
been more stable to him than the places called up by those he said only held
"memories of old memories." So it made sense that, more than a decade
later, when Reid died, his ashes would be interred in a village that had not
been occupied for more than a hundred years, rather than in the village of
Skidegate where most contemporary southern Haida people have been liv-
ing and dying since 1897.

However, despite the fact that Reid still saw change as erosion and con-
temporary Haida life in relation to an almost forgotten past, he was willing
to stand on the line for the larger dimensions of contemporary Haida cul-
ture, as well as for what he believed constituted his Haida origins. He wanted
a place for his four grandchildren and other young people to go to "as they
become the Haida of the future—the people who call these beautiful, boun-
tiful islands their home—they and their peers will have more than nostalgic,
regretful memories of 'how it used to be in the old days' upon which to build
their own visions of their past . . . and there create the myths of a living cul-
ture" (2000:212). Although Reid was referring to the doubts he had about
some kind of cultural revival, an examination of the history he wrote reveals
that he was caught in an atavistic "groping behind us toward the great days
of the past" (45). He was full of the contradictions of what it is to be in a per-
petual state of being and becoming; to be continually in the middle of one's
own story, and one's mutable beginnings.

Reid clearly had his own ideas about what it was to be Haida, which is
evident in his essay "Haida Means Human Being" (2000:131–46):

> By sharing with the original inhabitants of this continent the
> things that make up the essence of their own humanity—their
> legacy from their own original homeland—we and they may feel
> secure in accepting the priceless gifts that the Northwest Coast
> peoples left for their descendants—and that they left, as it turns
> out, for the whole world . . .
>
> As a descendant, in part at least, of the Haida people, I wish for
> each of us, native or newcomer—or, as so many of us are now,
> both—that however we say it, we can recognize ourselves someday
> as Haida" (145).

Reid's identity is difficult to interpret here, especially in relation to all his
other essays. One can't be sure if he meant that cultural differences do not
really matter, or, conversely, that being distinctly Haida means knowing who
you are, and knowing who you are is what makes you human. Or he might
have been saying that anyone who knows Haida history can call themselves a
Haida/human being, which seemed to be his point in "Curriculum Vitae 2":
"I must admit that for the most part now I go to Barbeau, Swanton, and all
those *other* good Haidas for the stories that are there" (2000:196, italics mine).
In *Solitary Raven*, Reid's identity is buried in the slippage between Northwest
Coast art history and his personal history; his mixed ancestries and simply
being human, and finally between the human race and Northwest Coast art:
"We can only look at what [the Haida] did produce . . . and also feel a certain
pride in belonging to the same race as a people who could create such inge-
nious, expertly made and beautiful objects: the human race" (52). Regardless
of whether he self-identified in terms of his Native or non-Native ancestries—
Haida or hyphenated Canadian—he continually buried any specific
citizenship in the broader context of his humanity.[35]

From this place, he put the ownership of Haida material culture into
the hands of the world of mankind: "I think that great works of the
human spirit, great works of creativity, belong to everybody—and that
legacy left us *by the old people* is as much the legacy of . . . everybody in the
world, as it is of the descendants of the those people directly" (Reid
2000:198, italics mine). Note that "owning" it also requires that one recog-
nize its value, which is defined in terms of "fine art": "[The Legacy] belongs

to any person who can respond to the essential universal humanity which exists at the core of any true creation of the *skill of human hands—the imagination and intelligence of the human mind, the power of the human spirit* (Reid 2000:181, italics mine).

In his introduction to *Solitary Raven*, Canadian poet and author Robert Bringhurst says quite rightly that "what [Bill] chose to say about the arts is addressed to all his fellow human beings, not to any private club of artists or collectors, anthropologists or critics, nor to *any ethnic group*" (2000a:10, italics mine). It's true. Reid does say this overtly and implicitly throughout the years spanned by the anthology. The international world of the arts and humanities, moreover, has claimed him as its own in correspondence with Reid's self-identification as a "citizen of the world." His art, Haida art, is recognized as having universal human value and is thus claimed by "the world" for the world. This part of the story is not only recorded in the media, it is entrenched in the disciplines of history, anthropology, Canadian art history and Canadian literature. But what Reid had to say about that was one Haida's view of Haida culture. It was just one Haida's contribution to what has become a less exclusive conversation in the public sphere.

At the same time, I would argue that Reid was clearly caught between his ideas and beliefs about contemporary "Northwest Coast art": the initial or original logic of its making (its historical reason for being), and how all of that intersected with the socio-political realities of contemporary Haida life. The question of whether Northwest Coast art could be reduced (or expanded) into a modern art form of international value, whose criteria for excellence was based primarily on form, "nagged" him. He said himself, "I don't think you can take the design and the art without taking the people as well" (2000:198). He wondered, as did Duff, whether it had become "a medium without a message" (166). Exploring the logic of its contemporary making by other contemporary Haida artists, and its use-value for Haida people—its reason for being—requires a different paradigm than the one Reid used. It requires putting Bill Reid—his beliefs, his stories, his assumptions, as well as those of his peers—in the middle of contemporary Haida history.

ENDINGS

Reid publicly accepted within the Haida communities the names Iljuwas (Manly One), Kihlguulins (The One with the Lovely Voice) and Yaahl Sgwansung (The Only Raven),[36] two of which are the only names on his gravestone. Like other Haida names, rituals, masks, poles and oral histories, they become alive through the process of being passed on from Haida to Haida. As the bearer uses and passes on aspects of his or her clan or house, the history of the object and the person are in a continuous state of being and becoming. One could say that the part of being Haida that is considered sacred enters into the zone of the existential through a name, a mask, a crest. That which is suprahistorical enters into history. Names and crests are linked to clans, clans to oral histories, oral histories to origins and land.

The assertion by Reid and many of his contemporaries that names, oral histories and material culture can be taken or passed on as art or literature for all human beings raises many questions. What happens when they are held by those outside of Haida culture—explained, redefined and owned by those who identify themselves first as human beings? At what point does that which has been distinguished—precisely because it is culturally Haida—become separate from its origins through identification as "universal" and cease to have the freedom to acquire selfhood? To be Haida?

It is possible to write public histories that hold the paradoxical and varied juxtapositions of colonization and the old ways in particular, powerful relation to each other, including conflict as just one of the elements (Hodgins 2001:130). In the middle of those stories, we can closely examine the ways that aboriginal peoples moved into the future. Such a history can be written without reducing its complexity to a time of heroic survival, or to assimilation and demoralization. These are the only two endings available to the salvage history written by Reid and "the strange tribe who inhabit the groves of Academe," upon whom, Reid claimed, aboriginal people have become dependent "for knowledge of their histories and almost forgotten cultural achievements" (2000:182).

Bill Reid had the right, as do we all, to tell his own story, to self-identify and to self-actualize. However, just as he claimed the Haida, we Haida also claim him. He will be enfolded in the histories that we have been recording, and the ones we have yet to write.

ENDNOTES

1 For a discussion of the migration into Skidegate by southern Haida, see Dalzell 1993:99–103 and Henderson 1985:5–7. See also, re smallpox and the Haida, Boyd 1999:202–22. For a limited critique of Boyd and a discussion of how the history of early smallpox epidemics and the change that followed have not been acknowledged, see Harris 1997:26–30.

2 Reid 2000:213–18. See also the chapter "Becoming Haida" in Shadbolt 1986:13–61.

3 Any university or gallery library has files of the multitude of clippings that situate Bill Reid as some kind of hero or redemptive saviour of Northwest Coast culture or Haida people.

4 Shadbolt 1986:171.

5 Reid wrote (2000:168): "The graphic and plastic arts could have been reinvented by anyone with the time, interest and ability."

6 Reid 2000:168.

7 Symposium "The Legacy of Bill Reid: A Critical Enquiry." University of British Columbia, 13–14 November 1999.

8 Reid was praised as "the spark that helped bring international attention to native art" by Oriana Wesley (1998). Michael Scott (1998) wrote: "His talent was all the breath needed to fan the last dying embers of Haida art back to life." And *Kahtou: The Voice of B.C. First Nations* ("Bill Reid Honored" 1994) commented that he was "internationally known as an artist and sculptor as well as for his role in reviving the cultural and artistic traditions of the Haida people, which had become endangered following the government ban on potlatches."

9 In Reid's collected writings in *Solitary Raven* (2000), the way in which he constructed the social conditions of aboriginal peoples' contemporary life as overwhelmingly hopeless and dark, and pointed to their loss of humanity, is discussed in the following essays, most fully in those marked with an asterisk (*): "People of the Potlatch," "Art of the British Columbia Indian," "Totem," *"Haida Means Human Being," *"A New Northwest Coast Art: A Dream of the Past or a New Awakening?" "Curriculum Vitae 2," "These Shining Islands," *"Becoming Haida," *"Joy is a Well-Made Object."

10 In *Bill Reid: A Retrospective Exhibition* (VAG 1974, n.p.) and in Shadbolt 1986:10.

11 Many First Nations artists have participated in a contemporary visual and performing art practice premised upon the creation of a linear art history that reaches back to their ancestors. Establishing such a pedigree makes certain presumptions about notions of origin, and about form and practice. It presumes that the values and meanings of pre-contact aboriginal material culture, oral history and ritual can be added to Western categories within the "arts" and that those very specific practices are somehow able to transcend time, place and culture. Such histories have, however, created a space for individual aboriginal artists to act as public narrators of their respective cultures. This authority has often been aligned with a desire to maintain cultural ways and to create social and political change—a complex discussion that is beyond the scope of this paper.

12 See Reid 2000: "If there is truly a renaissance of native Northwest Coast art, it is as much the accomplishment of a small group of dedicated academics—Hunter Lewis, Harry and Audrey Hawthorn, Bill Holm and others—as it is of the carvers themselves" (111); "I acquired my early knowledge of the culture not through contact with the native people but through the writings of

the early anthropologists, chiefly Franz Boas" (155); "Undoubtedly there were terms in the native languages by which the artists of the past identified the different elements of their art, but these have long since been lost . . . So we are left with the terms which Bill Holm so brilliantly created to describe these forms, previously unnamed in English, now the common language of all coastal peoples. These terms enable us all to much better appreciate the unique imaginative concepts underlying this great exercise in *human creativity*" (179, italics mine).

13 *BC Bookworld*, summer 1998, 45.

14 In two CBC productions, a radio and a film documentary in 1963, Reid, when identifying those on the trip (2000:58), referred to himself as both "a descendant of the Haidas and representative of the CBC."

15 Reid's text in *Solitary Raven* can also be reviewed for his use of pronouns, but each instance of self-identity needs to be considered in its context. The following are the most specific examples of the way Reid qualified his Haida blood with his non-Native blood and lived cultural experience: "I have always felt much more a native of all English-speaking North America than of any particular political division of it" (86); "My predecessors, with whom I have a very tenuous connection. I'm to all intents and purposes a good WASP Canadian. I look like one, I have the upbringing of one, I've never lived in native surroundings. I've visited a lot, and I know a lot of people and have learned what I can of it" (196); "I've never been involved in ceremonies. I'm not a dancer, and my relationship to the culture of my people is in fact a very remote one" (193); "I've spent most of my life with a feeling of identity with the Haida people—always, of course, at a safe distance in some urban location" (213).

16 The following are direct quotes of self-identity. Reid (2000) identifies in more subtle ways throughout the text of *Solitary Raven*, which the scope of this essay does not allow me to discuss: 38, 52, 58, 86, 87, 88, 114, 145, 151, 164, 188, 189, 196, 97, 98, 211, 215, 216, 217, 219, 220, 224.

17 See note 9 above.

18 Reid 2000:37, 45, 53, 64, 82, 183, 210, 223.

19 Reid 2000:139, 140, 144, 168, 169, 170, 222, 223. See also note 5 above.

20 Reid 2000:109, 138, 183, 196.

21 Reid 2000:38, 87, 88, 134, 180, 196, 202.

22 Reid 2000:115, 159, 174, 179.

23 Reid 2000:66, 95, 110, 113, 116, 120, 121, 180, 183.

24 Reid 2000:46, 50, 65, 66, 69, 159, 175, 181, 198, 199.

25 Reid 2000:45, 96, 191, 197, 220, 227, 229 (one could argue that Reid is the goldsmith spoken of on 227, whereas on 229, Reid is the Raven).

26 Reid 2000:139, 140, 144, 168, 69, 170, 222, 23. See also note 12 above.

27 Jack Hodgins, *A Passion for Narrative: A Guide for Writing Fiction* (2001:141).

28 Reid 2000:45, 54, 67, 162, 163. See also note 11 above.

29 Bringhurst uses salvage ethnology to rewrite and copyright Haida oral history as "literature (art)"— even as these are histories owned by clans, and having to do with mythologies connected to clan and house origins, land and lineage. In the Introduction to Ghandl 2000:22, he says, "Bill Reid . . . taught me much of what I know of Haida art." Bringhurst uses notions of a depoliticized author, whose individual genius locates his work in the realm of art and literature, which both he and Reid asserted belong to all human beings.

30 The information in this paragraph is informed by the work I did for my essay, "Construction of the Imaginary Indian" (1991). But most of the information is extrapolated from my M.A. thesis, "Indian Art/Aboriginal Title" (1993), which considered the historic construction of Northwest Coast Indian art and "mastery" parallel to First Nations political history. My thesis focussed on the 1967 *Arts of the Raven* exhibit for which Reid made many contributions as curator, consultant, artist and writer.

31 Doris Shadbolt's Foreword to the catalogue for *Arts of the Raven* (VAG 1967:n.p.).

32 Reid (2000:164) did acknowledge some of the artists practising at the time.

33 Personal communication from Dr. Marvin Cohodas, 15 October 2003. I am grateful to Dr. Cohodas for many important comments, which both confirmed and questioned aspects of my work.

34 See "Curriculum Vitae 1" and "Curriculum Vitae 2" in Reid 2000.

35 See note 15 above.

36 Diane Brown (this volume), a speaker and teacher of the Haida language, translates the name as "The Only Raven," while Bringhurst (2000a:14) translates it as "Solitary Raven."

III

Revisiting the Revival

What Is a Renaissance?

by DAVID SUMMERS

WHEN IT BEGAN to be said that Bill Reid's art had initiated a Haida "renaissance," he himself made the very reasonable objection that a renaissance of Haida culture could not be achieved simply by the recovery of the forms and themes of Haida art (Duffek 1986:23–26). A few years ago, any artist would have been delighted by such a critical judgment of a life's accomplishment—however offhand—and it seems to me that Reid showed a high degree of responsibility to his Haida heritage by insisting that his individual success should be regarded only as one of many to be looked for in other aspects of Haida life. By the time I was brought into the debate, this qualification seems to have grown into the broader, rather more prob-lematical, claim that the term "renaissance" is an inappropriate imposition of a category of Western culture upon another. Intellectual times and issues change, and, whatever Bill Reid might have meant by his demurral, reference to a "renaissance" may in fact raise all the ethical and political questions of the relation of European culture to other cultures at a time when faith in the ideologies of colonialism has faded. In these circum-stances, I suppose my contribution to be something like that of an informant, a native speaker, an actual inhabitant of the scholarly field of Renaissance studies who can provide some guidance through the history of the period and through its scholarly literature. From that vantage point—and this may perhaps tell us something about informants in general—it must be said right away that if those outside the field are not sure what a renaissance might be, those in the field make careers out of criticizing or

defending one or another version of the period. Inviting an "expert," in short, might only be multiplying controversy by controversy.

There is good reason to be sceptical about the use of Western historical terms, and even the whole Western scheme of cultural and art history itself, outside the history of Western art proper. Western cultural history, which began to assume its modern disciplinary forms in the eighteenth century, has been a narrative of progress along certain lines (as I shall discuss in more detail presently), according to which other cultures are located somewhere near the beginnings of the forward march to the Western present. In E.H. Gombrich's *Story of Art*, to take an example that has shaped the art-historical educations of millions of people worldwide, the art of the Haida is included in a brief first chapter entitled "Strange Beginnings," and is represented by the model of a chieftain's house in the Museum of Natural History in New York. Gombrich states at the beginning of his second chapter that the story of art "does not begin in the caves of southern France, or among the North American Indians"; rather it begins in Egypt, the millennial art of which was itself galvanized to life by the "great awakening" of Greek art (1972:19–30). One need not minimize the great accomplishments of Greek art to observe that for Gombrich, here a representative of broader Western assumptions, it was the Greeks who set art on its true path toward optical naturalism, a path to my mind interlaced through the centuries with the history of Western science and technology, and so continuing in modern photography, film and television. If we assume from the outset that progress in the imitation of appearance is the aim of art—an idea repeated in Europe since Greek antiquity, and especially repeated in the Renaissance and the centuries following it up to the rise of twentieth-century modernism, then art that does not imitate, that is based on the development of other aims and skills, can be called "early," not to say "primitive," with the further implication that the people who make it need to be brought up to cultural speed.

In other words, I agree that we should not use any of our customary terms about art and its history unreflectively, and it requires no great insight to recognize that even our presumptive definition of "art" itself is more often than not obviously inappropriate for the art of other traditions. I do not think, however, that the results of such sceptical critique are only negative; on the contrary, they provide the only means by which we may come

to better critical awareness, and thus to more satisfactory understandings and accommodations. We are all members of traditions and are therefore inescapably inclined to assimilate the unaccustomed to our own terms and expectations. Our cultural predispositions may be used to good purpose if we can treat them as intrinsically provisional and revisable, and as a means of coming to some understanding of what we did not understand before. If the description of what happens in one's own culture *is* treated as provisional and revisable, then such a hypothetical projection might actually result in useful conversation—like the conference on Bill Reid from which this paper developed—and greater mutual understanding, even if it is a mutual understanding of difference.

In what follows, I will discuss the idea of a "renaissance" in four overlapping but fairly distinguishable categories. The first category is *historical*: that is, it will be about *the* Renaissance, the period in European history that provides the comparative basis for any other "renaissance." The second category might be called *formal*: can we speak of a renaissance as a "shape of time," a set of events that might occur in many historical circumstances?[1] The third and fourth categories are *historiographic* and *critical*. The Renaissance itself was named centuries after the historical period the term has come to denote—in the history of art, the European fifteenth and sixteenth centuries—and so I will be concerned with the question of how this definition came about and what its implications might have been and could be. As we shall see, these historiographic questions lead directly to present-day critical uses of the term. People may have historical figures—Christopher Columbus or Leonardo da Vinci or Isabella d'Este—somewhere in the backs of their minds when they use the word "renaissance," but the term has also detached itself from such specific reference and is a more generally positive characterization of some enterprise and its likely, or hoped for, good consequences and prospects. These more popular critical usages—like "Renaissance person"—someone good at many things, as opposed to a jack of all trades—have filtered into everyday language from specialized historical discourse.

It would take a very long time to explain the Renaissance as a period in European history, what happened in it, and how historians have tried to explain these events. The period we call the Renaissance saw the consolidation of the middle class and the emergence of the modern system of

European nation-states; it was also the beginning of the period of European expansion, colonization and imperialism, the time in which European technology and institutions began to be brought to bear more or less forcibly on peoples throughout the rest of the world, with the deepest possible consequences for all of us. Columbus sailed into the Americas in the same year that Lorenzo de'Medici died in Florence, and Amerigo Vespucci, the new Ptolemy, after whom the continents were named by the cartographer Martin Waldseemuller in 1507, was from an old Florentine aristocratic family and an agent of the Medici bank in Spain. Machiavelli and Raphael were working at the same time, and Cortez marched into the Aztec capital of Tenochtitlan at about the same time Leonardo da Vinci and Raphael died. Western Christendom split during the Renaissance with the Protestant Reformation, and one of the great iconoclastic episodes in European history thus more or less paralleled the "age of discovery." If all of these important events happened in the Renaissance, however, they are not necessarily related by virtue of this contemporaneity, nor does a cultural renaissance depend on the reoccurrence of all of them.

In the history of art, as the examples in the last paragraph might suggest, the Italian Renaissance—the basis of comparison for broader uses of the word "renaissance," has been especially closely associated with the city of Florence. During the fifteenth and sixteenth centuries, Florence was small by modern standards, but it was wealthy, a banking centre whose currency was the standard of European finance, where modern bookkeeping began. It was a city-state, in which political institutions developed in shifting and complex relations between a new plutocracy, the older feudal aristocracy, the guilds and the rest of the population. Florence also was a centre of textile manufacture, in which division of labour was practised, where something like a proletariat developed and (unsuccessfully) demanded its rights. The city's rapid rise to historical prominence was interrupted in the middle of the fourteenth century when the Black Death devastated the city. I will return to the example of Florence from time to time in the rest of this paper.

If we speak of *a renaissance* rather than *the* Renaissance, it implies what I have called a formal meaning of the word, that there might be more than one renaissance: that is, that there are cultural patterns in important

respects like *the* Renaissance. When I began to write this paper I thought of established terms like "Harlem Renaissance," and I remembered that when I lived in Pittsburgh, it called itself the "Renaissance City." "Renaissance" is obviously a positive term in both of these examples, which, when turned to public relations purposes, may of course become inflated. By chance, I came across a newspaper article on Pittsburgh which said that the city "had not had one renaissance, but two, and a third is under way." (It was nearly a thousand years between the fall of Rome and the beginning of the period in European history we call the Renaissance; now, however, everything is speeded up, and "renaissances" are coming thick and fast.) I happened to hear on the radio the other day that the state of Michigan has been divided into eleven "Renaissance zones," and there are no doubt Canadian examples of which I am not aware. Bill Reid sometimes considered the term merely part of the rhetoric of art commerce, even though it was his art that had created the demand for critical judgment (Shadbolt 1998:173). Taken altogether, however, even if the term may be inflated, if its connotations may wobble, and enterprises called renaissances at the beginning turn out badly in the end, they have only failed to meet high expectations. I don't think the English language at this point allows us to say things like, "Oh, it's nothing but a renaissance," or "I hope this doesn't mean there will be a renaissance," and again, those who described Bill Reid's accomplishment as "a renaissance" certainly intended the highest praise, and, as I have suggested, his reaction to such elevated praise might have been as easily one of modesty as of geopolitical anger. Again, if praise was set in terms of the praiser rather than the praised, this is not bad on the face of it, and to my mind it must remain an open question—to be answered by the Haida—whether or not this term is mutually translatable.

When I accept invitations to write papers, I always begin to look at my scholarly surroundings differently and begin to notice the names of the people who invited me. Browsing in the National Gallery bookshop in Washington, D.C., I came across a volume entitled *Unpacking Culture: Art and Commodity in Colonial and Postcolonial Worlds,* edited by Ruth B. Phillips and Christopher B. Steiner. I opened it to find an article by Carol S. Ivory, "Art, Tourism and Cultural Revival in the Marquesas Islands," which begins its conclusion with the statement that "cultural life in the Marquesas Islands

is undergoing a far-reaching renaissance. There is both a renewed interest in the past and a developing vision for the future" (1999:332–33). This is not only clearly a positive and hopeful evaluation of events, it is also, as we shall see, a pretty good thumbnail working definition of *a* renaissance.

Our routine uses of the word "renaissance" descend from nineteenth-century historians, and, as I have mentioned, "renaissance" is a scholarly word that trickled down (or bubbled up) into broader currency. To be sure, scholarly terms have their own origins, although in the modern French from which the metaphor of "renaissance" was taken, the historiographic definition has actually supplanted other meanings. My *Larousse* gives the first definition of "renaissance" as the revival of arts and letters, the historical period of the Renaissance; "rebirth," the literal meaning of the word, is given as the second meaning, examples being the phoenix rising from the flames; return, as of spring; or revival, as of vegetation. (It should also be noted that it has assumed more contemporary connotations of recycling; every period, as Aby Warburg [1999:6] observed, has the renaissance of antiquity that it deserves.) What all of these have in common, and have in common with the popular variants just discussed, is the idea of rebirth, renewal, return, recurrence, even resurrection.

The connotations of the word "renaissance" itself are thus not simple, and so neither are the implicit metaphorical conditions out of which "rebirth" takes place. "Rebirth" might imply having been dead, but might also mean born a second time; "renewal," "return" and "recurrence" imply the completion of some cycle, and "resurrection" implies passage from one life to another, higher one. Debate over the definition of the Renaissance as a period in European history might in fact be seen as moving over this same metaphorical spectrum, and, in his *Story of Art,* which I cited earlier as an example of progressive Western history, E.H. Gombrich (1972:167–68) reviewed the usual meanings of the term "renaissance," but he also noted the deep roots of the period and its achievements in preceding centuries. The "Middle Ages"—at a popular level, we still use the word "medieval" disparagingly—were not blank, and they were not "dark" or dead.

The modern Western idea of culture as the expression of national, regional, ethnic and periodic "spirits" and "worldviews" began to emerge

in the eighteenth century, and the idea of stringing cultures together in a progressive history is nineteenth century, and is especially the deeply rooted legacy of G.W.F. Hegel's philosophy of history (Gombrich 1984:51–69). Christian writers (including Hegel) had always made the distinction between themselves and pagan antiquity, or between the old law of the Jews and the new revelation, and the rise of modern science paralleled the quarrel between the ancients and the moderns through the seventeenth and eighteenth centuries. Hegel's progression of historical periods was thus consistent with larger frameworks, and in his history of spirit the Incarnation was crucial in signalling the advent of modern subjectivity. Hegel's scheme for the history of art was, however, slightly discrepant relative to the history of spirit taken altogether. For Hegel, art progressed from *symbolic* art (ancient Egyptian art, newly in view after the expeditions of Napoleon), to *classical* art (the art of ancient Greece, following J.J. Winckelmann), and finally *romantic* art, the art of modern subjectivity. In this scheme, classical art was normative even though it was pre-Christian. Italian Renaissance art, as the reattainment of the classical, assumed this canonical mantle. And if High Renaissance art belongs to what Hans Belting (1994) calls "the age of art," it was "ideal," modern art of truly neo-classical aesthetic excellence.

It was in such historiographic circumstances that the Renaissance emerged in the nineteenth century as an exemplary period, and also as the first major example of a historical period in the way in which we have come to understand and use the term. Jules Michelet (1855) and then Jakob Burckhardt gave the historical period of the Renaissance its name. Burckhardt, in effect, made the Italian Renaissance the beginning of the modern period in his book *The Civilization of the Renaissance in Italy*, published in 1860 (see Burkhardt 1958). (The word Burckhardt himself used, by the way, was not "civilization" but rather *Cultur,* "culture.") The early modern period he defined was characterized by the idea and practice of what he called the "state as a work of art," the "development of the individual," the "revival of antiquity" and the "discovery of the world and of man." These identifying characteristics have been much debated, but for present purposes, it is most important that they not only came to define the

Renaissance, they also pointed the way to the definition of other historical periods and even of cultures in general. As "classical," the Renaissance at first stood above these other periods.

It will be useful at this point to examine the relationship between art and culture a little more closely and carefully. E.H. Gombrich, whose *Story of Art* I have twice cited as a bad example, also never tired of reminding and warning us that the history of art has played an important part in forming the present intellectual habit of characterizing entire cultures—in the broadest sense of that disputed word—in terms of inferences drawn from the expressive character of their artifacts (1979). Gombrich attributed this bad habit of historical imagination to the influence of Hegel, to what he called "Romantic historiography" (Summers 2002:139–49). Although Hegel's name is perhaps most quickly associated with abstruseness of the worst kind, his vision of a universal providential history gave philosophical principle to what have become broadly held Western assumptions about progress and human historical destiny. Gombrich (1979) argued that Jakob Burckhardt's definition of the Renaissance as a period in European history was not untouched by such Hegelian wrong-headedness because Burckhardt had set out to define the ways in which the Italian Renaissance was *essentially* unlike the periods preceding and following it (which is compatible with his argument that in important respects the Renaissance was continuous with the Middle Ages). Much art historical energy has been spent over the years in defining other periods—and cultures in general (including the "Northwest Coast")—in similarly essentialist terms, a debate that has now settled into the perennial administrative quiet of academic "fields" of art historical specialization and departmental budgeting.

The habit of thinking of cultures in such essentialist terms, complicated as its social and intellectual historical roots may be, is fairly simple and very familiar in art-historical practice. The Minoans, the flowing vegetal lines of their art tell us, were carefree and happy; the Italian Baroque is exuberant. A good joke at the expense of this assumption about art and culture was made by one of the participants in this conference, for which the first draft of this paper was written. Although the speaker, Diane Brown, is Haida, she said she could not draw an ovoid to save her life. Presumably this was a variant of the frequently heard insistence that someone "cannot draw a

straight line." But it was also more significant than that, as was the knowing chuckle from the audience that followed. The implication to be drawn from this passing joke—that the ability to make Haida art does not arise from some essence shared by all Haida—may be extended in directions very important for the argument I am making. It makes most sense to suppose that drawing ovoids does not arise directly from Haidaness, but rather, as in most traditions, that *some* Haida—persons with specialized skills, belonging to traditions of specialized skills—are able to make distinctively Haida art, that is, artifacts that serve Haida purposes, meet Haida expectations, that both define and respond to Haida tastes. It is a very different claim to say that Haida purposes, expectations and tastes have been suppressed or denied in specific ways than to say that the Haida "spirit" or "essence" has been eclipsed. And, by the same token, it is very different to say that a great tradition of craft and image-making has been resuscitated than to say that, by this resuscitation, the Haida spirit has been reborn. The Haida spirit was there all along, and in these terms, Bill Reid's "renaissance" is a return and a renewal of art and skill. In a basic sense, for Giorgio Vasari, the great biographer of Italian Renaissance art, the progress he chronicled consisted of the reclamation of lost skills, a reclamation that finally made a new freedom of conception and invention possible.

Renaissance writers themselves pointed proudly to what Burckhardt called the "revival of antiquity." Ancient Greek and Roman art and eloquence, they believed, lay dormant. By and large, however, Renaissance writers saw the revival of antiquity as a completion of Christian civilization, and perhaps the greatest example of this vision is the new Christian Rome of the "High Renaissance" of Julius II. Nineteenth-century writers could see this in more polarized terms, as the emergence of enlightened secularism from an earlier age of superstition, vestiges of which were still everywhere to be seen and still needed to be opposed. But the Renaissance break with the past, if less dramatic than its nineteenth-century retelling, was a break with the cultural centrality of the Church, in itself an inversion of traditional ideas so extraordinary that in his *Renaissance and Renascences in Western Art*, Erwin Panofsky (1969:10–11) compared it to the break signalled by Copernicus' overturning of the geocentric universe. If it was believed, and continued to be believed in the Renaissance, that fallen

Adam and mankind had been reborn through the Christian revelation, it was claimed in the Italian Renaissance that that regeneration was itself perfected by the reclamation of art and eloquence, which the Church had allowed to fall into decadence. This idea animated the fourteenth-century poet and scholar Petrarch, often called the first humanist: that is, the first person to devote himself primarily to ancient rather than ecclesiastical texts. But again, such aims should not be taken to mean that relations between humanists and the Church were simply oppositional.

I think it is fair to say that the Renaissance was defined first in the nineteenth century as a historical period because it was felt to be the springtime of modern Europe, essential to the story modern Europe told itself about its own beginnings. It was in the nineteenth century that Michelangelo became the great proto-Romantic genius and Leonardo da Vinci the great proto-empiricist. The nineteenth-century Renaissance idea was by no means uncontroversial. As the emergence of modern *secular* values, the harbinger of the Enlightenment, the Renaissance idea had many opponents. By no means everyone in nineteenth-century Europe embraced the vision of secular modernity, and what were the Dark Ages from the standpoint of the Renaissance and the Enlightenment were the great ages of faith for millions of others. An important battle between modern secular values and traditional religious values was thus fought over the question of the Renaissance. The contemporary conservative reaction to "secular humanism" is at least parallel to this reaction, which was also broadly important to Romanticism. As secular, the Renaissance was both approvingly and disapprovingly associated with the Epicurean and sensual. Walter Pater's *The Renaissance*, published in 1873 (see Pater 1986), is a kind of aestheticist manifesto that figured importantly in the formation of the idea of the period; and, in reaction, such projects as Ernst Cassirer's *Individual and Cosmos in Renaissance Philosophy* (1963) was written to show that the Renaissance had a philosopher—Nicholas Cusanus. As recently as 1949, Rudolf Wittkower's *Architectural Principles in the Age of Humanism* was written to show that its architecture had an intellectual rather than a simply aesthetic basis.

It was in the nineteenth century, in the full flood of industrialization and capitalism, that the Renaissance came to provide the pattern for an ideal of civic patronage, and it was then that the Florentine Medici especially

became synonymous with enlightened art patronage. To be sure, rulers had always patronized the arts as both a necessity and prerogative of rule, but the Medici, as the capitalist, politically behind-the-scenes plutocrats they were, provided a much better precedent than kings and emperors for nineteenth-century captains of industry in the Age of Revolution. The reception of this aspect of the Renaissance idea has also been mixed. We owe such things as national collections of art and many great public institutions we take for granted to the practice of this ideal of patronage, which just as surely, however, has produced criticism of the imbalance of wealth that makes such philanthropy possible. However we might feel about this still-living issue, I think it is fair to say that enlightened patronage is an ingredient in any situation we might call a "renaissance."

As a parallel to the ideal situation of patronage, the idea of the Renaissance emerged, more or less together with modern philosophical hermeneutics itself, as what might be called the ideal hermeneutic situation. That is, in a historicist age, it was the best example of the use of the past in the present, thus to figure very centrally in the nineteenth-century dispute between the natural sciences and the humanities, a dispute that led to the formation of the humanities as they have been instituted on a broad scale in the twentieth century. The Renaissance consequently came to enjoy a unique status in the humanities, both because it represented the creative use of the past and because this creative use of the past produced monuments in themselves normative and classical. Educational curricula into the twentieth century descended from the humanist study of ancient languages and literature, and, in art, the Italian Renaissance became the basis, the formative phase, of European neoclassicism. It thus became the foundation for art academies, and for the aesthetic standards of art academies, that held sway until the beginnings of modernism in the late nineteenth century. But, as this last statement suggests, the wheel of fortune turns, and all of this set the Renaissance idea up for a fall in the twentieth century, when its multi-connectedness with classicism and canonicity, and its status as one of the acknowledged moments of normative European culture, began to be resented and resisted on many fronts.

When Jakob Burckhardt wrote the book he called the culture of the Renaissance in Italy, he cannot be supposed to have been using the word

"culture" in a modern sense. This is a big subject in itself, but we now use the word "culture" to refer to the shared behaviour of almost any group; one frequently finds such terms as "gun culture" or "video game culture," referring to people who share interests, activities and more or less implicit values. But if we take "culture" to mean that behaviour into which people are educated, then the Renaissance also taught Europeans how to be "cultured." Even at the beginning of the twenty-first century, what we regard as a cultivated manner in men and women still bears the marks of the ideals to be found in Baldassare Castiglione's High Renaissance *Book of the Courtier* (see Castiglione 2002). The norms of such evident culture were exclusive both within and outside European societies, and they have also provoked resistance with the rise of democracy and the broadening of education.

As a more personal review of these historiographic issues, in the years I have worked in the Italian Renaissance, the general take on the period has changed drastically. In the early 1960s, when I went off to graduate school to become a modernist, the Renaissance, and especially the Italian Renaissance, was still in retrospect very much in the twilight of the nineteenth century. It had lingering associations with the Grand Tour and was still much in the shadow of people like Robert and Elizabeth Barrett Browning, or of Walter Pater, and, in art history, more immediately under the influence of Bernard Berenson, who helped to establish art-historical techniques of connoisseurship and attribution, which, although they may be neutral enough, and applicable to many fields, were in the case of the Renaissance intimately associated with the dealers and industrialists whose collections Berenson helped to form.

At the same time—I am still reminiscing about my own first studies— the Renaissance was "the age of humanism," a term understood in a fairly imprecise way as a concern with general humane values and confidence in human powers. By degrees, even among scholars of the Renaissance themselves, humanism was demystified to become the study of Greek and Latin, secular as opposed to clerical study, and humanists became ideologues, wordsmiths who served the interests of their patrons and masters in court. As art historians began to study patronage and art in its social context, they began to notice that Renaissance lords—even the Medici—used art as part of the exercise of their power, across the full range of possibilities

for moral or immoral action. More broadly, the whole idea of humanism came under attack from both the political right and the political left. In the academic world, many people in fact hold something like the humanist views that the right attacks as secular; nonetheless, on the left, the idea of humanism was rejected as inevitably exclusive, as ideological, covertly favouring dominant Western values. And so, something like the Renaissance of the pre-Raphaelites with which I was first presented gave way to a dis-abused view of the period like that to be found in one of the recent books on the period. There, Florence was the birthplace of the first secret police, a kind of urban proto-panopticon, one of the first scenes of the pessimistic vision of the modern capitalist world as a culture of anxiety and surveillance (Trachtenberg 1997).

Whatever explanations, sanguine or sinister, might be given, the city of Florence, which continues to be central to the definition of the Renaissance, exhibited an extraordinary artistic and intellectual vigour in the fifteenth and sixteenth centuries, and it will be useful to examine some of the condi-tions for this vigour. Much Florentine Renaissance art was public, not only in being in public spaces but in the sense of being subject to intense public scrutiny—judgments which might include throwing rotten fruit at newly completed works. Renaissance art also took shape from the beginning together with what were called *intendenti,* people in the know, who under-stood what were called the "difficulties" of art. Today we might call them connoisseurs or amateurs, in the original sense of the word, which meant "lovers" of art, not professionals, not artists themselves, but people who made it their avocation to understand art, to recognize and know how to praise skilful foreshortening, harmony of colour or learned reference. Many of the values associated with Renaissance art grew up in late medieval courts; *intendenti* were typically aristocrats of one kind or another, and their understanding was another marker of status (Warnke 1993). Artists, however, were with very few exceptions not aristocrats, although they came to be regarded as important people. Biographies of artists began to be written in the fourteenth century, and we remember the name of many more Renaissance artists than of Renaissance nobility. In any case, a new critical audience was made up of people who understood the vari-ous animating principles and values of Renaissance art, the rules it was

following, the goals it was supposed to achieve. One of the reasons we know so much about Italian Renaissance art, and think about it, and can't stop thinking about it, is that so much was written about it by interested non-artists. At the same time, all of this activity had a mordant, practical critical side, often inseparable from day-to-day personal and professional competition and jealousies. The sculptor Donatello is supposed to have said that his work was less good when he was not in Florence, where critical discussion was ongoing and where he was constantly subject to the bite of criticism.

If there were new patrons and audiences for Italian Renaissance art, however, it is important that artists still worked in traditional ways, for churches, guild halls and for private devotion, and their new literary visibility makes them seem more modern than they were. This is another way of saying that Renaissance artists practised crafts closely related to the purposes of their communities, and a painting we praise as highly innovative might be a *Madonna* or an *Adoration of the Magi*, themes with long, more or less formulaic histories, which at the same time offered opportunities for continual invention. I understand that something similar holds true on the Northwest Coast, where artists create new masks and other works that may repeat or innovate upon conventional imagery and that nevertheless represent inherited family rights and function within community contexts (Ostrowitz 1999).

As I have remarked, Renaissance artists and writers admired and emulated Greek and Roman art, and this neoclassicism became "classical" and canonical. Perhaps, like "renaissance," the term "classical" may be understood more generally and more usefully by separating it from neoclassicism. Everyday language certainly allows us to do that, and those who praise "classic" films or "classic" automobiles can hardly mean to compare them in some way to the Parthenon frieze or the Apollo Belvedere. They simply mean that some consensus has been reached that the films and automobiles to which they refer are among the best of their kind. When Filippo Brunelleschi, one of the acknowledged founders of the Florentine Renaissance, wanted to recover the architecture of the ancients, he took as a standard the ancient buildings in Rome and Florence and measured them in order to determine what principles had governed their construction. Renaissance artists did not reclaim classical forms all at once; on the contrary, reconstruction and

interpretation (to the degree that these may be separated) were ongoing, accompanied by great works of art all along the way. Artists, scholars and patrons contributed over generations. Similar undertakings are to be seen in other times and places, and I think it is entirely legitimate to think of the reformulation of the principles of a "classic" Haida art as analogous. Bill Reid worked closely with Bill Holm (Holm 1965), and the "philological" project of reclamation has continued in the splendid work of Bill McLennan and Karen Duffek (2000). Such study is inherently both backward-looking and forward-looking; it is not antiquarian but is meant to reinforce and guide practices in the present, and to lay foundations in the present for a different future. As Robert Davidson has written, "We are now singing our traditional songs . . . there are only a few songs that have survived, but there are enough to set a standard from which we can compose new songs, as our forefathers did" (quoted in Thom 1993:20). In general, apprenticeship and oral traditions are essential to teaching the highest skills in any culture, but traditions assume another dimension, and another voice when they also articulate themes, aims and values both within and outside a culture, and when there is a community of people able to apply, explain and elaborate these principles.

In *Renaissance and Renascences in Western Art*, Erwin Panofsky (1969:84–113) introduced what he called a "principle of disjunction." The disjunction in question was the separation of form (or motif) and content. What happened, according to Panofsky, was this. After the collapse of classical culture, numerous classical forms persisted, but continued to be used and modified in response to new needs, thus assuming new content. In the Middle Ages, the ancient in effect became part of given nature, what came to hand for present purposes. Classical images might become Christian, their forms being filled with new content—Apollo, for example, becoming Christ. From time to time in the Middle Ages, there were what Panofsky called "renascences," revivals of a certain number of classical forms, as occurred in the Carolingian court. But a real Renaissance occurred, still according to Panofsky, when disjunction was closed, and classical forms were put back together with classical content. This marriage of art and philology took place in the late fifteenth century, and was the fruit of the labours of artists, but also of humanist scholars, who restored, translated and interpreted ancient texts. The question of form is

more complex now because form has been separated from representation and from iconographic motifs. Still, there may be a parallel. Much twentieth-century art—various kinds of abstraction and expressionism—has proceeded from the premise that form simply *is* content, and Bill Reid seems to me to have been shaped by this generally modernist idea. At the same time, he resisted the demand for constant innovation this idea may entail, and his turn to Haida art might be supposed first to have been an engagement with Haida forms *as* forms (Shadbolt 1998). By degrees, however, this clearly became an engagement with Haida content. Ultimately, Reid joined younger generations of Haida artists in attempting to bridge the gap between the contexts of modern art—galleries, private collectors and museums—and the ritual and social contexts to which earlier Haida art was integral. Both content and context raise the question of imitation, which was the subject of lively dispute in the Italian Renaissance, just as the question has been raised with respect to Northwest Coast art production. How strong should tradition be? If the ancients were most excellent, then, some in the Renaissance argued, they could or should simply be imitated; but others took another view, that an artist should study the best of the ancients and synthesize a new style from this study, like a bee making honey (Summers 1981:186–99, 279–82). "He who follows," Michelangelo is reported to have said, "never leads." This did not mean, however, that he left the ancients behind, but rather that, having mastered their forms, he used them both freely and deeply. It is thus possible both to follow and to lead, to engage the art of the past and to invent at the same time. (It might even be asked if simple imitation, like simple representation, is even possible.) An artist may imitate in this second sense and at the same time run all the risks of success and failure.

Imitation brings us around to the question of a sense of history, and of estrangement from a unique past, a crucial question for any discussion of a "renaissance." In the first place, enough people in the Renaissance thought they *were* in a renaissance to make this belief a reality. There was a high level of confidence among these people, and a sense of more or less common purpose as they addressed common problems and competed in mastering acknowledged skills. They did not have modern ideas about historical periodization, but nonetheless thought themselves to be in a new age, one

successfully linked up with their own vital past; and they appealed to much the same metaphors to describe the state of affairs in which they found themselves as were to be used by their nineteenth-century historians. To me it is still moving to read the dedication to Filippo Brunelleschi of Leon Battista Alberti's treatise on painting, finished in 1435, in which he writes that he had believed Nature to have grown old, but now finds himself in the midst of a world reborn, in which people are doing great works to rival the ancients (see Alberti 1972). Giorgio Vasari (1906), the first modern historian of art, who chronicled what he considered to be the rebirth of the arts culminating in the art of his hero, Michelangelo, wrote of *la rinascita dell'antichita,* the rebirth of antiquity.

To be aware of participation in a cultural rebirth is also to be aware that the immediate past is unlike the more distant admired past, which stands at a temporal distance, and the Renaissance has often been called the beginning of modern historical consciousness. But the metaphor of a "renaissance" points forward as well as backward. Anything alive might die, and if the arts were born in antiquity, and passed through the stages of life, they also died; if they are born again, they might also die again. Vasari's *Lives of the Artists* has a distinct valedictory cast, and, writing at the end of the centuries-long revival of the arts in Italy, he says that his book was meant not only to praise a great accomplishment but to record how such a rebirth might take place again, should the arts be lost again.

I am of course not in a position to say how the Haida might feel about their relation to their past, or about historical interruptions in the patterns of their lives and culture. If it is felt that these patterns were never really disrupted, then rebirth is a poor metaphor to characterize the renewal of art traditions; and if it is felt that they were interrupted, it is not necessary to suppose that this sense of interruption necessarily implies a sense of history like the one that has pervaded European culture since the nineteenth century. To me, this is a crucial point for discussion to which the idea of a renaissance may bring us, and in the light of responses to which the idea of a renaissance might be amended and enriched.

Toward such discussion, I will briefly address some of the ways in which a new historical sense manifested itself in the Italian Renaissance, during which people admired the classical past and imagined a near future based

on the reclamation of its best forms and practices. Panofsky argued that there was a precise parallel to be made between the Renaissance pictorial device of one-point perspective and the historical distance of Renaissance writers from the past they so much admired. Just as perspective put the world in focus but at a distance for a subject, so antiquity was not simply used in the present but, as a precondition of its being used, was placed firmly in the past; it became the object of archaeological and philological reconstruction, an enterprise extending to our own time; but it also became the stuff of dreams. It was precisely because it was understood to be real and different, but also placed at a finally unbridgeable distance, that antiquity could exert its fascination and its deep imaginative pull in the present.

I believe that by and large people in the Renaissance had a much different sense of history than we have; they did not think of it as messily but relentlessly progressive in the way we have come to think of it since Hegel and Marx. One of the corollaries of the contemporary faith in the future as a whole, which the idea of progress entails, is disillusionment with the past as a whole. From the standpoint of such disillusionment, there is little point in the study of history, beyond, perhaps, weeding it out of our imaginations once and for all. The Renaissance attitude was much more complex. We can learn from the past, according to the definition of the prime Renaissance virtue of prudence: the use of experience in the present for the sake of the future. But in order to do that, we must once again first of all understand the past and other places as different from ourselves. No Renaissance person would have argued, as we (Americans) are inclined to do, that simple unreflective participation in the present will bring about a better world.

In a certain sense, the Renaissance rejected the modern, or set about to refashion the modern. "Modern" is from the Latin *modus,* and to be modern in the etymological sense of the word means to do things as they are currently done. In the early Renaissance, the term "modern" referred to what had become the more or less pan-European Gothic style in art and architecture, and it was opposed to the antique or ancient style, which came to be thought more principled and rational. What impulse lay behind this identification with a distinctly absent past? This is a complex ideological question, but to my mind it has partly to do with what we now call "identity." The modern style, the prevailing style, was also the *Gothic*

style (as we still call it): that is, the style of the Goths, the barbarians (from the Greek word for those who did not speak Greek) who finally brought classical civilization to its end. Sometimes the Gothic was called the German style, even though it had spread from France. But the point is that Renaissance writers regarded the "modern" style as a *foreign* style, an imposed and unwelcome style.

The same conclusion may be drawn from another example. Italian painting of the thirteenth and fourteenth centuries was largely defined by Byzantine painting, called Greek painting in the Renaissance. If German architecture was regarded as fantastic and irrational, filled with stylistic faults to be avoided, Greek (or Byzantine) painting was considered stiff and artless, again filled with the fundamental stylistic errors against which the virtues of Renaissance painting—variety, grace, manner, lightness of hand—were very largely defined. When at the end of the fourteenth century the minor Florentine painter Cennino Cennini wrote that his master's master Giotto had translated painting from Greek into Latin, he meant that Giotto, whom we still place at the beginning of Italian Renaissance art, had replaced a foreign style with a native style, an indigenous style (see Cennini 2001). Italy had been the centre of the classical culture that began in *ancient* (not Byzantine) Greek culture, and it should be so again. Seen in these terms, even though Italy did not unite politically until 1870, the renaissance of classical culture may be seen as one of the first nationalist awakenings, establishing a pattern often followed since. According to this pattern, it is necessary that a nation (a word that, like "renaissance," comes from the Latin *nascor, nasci*, "to be born"), establish an indigenous culture in order further to establish its legitimate nationhood. This pattern is very complexly tied to the emergence of the modern idea of culture itself and involves language and literature as well as visual arts. Italian humanists were concerned with the reclamation of classical eloquence—that is, the true classical rules for prose and poetry—but they were also concerned with the vernacular and with what was called "vulgar eloquence." Major cultural foundations for the Renaissance were laid by the Italian works of Dante, Boccaccio and Petrarch. As another example of the relation between indigenous culture and nationhood, we might briefly consider the example of Mexico. When the Spanish and their Native American

allies levelled the Aztec capital of Tenochtitlan, the works left undestroyed were buried as a new civilization was constructed atop the old. Buried works, however, re-emerged as monuments of indigenous civilization together with the rise of national consciousness and identity in the nineteenth century. This pattern has been repeated in many examples in the emergence of nation states in the modern period.

If the past is understood to be at a distance, this means that for the Renaissance, classical antiquity was at least as much a dream as a reality. The centuries of philological and archaeological labour that began with Renaissance humanism, labours that have now reached near limits of precision, all lay ahead. When, for example, the ruins of the Golden House of the emperor Nero were found in 1480, painters were lowered by ropes into its rooms to look at the strange paintings that came to be called *grotteschi*. These painters did not even know that it was the fabled Golden House and had little idea of what the building might have looked like as a whole. This did not, however, prevent them from using their imaginations in lavishly completing this or any other ruin. The point to be taken from this is that the study of the past, and perhaps especially of the normative past, is as much an act of imagination as it is an act of reconstruction. And of course it is always an act of imagination and construction in the present.

I wish finally to touch on some issues that in turn touch on contemporary local disputes (O'Hara 1999). The Renaissance saw the beginning of the modern myth of the artist. The word "creation," reserved in the Middle Ages for the activity of God himself, began to be used around 1500 to refer to the work of poets and painters (Summers 1981:53, 205, 473, 495–96). Now we use the word all the time, referring to things like "creative salad ideas." But however thoughtless such phrases may have become, they are not unimportant; we still associate creativity with some originality whose origin is our selves, and moreover consider it to be the goal of education and self-realization. But this idea was just aborning in the Renaissance, and the association of art with personal vision and autographic execution is another modern idea with Renaissance roots. But Renaissance artists still worked in shops, with assistants, apprentices, other artisans and masters, in numbers varying according to circumstances. Thus, although the ideal of the artist as the maker of altogether personal works began to stir in the Renaissance, Renaissance

works of art of any scale were much more corporate, and primary credit went to what was called the "inventor," the one who thought of the whole thing and saw it through to its final form.

I would like to sum things up by commenting on the definition of the modern given by Janet Berlo and Ruth Phillips in their book *Native North American Art*. This definition has to do with the production of "works that function as autonomous entities and that are intended to be experienced independently of community or ceremonial contexts" (Berlo and Phillips 1998). The split between art bound to community or ceremonial use and art that was not had only begun in the Renaissance, and the "fine arts" and aesthetics were yet to be defined in the eighteenth century. Renaissance artists continued to make art for traditional religious and civic purposes, but they also made works as "art" for different patrons, or according to different patterns of patronage, generally what is now called secular patronage. A *Madonna and Child* in a modern museum has strayed much farther from its Renaissance patterns of use than a *Birth of Venus*, which was intended for refined delight from the beginning, for experience now public and democratic rather than exclusive and aristocratic. Traditional themes might be treated beautifully or in "difficult" ways, in which case they addressed two audiences, and it is an accomplishment for an artist to have made works that meet both modern and contextual criteria, which may actually augment one another.

WHAT WOULD A renaissance be at the beginning of the twenty-first century? We cannot expect to see the rise of the middle class again, or the rise of capitalism or natural science and technology, or the beginning of a new age of European expansion. All of those things have not only happened, they have irreversibly changed the world, which is not to say they have triumphed, only that new historical conditions have emerged within and against which future history must be enacted. And, sticking to my guiding idea of cultures as heterogeneous, I think we might isolate a few features of a renaissance as a cultural phenomenon apart from the historical circumstances that gave us the term. A renaissance is a time when people make good art, and do so with a sense of a past to which they feel vitally connected. A renaissance is also a time of cultural confidence, actual historical circumstances notwithstanding. Finally, a renaissance is a more or

less broad movement, the work of many people: writers, poets, historians, philologists and patrons, as well as artists. So to the question "Did Bill Reid begin a renaissance?" I would offer the following answer. He did his part. He made art that has earned a place in the contemporary world of art, based on principles that may serve both as the basis for the renewal of Haida tradition and as the basis of the more than aesthetic explanation of Haida art and culture to the world. The rest, I would say, is up to others, to other artists, students, critics and patrons.

These last remarks still bear the stamp of the idea of a renaissance as what I have called an ideal hermeneutic situation, in which the past is used in the present for the good of the future. If I had another hour, I would reveal myself to be an incorrigible admirer of the Renaissance, because many people then made wonderful, powerful, beautiful art. This art may seem very much of its period, which is distant, and strange to our eyes. But I believe it surpasses such historical definition and may address us even if we know little or nothing of its original circumstances. Bill Reid could have been a Renaissance artist when he said that we must study the *finest* works of our ancestors, but also have a deep appreciation of natural forms, geological, biological and human forms, thus to make art that is part of the world conversation about art and culture. To say that the art of Bill Reid brought about a "renaissance" is not to say that Haida culture was dead, it is rather to say that Bill Reid restored a great tradition of art making to a new, high level. If the term "renaissance" has its origins in Western culture, it is still some of the highest praise that that culture can give to another, and I suggest should not simply be rejected as an example of the oppressive imposition of an alien category. In my judgment, the Haida will be able to take continuing pride in Bill Reid's having made Haida art once again an art of national and international importance, just as they may take pride in—and debate—the inclusion of their poetry in the canon of world literature, as they continue to speak for themselves and for their ancestors.

ENDNOTE

1 See Kubler 1962:74: "We are now enabled to view fashion, eclectic revival, and Renaissance as related
 phenomena of duration."

Reconsidering the Northwest Coast Renaissance

by ALDONA JONAITIS

I N AN ATTEMPT to move forward on a positive, constructive path and abandon the limiting constraints placed in the past on Western art history, Andreas Huyssen (1995:34) suggests that "We need multiple narratives of meaning at a time when the metanarratives of modernity, including those inscribed into the universal survey museum itself, have lost their persuasiveness, when more people are eager to hear and see other stories, to hear and see the stories of others, when identities are shaped in multiply layered and never-ceasing negotiations between self and other, rather than being fixed and taken for granted in the framework of family, faith and nation." I believe now is the time, similarly, to rethink a major episode in Native American art history: the Northwest Coast renaissance. Often characterized as a rather sudden rediscovery of lost artistic heritage, the events of the 1960s should, instead, be understood within a historical context beginning decades prior to the renaissance that involved substantial contributions by non-Native individuals and institutions, that responded to the expanding global art market, that excluded numerous demonstrations of cultural continuities and that imposed a nineteenth-century canon onto twentieth-century art.[1]

A renaissance—literally "rebirth"—implies a death. We need to know what kind of death preceded that supposed rebirth. On the surface, the answer is evident: Haida artists between the end of the nineteenth century and the 1960s, unworthy descendants of their honoured ancestors, operated outside a dead artistic tradition. Artists had lost genuine comprehension of

the northern style, due in part to the breakdown of an apprenticeship sys-
tem (Macnair, Hoover and Neary 1984:85); a form of aesthetic "degeneracy"
reigned (Macnair and Hoover 1984:190), producing works that represented
"a low point in Haida art history"(Sheehan 1981:66). Peter Macnair, one of
the most knowledgeable connoisseurs of Northwest Coast art, provides an
eloquent description of this apparent decline: "The minor practitioners
who dominated the years 1900 to 1950 worked awkwardly and often with-
out training, and almost exclusively in argillite. Regrettably, promoters of
the commercial form continued to equate "argillite" with "art". . . [Argillite]
remained popular with collectors but when compared with nineteenth-cen-
tury examples, it was artistically and intellectually moribund" (1993:52).

Preceding that death is the *original* birth—the flourishing nineteenth-
century style that some judge the finest, most classic form of Northwest
Coast art.[2] Bill Reid, according to Alan Hoover and Kevin Neary (1984:186),
"was the first Northern artist born in the twentieth century to compre-
hend the formal rules of this complex intellectualized art tradition, the
principles of which had been lost." Reid produced works that adhered to
the stylistic conventions of nineteenth-century northern Northwest Coast
art that he and Bill Holm (1965) identified: unifying organization of primary
and secondary formlines; systematic distribution of ovoids, U forms and split
U forms; orderly application of conventionalized eyes, feathers and other
body parts—all utilized with restraint and symmetry to ensure a refined
and elegant product.

Reid's personal version of Haida artistic historical birth/death/rebirth
assumes the graphic form of a line through time. He places Haida golden-
age art on a high plateau. The trajectory plummets, with only a "large
bump" for Charles Edenshaw. A long flat line along the bottom indicates
the period of tourist art: "from that bottom level a few lines begin to stretch
upward again; one represents Reid, one Robert Davidson, one or two are
unnamed" (Shadbolt 1998:182). For Reid, a man of impeccable and very
high standards, even the renaissance produced just a few good Haida artists.

Let us extend time backwards from Reid's graph. The nineteenth-century
fluorescence of northern art was, in part, a consequence of interactions
between Native and non-Native peoples meeting in the "contact zone" of
trade. Although solidly founded on a pre-contact artistic foundation, the

codification of canon and exceptional development of the formline style occurred within the context of encounter and exchange. Thus, one might consider the history of Haida art as a cyclical flowing and ebbing of creativity and attention to canon within a dynamic transcultural milieu rather than a birth, then a death, then a rebirth.

Preoccupation with aesthetic perfection has characterized the discourse surrounding the renaissance and limited our understanding of the complexities of twentieth-century Northwest Coast art history. The term "renaissance"—a kind of metanarrative to which Huyssen refers in the quote above—controls how we perceive an assortment of facts.[3] No one could dispute that events of the 1960s resulted in exquisite art of significantly better quality than that of previous decades. Nonetheless, the standard representation of the Northwest Coast renaissance (birth-death-rebirth, stability-despair-celebration, purity-contamination-purity) adheres to the now discredited ethnographic trope that mourns the lost golden age of authenticity and the irreparable damage done to cultures accommodating to modernity. Because today we recognize the fallacy of essentializing Native cultures as traditional or acculturated, we should reassess the judgments of renaissance enthusiasts who grieve for a lost golden age while disregarding works actually made throughout the twentieth century.

Steve Brown (1998b:139) offers a more sympathetic assessment than Peter Macnair does of the Haida who carved argillite and silver for sale to the small tourist market: they "nonetheless did their best to continue affirming the explorative visions of their predecessors, to keep the stories, the techniques, and the joys of traditional arts and culture alive . . . unquenched by the limitations and restrictions that the outside world had either directly or indirectly imposed upon them." Brown (1998b:142–43) identifies the Haida artists working under these difficult circumstances: John Marks (1876–1952), Isaac Chapman, Daniel Stanley, Charles Gladstone, John Cross (1867–1939), Henry Young (1872–1950), Jim MacKay (1890–1945), Lewis Collinson (1881–1970), George Smith (1880–1936) and Pat McGuire (1943–1970), an artist whom Robert Davidson credits as a major inspiration (Jonaitis 1993:19). Because the stigma attached to "tourist art" has all but been demolished by the wealth of scholarship on commodification and Native art, we can appreciate, and perhaps even honour, those northern artists who, under difficult

circumstances, continued producing visual expressions of Native identity—canonical or not.[4] The notion of "renaissance," and the aesthetic improvement it implies, has overshadowed the cultural continuities evident on the Northwest Coast throughout the twentieth century. Artistic activity and creative expressions did not in fact die out during this period, thus representing challenges to the metanarrative of renaissance.

INTERVENTIONS TO COUNTERACT THE DECLINE
OF NORTHWEST COAST ART, 1920S–1950S

Mourning the collapse of Northwest Coast art and culture, and enthusiastically praising interventions intended to reverse this decline, predate the renaissance by decades. During the mid-1920s, archaeologist Harlan Smith worked with the Canadian National Railway (CNR) to repair and restore Gitxsan totem poles along its Skeena River route (Darling and Cole 1980). Newspaper coverage of this project substantiates the cultural demise while it transforms Smith into a hero. The *Vancouver Sun*'s story, headlined "Aboriginal Art Is Lost" and subtitled "Belated Efforts Being Made To Save Remaining Indian Totem Poles," recasts these carvings, originally intended as memorials to the dead, as tombstones for cultural extinction: "It might be said that the totem pole is the memorial of a people who are dead. Our Indians of today are being civilized according to the white man's definition of the word. Few of them can even read the totem poles that stand sentinel over their villages. Their father's ways are not their ways."[5] The image of demoralized, culturally impoverished Natives contrasts with that of benevolent, knowledgeable, and responsible white specialists: a story titled "Relics of British Columbia To Be Preserved" contends that "Skill and resources of the white man must be employed to restore and repair the finest examples of this Indian magic, if the best illustrations of the skill of these ancient people are to be preserved."[6]

Not everyone assessed these poles so positively. For C.F. Newcombe, the restorations painted with bright, gaudy colours and erected in straight lines rendered unrecognizable the poles' excellent sculpture. Artist Emily Carr criticized the poles for having "lost much of interest and subtlety in the process [of restoration] . . . [and having] the heavy load of all over paint

[that] drowns them" (quoted in Darling and Cole 1980:46). Wilson Duff (1952) later similarly assailed this and other restoration projects as aesthetically inferior.

After the Second World War, Canada embarked on an effort to develop a nationalist cultural policy that supported the arts and promoted a uniquely Canadian culture showcasing Native art (M. Bell 1993). The well-known roles played by the University of British Columbia (UBC) and the British Columbia Provincial Museum (BCPM, now the Royal British Columbia Museum) to bring attention to Kwakwaka'wakw art and introduce Mungo Martin constitute a major chapter in twentieth-century Northwest Coast art history.[7] In a pamphlet for the totem poles of Thunderbird Park at the museum, Provincial Anthropologist Wilson Duff (N.d.:29) describes the motivations behind this project: "It was decided to obtain skilled Indian carvers to carve exact copies of the best old poles, and some new ones, to replace the old exhibits and produce a permanent and representative outdoor display of this unique art for the benefit of future generations. By employing native craftsmen and having them work in public view in the park, the programme accomplished the added aims of keeping alive native art and providing a public educational attraction." Thus the museum, like the knowledgeable men involved years before with the CNR project, becomes the instrument of salvation for Native art.

With the success of Mungo Martin's first replications, Duff initiated projects to rescue other abandoned poles as he championed a rediscovery of lost artistic heritage. In 1953 and 1956, Duff travelled to Haida Gwaii to salvage poles. Bill Reid, who had accompanied Duff and become smitten by these deteriorating masterpieces, was hired in 1958 by UBC to replicate some Haida poles. Soon Reid was creating works that transcended the concept of replication and instead represented original artworks. Wilson Duff, a tireless champion of Northwest Coast art's artistry, wrote passionately of Bill Reid's UBC carvings:

> The poles of the Haida village in Totem Park . . . have still not received their due recognition as fine modern sculpture. To me, these are the clearest markers of the intersection: Haida art and

modern art, both at the same time. In these, too, the distinction
between "original" and "copy" loses all of its usual force. Bill
chose to combine, in varying measure, the roles of performing
artist and original composer. None of the poles is a simple copy,
although some are repetitions of older compositions, either those
salvaged from deserted village sites and stored as bleached and
fragile chunks in the shed in Totem Park, or others known only
from photographs . . . I remember the ruins in the rain on Anthony
Island in 1957, and Bill's adoration of the spongy remnants of
Chief Ninstints' frontal pole, and the care with which we saved
them. Bill's scaled-down interpretation of that fine pole, on the
front of the little mortuary house, was his overture to the concert
of modern Haida artistry in Totem Park (VAG 1974).

It is important to note here that Doug Cranmer (who has an essay in
this volume), a highly accomplished Kwakwaka'wakw artist, worked
closely with Reid on the UBC project, and should be given credit for con-
tributing to the creation of these masterpieces.

Unlike so much twentieth-century Western art that consciously breaks
with the past in its drive for original form and expression, Northwest Coast
art did remain conservatively grounded in its artistic heritage. In *Privileging
the Past,* Judith Ostrowitz (1999) demonstrates the centrality of copies in
Northwest Coast artistic culture and argues that far more meaningful than
the novelty of an image is its social or spiritual significance, the right to cre-
ate and display it, the prerogatives it embodies. An observer unfamiliar with
the subtleties of Northwest Coast art might easily judge Reid's poles as slav-
ish imitations of their models, confined by formal traditions and indifferent
to innovation. Indeed, this art, with its respect for the past, inspiration in
earlier works and avoidance of outright inventiveness, adheres to a long-
standing tradition. Despite this, Duff sought to position Northwest Coast
art alongside all other twentieth-century styles. Because he understood that
mainstream modernist art consciously aspired to ever-inventive works, by
defining Reid's carvings as original creations, Duff situated Northwest
Coast art more comfortably within a modernist context.

NON-CANONICAL ARTWORKS AMONG
THE GITXSAN AND SOUTHEAST ALASKAN NATIVES

In 1952, Wilson Duff visited Hazelton, Kispiox, Kitsegukla, Kitwanga and Kitwancool in order to survey extant Gitxsan poles. Taking as his baseline information from Marius Barbeau's 1929 *Totem Poles of the Gitksan,* Duff reports that eighty-two poles still stood (although some had changed location), twenty-one had fallen and were in varied stages of decomposition, and seven were nowhere to be found. His summary of Gitxsan art history presents a new version of the birth/death narrative. During their art's "golden age," from the 1850s to the 1890s, the Gitxsan raised fifty-three poles, but during its "dying" phase, 1890 to 1920, only eighteen. Yet despite Barbeau's prediction of the utter demise of their art, between the 1920s and 1952—that is, during and *after* the CNR project—the Gitxsan either restored or carved anew twenty-seven totem poles and hosted seventy totem pole–related ceremonies, a vivid indication of cultural endurance. Duff ascribes the increase in restorations to a desire on the part of the Natives to preserve their heritage, something they learned in part from the whites. During the last quarter century, totem-pole carving had begun to increase, representing, "in a very real sense, a revival of the native culture" (Duff 1952:26). Despite such optimism, Duff laments that few Gitxsan had the resources to sponsor more than one major potlatch in their lifetime and that the only carver active in the region, seventy-four-year-old Arthur McDames, "the last of the Gitksan carvers," was training no successor (1952:27).

According to this reading, while the Haida had lost everything with the death of Charles Edenshaw, the Gitxsan were *soon* to lose everything. And in certain ways they had already lost everything, because the art they produced was inferior; regretting the decline in nineteenth-century aesthetic standards, Duff criticizes more recent poles as "weak copies of the old poles, poorly conceived, skimpily carved, and brightly painted" (Duff 1952:22). In 1958, Duff had several surviving Kitwancool poles transported to Victoria and properly recarved, under supervision, by non-Gitxsan (see Duff 1959a). Judged by Duff to possess limited skills and lost artistic knowledge, the Gitxsan were denied the opportunity to replicate their own historic carvings. Margaret Anderson and Marjorie Halpin (2000:41) suggest that, in taking these decisions, Duff saw these poles only from an aesthetic

perspective, because for the Gitxsan, "a pole is a carrier of social, spiritual, territorial and economic rights and privileges. This is not to say that individuals do not see or respond to aesthetic form, but only that it is not what totem poles are about." Duff did recognize the social significance of the poles but felt that this, like everything else in the region, was rapidly disappearing: "The artistic and mythological heritage of the Gitksan has almost completely slipped into the past . . . Most of the traditions have been forgotten; few owners of poles can explain all the figures carved on them" (Duff 1952:24).

Duff actively promoted quality in Northwest Coast art. In 1969 Jane Wallen, Director of the Alaska State Museum, asked Duff in the role of "Research Associate of the Smithsonian Institution," and Joe Clark, a wood pathologist at the U.S. Forest Products Laboratory, to help her survey southeast Alaskan totem poles. In the 1930s the United States government, as part of the Indian Civilian Conservation Corps (CCC) of the New Deal, had sponsored the retrieval of numerous poles from abandoned southeast Alaskan Tlingit and Haida villages, and their restoration or replication and re-erection in more populated areas (Jonaitis 1989). Unlike the accounts of the Skeena River project, which ignored the Native artists who actually restored the poles (however badly), individual Alaskan artists emerged from anonymity, in part because this project, administered by a government bureaucracy, required a hierarchy of head carvers to supervise teams of subordinates. These "bosses" became known beyond their villages as totem-pole carvers: Jim Peele of New Kaasan, Tom Ukas and John Thomas of Wrangell, Charles Brown of Saxman, George Benson of Sitka and John Wallace of Hydaburg.[8]

These CCC totem-pole project supervisors worked with teams of young, unemployed men still subject to considerable discrimination and for whom celebrating Native heritage was a novelty. Linn Forrest, administrator of the U.S. Forest Service which oversaw the project, describes the effects that older artist role models had on these young men:

> The object was to put people to work . . . It was certainly logical;
> they had the timber and knowledge in that respect . . . I just think
> the whole program was a wonderful thing for them . . . The head

men, the heads of these projects in various areas, were respected
in their communities and they were boss. I think the rest of the
people had a lot of respect for them—the workmen that is. I think
it did an awful lot for the younger fellows that were part of the
program, too. It gave them an interest back in their history that
they probably would have lost . . . These fellows were proud of
their work; these meant something to them—I think much more
to them after we started the project than it ever did before. And
they would, of course, bring out . . . they had all kinds of relics and
things stashed away. Like a Haida eye was shaped different than a
Tlingit. Just a lot of things they knew (Forrest 1971:9, 11).

Unfortunately, World War II arrested this momentum of Native artist
training which had the potential to develop into a major economic and
artistic presence in Alaska.[9] For almost thirty years the poles stood in
totem-pole parks, viewed with uncritical enthusiasm by the growing num-
bers of tourists travelling north along the Inside Passage (Jonaitis 1999).

Duff edited, and doubtless wrote, the majority of the final report,
"Totem Pole Survey of Southeast Alaska: Report of Field Work and Follow-
up Activities, June–October 1969," a thorough study of all Alaskan poles
still *in situ* as well as in cities, parks and Native communities. He criticizes
the quality of the ccc poles, which, during the Depression, offered such
pride to Tlingit and Haida. The document contains technical advice on
conserving the totem poles of the region and a discussion on "The Artistic
Use of Paint," which bemoans the many layers of paint that have covered
so many restored poles: "It is difficult to understand why even the earliest
restorations, at Sitka and elsewhere, were painted so garishly . . . Whatever
the reasons, it became customary to cover restored and copied poles com-
pletely with paint, and a trend was established to use more and brighter
colors. The unfortunate results can be seen today in Juneau, Wrangell and
Ketchikan, Hydaburg and Saxman, and New Kaasan" (Duff, Wallen and
Clark 1969:85–86).

Duff then details the correct method of painting replicated or restored
poles "in more authentic and tasteful ways." Copies should be painted only
as brightly as they would have been (in the nineteenth century), then

allowed to weather and never be repainted. Since it would be impractical to remove all the paint from poles—although Duff clearly would have approved of doing so—in future no more paint should be applied, the current paint should be allowed to weather and, when appropriate, repainting done according to proper canons. The report lists formulaic "guidelines" for repainting Haida poles:

> Colors should be limited to a flat black, red, blue-green and white. Black was traditionally used for eyebrows, eyelids, and the large circular irises of the eyes . . . Beaks and the formlines outlining ears were also usually black. Red was used for lips, tongues, nostrils, and the inner parts of the ears. The hollows around the eyes were often blue-green. Teeth and the whites of the eyes were often painted white. In general, the painting should be kept as simple and bold as possible. To avoid the fussiness that obscures the boldness of the carving, no details should be painted in unless they are already outlined by carved lines. Bodies, foreheads, limbs and the long cylindrical hats should usually be left unpainted (Duff, Wallen and Clark 1969:87).

Tlingit poles, the report continues, were apparently more heavily painted, but not with the brilliant tones seen throughout southeast Alaska. "We can only suggest that a conscious effort be made toward a more restrained use of color, so that the poles are shown as works of sculpture rather than as the garish stereotype which has come to represent the totem pole in the popular mind" (Duff, Wallen and Clark 1969:88). Duff fails to mention that Tlingit and Haida men restored Alaskan poles, however poorly, during a moment of cultural resurgence during the 1930s. Once again, as was the case with the Gitxsan, this art, judged substandard, had no cultural importance.

Duff's appraisals underscore an indispensable aspect of this history: art that functions acceptably within a community may not intersect with art that connoisseurs judge acceptable. In the 1920s, the lamentation over the decline of northern Northwest Coast art had addressed the disappearance of an art tradition which whites had to rescue from oblivion. Duff's

laments concern art recently produced, but badly. By defining the "proper" type of Tsimshian, Haida and Tlingit art, he helps formulate a canon, laying the foundation for Reid's and Holm's analytic work on northern Northwest Coast art. It is ironic that concurrent with the reintroduction of northern Northwest Coast canons, historians of Western art began to contest the criteria upon which art was judged, the roles those criteria played in ascertaining market value, and the interconnections between canonical-defining connoisseurial activities and the wealthy classes. Whereas Western canons, according to these (literal) iconoclasts, embody patriarchy, racism and colonialism, Northwest Coast canons became central to determining quality of art, condemning Native work that did not measure up to uncompromising criteria.

WHY DID THE NARRATIVE OF RENAISSANCE
TAKE HOLD DURING THE 1960S?

Was the imposition of a canon that ensured the creation of "correctly done" art the sole prerequisite for a successful Northwest Coast renaissance? Had the war not intervened, might Alaskan Haida and Tlingit artists working on the ccc projects have become well known and perhaps influential to later artists? Could the Northwest Coast artists of the 1960s and 1970s have slipped into oblivion, as did the earlier Alaskan totem-pole carvers? All these artists, one could argue, participated in a kind of rebirth of cultural creativity and ethnic pride. Why did Northwest Coast art attain its favour and prominence when it did? The answers to all these questions, I suggest, revolve around the blossoming post-World War II art market. In its December 1955 issue, *Fortune* magazine announced that artworks were now first-rate investments and that living artists who represented "investments for the future" were best buys. While *Fortune* was considering contemporary mainstream art, its recognition of art as major investment was a necessary precondition for Northwest Coast art to flourish.

A major "art boom" between 1945 and 1980 stimulated the founding of new museums and corporate collections; galleries flourished as they promoted their favourite artists and sought out new talent. Artists could be exceptionally talented, but without the public exposure granted by museums, they would remain relatively unknown. Museums could make the

reputations of artists, as did New York's Guggenheim Museum in 1963, when Lawrence Alloway's *Six Painters and the Object* bestowed instant fame on those artists. The roles of museums had subtly shifted: "It's not . . . that [museums] provide space into which great art can be brought for display, rather that they confer 'greatness' on works by deciding to display them" (Frascina 1993:81). While the art scene in the Pacific Northwest was in no way as competitive and trendy as that in New York, or even California, the role of museums, universities and galleries in promoting Northwest Coast art during this "art boom" cannot be minimized. The University of British Columbia hired Bill Reid, along with Doug Cranmer, to create very public artistic statements.[10] In 1967, the Vancouver Art Gallery proudly displayed Northwest Coast art, including contemporary pieces by Reid, in what its organizers claimed was the first true *art* exhibit of these pieces, *Arts of the Raven*. In the 1960s and 1970s, all areas of Native American art began to achieve prominence in the art world. Northwest Coast art appeared alongside other First Nations artworks in the Whitney Museum's *Two Hundred Years of American Indian Art* (Feder 1971), the Walker Art Center's *American Indian Art: Form and Tradition* (Walker Art Center 1972), the Art Institute of Chicago's *The Native American Heritage: A Survey of North American Indian Art* (Maurer 1977), and the Nelson Gallery of Art–Atkins Museum of Fine Arts' *Sacred Circles: Two Thousand Years of North American Indian Art* (Coe 1977).[11]

The art market responded to the new attractiveness of Native art. Galleries in Vancouver, Victoria and Seattle began to specialize in Northwest Coast art, thus offering a willing market easy access to artists. New York "primitive art" dealers George Terasaki, Julius Carlebach and Marge Simpson began carrying larger amounts of Native American pieces (B. Bernstein 1999:60). To help inform the marketplace, *American Indian Art* magazine published its first issue in 1975.

Strong incentives existed for dealers in cities such as New York City and Los Angeles to seek out innovative men (and some women) who might become future Famous Artists or to "discover" art that had been thus far neglected: Amish quilts, Haitian sculpture, and, of course, First Nations art. Every time a type of art gains recognition, its value soars. The Northwest Coast market reflected the growing prominence throughout North America of art as investment, and the concurrent emergence of an elaborate selling

and purchasing culture. Enthusiastic consumers willing to pay significant sums for "traditional" Northwest Coast art developed, limiting its purchasers to museums and the very wealthy.[12] A niche opened for relatively affordable quality contemporary art, transforming the creations of Bill Reid and a small handful of other artists, most notably Robert Davidson, into major investments, with a concomitant elevation in value. Nonetheless, much art by other Northwest Coast Natives, especially prints, remained accessible to the more modest collector.[13]

THE ARTIST AS PERSONALITY

The art market thrives on personalities. Jackson Pollock became almost more famous than his works, as an impressive spread in *Life* magazine (8 August 1949) testifies. Irving Sandler, in *Art of the Postmodern Era* (1996:xxiv), comments that dealers and promoters worked so diligently to enhance artists' reputations that one had to "take into account as never before the workings of the market and hype, and to discount mercenary attempts to inflate the reputations of artists." To succeed in this world, artists sometimes cultivated entrepreneurial skills and acquired larger-than-life personalities, the most famed being the invention that was Andy Warhol. Art historian and critic Thomas Crow (1996:144) describes the 1966 New York City art scene at Max's Kansas City, a club that attracted rock stars and Hollywood celebrities as well as artists: "It was in this competitive fishbowl that artists had to establish and maintain a dominating personal aura, that is, if dealers were to be successfully cultivated, critics cajoled or intimidated, and fascinated collectors convinced that supporting this art offered an entree to flattering recognition and a share of the glamor themselves."

Sophisticated, cultivated and astute, Bill Reid presented himself magnificently throughout his lifetime, gaining recognition in the press, charming collectors, captivating curators, becoming a genuine luminary. His experiences as a radio personality certainly enhanced these achievements. His *The Raven and the First Men* was a favourite at the University of British Columbia Museum of Anthropology (MOA), while *The Spirit of Haida Gwaii* became an icon in both Washington, D.C., and at Vancouver International Airport. Hoover and Neary write in *The Legacy* (1984:186): "In this role, as connector, link, an active intelligence that has revived and carried

on a remarkable art tradition, Bill Reid's greatness is secure." The celebratory statements at his memorial service described a man whose personality played a large role in creating his aura. Barry Herem (n.d.) writes, "Bill Reid was widely honored in his life and . . . will certainly retain his renown not only because he was a significant artist but also because of *his personal charisma and star-power as an individual*" (italics mine). Herem's description of the ceremony conveys an almost religious intensity; the canoe bearing Reid's ashes was "set down amidst a host of overlooking totems" in the Museum of Anthropology; as the evening grew dark, "the great glass-sheathed and totem-filled museum hall glowed with the amber lambency of one of Reid's own golden creations." One needs only alter several words and this becomes a state funeral held within a Gothic cathedral.

While other contemporary Northwest Coast artists with similar gifts have achieved measures of fame and success, here, as in the rest of the international art world, those talented artists unwilling or unable to promote themselves and negotiate within the art-market system—or those without active and aggressive promoters—remain at a disadvantage. Let us briefly examine the case of Mungo Martin, who to be sure was praised by Wilson Duff (1959b) as "carver of the century." While some accounts of the renaissance do acknowledge Kwakwaka'wakw cultural resilience throughout the twentieth century, Duff characterizes Martin himself as "one of the few surviving authorities in the old ways of life," according him a rare and tenuous knowledge of his heritage which the museum is able to share with the public (Duff n.d.:29). It is rarely emphasized (though of course never denied) that in Thunderbird Park, Mungo Martin replicated not only poles of his own people but also, with his Kwakwaka'wakw assistants, two Gitxsan and two Haida poles.[14] He was also the principal carver of the Haida pole at the Canada–U.S. border crossing at Surrey, B.C., which is often described as Bill Reid's first venture into Haida carving. It is curious that this man, raised in a Native village and less than comfortable with English, is given little if any credit for the renaissance, despite the fact he seems to have been the first to actually carve properly canonical northern-style poles in the twentieth century. Thus, Martin appears to be relegated to the same neglected status as Haida workers in argillite and silver, Gitxsan pole carvers and Alaskan

CCC workers. Mungo Martin simply could not compete as did Reid in the glittering world of artist as superstar.

The market rewards those who function skilfully in it. Some may judge this commercialization of art as a decline into crassness, a corruption of true artistic creativity. But Tyler Cowen's *In Praise of Commercial Culture* (1998:1) argues that these very market forces propelled recognition of previously excluded creative styles: "The capitalist market economy is a vital but underappreciated institutional framework for supporting a plurality of coexisting artistic visions, providing a steady stream of new and satisfying creations, helping consumers and artists refine their tastes, and paying homage to the eclipsed past by capturing, reproducing, and disseminating it." This market certainly provided a space for Northwest Coast artists.

THE CACHET OF THE INDIAN
Northwest Coast contemporary art had little in common with abstract expressionism, pop, minimal art or other movements that achieved prominence. It appeared obscure to those who did not take the time to learn large amounts of ethnographic information. But Native artists, by virtue of *being* Indian, were acquiring a kind of cachet, and so was their art. By the late 1960s, modernism's utopian ideal of progress and perfectability had been eroding for some time. The third world interpenetrated the first world, forcing it to acknowledge its presence, recognize the legacy of imperialism and admit the economic impact of countries inhabited by people of colour. Protests against the Vietnam war in the United States, student uprisings, universal fears of nuclear annihilation emerging from the Cold War, and a general sense of alienation among those not part of "the establishment," contributed to a dynamic and politicized culture. The rebellious nature of the period led to extensive artistic experimentation and an unwillingness to adhere faithfully to a specific school, following dictates of authoritarian critics. New modes of expression abounded, resulting in earth art, neo-expressionism, installation art, graffiti art, performance art, happenings and many other hybrid forms that questioned the nature and limits of art itself.

Artists, eager to reject the dominance of the establishment, began looking beyond the Euro-American art scene for different forms of creativity.

Although so-called primitive art had been "discovered" several times, by Picasso, by the surrealists, by New York's Museum of Modern Art in 1941, by the abstract expressionists, it was only in the late sixties that the art world began to include art of the "other" more permanently within its domain.[15] Critics hailed Benin bronzes, Maori carvings and Bering Sea ivories as masterpieces. Art created by contemporary people of colour—African-Americans, Chicanos, Native Americans—became admired as visual expressions with substance, merit and social relevance by subjugated people. In this era of politicization and upheaval, art by people who had been shackled by colonialism and oppressed by racism gained prominence. Even Europeans took advantage of what they considered the superior ways of Native Americans. During the mid- to late 1950s, the French Lettrist International, a group of leftist revolutionary artists who objected to the rapid increase in consumer goods that threatened the very meaning of life, titled their journal *Potlatch* because they believed this Northwest Coast Native ceremony where goods were given away represented a similar disdain for possessions (Crow 1996:52).

The art of First Nations had an additional appeal for some. In the late 1950s, California artists embraced the rebellious San Francisco Beat culture with its mystical leanings and experimentation with psychotropic drugs. Their fascination with the Indian as Shaman became quite widespread in the 1960s, and translated into a wholesale revitalization of the Noble Savage, with First Peoples becoming the first environmentalists, the first American mystics, the originators of altered states of consciousness (Brand 1988). Those seeking new ways of seeing, learning and living became smitten with Native Americans, and books such as *Black Elk Speaks* and *The Teachings of Don Juan* became best sellers. Romanticizing and mythologizing stereotypes (which have been fully deconstructed in recent years) fostered new openness to First Nations artworks. The enhanced status of the Native, the art market which constantly sought fresh creations and the cult of the individual artist as celebrity together contributed to an environment in which a master such as Bill Reid could thrive (Jonaitis 1981).

WHOSE CANON IS IT?

The art market played a significant role in creating the space for a Northwest Coast renaissance. As any market requires standards to determine value, this

history includes the crafting of canons and championing of individual artists. The Institute of American Indian Arts (IAIA) in Santa Fe, New Mexico, offers intriguing parallels to aspects of the Northwest Coast renaissance. Although the institute fostered a kind of art almost diametrically opposite that of the Northwest, in both cases forces external to the Native community adjudicated quality and championed certain types of art.

Joy Gritton's (2000) provocative and thoughtful history of the IAIA describes how, in the early 1960s, the Rockefeller Conferences supported a University of Arizona program designed to steer young Indian artists away from "traditional" modes and encourage styles more appropriate to contemporary mainstream art. Lloyd Kiva New, a Cherokee artist, enthusiastically promoted creativity and individual expression: "Encouraged to test new media and to experiment with new methods we may expect Indian art to flourish only in proportion to its validity. This validity would contain truth of expression based on tradition, but not necessarily limited to it; it would involve true creativity, and not slavish reproduction of old Indian form" (in Gritton 2000:46). The University of Arizona program led to the establishment of the IAIA in Santa Fe, founded on the "canon," if one might call it such, that modernism was incompatible with "traditional" Native cultures and art. The catalogue for the school's *First Annual Invitational Exhibition of American Indian Painting,* held from November 1964 to January 1965, uses the word we have been discussing in this essay, although with a different connotation: "Beginning in the late 1950s, and more especially during the past several years, Native American art has experience [*sic*] considerable revitalization through a wide-spread *renaissance* of interest in experimentation with both media and new forms of expression . . . The invitational section of the exhibition which includes the work of several recent Institute students, vividly reflects the new experimentation and invention now at the command of Native American artists" (Gritton 2000:111, italics mine). Although Native instructors worked with the young IAIA students and Lloyd Kiva New served as art administrator, Gritton argues that the school's educational model was colonialist in that it embraced the modernist aesthetics and commercial values of the Anglo world, steering young artists away from their heritage and toward an internationalism prevalent at that time (Gritton 2000:154).

On the surface, the Northwest Coast renaissance differed considerably from IAIA's "renaissance," as it promoted rather than discouraged adherence to tradition. Nevertheless, Gritton's post-colonialist analysis of the Santa Fe school's agenda, and the strong presence of non-Native values within a Native organization, suggests that we look at events farther north from a more critical perspective. The narrative of Native people submitting to acculturation but then encountering a knowledgeable saviour or saviours of their art dominates representations of Northwest Coast twentieth-century art histories, from Harlan Smith's involvement with the Skeena River pole-restoration project, and Wilson Duff's directing of the Haida and Gitxsan programs and critiquing of Alaskan CCC poles, to Bill Reid's formulation of northern two-dimensional Northwest Coast style. And most often, that saviour is not a Native. Indeed, the *only* Northwest Coast First Nations individual included in this aspect of history is the cultivated, polished and sophisticated Reid, who connected to his Haida heritage only in adulthood.

With the insights provided by the passage of time and perspectives acquired from critical reassessments of histories, we should reconsider the constraints imposed upon us by the renaissance metanarrative, which omits references to the continued life of twentieth-century Northwest Coast art, ignores the major roles played by non-Native experts in the invention of the renaissance and overlooks the influence of the art market. It should be more overtly acknowledged that the intervention of authoritative experts, most often associated with museums, authenticated genuine Northwest Coast art and dismissed what they judged as substandard. Those same experts identified, endorsed and confirmed the very existence of the Northwest Coast renaissance. With intriguingly complex and interconnected roles, Bill Reid operated as both an expert who authenticated good art and as an artist whose works became archetypal for the renaissance. A Northwest Coast Native art history focussing solely on Bill Reid and those whom he influenced would be not only inadequate but fallacious, for this history embraces more stories, involves more diverse players and extends beyond the geographic boundaries of the region.

During the 1960s, Northwest Coast art underwent one of its many metamorphoses, in keeping with the ebbs and flows that have characterized

its complex history of contact zone encounters. However one character-
izes and analyses the events of this period, their consequences are
undeniable. The larger culture accepted, legitimized and celebrated
Northwest Coast art in part as a reflection of itself, creating space for new
generations of Natives to strengthen their cultural continuum and provid-
ing opportunities for inventive young artists to practise on, and innovate
from, earlier artistic statements. Of course, counteracting these positive
aspects of the renaissance was its unfortunate dismissal of Northwest
Coast artists whose artistic expressions diverged too far from, or became
too independent of, that canon. Even today, Northwest Coast artists often
feel the constraints of tradition if they attempt a level of creativity thought
by communities or critics to be unacceptably innovative. To construct a
more legitimate history of Northwest Coast art, we must challenge the
metanarrative of renaissance and incorporate multiple narratives so that
we may more thoroughly appreciate and understand *all* the creations of
Native people who, functioning in a world considerably different from that
of their ancestors, express a unique cultural and artistic identity. Bill Reid,
prominent as he was, represents but one of many threads in this history.

ENDNOTES

1 For discussions of this "renaissance," see Vastokas 1975; Blackman and Hall 1982, Ames 1992:59–60,
 83–86.

2 See, for example, Macnair 1993:51.

3 This is not unlike James Clifford's concept of "ethnographic allegory" put forth in *Writing Culture*
 (Clifford and Marcus 1986).

4 In the catalogue for *Robert Davidson: Eagle of the Dawn,* Davidson's historic exhibition at the
 Vancouver Art Gallery, I wrote an essay on Haida art that analyses twentieth-century work from
 this perspective (Jonaitis 1993). For literature on tourist art, see Phillips and Steiner 1999.

5 *Vancouver Sun,* 6 December 1925.

6 *Vancouver Sun,* 15 January 1926.

7 Mungo Martin worked at the University of British Columbia from 1949 to 1951 and at the British
 Columbia Provincial Museum from 1952 to 1961.

8 Thanks to the research of Robin Wright (2001:313–18), we have a good deal of information about
 John Wallace (c. 1861–1951), who shared his Native name, Giaduda, with his grandfather, a great
 Kaigani carver. Although encouraged by his family to become an artist, Wallace, by no means a tra-
 ditionalist, chose to become educated and abandoned carving. He was over seventy years old when,
 in the 1930s, others began recognizing him as an accomplished artist. In 1931, United States Secretary

of the Interior Ray Lyman Wilbur commissioned Wallace to carve two small poles for his office. Six years later, he carved a large pole for a cannery at Waterfall, Prince of Wales Island. By the time the Hydaburg CCC was being structured, there was no question who would be head carver. Later, Wallace, now a well-known artist, travelled to San Francisco for the world fair's Indian art exhibit and to New York City for the *Indian Art in the United States* exhibit.

9 For more on the activities of the United States Government in promoting Native art during the Depression, see Schrader 1983.

10 At this time, the University of British Columbia Museum of Anthropology consisted of a suite of rooms in the library basement; the Arthur Erickson–designed building had not yet been constructed. While Harry and Audrey Hawthorn co-ordinated aspects of the project, the university initiated it and displayed the houses and poles at Totem Park until they were moved to the museum's grounds in 1978.

11 This exhibit opened in 1976 in London and the next year in Kansas City.

12 John Hauberg, for example, amassed a major collection of Northwest Coast art which he eventually donated to the Seattle Art Museum (Brown 1995).

13 See Hall, Blackman and Rickard 1981 and Duffek 1983a for two "guides" to purchasing Northwest Coast art.

14 For information on Mungo Martin, see Duff 1959b and B.C. Indian Arts Society 1982.

15 It was also once again discovered in 1984 with the *Primitivism in Modern Art* exhibit at the Museum of Modern Art in New York (Rubin 1984).

"Other-Side" Man

DOUG CRANMER

*Between 1958 and 1962, 'Namgis carver Doug Cranmer worked with Bill
Reid to complete the six poles and two plank houses that now form the
Haida village complex outside the University of British Columbia
Museum of Anthropology. Reid recalled his partnership with Cranmer
in these words, published in 1976: "Nobody, I'm sure, including me, could
have influenced Doug one iota in any direction. He was his own man and
always has been, and he reluctantly carved Haida style for three years
and did a really good job of it. But he stuck to his own approach in his
work; and if he learned anything in that period it was just improving his
technique. He retained his own style, which he still does" (Maranda and
Watt 1976:34).*

O NE NIGHT, there was a phone call from Bill Reid. He was a total
stranger to almost everybody who didn't listen to the radio. He
asked me if I wanted a job. This was in 1958. That was the beginning of my
carving career.

I arrived in Vancouver and we started to work. At the beginning—
Christ!—we were just a couple of bloody greenhorns. I didn't know what
the heck we were doing, and neither did Bill. To this day, I'm still curious as
to how this guy who had never carved anything in his life got this job. Bill
didn't know anything about tools to begin with. He was worse than I was.
He didn't know how to run a chainsaw. I knew woodcarving, but just small
carvings. The Haida thing was different. I had no idea what it was all

about. I thought it was going to be the easiest thing in the world to do—I
figured it would be like carving one big freakin' plaque. I sure found out
different: after we got into it, there was more shape to those poles than I
figured. Yeah, that's something I learned about a Haida pole.

We were using photographs of old poles and copying the fragments of
Haida poles, using the actual pieces exactly as we saw them because they
were right there at the University of British Columbia (UBC). We copied a
mixture of the old pieces, using callipers and other measuring tools of
Bill's to transfer measurements from the originals to ours. We weren't
doing anything but copying the things we saw. I don't know—the poles we
did might have been the last very close copies of Haida poles ever done.
There were other people carving Haida poles at that time, but they were
really nothing like old-style Haida poles at all.

I read somewhere that Bill was teaching me which end of the adze was
"work." Bill didn't show me how to handle a tool, ever. I had learned every-
thing from Mungo Martin. Mungo taught me how to carve designs: how
to design something. He didn't have to say anything—he'd just come
around and take it out of my hands. Bill had spent some time with Mungo
too and learned how to use the tools, I think. I showed him how to move
wood, that's about it. Most of the time we worked together, I ran the
chainsaw. You can look in the archives at the pictures: 99 per cent of the
time I've got a chainsaw in my hand (figure 19).

Agronomy Road used to run right to our carving shed before they built
the university residences. There used to be a couple of tour buses every
morning. Bill would let the people in and walk them around. They'd
always ask me the same questions, and I wouldn't give very good answers.
"How long is it going to take?" "Is this the right way of doing things?" "Are
you supposed to use a chainsaw?" You'd have an adze in your hand, you'd
have a log that's beginning to look like a totem pole, and people would ask,
"What are you doing?" I used to hate having to work there, in public view,
on these poles. Godfrey Hunt used to work with me; he'd say, "Let's speak
Indian all day today." And that doesn't work. I'd crank up the chainsaw just
for the hell of it, to get rid of them.

The first pole that we carved was the small mortuary-house frontal
pole. That damn thing was so rigid. Bill maybe knew what the heck the pole

was supposed to look like, but he'd never carved one. We kind of loosened up with the designing as we went along, but then I'm not an expert in Haida carving even now. I can't say anything more about what we did. We just carved the poles and that was it.

Before we started carving the poles, Bill came up with this idea that you've got to forget everything that you ever learned about carving from other people, because we're going to do it his new way. Herman Collinson was there too; Reid had brought him down from the Charlottes as a helper. We sat and listened to what Bill had to say. Bill took a whole length of brown paper. He had blocked it off and drawn what was going to be on this pole—exactly, as to what he thought. We said okay. We had this log all rounded off and we stuck the brown-paper drawing on there. He said, "Okay, every time you cut out the line, you take the template and stick it back on, and then draw it back in. Never lose the line." I said, "I don't think it's going to work, Bill." After a couple of whacks at it, you know what the hell's going to happen with this thing: the more you hack away at the wood, the smaller it's going to get. All of a sudden the paper isn't going to fit anymore. That's when I found out that Bill had tantrums.

So we went back to the way we've always done it, the way that works: looking at what you're copying and not doing it on paper. But Bill still took a long time getting down to what these damn things were going to look like. He'd sketch, then he'd make a paper model (figure 20), then he'd do a clay maquette of each pole, and then he'd make a little bigger one, and then he'd scale it up again. He measured everything to scale. He's a great, wonderful artist doing models and then scaling it up. This is something I never do. I think it's a waste of time. But we sort of got along after that. He stayed on his side of the pole and I stayed on mine. He went up the right side; I was the "other-side" man. And I did that with all those poles. I just went up the left side like a machine, doing exactly the same thing Bill was doing. I also did the left side of any figures that were on the right.

Besides the poles, we also carved two figures of a Wasgo and a Bear. There was a little wolf carving by Tom Price that we copied for the Wasgo figure, but we never got anywhere near what that little thing looked like. We ended up with a great big blob compared to Price's carving. But then, all I did was carve. Bill Reid was the designer. He was nuts about it.

With the Beaver pole, Reid worked on his own because he wanted to use the adze to finish it. I believe that Haida poles were adzed at one time—some of them were. They weren't all smooth. The only thing in UBC's Haida village that Bill adzed was the Beaver pole; this was really his debut. It was no great adze job, but he did it.

Yeah, that was the last pole we did: the Beaver. The Beaver figure itself is a separate piece of wood altogether from the upper part of the pole. I was hacking away at the inside of that thing; I had my feet in there with the adze coming between them. One morning I severed my tendon. I walked over and said, "Hey Bill, I think I really did it this time." That was the end of that carving project for me, really. One afternoon they had a bunch of people from the art school come to paint the poles. It didn't take any time at all because there was hardly any paint on them. But I missed all that—I was in the hospital for five weeks, I guess. I had enough of Bill by then, anyway!

I always look for the easiest way, the quickest way. Soon after I finished working with Bill Reid, I started making changes in my own work, taking out an awful lot of things that Mungo said were supposed to be included in a design. I did it more and more. I was looking at everything: Tsimshian, Haida and other styles. I picked out Tsimshian designs that I liked, Haida designs that I liked, and just added them to the designs I was doing. I started this very early, pulling things out of the air. After a while, people were recognizing my work without having seen a signature. My work wasn't Kwagiulth any more, it wasn't Haida. It was all really Doug Cranmer's now. That's when I started carving for a living.

In the early days, we weren't measuring everything up to make sure it was exactly symmetrical. We weren't fanatical about symmetry. The old carvers, I think, they just eyeballed everything, with only a bit of measuring. Mungo wasn't pushy. Even if it was a little off centre, he said it was okay. It wasn't the wrong thing to do. It was Bill Holm and Bill Reid, I guess, who set rules. After Bill Holm's book, *Northwest Coast Indian Art: An Analysis of Form*, came out in 1965, all of a sudden we had a right and wrong way of doing things, which had never happened before.

Without Mungo, this whole "revival" thing never would've happened. It was always Mungo. That's how the revival began. But now the story always seems to begin with ol' Bill. Bill was a very intellectual guy, you

know. He had some pretty uptown friends: a lot of people in places like the museum, the CBC and television stations. He was known already, not as a carver, but as Bill-Reid-who-was-once-a-radio-announcer. He could talk art—any kind of art. He was a jeweller who was better than most. But as for being a carver, I never thought Bill Reid "revived" a damn thing. I don't think that he had anything to do with the bringing back of the carving. Mungo had already done that. When Bill did something, he did it for himself. All Indians were dumb to him, at the time. It took Bill three and a half years to learn to carve. All the time it took us, somebody else would have done three times as many poles. And where would he have been without the opportunity that the university provided?

When people asked me, "Did you work with Bill Reid?" I used to reply, in fun, "Yes, I taught him everything he knew."

ENDNOTE

Compiled and edited by Karen Duffek and Charlotte Townsend-Gault from personal interviews with Doug Cranmer in 2001 and 2002, and from interviews recorded by the late Rosa Ho in 1994 while Cranmer was artist-in-residence at the University of British Columbia Museum of Anthropology.

Memories of Bill Reid: A Most Unlikely "Indian"

by KI-KE-IN (RON HAMILTON)

IN GRADE FOUR, my teacher, in a rare moment of kindness, allowed my class to watch a film about a crew of white men saving totem poles on the Queen Charlotte Islands. The film's narrator spoke in a sonorous, engaging, almost hypnotic voice. For the duration of the film, it seemed nothing else in the world mattered as much as those rotting Haida poles. Of course, the narrator of that long-ago film was Bill Reid: Bill projected that kind of authority when speaking about his favourite subject, the great works wrought by his maternal ancestors, the Haidas of old.

Bill helped to organize the Vancouver Art Gallery's exhibition *Arts of the Raven: Masterworks by the Northwest Coast Indian*, which opened in 1967. He helped to select the wide array of old and contemporary material included in this major show. The show did not feature a single Westcoast[1] piece, and so I felt Bill was rather prejudiced in his judgment and the show incomplete and somewhat of a failure. Years later, when we met, I raised the issue with him. He said something like, "Westcoast things are really difficult. They exhibit so much freedom, so much variance in detail of form and individual style, and so many colours. In fact, Westcoast stuff is much harder to understand. Some of it is just crazy! I've seen some very nice very early Westcoast things in Europe and some nice later stuff scattered here and there, but it just seems to be a whole other thing. That's why we decided to leave it out of the show."

As much as I wished that the show had included at least a few good things from my homeland, I agreed with Bill's sense that Westcoast stuff

did present a problem. Inasmuch as there are basic general principles of design that underlie old Westcoast material, and inasmuch as there are forms common to both northern and Westcoast painted and carved designs, the two are related. At least in my mind that relationship deserves to be looked at and understood anew. Looking back on that time, I realize Bill was only one of the organizers of *Arts of the Raven* and cannot be held responsible for everything about it.

IN 1968, WHILE I was at the Institute for Adult Studies in Victoria, I used to visit Thunderbird Park as often as possible. Soon, I was working as an apprentice under the master Kwakwaka'wakw carver Henry Hunt. Henry was renowned for the seemingly endless stream of high-quality model poles, masks, and full-scale poles he produced for the commercial market and for institutional and private collections. Henry was also known among a close circle of relatives and friends as a master raconteur. He loved to recall his early days at Thunderbird Park when he and his father-in-law, Mungo Martin, produced so many big poles.

Once, when Henry was finishing the last details of a small face on the memorial pole to be raised in honour of Mungo, he recalled another little face on another pole. He talked about how Mungo had been instructing Bill Reid in some of the basics of pole carving, when Bill smarted off about the greatness of all things Haida. They were the greatest traders, the greatest carvers and the greatest warriors. Henry chuckled as he recalled how Mungo reacted to Bill's arrogance by telling the story of Gitaxaan, a famous Haida warrior, captured by Mungo's Kwaagyuulth[2] ancestors sometime in the latter half of the 1800s.

> During a Haida attack on the Kwaagyuulth village at Tsaaxiis, their war chief, Gitaxaan, was captured and enslaved. Predictably, his captors found every possible excuse to use Gitaxaan for the rudest manual labour. Local warriors enjoyed Gitaxaan's humiliation. Mungo relished the fact that even the youngest children playing on the beach took part in degrading the great Haida warrior.
>
> One morning bright and early, a group of young boys were about to begin playing at war, when, much to their surprise, they

saw that their "war canoe" was missing. Their "war canoe" was a dilapidated and much cracked little duck-hunting canoe filled to within inches of its gunwales with sand. It had no thwarts and had long since seen its last days in the water. Shortly afterward, someone noticed that Gitaxaan was missing, and one of the chiefs realized what had happened. He issued muskets to the young boys on the beach, allowed them to take his big canoe and encouraged them to pursue Gitaxaan. He could only be headed north toward his home.

The boys piled into the canoe and began paddling frantically. Soon enough, they spotted a small canoe with a single paddler. It was Gitaxaan. When the famous warrior saw the boys drawing near, he turned toward a little island and stepped up his own pace. The boys began to fire at him, with most of their shots missing him. However, at least two times, the boys heard their musketballs hit him, and they saw blood running down his back.

Very quickly, Gitaxaan beached his canoe on a little rocky island and ran up the beach. When the boys landed, they could see no blood but followed his footsteps into the bush. Soon they had lost any trail of Gitaxaan and they adopted a strategy for finding him, lining up and moving across the island in an orderly fashion, combing every nook and cranny. Suddenly, one of the boys began hollering and pointing up into the tallest tree on the little island, and the others rushed to congregate beneath the big spruce. There, near the top, was Gitaxaan, curled around the trunk of the tree and resting on one of the branches. They began firing and laughing when they hit him. In the end, of course, they ran out of shot and simply had to wait. Gitaxaan died and fell out of the tree. It was then the boys learned why he had left no blood trail running up the beach. He had been chewing wads of cedar bark, and several of his wounds were plugged with that material.

Henry enjoyed telling this story so much that when he was finished, he shook all over, and his deep rumbling voice was something to hear when

he laughed. He seemed to enjoy the fact that Mungo in turn had almost doubled up laughing when he told Henry the story. Amongst these people, three generations from Mungo, this story was perhaps more hilarious than it had been originally, and I wondered if Bill knew how much fun he had provided us all through his innocent arrogance.

DURING MY TIME at Thunderbird Park, I ran into Bill, who had by then acquired massive stature, a number of times. He always asked what I, an apprentice carver, was working on and showed a sincere interest when I answered him. During one of these exchanges, in the breezeway between the curatorial tower and the main display building, I showed Bill a small print I had just completed. He showed me a series of prints he had just finished and suggested we trade. I was pleasantly surprised when he offered to trade straight across, one of his large prints for one of my small ones. Bill was more interested in developing a respectful relationship with me than he was in the disproportionate monetary value of the exchange, and this endeared him to me. This incident also showed me that Bill in fact wasn't prejudiced against all things Nuu-chah-nulth as I had thought during the *Arts of the Raven*.

An interesting aside to this little story is that, during the course of our conversation, Bill said something I thought was quite remarkable: "I don't really like doing prints, but when I need money I can make a set of prints quickly, and it's just like printing money."

IT WAS DURING my time at the British Columbia Provincial Museum (BCPM, now the Royal British Columbia Museum) that I became aware of the fact that, over the years of his career as a jeweller, Bill had changed his signature that appeared on the inside of the bracelets he was engraving. I saw an early bracelet he had signed, in large capitals, "HAIDA ART"—and underneath, in a much less important-looking font and in much smaller lettering, "Bill Reid." Years later, I noticed the pieces were signed "Bill Reid," then simply "Reid" in a fluid script resembling handwriting. It seemed to me that Bill had at first pre-empted any queries about his "un-Indian" looks by shielding himself with the Haida banner. Later, when he

had gained some fame, he downplayed the Haida connection, and then dropped it completely. In the end, his signature was like a brand name or a logo for a popular cologne or soft drink: one short word—Brut or Coke.

IN 1971–72, THE BCPM mounted *The Legacy,* its first major show of contemporary Northwest Coast carving, jewellery and painting. I was honoured to have several pieces of my work included in the show and went to the opening to hear what Bill had to say. I was a bit taken aback when he said, "I must be the most unlikely Indian in the world, but I do have the proverbial drop of Indian blood in me." It seemed bizarre to me that a man whose stature owed much to the patronage of wealthy non-Natives and whose public persona was so inextricably linked with the label "Indian" should all but declare that he wasn't Indian. Bill then went on to provide in his opening comments the historical and intellectual context for the material in the show. As always, Bill confounded others' views of himself by speaking honestly about his personal confusion regarding his relationship with his Haida relatives.

DURING THE EARLY 1970s, on a number of occasions, I spoke with Roy Vickers about forming an organization to help young up-and-coming students of Northwest Coast design, jewellery and carving. By 1980, the Northwest Coast Indian Artists Guild was officially established and was selecting its second collection of limited edition silkscreen prints for gallery release. The selection jury included Bill.

When the suggestion was made that someone begin the process by putting a painting forward, I gladly went first. I had a suite of five paintings and propped them up one next to the other. Bill quickly commented that he liked two of them a lot, then, after a pause, that the rest struck him as reminiscent of cartoons. One after another of my fellow guild members echoed Bill's analysis with comments such as: "I agree there is something about these three that is cartoon-like" and "I couldn't agree more with Bill, these three are kind of cartoonish" and "Yes, they are cartoony, there is something Mickey Mouse about them." Bill interjected, "I don't mean to interrupt, but I should make clear when I said 'cartoon,' I didn't mean it in

the sense of animated or comic book cartoon. What I meant was these paintings seem to be works in preparation for a larger project. They seem to illustrate a story." At that point, I related a brief version of the stories from which each of my paintings had sprung. I am trying to point out here the almost sycophantic reverence in which Bill was held by the younger generation of men who, at that time, called themselves Northwest Coast Indian artists.

FROM THE 1970s TO THE 1990s, I visited my Haida school chum, Gitsgha, in Skidegate Mission several times. During one of these trips in the late 1970s, I was on the ferry to Queen Charlotte City, when a striking blonde woman in high black boots and a poncho-like cape approached my car and said, "Mr. Reid would like to see you." I said, "What?" and she repeated herself, as did I. Finally, the third time around, fondling her impressive Dogfish pendant, she made it clear that "Bill Reid, the famous Haida carver" wanted to speak to me. Ignorant of just how far his Parkinson's disease had advanced, I said something like, "If Bill wants to talk to me, he knows where I am."

In my rearview mirror, I spotted Bill struggling out of the little truck they were travelling in and went to meet him. After exchanging salutations in the blustery weather, he began a tale of woe. "I have just completed a house-front pole for the Skidegate band office, and during the whole project no one has really shown any interest. There are no real Haidas left, I guess. Their idea of a potlatch is more like a businessman's luncheon than a real potlatch. They show up for feasts here in dark suits, white shirts and ties. Very few people here know any of the traditional songs, either. Do you think you could come up and act as master of ceremonies for the pole-raising?"

My answer was that if Bill could get me a letter from the local tribal council acknowledging that they thought it a good thing for me, a Nuu-chah-nulth ritualist, to come and act as master of ceremonies for the occasion, I would come. With the question of my participation in the pole-raising settled like this, we turned our attention to other matters. Bill trudged back to the truck and returned, wispy white hair flapping in the wind, to show me a repoussé silver bowl he was working on. It was a fat little bear and exhibited some of the voluptuous forms and fine lines

characteristic of his best work. Still, other details looked as though they might have been rendered by the hands of an idiotic drunk with no respect for Bill's work. He offered the treasure to me for what I knew was a ridiculously low sum of $12,000.

This incident raises a number of questions. Was Bill sincere in offering the bowl to me? I believe he was. Why was he attempting to sell me this incredibly beautiful—but fatally flawed, in my opinion—silver bear bowl? Did he share my opinion of it and was he therefore trying to unload it? Or had he lost, perhaps for the moment, his ability to look critically at his own handiwork? Did he believe that I could afford it? I certainly couldn't. Was it because he wanted, for a change, something of significance to end up in Native hands? Perhaps. As always, Bill left people with more questions than answers.

MY FRIEND GUUJAAW helped Bill with his big canoe project, *Loo Taas*. With launching day approaching, Guujaaw came to me on Bill's behalf and asked if I would lend them a paddle song for the maiden voyage. Guujaaw was concerned that Bill had left preparations for the launch to the last minute. He felt that somewhere on the Charlottes there were Haida people who knew paddle songs, but that Bill just wouldn't take the time to seek them out. I assured him that, for the occasion, I would be glad to lend a paddle song that I'd composed some years before. Sometime later, Bill said he wanted to thank me for the use of the song. He invited me to steer the canoe on a trip out along Spanish Banks and Point Grey with a crew of paddlers from the Emily Carr Institute of Art and Design.

IN 1988, I BEGAN a course of studies at the University of British Columbia. There, I met Lyle Wilson, who took me to Bill's Granville Island studio, where he was working on the plaster mockup for his famous *Spirit of Haida Gwaii,* the bronze canoe crowded full of mythical characters. Bill was looking for someone to help him finish painting a bunch of paddles he had roughly designed and to do some other unrelated work. Bill's request, and my refusal to accept because I was busy, led to several other meetings During one of those meetings, Bill said that he had heard me sing and enjoyed it. He invited me to his home and said, "Sometime we should get together and trade. You could sing and I could entertain you in some way in

return." We did get together at his Cornwall Street apartment. Bill began to read classic poems such as "The Charge of the Light Brigade" and "The Rime of the Ancient Mariner." It was remarkable to me that when Bill began to read, the start-and-stop stuttering of his then current speech pattern slipped away and was replaced by this beautiful, fluid and resonant delivery. My side of the trade was to sing and beat a small drum Bill had designed with a bear's head, rather like the bear's head on the silver bowl he had offered me. I later discovered that he had also had the head copied and cast as bronze doorknobs. At any rate, the design on the drum was roughly drawn and unpainted. I sang some Haida love songs and a range of different types of songs from the west coast. We alternated in this way a number of times, and then Bill got up to see if there was something for us to eat. We ate, briefly, and returned to our singing and reading.

A number of times Bill seemed to grow tired, and I thought our visit was over. However, he would come back with more energy and extend the visit repeatedly. At one point, he said: "I want to give you something." He then began piling before me a great number of pencil drawings, prints taken off engraved metal objects, silkscreen prints, etc. As I sorted through them, trying to soak up everything I could about these mostly early works, he said, "Take whatever you want." I was, once again, struck by his generosity. But that was not the extent of it. He said, "I saw your big copper for the museum in Osaka, Japan. It's a beautiful thing. I once planned to make a copper myself, but I still haven't got around to it. Roy Smith made me a big graver for that project, and I still have it somewhere here. You can have it if you want, and if I can find it." After some fumbling around in lower shelves, Bill produced what looked like a giant graver's tool and began miming its use with a chasing hammer. It is now one of my treasures.

SOMEWHERE NEAR the end of my four years in Vancouver, Bill Good, a local TV personality, interviewed me for a feature he was working on, in preparation for what was assumed to be Bill's imminent death. He told me that in answer to his question, "Who would you like to speak about your life?" Reid had named Arthur Erickson, Doris Shadbolt and myself. Good came to my home on 16th Avenue and shot some footage of me doing design work and talking about Bill. Not too long after, it became clear that Bill

was not going to die, but the piece was aired anyway. The next morning, Bill called me in a storm and cussed me for a long time. But in the end, he said he shouldn't be so mad, as I could have been a lot tougher on him. That was a long time ago, and I don't remember what I said on the tape. However, I do recall Good asking me, "If you had to speak about Bill Reid's life, in a single sentence, what would you say?" I said something like, "Bill Reid has milked the words 'Haida' and 'Indian' for everything they are worth, but he has never taken responsibility for being either of them."

THE LAST TIME I saw Bill, Parkinson's disease had robbed him of a great deal of his balance and mobility. He struggled with just about any physical effort, including simple speech. He did show me a little book, recently released, that had a brief passage about his relationship with Robert Davidson. He read from the passage and then blurted out, "Is this what my life has come to mean? Has all of my hard work simply amounted to a footnote in the history of Northwest Coast Indian art? Has my *#!/;&#$%*ing role simply been to pass on to Robert, over the years, the basic skills I learned from Mungo, in a few short weeks?" Bill was livid! I, however, was laughing uncontrollably, and in a few minutes, he was laughing with me. I was struck by the seeming pettiness, that a man of Bill's accomplishments and status should be concerned about a few lines in some now long forgotten and insignificant publication.

MY COMMENTS HERE have been intended to cast light on Bill as a human being. However, he will always be best known and remembered as an artist and a commentator on "classic" northern Northwest Coast art. Perhaps the most powerful myth associated with Bill is that he rose to prominence during the art's renaissance in the last half of the twentieth century. Part of that myth was that Bill created the renaissance or was at least its chief impetus. There was no renaissance. But as white people began to see more, learn more and understand more about what they call "Northwest Coast Indian art," they began to think that there was a reawakening of a long-dead tradition. After all, hadn't the government of Canada enacted a potlatch ban that made feasting illegal? Hadn't it also taken the children away from these communities for several generations and sent them to Indian residential

schools, where all Native traditions were frowned upon and even punished? And now, wasn't there an intelligible, articulate, non-threatening and gifted "Indian" they could understand and even look up to, who was producing unquestionably beautiful things? What was happening was that the very things government policies had tried to do away with, but hadn't, were now becoming acceptable, popular, even chic.

There was then no renaissance. There was no leader of a renaissance. But there was a wunderkind—"a most unlikely Indian"—who had opened up a clear, if narrow, conversation with the public in the popular media and, perhaps more importantly, with connoisseurs and patrons in the "best" galleries and museums. That conversation has taken on dimensions undreamt of, and unpredictable, when it began nearly forty years ago.

ENDNOTES

1 Native people of the west coast of Vancouver Island have been designated, over time, by various names, including Aht, Nutka, Nootka, Westcoast and Nuu-chah-nulth. Most refer to themselves locally as Westcoast people.

2 There are various orthographies and spellings of tribal names in circulation. Another common spelling is Kwagiulth.

Was Bill Reid the Fixer of a Broken Culture or a Culture Broker?

by AARON GLASS

I NEVER HAD THE privilege of knowing Bill Reid personally. I saw him around the Museum of Anthropology at the University of British Columbia (UBC), but we never met. In fact, the closest encounter we had was during a tour I was giving to a beginning ESL group. Because of the serious language barrier on such tours, guides tend to emphasize a few simple lessons: that First Nations people and cultures are still alive, that totem poles were not worshipped and that most images in Northwest Coast art represent stylized crest animals. I was illustrating this last point by mimicking the movements of a raven in front of Reid's *The Raven and the First Men*—an object, I will argue, that was pivotal to the historical valuing of Northwest Coast materials as fine art—when Bill McLennan pushed Reid, in his wheelchair, past the rotunda. I could swear that he looked up at me just as I crouched down, flapping my arms, saying, very slowly, "BIG BLACK BIRD." Here I was, reducing what many hold to be *the* masterpiece of contemporary Northwest Coast Native art to a crude charade right before the eyes of the master himself. I thought my career on the Northwest Coast was over. So I would like to begin by thanking the editors of this book for giving me the opportunity to publicly redeem myself, to save face in the manner customary on the coast.[1]

This anecdote illustrates some of the themes I would like to explore in this essay, questions of translation and translatability across different cultures, histories and value systems. At issue is Bill Reid's relationship to the larger historical moment of the late twentieth century, which witnessed a

transformation in the cultural activities of Northwest Coast First Nations. The term "renaissance" is, first and foremost, a historical term in two senses. One, it describes a general mode of historical action made with specific reference to the past; hence, its connotations of rebirth and revitalization. And two, applications of the term are usually modelled specifically on the period of Western history in which classical forms and values were revived in Europe. Thus, the term "renaissance" tends to imply both a narrative *internal* to given moments in time (that is, the *process* of resuscitating the historical past) and to the bounded moment of time itself, visible only along an *externally* determined timeline (that is, the historical *event* seen from some future vantage point). The first sense suggests a discrete group of actors performing, or undergoing, the rebirth; the second sense suggests a discrete group of observers witnessing and recording their actions.

I am suggesting that there are two very different histories at work here. The first is the history of *making, performing and living* First Nations art and culture on the coast—a history of indigenous production. One of the problems in applying a term like "renaissance" to this history is that it implies an internal cohesion and consistency, a regular pattern of borrowing from or reviving past cultural actions. In fact, coastal First Nations have radically different histories of assimilation, accommodation and resistance to colonialism. The production of what we would call "art" and "culture," not to mention how the category of "tradition" was evaluated, varied widely from region to region, village to village, decade to decade. Scholars—both Native and non—have increasingly disentangled such generalizations, recovering the specific histories of local twentieth-century production, with their unique blends of continuity and rupture, ceremonialism and commodification.

The second history at play here is that of non-Native *awareness and appreciation* (and, some might say, *appropriation*) of those activities—a history of public reception. This story, too, predates Reid's activities over the last forty years and must be expanded to include turn-of-the-century world's fairs and ethnographic museum displays, pivotal art gallery exhibits in Ottawa (1927) and New York (1941, 1946), and the interest taken in Northwest Coast materials by the Group of Seven, the surrealists and some abstract expressionists. Yet between the years 1956 (when *People of the*

Potlatch displayed ethnographic materials in a public fine arts venue, the Vancouver Art Gallery) and 1976 (when the newly built Museum of Anthropology at UBC displayed the same objects as fine art within a university museum of ethnography), the larger discourse surrounding Northwest Coast objects underwent a profound shift. Thanks to the efforts of a very small group of devoted anthropologists, scholars, entrepreneurs and artists—backed by the institutional support of universities, art schools, galleries and museums—Northwest Coast material culture came to be valued as fine art in public as well as academic consciousness. These individuals (including Audrey and Harry Hawthorn, Wilson Duff, Erna Gunther, Bill Holm and Bill Reid) jointly engineered a long series of exhibits, catalogues, commissions and collections, all of which helped to define and codify the value of Northwest Coast "art." Reid himself (1976) credited this group as much as anyone with the so-called renaissance.

Yet, if we identify these people as the "patrons" of a new movement in the recognition of Northwest Coast art, we must be careful to recognize that Native people were neither the clients nor the immediate beneficiaries of such a transition. For all the talk of a rebirth of Native pride and cultural awareness, these things could only effectively emerge internally in Native communities, and any financial gain from the returns of a growing art market would be a delayed reaction. The immediate result of this activity was a shift in the general cultural values attached to Native materials, the venues and details of its display, the status of its creators. On the one hand, legalization of the potlatch in 1951 provided the context for the return (in some cases, the re-emergence) of the potlatch as a motivator for local production; at the same time, an expanding indigenous "art world" provided support for global recognition. While these developments occurred simultaneously, they had very different internal dynamics, and I think we should be cautious in exploring the historical features and processes that link them.

I would like to approach Bill Reid as a site of articulation between local histories of production and histories of global reception. He was one of a few select individuals capable of translating the cultural values of different communities (I am hesitant to reify them into different "cultures"). Such individuals are often called "culture brokers," not because they are necessarily engaged in commodity transactions (though Reid was) but because they

are entangled in the movement of objects, knowledge, values and histories (see Barth 1966; Paine 1971; Steiner 1994). Culture brokers are often located at the intersection of differing cultural systems, and they often have the values of those systems projected onto them to define and ensure their mediating role. It is important to note that brokers may have very different functions for patrons than they do for clients; very different value systems may adhere to the single figure caught between them.

Vancouver media artist Stan Douglas, for his 1992 installation *Horschamps,* filmed a jazz performance with two cameras, from two points of view; in the gallery setting, he projects a smooth, program-quality version on one side of a screen, while projecting the edited outtakes simultaneously on the other. The result is two versions of the same event seen from different vantage points. I am suggesting that Bill Reid, like other culture brokers, can be approached as a similar screen onto which two histories are being simultaneously projected.[2] While I recognize that this metaphor assumes the neutrality of the screen, I am not attempting to erase Reid's own agency from his artistic practice. Instead, I am examining the ways in which he— and others through him—uniquely articulated a shift in cultural values, and why he—more than any other Northwest Coast culture broker—became the public persona most closely associated with the so-called "renaissance" of the last forty years. In approaching history as an active and creative cultural negotiation of the past and present, I hope to reassess the legacy of Bill Reid and offer an alternative to the renaissance model.[3]

HISTORICAL PRECEDENTS: CULTURE BROKERS ON THE NORTHWEST COAST

There is a strong legacy of indigenous cultural mediation on the Northwest Coast. In societies based on private knowledge, restricted access to resources and limited claims to hereditary ownership and display, individuals who control the dissemination of information also control the circulation of values (both economic and social). Long before Europeans arrived, and continuing right through the commercial and colonial encounters that ensued, there emerged certain individuals who took it upon themselves to negotiate the intersection of cultural knowledge, values and experience. Chiefs or lineages claiming restricted ownership over important

resources, such as oolichan, often controlled exchange with neighbouring and distant groups, and their travel and trade resulted in the borrowing and transformation of cultural forms and practices. Some of these chiefs, such as Maquinna among the Nuu-chah-nulth, consolidated their power by extending control over trade and cultural contact to the newly arrived Europeans. At the same time, artists exchanged, adopted and adapted both new materials and forms, resulting in early "hybrid" argillite pipes, button blankets and silver bracelets.

With the shift from a sea- to a land-based fur trade and the increase in permanent European presence with the mid-century gold rushes, a new type of intermediary arose, more savvy in the ways of the white man. The life of Arthur Wellington Clah is one remarkably well documented case of a Tsimshian taking full advantage of the settler economy. Clah learned English and acted as a translator, travelled extensively throughout British Columbia to transport settlers and trade, and balanced his traditional seasonal rounds with the emergent wage economy. While he used his hereditary and marital privileges to broker trade relations with both neighbouring groups and Europeans, he also used his newfound wealth, literacy and conversion to Christianity to broker increased status for himself within an increasingly fluid indigenous social network (Galois 1997–98). In Alaska, Cudgen, or "Princess Tom," became famous for selling Tlingit curios while consolidating her own status through entrepreneurship and marriage.[4] Others, such as the famed Haida chief Albert Edward Edenshaw, may have strategically negotiated relations with Europeans in the shifting demographics of Haida society to claim a chiefly title and to solidify a (locally contested) place for himself in both Haida and Euro-Canadian histories (Sparrow 1998). Another domain for brokerage was that of the spiritual, and Native individuals emerged as prophets (such as the Wet'suwet'en Bini), as converted missionaries (such as the Tsimshian W.H. Pierce, author of *From Potlatch to Pulpit*) and as leaders of syncretic movements (such as the Salish John Slocum, founder of the Shaker Church); each of these men balanced and translated the values of Christianity and indigenous beliefs in unique ways (see Knight 1978). In addition, the Native Brotherhood emerged as a site of religious and political articulation, and many famous members were active as culture brokers on the side (such as

Alfred Adams for the nineteenth-century Haida and William Scow for the twentieth-century Kwakwaka'wakw, both of whom helped negotiate sales of objects and transfers of cultural information).[5]

By the late nineteenth century, the presence of colonial administrators, settlers, collectors and ethnographers suggested new contexts for indigenous brokerage, and many talented and enterprising individuals arose to satisfy the demand. Perhaps the most famous and well documented of these were George Hunt for the Kwakwaka'wakw (see Canizzo 1983), William Beynon for the Tsimshian (see Halpin 1976) and Louis Shotridge for the Tlingit. Often born to parents of mixed ancestry, such figures learned phonetic transcription alphabets, collected ethnographic objects and information, travelled widely beyond their home territories (often to world's fairs), and were central to the amassing of museum collections and monographs for a number of anthropologists in North America and abroad. These individuals were in the unique position of negotiating the confluence of past, present and future histories of coastal First Nations, of helping to codify what is now considered to be "traditional" culture, of aiding in the alienation of objects of secular and ceremonial use from their own and neighbouring communities, of recognizing the values of both academic and indigenous world views. At the same time, a new generation of artists arose—partially constrained by the potlatch prohibition and partially liberated by both the loosening of strict hereditary ownership and the expanding market economy. Artists such as Charles Edenshaw (Haida) and Charlie James (Kwakwaka'wakw) helped to carry classic visual forms into the twentieth century by adapting and elaborating them in the context of tourist art and ethnographic reproduction. They were among the first Northwest Coast Native artists to become known by name in the broader community, to experiment with new media and to skilfully articulate the intersection of European and indigenous value systems with regard to newly made objects. It is no wonder that many contemporary Haida and Kwakwaka'wakw artists claim descent from these two.

Ten years before Bill Reid emerged on the scene, Mungo Martin, then a seventy-year-old Kwakwaka'wakw carver and stepson of Charlie James, came to work at the University of British Columbia and the British Columbia Provincial Museum (now the Royal British Columbia Museum).

Between 1948 and 1960, he helped to restore old totem poles, he carved new and replica poles for museums and villages as part of salvage efforts, he trained a number of younger carvers, he recorded many songs and much ethnographic material with anthropologists, and he helped to negotiate with community members for the sale of their masks and regalia to museums (see Glass, in press). Martin was presented to the public as a "man of two worlds," both a high-ranking chief and expert in traditional culture, and a talented, hard-working Native artist. He was depicted as both the last of the great totem carvers and the link to the next generation. In fact, it was said about Martin (probably by Audrey Hawthorn in the mid 1950s)[6]: "If there has been a revival in Native arts this century... Mungo Martin by his example and by his own astonishing gift of art and memory is the inspiring genius." As late as 1971, Clive Cocking published an article entitled "Indian Renaissance: New Life for a Traditional Art," which privileges Martin (already dead ten years) as the "one man [who] played a vital role" in the revival, crediting him with teaching Bill Reid, who otherwise hardly is mentioned. Yet Martin, an elderly Native who spoke little English publicly, would not in the long run be credited with the proverbial renaissance, despite his popularity with the public and local anthropologists. His objects were too loaded with ethnographic content to be transformed into fine art under a modernist regime of value; he was too much a Native and not enough an artist in the public eye.

BILL REID: THE FIRST MAN AND HIS RAVEN

It was only after 1974, the year of Bill Reid's solo show at the Vancouver Art Gallery, that the revival discourse shifted onto him. Claude Lévi-Strauss, in the exhibit catalogue, very closely echoed Hawthorn's earlier sentiment about Martin, claiming: "Our debt to Bill Reid, an incomparable artist, is that he has tended and revived a flame that was so close to dying. That is not all; for Bill Reid by his example and by his teachings has given rise to a prodigious artistic flowering" (VAG 1974). The following year, Joan Vastokas (1975) published her article "Bill Reid and the Native Renaissance," thereby codifying what would remain the received public wisdom for the next twenty-five years. What Bill Reid was able to articulate that Mungo Martin was not, was the fusion of indigenous form (and to some extent, content)

associated with "traditional" Native art, with the universal aesthetic values (and to some extent, materials) associated with modernism. As a culture broker, Reid was located (by both himself and others) at the intersection of an indigenous history of producing "material culture" and a critical history of appreciating "fine art." And like many such individuals, he was often represented as bicultural, as a bridge of sorts, as a link in some linear chain. But like many brokers, the ambiguities in his positioning result in and reflect the contradictions felt to hinder total integration of the two worlds in question (an ambivalence that may be a lasting legacy of colonialism).

Like Mungo Martin before him, Bill Reid was valued as an authentic Native and a trusted public figure, both conferring on him expert status in different realms. We are constantly reminded that he was of Haida blood, that he was a descendant of Charles Edenshaw (which is not technically true, as he was a great-grandnephew), that he mastered the rules of the traditional art form and that he was trained by Mungo Martin in the traditional apprenticeship manner—a widely circulated myth, according to Reid himself: "I think my instruction consisted of Mungo saying, 'Well, I'm going to carve here, so you carve there'" (1983:192). At the same time, he was a well educated, extremely well spoken figure of public media familiarity. Reid was "cultured" in both senses of the word, with the craftsman's skills of production and the connoisseur's knowledge of consumption. In fact, Nelson Graburn (1993:197) suggests that unlike in the United States or Europe, here, in the birthplace of multiculturalism, "Canada needs its modernist Indian artists to signal its multi-ethnic identity." Like Mungo Martin, Bill Reid was described as "having a foot in each culture" (Shadbolt 1983:268–69). Like Martin, Reid was valued as both an artist-maker *and* as an interpreter-communicator (VAG 1974), as well as both a silversmith and a "wordsmith" (Hoover and Neary 1984:186).

Yet unlike Martin, Bill Reid was also held to be situated at the "intersection" of Native and modern art, to be "by happy circumstance both a Haida and a practicing artist" (Duff in VAG 1974), as if those were mutually exclusive categories. This was increasingly true, as indexed by his major sculptural commissions: the Haida house and poles of 1960, which were the earliest and most "traditional"; the large wooden screen of 1968, which applied panel pipe composition to a large format; the Raven of 1980, which fused Haida

design elements and mythic content with monumental narrative sculpture; the Killer Whale of 1984, which introduced bronze casting at the monumental scale; the black and "jade" canoes of 1991 and 1994, which freely adapted Haida conventions and mythic elements to a figural format and universalistic message. In these creative fusions of Haida and European motifs and materials, Reid came to represent the (potentially contradictory) modernist ideals of both primitivism and humanism. As Doris Shadbolt implies in the new conclusion to her book *Bill Reid* (1998:207), he turned to the values of the West to elevate and gain recognition for Haida art and culture, just as he turned to the values of the ancient Haida to help heal the broken soul of the West.

Reid embodied—and was held to exemplify—modernist values in a number of ways. He spoke a language of pure form, of universal aesthetic appreciation of quality regardless of origin. In fact, before the postmodern days of pluralism and fragmentation, he was said (Lévi-Strauss in VAG 1974) to be freed from the restrictions of Haida heritage because he was "sensitive to the universal import" of its messages, freed to introduce Northwest Coast art "into the world scene: into a dialogue with the whole of mankind." In other words, he was creating art, not artifacts. And singular pieces rather than the multiples characteristic of both ethnographic objects and commodities.[7] Despite the Hawthorns' attempt to so elevate Mungo Martin, Bill Reid was really the first contemporary Northwest Coast Native to be fully integrated into the modernist cult of the artist as genius, that construct of the Western Renaissance that created the stereotype of the tragic hero, the conflicted individual negotiating the past and the future, the self and the other, objective reality and subjective experience. The colonial irony of such associations is that, in the larger art world of the 1960s and '70s, modernist values were on the way out, challenged as being positivistic, oppressive, hegemonic. It was only once modernism was considered passé that Native people were allowed into its ranks.

In fact, Reid himself was a critic of certain aspects of modernism. He had little patience for conceptual art and the rhetoric of progress that accompanied abstractionism. In some ways he was deeply nostalgic for the pre-modern Native condition, for the romantic balance and harmony that First Nations were deemed to embody before colonization (exemplified in his text for Adelaide de Menil's 1971 photography book *Out of the Silence*). His art was

held to be anchored in this past, infused not only with traditional forms but with the intrinsic narrative "meaning" that comes with mythical content, even (or especially) if it is inaccessible to most viewers. He was safe to draw upon, individualize and commodify those resources for two basic reasons: one, in the late 1950s, the culture was held to be dead, relegated to the ancient past and therefore amenable to appropriation or revitalization in the modernist present; two, he was largely free from the local political activities and the hereditary responsibilities of Native life. Reid was thus positioned between a viable community context for past art and the present engagements of Native art with global markets, local performances of ethnicity and the political climate of treaties and repatriation. He was held to be primitive and modern at the same time.

The media in which Reid worked confirm his status (and ambiguity) as such a mediating figure. While the monumental bronzes signal the fine-arts status of Western sculpture, the miniature scale of jewellery makes for an intimate—and eminently collectible—experience of Native culture. Doris Shadbolt (1998:94, 118) speaks of the miniature pieces (applying equally to early tourist art and to jewellery) as being "culturally portable," amenable to movement across both space and value systems. While work in bronze signals familiar value, miniaturization and work in precious metals signal decorative arts and crafts, usually set against fine art in Western dualism. Reid vacillated between these designations, each used as markers for status under different value systems, and this may have been one of the secrets of his success. He was an innovator and experimenter (albeit a conservative one), and he believed in the common denominator of universal aesthetics; at the same time, he was a master craftsman, anchored to traditional forms and specific practices, and therefore continuous with the past rather than hindered by expectations of artistic disruption. Yet I believe this tension to be at the heart of the recent controversy over Reid's use of assistants and fabricators (O'Hara 1999). Native art has been valued as a direct, handcrafted alternative to modern industrial and mechanical processes. One of modernism's innovations was the removal of the artist's hand from the finished product (be it Duchamp's "readymades" or Donald Judd's fabricated cubes), a factor that is apparently still hard to reconcile with the prescribed value of indigenous art.

Bill Reid increasingly explored possibilities for synthesis between the two worlds he felt kinship towards, from introducing European techniques and materials to Haida imagery and forms, to introducing a Haida sensibility to modern abstract compositions in metal. Yet the first true monument to the success of his cultural brokerage, what would become a sort of public litmus test for the viability of a contemporary indigenous fine art, would be *The Raven and the First Men* (1980). It was the first large Northwest Coast sculpture to depart from the customary totem pole or mortuary monument; its historical references were to both origin stories and to tourist art; it combined Haida formline designs with Western naturalism; it fused Haida mythical allusions with a Western narrative sensibility that would ensure its ability to be "read"; it existed at both miniature and gigantic scales.

Doris Shadbolt (1998:143) claims that, developmentally, this sculpture marked Reid's emergence from the strictly bounded container of both ethnic heritage and the wood itself. This suggests that we might "read" the sculpture as depicting the birth, or rebirth, of Reid himself, that the little humans are self-portraits crawling out from under the burden of history and tradition. Yet when Shadbolt (1998:144–45) describes the Raven as "the original wunderkind whose world-shaping, wonder-making transformations had nothing to do with pious good intentions but emerged from an improbable but fortuitous creative intuition coupled with a detached and open self-interest," it is hard to ignore the implication that Reid is represented here as the Raven itself. The Raven is not the creator but the trickster and transformer and cultural educator. The Raven is credited with (if not exactly responsible for) the rebirth of Haida culture after the mythical flood and, by extension to Reid, again in the late twentieth century. This reading is reinforced by a political cartoon from 1987 (reprinted in Gray 1993), depicting Reid as the Raven, carving a role for himself as an artist and public persona while mediating Native logging protests by threatening to withhold a major commission from the Canadian Embassy in Washington. Here, the little figures are white politicians trapped in the shell, struggling under the weight of Reid's growing influence. Yet this suggests a third reading of the sculpture, one in which Reid himself is represented not as the mythical Haida Raven or as one of the newly emergent (or trapped) beings but instead as the clamshell. I am suggesting that we

might approach Reid as a relatively passive but extremely vital receptacle, vehicle, catalyst, for a different kind of birth, the birth of a way of seeing and valuing Northwest Coast art from both indigenous and non-Native vantage points. The weight of tradition oversees and to some extent regulates this process. And the diversity in responses is captured in the variation of gazes and expressions and identities found on the faces of the new humans, figures combining Haida motifs and realistic anatomical details. In the breaking and opening of the clamshell, there is the utopian ideal of reconciling past and future, Native and non.

The logic of modernism presupposes both the essential difference of the "other" and the capacity for a universalistic aesthetic to apprehend and commune with that other. Culture brokers are often characterized as such "bridges," conceptual links between the two worlds they are held to mutually inhabit. Like Mungo Martin, Bill Reid was repeatedly characterized as a bridge of two sorts: over time and over space. As a link between the past and present, Reid was celebrated for carrying Haida artistic traditions out of the silence of the past into the vitality of the present. Bill Holm (in VAG 1974) suggests he was like a shaman bringing the art back to life; Joan Vastokas (1975:20) claims he carried the art back from the grave; and Alan Hoover and Kevin Neary (1984:186), that he was the bridge between Charles Edenshaw and Robert Davidson. Reid's role as a temporal bridge makes sense (if at all) only in terms of an indigenous history, a narrative internal to Haida time. His role as a spatial or conceptual bridge between cultures, however, highlights a different history, *our* history of understanding and appreciation. Wilson Duff (in VAG 1974) emphasizes that Reid was not a link to the old culture but a bridge of communication allowing popular access to Haida motifs; Barbara DeMott (1989:11) calls him a "bridge to mainstream culture"; and Doris Shadbolt (1998:207) says that he opened a "bridge of understanding," a space for contemporary Native artists to navigate both indigenous and commercial value systems.

It is important, however, to recognize that all such bridge imagery presupposes the temporal and spatial distances over which it is built, and one of the key rhetorical strategies in representing brokers of any kind is the exaggeration of distance and difference between exchange partners. Emphasis on temporal linkage privileges the authenticity of the past and

ignores the realities of cultural dynamics; emphasis on spatial or conceptual links privileges the authenticity of reserve or remote village life and ignores the realities of diaspora and urban synthesis. Reid embodied, more dramatically than anyone else, the complex dialectics of contemporary Native art: salvage paradigms in anthropology and the universalist aesthetics of modernism provided a rationale for the removal and decontextualization of indigenous objects and imagery, while the perceived loss of this ethnographic context was a precondition for that material's transformation into fine art.

FROM ARTIFACT TO ART: REVIVAL, RESTORATION AND VALUE

By way of conclusion, I would like to sketch three suggestions as to how we might better evaluate the term "renaissance." First, essential to any process of rebirth is the process of death. If we track the publications exploring this metaphor, a distinct discourse of cultural death permeates them. In 1954, Wilson Duff called it "A Heritage in Decay," whose only hope was rescue, restoration and preservation in museums (an ideal typified by the *People of the Potlatch* exhibit at the Vancouver Art Gallery in 1956). By 1963, Audrey Hawthorn described how disease, death and cultural decay were being transformed into a recaptured "Living Haida Craft" under the University of British Columbia's preservation efforts, aided by Bill Reid in the creation of the Haida village. Following the seminal exhibits *Arts of the Raven* at the Vancouver Art Gallery in 1967 and *The Legacy* at the British Columbia Provincial Museum in 1971,[8] both of which elevated the display of material to fine arts status and introduced objects of recent production, Clive Cocking declared in 1971 an "Indian Renaissance: New Life for a Traditional Art." He mentioned a resurgence of pride but noted that this was not a cultural revival, simply an imitation of past forms. Following Bill Reid's retrospective in 1974, Susan Mertens announced "Haida Art Alive Again." Joan Vastokas began her 1975 article, "Bill Reid and the Native Renaissance," by describing the "death blow" of potlatch prohibition and comparing it to the Black Death of the Middle Ages. At the close of that article, she emphasized the importance of death to the symbolism of rebirth associated with the Renaissance (1975:12): "The culture of the past was dead . . . 'a totality cut off from the present'" (Panofsky 1969:112–13). She confuses, however, the

two types of history I mentioned earlier, indigenous history (which, it turns out, did not perceive itself to be totally dead) and academic history (which was doing the defining). It was the modernist regime of progress that demanded that indigenous cultures be dead before we could, in good conscience, decontextualize their objects and revalue them as fine art. In fact, it was only a year later, in 1976, that the new University of British Columbia Museum of Anthropology opened with its fine-art display practice and that Reid began work on *The Raven and the First Men,* thereby completing the cycle of transformation from artifact into a supposedly reborn art.

The salvage paradigm active in academia at the time assumed the inevitable loss of traditional cultures, and anthropologists worked furiously to save what they could for the benefit of science and humanity. The semiotic reliance on themes of death highlights the importance of the salvage paradigm to the emergence of indigenous "art" as a category. The denial of use is essential to classic regimes of value for the art object, and the salvage paradigm signalled this denial in two ways: it assumed the death of the local, functional context for indigenous materials, and it physically removed these materials from what context there was. In privileging the authenticity of the distant past, salvage ensured that romantic nostalgia could continue to infuse objects with "meaning" while they were recontextualized to appeal to a universal modernist aesthetic gaze. Reid, at least through the 1970s, remained a participant in salvage projects and a critic of the so-called cultural revival, which he saw as spurious and misguided. The past was gone, he believed, presenting itself merely as an ideal for future contemplation and inspiration. There has been a recent shift in the discourse surrounding such issues, thanks partially to figures like Robert Davidson, as witnessed by William Kowinski's 1995 article "Giving New Life to Haida art *and the Culture It Expresses*" (my emphasis).

If we now deny that Native cultures died over the turn of the century, then we must recognize that the last forty years cannot be considered a rebirth. Marcia Crosby (1991), Aldona Jonaitis (1993) and Martine Reid (1993) have all made this clear in describing modes and models of continuity as well as the very new cultural contexts (indigenous or otherwise) in which objects and images are being produced today. If we choose to examine indigenous histories of production, we are immediately confronted with a

great diversity in experience. Today's narratives would mention that the Haida gave up potlatching early and returned to it late; that the Tlingit went out with a blast; that the Tsimshian and their neighbours transformed and negotiated; that the Kwakwaka'wakw resisted all the way. In fact, we may even have to question the viability of a category like "the Northwest Coast" when trying to characterize multiple histories. In addition, the time frame of drastic cultural rupture was anywhere from one to four generations, depending on the group; this cannot compare with the space of a thousand years separating the Greco-Roman era from the Italian Renaissance.

In fact, if we look closely at the cultural dynamics at play in many twentieth-century communities, a very different historical model presents itself, and this is my second point. After the potlatch ban was lifted in 1951 and ceremonial activity returned to the public arena, families increasingly began to assert hereditary privileges and status. Given the inevitable loss of genealogical details since the turn of the century (variable for different groups), there was a degree of social flexibility reminiscent of the late nineteenth century. Many chiefs and families began vying for local political control, appealing to ancient ranks as well as contemporary achievements. At the same time, artists like Mungo Martin and Bill Reid were engaged in totem-pole restoration projects; these projects were eventually abandoned or redefined as the creation of something new. Might we look back to the English Restoration of the seventeenth century for a paradigm of cultural rebuilding, a time when families reinstated their status by selectively appealing to the past and to aristocratic models, building lineages and building houses (literally and genealogically) to display their social position? It is interesting to note that both Martin and Reid are credited with building actual houses (importantly, both at museums), the first such "traditional" bighouses in decades. Martin also held the first public potlatch after prohibition to officially open his bighouse in Victoria, an event at which he claimed the chiefly title Nakapenkum by which he would be known since. In fact, if we look back to nineteenth-century culture brokers like Clah and Beynon, both of them built new lineage houses late in life, claiming new chiefly positions based on the wealth and status resulting more from their intermediary activities than from birthright. If we do adopt a model of restoration to describe First Nations cultural activities of the twentieth century, it is important to note that

restoration—of objects, of status or of culture—is never the simple return to a previous, original state. It is always the building of a new legacy with explicit and selective reference to the past. Never simply the removal of temporal residue, restoration always involves the historical accretion of new layers of meaning, new decisions, new negotiations.

If there was no renaissance in Native production, neither was there a renaissance in non-Native reception, and this is my final point. Again, this would imply a return to a previous state, to previous values. The emergence of Northwest Coast art as a critical and publicly recognized category was a new phenomenon, a "naissance," an extension of modernist aesthetic values, shifting anthropological predilections, increasing First Nations visibility and a growing consumer market. At the intersection of these forces we find Bill Reid, the talented maker of things, speaker of words, articulator of values. If Reid the artist/hero was a screen onto which others projected their historical gazes, he was also a condensing lens through which the values of a Western art world and cultural marketplace were projected onto indigenous objects. He helped to bring the issues and articulations into focus, translating and transmitting them over space and time. And by the end of his life, he came to recognize both the viability of a contemporary Haida society and the role that art might play in its political and cultural sphere. Thanks in large part to Bill Reid, museums and the public now take it for granted that indigenous objects are art. But the discourse around Native objects is shifting again; a new slide has been inserted. What was once artifact, then art, now becomes ancestor in the rhetoric of repatriation. We have moved "Beyond the Essential Form" (Duffek 1986) and "Beyond the Revival" (DeMott 1989). Are we ready to move "Beyond Art"?

ENDNOTES

1 I would also like to thank those people with whom I spoke about this project or who read drafts of the talk and final essay, especially Ruth Phillips, Charlotte Townsend-Gault and Karen Duffek.

2 This comparison with Stan Douglas's work emerged from conversations with Alan Elder.

3 More recently (Glass 2001), I have revisited the issue of renaissance discourse in Northwest Coast art, taking into account the remarks made by David Summers at the Bill Reid symposium. There, I take up his call for a more nuanced comparison between the European and Native histories at issue. Here, I focus more specifically on Reid's role and less on the general historical phenomena.

4 This information is based on research presented by University of Washington student Sylvia Koros
 at the Native American Art Studies Association conference in Victoria, British Columbia, 14–16
 October, 1999.

5 Incidentally, it was Scow, speaking for Neel, who officially "gave" the University of British Columbia
 the "rights" to use the Thunderbird as its mascot and symbol in 1948 (Nuytten 1982:49–50).

6 This quote is from an unsigned manuscript in a file of Audrey Hawthorn's papers, UBC Museum of
 Anthropology archives.

7 This slippage between the value of the singular and multiple may underlie the controversy over the
 casting of the second, "jade" canoe, and the perceived loss of value to the one held to be original
 and authentic.

8 The original *Legacy* exhibition opened at the British Columbia Provincial Museum in 1971; the second
 Legacy opened there in 1980.

IV

Reconciling Aboriginality and Modernity

Two Bears

by SCOTT WATSON

WORKS OF ART derive much of their meaning and even their form from those who commission them. If we imagine the history of First Nations art in British Columbia to include those who commissioned works as well as those who produced them, we might begin to address the complex, culturally and politically volatile investment that has been made in this art by non-Natives in particular. The needs of non-Native patrons have played a major role in the interpretation of traditional First Nations cultural objects, including, above all, the conscription of masks, food vessels and totem poles et al. as works of art. If an object's purpose and power is actually to document issues around territory and family, then recasting it as "art" is an act of suppression, even if it is done in the name of emancipation or cultural recognition. My paper concerns mostly First Nations art of the middle decades of the twentieth century. I am concerned with the tensions between the demand and desire to restore traditional art practices to an earlier period of glory and a counter impulse to innovate, transform and modernize them either through developing the interior logic of old styles or by hybridizing old design traditions with European ones. Throughout, I do use the terms art and artist; bringing into play the post-colonialist and First Nations-generated critique of these terms is meant to unmoor them from certainties about universality and context, not to ban them from use. After all, the artists I discuss, and most certainly Bill Reid, were engaged in a struggle to be recognized as artists. This struggle was political and part of the struggle for rights and territories.

The 1967 Vancouver Art Gallery exhibition *Arts of the Raven*, curated by Doris Shadbolt with Wilson Duff, Bill Holm and Bill Reid, was a turning point in the twentieth-century revival of traditional First Nations art in British Columbia. That exhibition argued and demonstrated that First Nations art ought to be considered art first and foremost. Out of the exhibition arose the subsequent career of Bill Reid, who was given a one-person exhibition at the Vancouver Art Gallery in 1974. The University of British Columbia's Museum of Anthropology, which commenced construction also in 1974, was partly designed around a Reid commission. In a spirit shared with the *Arts of the Raven* exhibition, the museum's architect, Arthur Erickson, set out to design a building that would provide a modernist setting for "masterpieces" of art as well as ethnographic objects. The period roughly bracketed by *Arts of the Raven,* the new museum and the Reid retrospective saw the large-scale revival of traditional Northwest Coast art as part of the picture of modern art in British Columbia. Anthropologists, curators, artists and others worked together to establish First Nations traditional art not just as art with a capital "A" but as contemporary art. A shared belief in socially responsive humanist/modernist aesthetics as they were understood in this region underlay the large institutional involvement in these events. The period has been criticized for, among other things, promoting a "Haidacentric" view of Northwest Coast art, romanticizing and fictionalizing its traditions by tying issues of authenticity to a "timeless" pre-contact past, and being either too blithe or too optimistic about the relation between art and politics.[1] The Haida-focussed *Arts of the Raven* exhibition, for example, overemphasized the rupture with the past.

Since 1974, notions of exactly what constitutes "art" in the context of traditional carving and design have been challenged. Post-colonial criticism asks if the process of treating, as art, traditional objects that were not originally produced as "art," does not work to suppress the original function and cultural context of the object. And, in the particular context of British Columbia, where land and rights have been contested since Europeans settled here, it might be relevant to ask if the nomination of these objects as art is not also about property: that is, if calling them art devalues them as markers of land claims, then calling them art serves the dominant culture's claim to the territory. Yet, from the 1920s to the 1970s, promotion of the

idea that traditional First Nations art on the Northwest Coast was art of a very high order was thought, by Native makers and non-Native patrons alike, to be an important aspect of a larger necessary movement to recognize Native culture and rights.

The drive to restore authenticity and high artistic quality to Native art was often entangled with this emancipatory goal, as well as with more patronizing and assimilationist ideas about appropriating Native heritage as markers of regional and national identities. The desire to revive or restore tradition often ignored those who wanted to innovate, commercialize, decontextualize and hybridize, and those who also thought their works helped a progressive Native movement. Differing views of what Native art ought to be and, more importantly, what it ought not to be, were formed with large extra-aesthetic agendas in mind. A great deal of First Nations art did not come to be considered distinguished art until well after *Arts of the Raven*. The continuity between rare, exquisite and refined objects in museums and cheap tourist curios is not unique to Northwest Coast art. Every tradition has its kitsch mirror. But what is unusual is the deployment of this continuity by the Northwest Coast's most celebrated artists. Bill Reid's 1962 *Bear* sculpture (figure 21), installed in the Great Hall of the University of British Columbia Museum of Anthropology, is a work that exemplifies what I mean by tradition. It was commissioned by Walter Koerner for his grandchildren to play on and donated to the university in 1963. In 1989–90, it travelled to Paris to be exhibited in *Les Amériques de Claude Lévi-Strauss* at the Musée de l'homme.

The *Bear* carving refers to the traditions of the past. Indeed, it is installed in front of a wall of photographs and didactic texts that emphasize and prove the continuity of the traditions of which they speak. As a work of art, the *Bear* is a powerful object with an engaging presence and is part of a story the Museum of Anthropology is trying to tell about history. The sculpture is Reid's invention, based on historical coffin support figures for a chief's burial chest.[2] Perhaps the origin of the motif in funerary sculpture lends some gravity to the figure. The museum is presenting the work as an example of the high culture and style of a people, not just as the work of an individual. A stuffed toy bear version of Reid's bear is sold in the museum shop (figure 22). The museum shop is part of the museum, but the objects in it are

different. They are for sale, to take home to become part of the narratives
and lives of museum shoppers. It might be assumed that the object in the
Great Hall is part of a narrative about history, art and human creativity
while the toy in the shop is just a tourist souvenir. At first, I thought the toy
bear diminished the original, yet the idea of it was Reid's, and he carefully
supervised its design. Perhaps he wanted to return the bear to the use of
children, the purpose of the original commission. But I am interested in
how the museum presents the *Bear* now and how the sculpture and stuffed
toy inform each other in narratives not presented by the museum.

IN THE YEARS leading up to *Arts of the Raven*, other less conspicuous attempts
at "revival" met with more modest success and/or failure. But the attempts
illuminate something of what was at stake in the revival, and issues and
strategies that failed to register in 1967 or 1974 may have new resonance in
the present context.

In the twentieth century, First Nations art was commissioned by five
intertwined non-Native groups: ethnographers and their museums, educa-
tors teaching Native children, the tourist industry, the art world and
governments. First Nations art was, of course, also commissioned by
Native organizations, families and individuals, but this market was almost
destroyed during the first half of the century, after 1884 when the main
occasion for the use and display of art, the potlatch, was made illegal.

Although Native producers clearly understood this connection,
"white" interests that campaigned for the revival of traditional First
Nations art seldom seemed to comprehend the relationship between the
criminalization of Native culture and the sad state of the traditional arts.
The project to claim Native art for the national heritage sometimes seems
part of the ideology of assimilation while at the same time voicing a critique.
The movement to revive old traditions of design and carving occurred
while the state was attempting to erase Native languages, cultures and
sovereignty. In some instances, what might appear as contradictory
impulses—the idea of saving and revising the artistic culture, and the pro-
gram of eradicating the linguistic and political culture—can be seen as
aspects of one another in which the aesthetic or "cultural" is used to subdue
the political. Thus, the revival of First Nations art—at least as commissioned

by white interests—takes place on uneven ethical terrain wherein the desire to help and improve relies too much on the condition it wishes to mitigate. The producers who were expected to make art and craft objects in order to better themselves were in a subaltern position, as they were denied many of the rights and opportunities most Canadian enjoyed. The standards of quality were established by white taste-makers, and their own art history was mediated by non-Native experts. For the better part of the twentieth century, the determination of what was and was not authentic or valid First Nations art of quality was made by non-Native interests.

Artists and anthropologists have been the most persistent non-Native advocates of First Nations art. For some of its early twentieth-century enthusiasts (Emily Carr, Lawren Harris, Marius Barbeau and Jack Shadbolt, to name a few), it was a vehicle to extend a "psychic claim"—to use Northrop Frye's term—into not just the landscape but deep into the past. For these artists (and ethnographers), Native art prefigured and naturalized the modern as well as Canadianized it. The abstract and expressionist forms they saw in First Nations art gave legitimacy to their own abstract and expressionist works. Certainly, this was the logic that oversaw the famous 1927 National Gallery of Canada exhibition *Canadian West Coast Art, Native and Modern*, organized by Eric Brown and Marius Barbeau. This exhibition juxtaposed works by Emily Carr, A.Y. Jackson and Edwin Holgate with museum antiquities of Native art. It formulated an expectation for First Nations art that might at first seem antithetical to the idea that it belongs next to Canada's modern masters. This was the hope that Native art could be revived as an industrial, rather than as a cultural or studio, practice. Carr's pastiche pottery and hooked rugs were included in the exhibition as a prototype for what might expected of the "invaluable mine of decorative design which is available to the student for a host of different purposes."[3] Both expectations, that Native art would vitalize Canadian art through its primitivism and that it would enter daily life through industrial production, are profoundly "modernist" and detached from considerations of what First Nations art meant to First Nations people.

At this juncture in the 1920s, Native artists themselves were barely part of the formula. There was more interest in the artifacts, designs and monuments (totem and house poles) found in museums than in living makers.

The negotiations for the legacy of First Nations art were conducted with the past of First Nations people and not their present. Brown and Barbeau's exhibition depended on a view of Native art as antiquity, divorced from a living culture (which was then thought to be dying rather than suppressed). Working against any revival in British Columbia was the law that banned the potlatch, instigated in 1884 and not dropped until 1951. In 1927, in the very year the National Gallery celebrated Native art, albeit as "heritage," an amendment to the Indian Act made it a criminal offence even to raise money to advance Native land claims. Under such circumstances, it is difficult to see how a revival of traditional arts could have taken place. But between 1927 and *Arts of the Raven,* there were further attempts on the part of non-Natives to foster and then claim First Nations art as a national heritage. These attempts encouraged the revival and continuity of traditional arts but they also encouraged the adaptation or assimilation of Native arts to new contexts.

For example, the B.C. Indian Arts and Welfare Society (BCIAWS), established in 1939, mandated itself to both revive and transform Native art. The society's founder, Alice Ravenhill, had been a hygenicist and educator trained in Victorian England before she emigrated to Canada and extended her interests to British Columbia's Indians. Through the society, she planned to industrialize Native design, hoping to increase Native incomes and to promote Canadian identity. She was interested in how Native designs could be adapted to "modern objects" and campaigned to see traditional images enter the lexicon of industrial textile design. Her own interest was in needlepoint, but it would appear that only the Second World War impeded her plans to have a Manchester cloth mill commission designs through her society.

The society's activities included attempts to establish a standard for craft production, a situation it found unruly, unregulated and degraded. In this, they looked to the older Canadian Handicraft Guild in Montreal. In order to effect these standards, the society held exhibitions and collected, it surveyed and encouraged the teaching of Native art in residential and day schools, organizing exhibitions of student art that often travelled nationally. All this was meant to be a rebuke to the "low" tourist curio and a call to educated middle-class collectors and their decorators.

In 1948, the BCIAWS organized a conference and an exhibition at the University of British Columbia.[4] The exhibition included contemporary crafts, as well as art by Emily Carr, George Clutesi, Judith Morgan, Francis Baptiste and others. In addition, the society published a small book of silkscreened Indian designs. After a brief idyllic account of pre-contact life, the book's introduction laments the current state of Native arts and crafts, attributing this situation to two causes: education in schools that decultures the children, and the tourist trade whose merchants insist "that the workers turn out great quantities of articles, with little thought to the right colouring and detail. This has meant that instead of works of beauty and quality being produced, it is merely cheap and tawdry." The introduction went on to state:

> The B.C.I.A.W.S. has tried to counteract this state of affairs by hold-
> ing annual exhibitions of Indian art and handicrafts, and by
> granting scholarships to Natives to enable them to do research
> work in Native design at the Provincial Museum . . .
> During the last two years, the members of the B.C.I.A.W.S. have
> been highly successful in finding markets for some of the best hand-
> icrafts. However, time and again, a fine piece of carving or a basket
> has been spoilt by lurid colouring. It is to remedy this situation that
> the Society has arranged for the publication of these reproductions
> of authentic Indian design, in the hope that they may assist the
> craftspeople to regain the skill of their forebears (Walsh 1948).

This was plainly a revivalist project, though the instructive silkscreened plates had a very dubious and distanced relation to the "authentic." These crude productions may be the first silkscreens of Northwest Coast designs, but the designs are radically decontextualized from the objects and sites they once adorned (figure 23). Clearly, the society meant design and design alone when it called upon the "authentic," and decontextualization was a matter of course for pedagogical and industrial uses. It is worth noting that the society saw itself as mediating "authentic" design from the museum to the contemporary producer.

The society was also interested in Native education. In fact, Ravenhill founded the society after attending a lecture by Anthony Walsh, who, though

not Native himself, was teaching Native art at the Inkameep Day School in the Okanagan in the 1930s. Due partly to her own importuning, in 1940 Ravenhill was commissioned by the Department of Indian Affairs to make twenty coloured charts for circulation in residential and day schools, "in order to provide teachers and students with a record of former tribal decorative arts and crafts which have possibilities of further development and utilization in modern life." (These were reproduced as black-and-white plates in her *A Cornerstone of Canadian Culture: An Outline of the Arts and Crafts of the Indian Tribes of British Columbia,* published in 1944 by the British Columbia Provincial Museum.) One of these designs was used by Bill Reid in 1954 for a silver brooch, *The Woman in the Moon.*[5]

The idea of teaching Native art in the schools was not new, if uncommon. In the 1920s, the great Kwakwaka'wakw carver Charlie James had been a volunteer art teacher at St Michael's Residential School in Alert Bay. And George Raley, a Methodist missionary, collector and school superintendent, initiated the teaching of Native crafts at Coqualeetza Residential School in Sardis before the First World War (see Hawker 2002). By the 1940s and 1950s, perhaps stimulated by the society's exhibitions, some—by no means all or most—residential and day schools participated in Native art education programs. However, the art the children produced belies the notion that the youngsters arrived empty of all notions of their art and culture.

From a small sample, it appears that the student art, as it pertains to "Indianness," is of two types: "Western-style" genre paintings of Indian life that may or may not incorporate Native design, and designs that are based on tradition but which can be wildly innovative. Figures 24 and 25 show two photographs of a 1951 exhibition organized by BCIAWS at the B.C. Provincial Archives. Nothing in these exhibited works resembles anything in Miss Ravenhill's charts or in the society's design manual. Rather, we have a record that students brought traditional design to the classroom from their communities. For instance, in figure 24, five pictures are by Willie Hawkins of the Kingcome Indian Day School, of designs taught to him by his uncle. The other works are from the Alert Bay Indian Day School. On an anecdotal note, Arthur Lismer saw this exhibition in Montreal when it went on a national tour and wrote in the guest book: "It's from the Indians that we learn how."[6]

The society's intentions for a Native art revival, while not clearly artic-ulated, are evident not only in the distribution of charts, manuals and decontextualized designs but in the fact that many of their scholarship recipients were not students who achieved notice with traditional designs or innovations thereof, but with genre paintings of Indian life. Anthony Walsh encouraged the career of Francis Baptiste and raised money to send him to school in Santa Fe, New Mexico (see Gritton 2000), in 1939. Baptiste's work is not revivalist, nor particularly localized around British Columbia cultures. His work is, rather, genre pictures of Indian life, authenticated by Baptiste's Indianness and influenced by the genre of southwest Indian painting to which he had been exposed. His success was put forward as a model for potential young artists among the student population of the province's day and residential schools.[7]

The first B.C. Indian Arts and Welfare Society scholarship student, Judith Morgan (a Gitxsan at the Alberni Residential School), was celebrated as a prodigy when she was a teenager. Her scholarship was designed to allow her to study Native objects at the B.C. Provincial Museum in Victoria—as if these objects and not living practitioners were the teachers of the old ways. In the press, the fact that she was from Kitwanga—a site Carr had painted—was emphasized, perhaps at the instigation of Carr's mentor and saviour, Lawren Harris, who took up Morgan's cause and arranged for an exhibition of her work at the Vancouver Art Gallery.[8] Morgan's art of this period is obviously student work, but it was thrust into the limelight because it served the modernist agenda of the Harris/Carr circle to integrate Native and modern art. A precedent had been the career of George Clutesi, also a graduate of the Alberni Residential School. Clutesi had an international career by 1947, Morgan's year of discovery. It was a career also supported by Harris and Carr. Emily Carr herself had bequeathed her art materials to Clutesi in her will, a symbolic gesture of handing on the task of a modernist indigenous art to a First Nations artist.

Baptiste, Morgan, Clutesi and others not only held part of the divided attention of the society, which advocated a revival of traditional practices, they were, as far as the Harris/Carr circle was concerned, the next generation of British Columbia artists. This was because their work could be said to follow the example of Harris and Carr in that they took on Indian subject

matter from a Western perspective. The careers of artists like Morgan, Clutesi and Baptiste are today still undervalued, probably because their involvement with "genre" and oil painting rendered their production much less "authentic" in white eyes than the revival of traditional designs and carving. It is ironic that the genre painters (especially Morgan) could lay legitimate claim to the recording of community history and memory while their educators expected them to turn to objects in the museum in order to learn how to make Native art. The spectacular success of Bill Reid's generation all but eclipsed this other modernist "path not taken."

INDEPENDENTLY OF the B.C. Indian Arts and Welfare Society, and in contrast to white-tutored painters of Indian life, Kwakwa̱ka'wakw artist Ellen Neel (1916–1966) (figure 26) was an early advocate of the revitalization and modernization of traditional arts.[9] Neel is important for a number of reasons. She is one of the most prominent woman carvers of the twentieth century, and, unlike the claims made for Bill Reid and the revival of Haida art, she could point to an unbroken connection to the traditions of the past through the tutelage of her grandfather, Charlie James, and her uncle, Mungo Martin. As with the genre painters, Neel's reputation waned in the 1960s. She was also an advocate of the industrialization, even commercialization, of First Nations design rather than a guardian of maintaining rules and old practices. As the keynote speaker at the 1948 conference the society held at the University of British Columbia, she said that the traditional arts would survive only if they found new contexts. "I believe," she stated, "it [Native Art] can be used with stunning effect on tapestry, textiles, sportswear and in jewelry. Small pieces of furniture lend themselves admirably to the Indian designs. Public buildings, large restaurants and halls have already begun to utilize some of the art."[10]

Neel's grandfather and teacher, Charlie James (figure 27), had also presented himself as something of a modernist. In addition to his better-known work such as totem poles that now stand in Stanley Park, he made furniture for his Vancouver dealer, Bill Webber. While much of James's early work was made for Native clients, after the 1921 "bust" of Dan Cranmer's "Christmas Tree" potlatch, he turned more and more to the production of carvings and paintings for Webber's shop. This included not just the production of masks,

bowls and other traditional objects but furniture, trays, paintings and wall plaques that were decorated with his Kwakwa̱ka'wakw designs. He bequeathed to Neel a collection of his own watercolours of traditional designs,[11] and these served as her source material.

Neel moved to Vancouver from her home village of Alert Bay in 1943, and in 1946, after her husband suffered a stroke, she established Totem Art Studios to produce high-quality poles and other carvings for the tourist market. Thus, by the time of the BCIAWS conference in 1948, she was an expert on tourist art and the economic realities of its production. She told the conference that the potlatch ban had led to a situation in which a non-Native clientele had become the main support for Native art. She also pointed out that raising the standards of curio production to a craft with an authentic relation to tradition was an economic consideration for the producer. For most suppliers to tourist shops, it was pointless and uneconomical to make well-crafted objects. In the tourist curio trade, there was always more remuneration for quantity than for quality. Neel was not the only person to tell the society that its goals were unrealistic. The society was told, time and time again, by Indian agents and the curio producers themselves, that there was no economic incentive to produce quality crafts.

For her Totem Art Studios, Neel devised an almost assembly-line like method to speed the production of poles made in various sizes and "lines." This industrial approach was an experiment to produce the highest quality at the lowest cost. Her Vancouver profile was raised by her participation in the society's conference, and this resulted in two new situations for her. First, the Vancouver Parks Board offered her space in Stanley Park to hold workshops and sell Totem Art Studios' products. Then, in 1949, she was commissioned to restore poles at the University of British Columbia's Department of Anthropology. She soon recommended that the project be handed over to her uncle, Mungo Martin, as the restoration work meant that production at Totem Studios was slowing down. Whether the reasons for choosing her entrepreneurial career over restoration work for the ethnographic museum client were financial or not, she was clearly more interested in producing new work and moving it into the mainstream than she was in preservation projects. In May 1950, the *Native Voice* reported that Neel had had some success placing work with modern interior decorators

and that she herself received a large commission to decorate the lobby of a new hotel at Harrison Hot Springs. She also became involved with the resurgent Totemland Society, a tourist promotion group that wanted totem poles to become internationally identified with Vancouver. Neel designed and carved a pole for the society. Its middle section is an oval-shaped planet earth with but one continent: British Columbia.

The humour of Neel's hybrid approach to the totem pole's possibilities was not appreciated by everybody. In 1950, for instance, there had been a controversy about plans by the Vancouver Optimists to commission a large pole with the likenesses of Bing Crosby and Bob Hope. The *Native Voice* reported that the issue was discussed at a meeting of band representatives in Vancouver, resulting in Chief Harold Sinclair's (Kitwanga) denunciation of the plan. "Totem poles," he said, "are the sacred memorial historic property of our forefathers."[12] Ellen Neel must have known of the controversy when, three years later, in 1953, through the Totemland Society, her son David's carving of a small pole with a likeness of Bob Hope was presented to the actor in a Vancouver photo opportunity.

Neel's attempt to create a Kwakwa̱ka̱'wakw design industry was not a financial success. Totem Art Studios was always a marginal operation. Before her untimely death in 1966 at the age of fifty, she began to sell her grandfather's magnificent watercolours of Kwakwa̱ka̱'wakw designs for five dollars each, demonstrating that, despite her work and the promotions of the B.C. Indian Arts and Welfare Society, there was still little market for high-quality Native art.

The young Bill Reid was a friend of Ellen Neel's. In one of her notebooks, circa 1950, is this intriguing notation: "Haida replicas by Queen Charlotte Enterprises, Victoria. Call Bill Reid about this" (Nuytten 1982). If Reid learned a lesson from her, it might have been that the tourist market would always reward quantity over quality and so could never be the basis for a revival of carving and design that had a serious and thoughtful relation to tradition. Only the art world could provide such a market.

In the late 1940s and early 1950s, Native works were often included in the many craft and design exhibitions sponsored by the Community Arts Council and the Vancouver Art Gallery to promote modernism in the hope of encouraging a local design industry. The most notable of these

was the *Art in Living* exhibition, held at the Vancouver Art Gallery in 1949. Included in that exhibition was a chair with a wooden armature designed along modern lines by Catherine Wisnicki and side panels woven by Salish weaver Mrs. Jim Joe. The opening of that same exhibition, pictured in the Vancouver *Province,*[13] featured a more unfortunate act of assimilation: an ancient stone carving used as a table centrepiece reveals at once the downside of decontextualization. The notion that Native art was exotic, ancient and alien survived and coexisted with the idea that it was proto-modern.

The idea that Native design could be decontextualized and integrated into modernist design persisted well into the 1950s and 1960s. David Lambert, who knew Neel, established a pottery that used Northwest Coast designs. The cover for his promotional booklet (figure 28) was designed by architect Ross Lort, who also designed the 1950s façade of the old Vancouver Art Gallery. In 1956, the Canadian Pulp and Paper Association published their rather unhelpful *National Asset, Native Design,* with cover art by Arthur Price and designed by A.J. Casson; Marius Barbeau was the text "consultant." The cover (designer unknown) for the 1963 publication of silkscreens by Henry Speck (figure 29), reveals how fragmenting and cropping Native designs might have woven them further into a modernist idiom.

The vocabulary of traditional Northwest Coast art did not fully enter the modernist lexicon in the 1950s, the first decade of the lifting of the potlatch ban, but it can be said to have done so by 1967 and the *Arts of the Raven* exhibition. What entered that lexicon was not the genre painting of Clutesi, Morgan or Baptiste, nor the modernized Kwakwaka'wakw art of Ellen Neel and Charlie James; it was the revived traditional Haida art of Bill Reid. Neel's legacy can be found in the hybridizing work of her son David (figure 30), her grandson David, Roy Henry Vickers and Lawrence Paul Yuxweluptun, to name but a few artists who freely mix ancient design traditions with Western styles of representation.

The revival of the 1960s is commonly credited to the *Arts of the Raven*. It was the friendship between Bill Reid and Vancouver Art Gallery curator and Emily Carr scholar Doris Shadbolt, along with anthropologist Wilson Duff and art historian Bill Holm, that provided the aesthetic and ethical impetus for the show. The exhibition proposed that the traditional arts of the Northwest Coast belonged in the world of art, not merely in the

ethnographic museum. Reid was foregrounded and was seen thereafter as
the originary figure of a post-war revival of Haida art. From the beginning
of the art world's interest in it, Native art, like all great art, was held to be
an artistic expression of a universal human essence. That was the very
quality that made it a candidate for high art and what was most valuable
about it. This artistic quality transcended any cultural agency or use,
Native or non-Native. The strategy of making a claim for Northwest Coast
traditional art as high art was in many ways worthy and successful. But at
the same time, the modernist tendency to dismiss context allowed many of
the anthropologists of the day to miss the connection between the land
claims litigations at which they were often called to testify and the art
which they saw as timeless and universal.[14]

It is probable that the idea that the traditional art of the Northwest Coast
was high art in a universal sense—an idea endorsed by no less an authority
than Claude Lévi-Strauss—was a necessary element to the success of the
revival. It was as art that these works entered the museum, institutions of
learning and the marketplace. The earlier attempts to "revive" Native art
occurred during an era when First Nations cultures were themselves under
the extreme duress of government policies designed to eliminate them.
These attempts all "failed" to create a sustainable revival. The most intense
efforts to raise the standard of curio production (and to ensure such produc-
tion was in the hands of Native producers) reached its high point and end
with Ellen Neel's studio. The idea that traditional design could be assimilated
into industrial design never went very far. For one thing, issues about the
ownership of design were always a source of contention. The careers of the
painters of Native life of the 1930s, '40s and '50s have yet to be accounted for
by any museum or gallery.

The twentieth-century revival is historically linked to the adaptation of
traditional practices to new situations created by oppression and duress.
The production of tourist curios was brought to a very high level by Ellen
Neel, whose studio made fine handcrafted multiples. She offered an example
of how to transform the curio into a marker of regional identity and how
an artist might introduce new icons and forms into the traditional lan-
guage. In more recent years, even artists of the stature of Bill Reid or
Robert Davidson have produced gold-embossed greeting cards or boxed

chocolates from their tradition-based designs. These attempts to market and mainstream Native design have a history that I have tried to begin to outline. The tension around such productions is the result of differing claims about Native design and art. In such objects, the sacred and the kitsch, the authentic and the pastiche, high art and tourist curio, all come forward as a cacophonous index to a long history book about land claims and cultural genocide. The commissioning of traditional art—including a cast of Bill Reid's *The Spirit of Haida Gwaii* known as *The Jade Canoe* (1994)— for the Vancouver International Airport, surely represents the apogee of the use of tourist curio as a marker of regional identity. At the airport, the curio becomes a monument. But the dialogue between the large works, placed in settings that signify natural rather than art or political history, and the "real" tourist curios in the airport shops, bristles with irony. For British Columbia is still largely without treaties with the people repre-sented by the art that visitors to the region first encounter.

Paradoxically, the more that contemporary Northwest Coast First Nations art refers to traditions from time immemorial, the more securely it belongs to a universalizing European aesthetic and its traditions, while art that seems at first to have been decontextualized, commercialized or modernized speaks of the reality of First Nations economies and tradi-tions. In this way, one might begin to see that the Bill Reid plush bear sold in the Museum of Anthropology shop is a cultural object informed by tra-dition and history, while the monumental Bear sculpture inside the museum's galleries has a much more ambiguous relation to tradition and history than its resemblance to older museum pieces might suggest.

ENDNOTES

1 A critique examined usefully in Crosby 1994.

2 I am indebted to Karen Duffek for this information.

3 The National Gallery of Canada, *Canadian West Coast Art, Native and Modern*, December 1927. See Morrison 1991.

4 *Report of Conference on Native Indian Affairs at Acadia Camp 1948*. The conference was held at the University of British Columbia, 1–3 April 1948.

5 Doris Shadbolt pointed this out to me. Reid's silver brooch, *The Woman in the Moon* c. 1954 is repro-duced in Shadbolt 1998:127 and in Duffek 1986:7.

6 On the back of the photograph is a note: "Arthur Lismer: Montreal, July 28 [1951] 'It's from the Indians that we learn how.'"

7 Letter from Anthony Walsh to "Madame Secretary" [of the BCIAWS], 22 January 1940. B.C. Archives.

8 Lawren Harris's involvement in Morgan's 1948 Vancouver Art Gallery exhibition and his interest in the situation of Indian art in schools is commented upon in the *Native Voice* (November 1947), 11.

9 Nuytten 1982 is my main source of information about Ellen Neel. See also K. Phillips 2000.

10 *Report of Conference on Native Indian Affairs 1948.*

11 Similar to the paintings in figure 27, but more freehand. Some had nontraditional but stylized figures wearing traditional masks.

12 *Native Voice,* January 1950.

13 *Vancouver Province,* 10 November 1949.

14 Crosby 1994 and Townsend-Gault 1994.

Struggles with Aboriginality / Modernity

by CHARLOTTE TOWNSEND-GAULT

O NE OF THE truisms that circulate around Bill Reid and his work is that he
played a significant role—and a knowing one—in the creation of his
own legend. There are several ways of understanding this. The one I want to
emphasize takes his self-fashioning to be part of his struggle to be modern, a
modern Haida artist. Modern art has been described by one of its historians,
Serge Guilbaut, as "The rejection of the past and of the direct quotation, the
disdain for an idealized world, the cult of the present in order to liberate the
future" (1983: xi). It is a critical project aimed at freeing the individual from
oppressive social systems. This degree of freedom appears to run counter to
the constraints implicit in identifying with a distinct culture and its traditions.
But modernism's critique is double-edged, as Guilbaut notes, putting the
modern intellectual "in the awkward position of confronting a crisis of
confidence in his or her own tools of analysis, in his or her own culture."
Perhaps in acknowledgement of Reid's struggle with this double-edged cri-
tique, Gwaganad (Diane Brown), at the 1999 symposium "The Legacy of Bill
Reid: A Critical Inquiry," said of his way of working: "He broke all the pro-
tocols and came rushing through."[1] Ignoring rules was a modern thing to
do. Importantly for the legend of the self-made individualist, of the modern
artist, Reid maintained that his sculptural work could stand alone and be
generally understood in the ways that mattered for modern art, needing no
special pleading. In fact, to the extent that his work was dependent on such
pleading, it would have failed in its universal reach. Important as its Haida
references were, the work was not totally dependent on them. In this way, he

made his ambivalence toward bringing the Haida past into the present, commented on by many contributors to this book, central to his own identity as a modern artist. Equally, that his work be judged on its own terms was the most effective way to acknowledge its Haidaness. Many others have endorsed the claim that Reid's work came into its own as detached, autonomous, modern (Duffek 1986, Bringhurst and Steltzer 1992, Tully 1995, Shadbolt 1998, Berlo and Phillips 1998). With the publication of Reid's collected writings (2000), we learn how he worked out ways of thinking about Haida history and memory, and then struggled to make modern their resonances in the present. He understood it to be a solitary, *modern* struggle. It is not surprising that it pleased him to be given the name Yaahl Sgwansung, which translates as "the Only Raven," by Florence Davidson.

In mourning cultural loss and forgetting, Reid seemed to imply that the best way to cut the losses was to be modern. Although he was using newly available technologies and never denied that the myths and histories—of the Raven, of Qaganjaat (the Mouse Woman), of the Bear Mother and her cubs—were supplemented from his own imagination, he expressed the hope that his work might relay some of "the old, universal magic." His struggle is implied in that phrase "old universal magic," which appeared in his riposte, republished in *Solitary Raven* (Reid 1982), to a review of *The Legacy*. This was a widely circulated exhibition that brought together the work of forty artists (including Reid himself)—promoting the term "artist" over the previously more usual "carver"—who were identified by the curators as sharing and perpetuating a Northwest Coast Native "art" style from the late nineteenth century to the present (Macnair, Hoover and Neary 1984). The review by Marnie Fleming (1982a), asked for more explicit narratives about the cultures than *The Legacy* chose to provide and for insight into their informing cosmologies, in the expectation that the understanding and appreciation of visitors to the exhibition would have been enriched thereby. Wanting to know more, having the right to know all that can be known—however illusory or hubristic this may now seem—is itself a legacy of the belief in rational enquiry that was central to the European Enlightenment, and inherited as one of modernity's own traditions.

By the end of the twentieth century, and increasingly today, such so-called free enquiry runs up against the constraints imposed by the desire of

First Nations to protect cultural knowledge, and by disputes over ownership of and access to it. Reid was certainly not alone in having a complicated relationship with these constraints—responding to them and helping to define them. His work and career identified a tension which characterizes the work of the four younger artists discussed here. And then, in the nature of contemporary art, he is a figure to work with and against. He helped to set the agenda of younger artists, and they must move beyond it. However, in the early 1970s, enquiry ran up against another constraint, that of self-referencing modernity, as the Reid/Fleming exchange illustrates. Asking for more information was to miss the point that modern art told you everything you needed to know—on its own terms.

Modernism's terms were already well established for the Northwest Coast. In 1925, anthropologist Marcel Mauss had identified the universal reach of elements of the "potlatch," making it the model for his enormously influential ideas about social exchange in *The Gift* (see Mauss 1990). From the centre of surrealist activity in Paris, artists and writers like Wolfgang Paalen (1943, 1945) and Georges Bataille (1985) found in its forested shores, its elaborate cultures and its art, as others had done in the Arctic, something mysterious and uncannily "different" that reverberated in their own "unconscious." There are echoes of Paalen in Reid's writing. And indeed words like "mystery" and "magic"—giving the universal appeal of the inexplicable—continue to colour a prevalent non-Native view of Haida Gwaii. Claude Lévi-Strauss, his own anthropology influenced by the surrealists' fascination with juxtaposing the un-alike, had bestowed an unequivocal internationalism on Northwest Coast art in his writings since the 1940s (1943, 1963, 1974, 1989). Specifically, he wrote: "Hereafter, thanks to Bill Reid, the art of the Indians of the Pacific coast enters into the world scene: into a dialogue with the whole of mankind" (1974).

In her essay for the catalogue of the *Arts of the Raven* exhibit at the Vancouver Art Gallery in 1967, Doris Shadbolt asserted that the Native-made objects were "art, high art, not ethnology." This proved to be a canonical summation of the Northwest Coast aesthetic that Reid worked out with Bill Holm, an aesthetic based on the autonomy of a work of art, and its formal and self-defining properties. This idea, derived from philosophers such as Immanuel Kant and Theodor Adorno, is somewhat removed from the

cultures of which Reid and Holm were themselves such avid students (Foster 1985, Adorno 1997, J. Bernstein 1991). However, it appears, concentrated, in Shadbolt's often-quoted, lapidary summary of this struggle as being aimed at a definition of art that was distanced from ethnology. Ethnology in this usage means something like broadly sympathetic, usually outsider, accounts of specific cultures, including their pre-modern cosmologies. However, such cosmologies are part of what the common usage of the term "culture" connotes, and Reid wrote about them eloquently. His prose poem "Out of the Silence" (1971) is a paean on this theme. But contradiction is endemic to struggle. The term "struggle" seems justified, for, as Gwaganad makes clear, she and others felt implicated: "Bill made us think and he made us research more than we would have if he wasn't there, to make us do things right. A lot of the times we had conflict, and not all conflict is bad."[2]

But in 1982, Reid was also exasperated and, deliberately or not, misunderstood Fleming to be trying to reanthropologize Native people, to put them in a different category from other artists, to suggest that their work needed the kind of explanation that art, as an international language, could do without. And did do without. Fleming's request for the local and specific cut right across the claims for universalism, or so it must have seemed to Reid. It might also be asked how disingenuous, or how wry, he was being by insisting in his essay that the kind of knowledge required to understand was not to be found in a reference library but in the sensibility of anyone with "judgment" (a very Kantian idea). The relationship between modern art and its "primitive" influences has been one of the most widely canvassed issues in the volatile terrain where art history and anthropology intersect (Foster 1985; Clifford 1988; Miller 1991; Rushing 1995). Vancouver had been the stage for an ongoing debate about how "modern" "native" could be since the mid-1960s, perhaps earlier. One notorious culmination, in a place which thought of itself as central, was the 1984 symposium held in New York at the time of the Museum of Modern Art's exhibition *"Primitivism" in 20th Century Art: Affinity of the Tribal and Modern*. Reid was there and attempted to join in. The only Native person present, he was unknown to many, perhaps most, of the academics and art authorities present. The chair, William Rubin, called the lunch break while he was speaking. Although Reid

objected, and persisted, such an interruption was indicative of entrenched attitudes according to which "primitive art" and "Native artists" were scarcely connected. In the loaded words of Sally Price, author of *Primitive Art in Modern Places*, who observed the incident: "This is a moment that captures, for me, something pretty important about the art world."[3]

It is also a pointed reminder that Reid's struggle was different in different places and that historic reversals on who may speak with authority complicate the subject position of any artist/protagonist. This struggle continues today, differently inflected, of course. The dispute between the poet Robert Bringhurst, one of Reid's great apologists, and some members of the Haida Nation over Bringhurst's translations of the work of Skaay and Ghandl, has resulted in some unequivocal exchanges over just such authority.[4]

Reid, then, had struggled to be modern. In this he was not alone. Across North America, Native artists—Alex Janvier, Allen Houser and Norval Morrisseau amongst them—were working towards a modern lingua franca while remaining loyal to their cultures (Nemiroff, Houle and Townsend-Gault 1992; Berlo and Phillips 1998; Rushing 2002). It has often seemed that contemporary Native art grew out of the productive and mutually defining relationship between modernism and aboriginality. Now it appears that aboriginality, working by its own rules, is in the ascendant. And it has been put there by two succeeding generations of First Nations artists increasingly confident of furthering ideas and ways of articulating them that lie outside the parameters of knowledge formation inherited from the European Enlightenment. That they themselves, participating in a liberal humanist democracy, are also enmeshed in exactly this knowledge formation, is well enough understood and evident in their work: cross-cultural entanglement beyond deconstruction, heavily ironic encounters, mutual (mis)appropriation—beyond salvage and beyond reprieve—and some good jokes at everyone's expense. And yet, as new ways are found of segueing the old into the new, of playing origins and futures off against each other, there is an attempt to disentangle, to separate out the indigenous.

This attempt was first brought to attention in *New Works by a New Generation*, an exhibition that marked a turning point in Native North American art. Curated by Saulteaux artist Robert Houle in 1982 in Regina, Saskatchewan, it identified a recognizable contemporary Native art. As Gerald

McMaster said of that exhibition: "It brought together aboriginal artists not as malcontents, but rather as exceptional individuals who considered their aboriginality as a constituent part of a whole" (1999:86). It asserted the power of such work to represent the culture of its maker in some sense but also that the maker was in a fundamental way regulated by that culture. Herein lie the constraints which, equally fundamentally, identify Native art and have been widely discussed (Crosby 1994; McMaster 1998; Jonaitis this volume). Strong claims have been made for works, such as Reid's *Spirit of Haida Gwaii,* as representing the strains and successes of a multicultural society (Tully 1995) and of identifying points of greatest tension. However, the exchange of ideas and mutual appropriations that inevitably accompany cross-cultural encounters do not thereby level the playing field (Thomas 1991; Marcus and Myers 1995). And Nicholas Thomas cautions against optimism over "the hybridizing tendencies that post-colonial curators and intellectuals have been anxious to identify as the exemplifications of creative subversion in the global cultural order" (2000:199).

Another tendency can be detected now which includes, but overrides, cross-cultural entanglement, or even hybridizing. Gayatri Spivak, referring to the ways in which marginalized minority cultures defend themselves— insisting, for example, on controlling access to, and thus drawing a boundary around, their cultural property—uses the phrase "strategic essentialism" (1988). What happens in British Columbia is something more like strategic disentanglement. First Nations' current, confident insistence on indigenous knowledge includes their own adaptations of that knowledge, showing them better positioned to determine the limits of disclosure and cultural trespass, and continuing the turbulent struggle that has been going on for centuries in Canada to define and give authority to aboriginality.

Canada's 1982 Constitution acknowledged pre-existing aboriginal rights. The act was an extension of constitutionalism as Tully (1995), Mercredi and Turpel (1993) and others, have pointed out, and there are many who treat this apparent advance with caution born of suspicion of statist solutions to "the native problem" (N. Dyck 1991). While "ownership" of other parts of what is now Canada were "settled" through treaties, British Columbia is different in this respect—with a few exceptions, it never concluded treaties. In 1993, the British Columbia Treaty Commission was appointed to rectify this, to settle

land claims outstanding for more than a century. Some fifty-one aboriginal groups and three levels of government are currently participating in this "treaty process," a misleadingly anodyne phrase for the most politically and socially convulsive decade in the province's history. Land claims made against the crown by people who think of themselves as Native first and Canadian second is a colossal irruption from within the polity. Desire to correct historical injustices—which deprived aboriginal groups of their rights as citizens—is again pitted against anxiety about potential settlements that could allocate different degrees of self-determination in enclaves across the province, disrupting the tenets of an egalitarian liberal democracy where multiculturalism is legislated policy.

Accordingly, and as if to pick up on the terms of the Reid/Fleming exchange, far from distancing himself from ethnology—a term now often synonymous with cultural knowledge—the Coast Salish artist Yuxweluptun promotes functionalism on his website.[5] He wants his work to be understood as adding to the store of expressions of Coast Salish culture and, as such, able to *do* something in the sense of acting upon audiences, affecting, constituting, their responses to matters outside the canvas. Like Yuxweluptun's paintings, the aboriginal agency of Robert Davidson's masks persists in disparate settings. Davidson, like many other artist-carvers, makes masks that can equally be found in museums, art galleries, in the homes of collectors, or danced in ceremonies in Haida communities. They may have to be borrowed back to be danced, or, having been danced, their value will be recognized as enhanced. As has always been the case, virtually identical masks are produced, often on commission. These sorts of replication, commoditization, adaptation, are not in themselves blocks to aboriginality. For instance, T-shirt designs and increasing numbers of personal and domestic items disperse Native-produced Native images and motifs into global circulation. Davidson's own designer chocolates enable Haida figuration to be embodied in a rather literal sense. Chris Pinney (2002), in his discussion of the ways in which notions of the Orient seeped into the consciousness of Europe, creating a "creole Europe," suggests that something like a field of figuration is being formed. Rather than tracking the social trajectories of discrete objects, it is this "field" made up of Raven or Bear or Eagle imagery, the transforming beings on masks and prints, that has social life and thus agency.[6]

Artists who identify themselves as aboriginal, but for whom the designa-
tion goes beyond that of personal identity, can be thought of as working via
such a "field." Their work is intended to *do* something, often more than one
thing: to function as markers of prestige and status, as stores of value, as
tokens of goodwill, as advertisements, as covetable goods, as ethical and polit-
ical assertions. All of this is familiar from the ethnographic discourse around
items of Native manufacture understood as active in social relationships.[7] Yet
there seems to be a renewed and wider understanding of culture as capable of
having agency in this way. (I use "culture" here with the presumption that it is
a frustratingly imprecise term about which there is nevertheless some kind of
abrasive consensus in currency.[8]) It is not that modernism's tendency to oblit-
erate the past while appropriating "primitivism" has been replaced by a
comforting symmetry between cultures nor by a utopian, open-to-all negoti-
ationism. A glance at the Vancouver newspapers, at any time over the past
decade, would correct such a fantasy. The current negotiated treaty process is
not working. The perpetuation of the cliché that Reid mediated between two
worlds overlooks how those "worlds" have changed and how the relationship
between them has shifted. He worked against ignorance, forgetfulness and
disdain in his ambassadorial role. But the difficulties of doing so in the 1970s
and '80s should not be masked by the acclaim, from many but not all quarters,
that greeted his conspicuous commissions. Again, the episode at the Museum
of Modern Art can serve as a reminder.

The heroic status that Reid enjoyed in some places as a successful mod-
ern Haida artist insulated him against the kind of critical attention that is
the only route to being taken seriously. His successors make their way in a
changed climate. Reid's struggles with the terms of modernity paved the
way for his successors to struggle with the terms of aboriginality and to
consider some of the ways in which they could make those terms their
own. Reid's initiative is everywhere apparent. He showed his respect for the
Haida by seeking external, increasingly international, audiences for their
myths and cosmology, even though he thought of them in the past tense.
He drew attention to the defining quality of "the well-made object" emerg-
ing from sensitivity to materials. His own tactical role in the positioning
of his major works—in a shrine at the Museum of Anthropology in
Vancouver, as a flagship for Canada in Washington—show him eminently

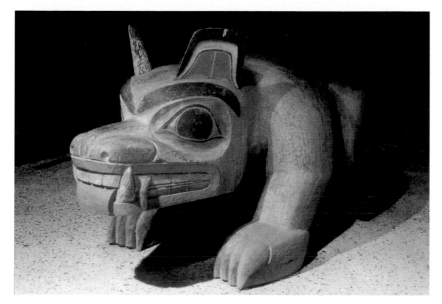

FIGURE 21

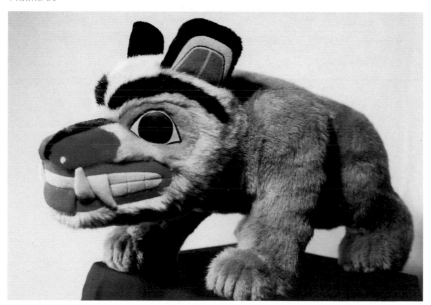

FIGURE 22

Two bears. Figure 21: *Bear* by Bill Reid c. 1962, cedar, H 1.6 × W 1.3 × D 2.1 m, UBCMOA A50045. Figure 22: plush bear, H 28 × W 25 × L 48 cm, designed by Bill Reid and produced in 1995 for sale at UBC Museum of Anthropology. Photos by B. McLennan

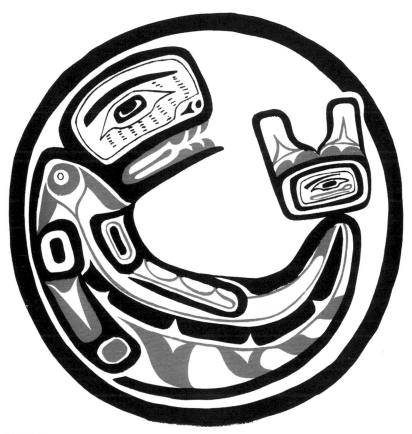

FIGURE 23

Silkscreen reproduction of a Killer Whale crest on a Kwakwa̱ka'wakw drum in
the Royal British Columbia Museum, from *Native Designs of British Columbia,*
published 1948 by B.C. Indian Arts and Welfare Society.

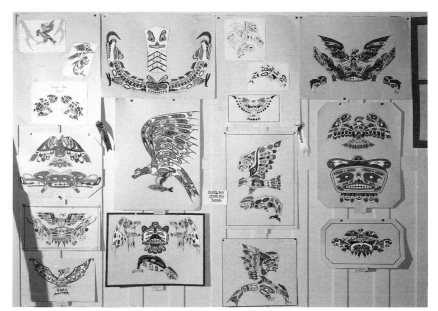

FIGURE 24

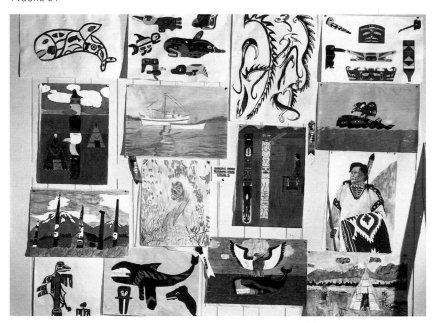

FIGURE 25

Artwork by children, part of an exhibition held by the B.C. Indian Arts and Welfare Society in 1951 in Victoria. Figure 24: works from Alert Bay Indian Day School, B.C. Archives B-02580. Figure 25: works from Alberni Indian Residential School, B.C. Archives B-02581

FIGURE 26

Ellen Neel (right) presents a
"Totemland" pole to Maria
Tallchief, prima ballerina with
the American Ballet Theatre,
1961. Photo Vancouver Public
Library 62660

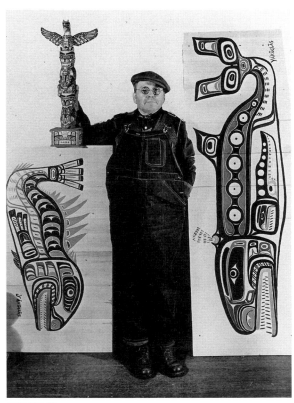

Charlies James c. 1928.
Photo courtesy
Vancouver Museum
neg. 445

FIGURE 27

The drawing by Ross Lort on the cover of this pamphlet promoting David Lambert's pottery was based on an oolichan box in the Prince Rupert City Museum, c. 1958.

FIGURE 28

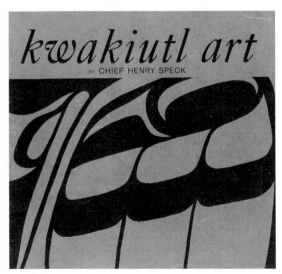

Chief Henry Speck's artwork on the cover of a pamphlet produced to advertise his silkscreen prints, c. 1963.

FIGURE 29

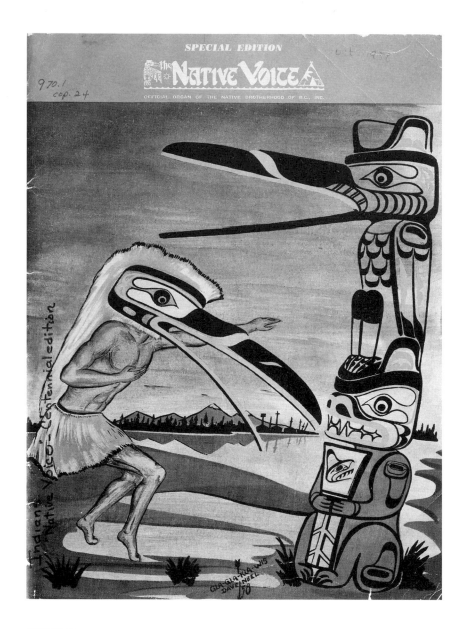

FIGURE 30

Cover art by David Neel (Gla-Gla-Kla-Wis), son of Ellen Neel, for a special edition
of the *Native Voice* marking British Columbia's centennial in 1958.

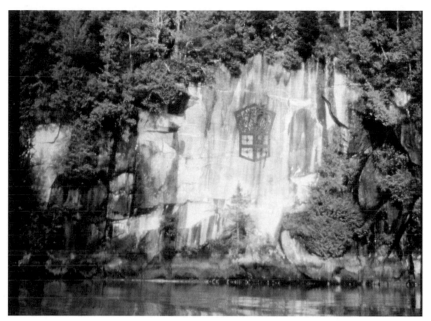

FIGURE 31

Copper painted by Marianne Nicolson on a cliff face near Gwa'yi, Kingcome
Inlet, B.C., 1998, red oxide paint, H 11.6 × W 8.5 m. Photo by Marianne Nicolson

Double-Headed Serpent, by
Yuxweluptun, 1995, acrylic on
canvas, 163.0 × 105.0 cm.
Collection of Dana Claxton.
Photo by Yuxweluptun.

FIGURE 32

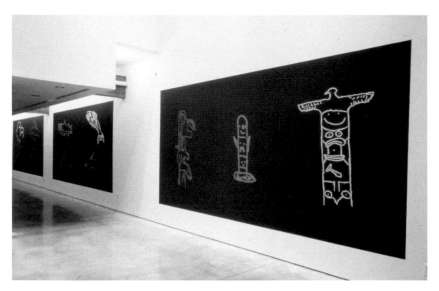

FIGURE 33

Untitled mural installation at Charles H. Scott Gallery, Vancouver,
by Brian Jungen, 1999, mixed media, 1.8 × 3.0 m. Photo by Linda Chinfen

FIGURE 34

Untitled, by Robert Davidson, 1999, acrylic on canvas, H 74.2 × W 101.6 cm,
collection of the artist. Photo by Robert Davidson

aware of political strategy. Upon all this his successors have built. They also have complicated and interrogated them, as successors tend to do.

It is as part of this struggle that the emergence of these artists, younger than Reid by a generation, or two, their attitudes variously deferential or adversarial towards him, needs to be understood. If conventional categorization were to be followed, serious contortion would be required to bring such a heterogeneous group together: Robert Davidson, Yuxweluptun, Marianne Nicolson and Brian Jungen. But heterogeneity is exactly the point. The shared effort of working out the contemporary significance of aboriginality overrides conventional distinctions between tradition and innovation. It collapses the difference between artists trained through the apprenticeship system, or by observing and copying, and those submitted to the prevailing ideas of art schools in metropolitan centres. Working on aboriginality is always heterogeneous and addressed to heterogeneous audiences, some disputatious, some complacent, some receptive, some enquiring. This needs to be taken into account; reducing all to a generalized condition of Nativeness again can hardly be a fitting goal when the goal posts are set so differently.

Rather than attempting to define what exactly, or even inexactly, is meant by "aboriginality" at a time when the word has wide currency in political, legal, administrative and public spheres, I will try to show three directions, or valences, where the struggle with its usage is most evident. These valences, very broadly, are: demonstrations of the endurance and adaptability of indigenous knowledge; concern with the nature of materials and technologies, going far beyond a narrow band of "visual" art to encompass the broad-band sensorium; and positioning, the deployment of relations between work, site and audience, making clear an intention that the results *do* something, personally, culturally, politically. In taking these points in order, they will appear more analytically separate than they should.

INDIGENOUS KNOWLEDGE

On the way to the village of Gwa'yi, on the central British Columbia coast, there is a sheer rock face that drops 36 metres (120 feet) into the waters of Kingcome Inlet. The image is unmissable by anyone going up the inlet to Gwa'yi by boat—the only way. With the consent of the Dzawada̱'enux̱w, of

the Kwakwaka'wakw, the cliff is now emblazoned with a 12-metre (40-foot) image of a copper (figure 31), that ultimate repository of value and prestige. In the upper section of the copper, a Wolf, with a treasure box, turns the cliff into a storyboard for the history of the little Kwak'wala-speaking community of Gwa'yi. Marianne Nicolson had herself suspended in front of the cliff to apply the red oxide paint, guided by a huge canvas stencil. (The paint was a compromise. It became clear that the traditional medium of naturally occurring pigment mixed with salmon-roe binder was impractical at this scale.)

Pictographs and petroglyphs are found throughout British Columbia. Although they are difficult or impossible to date accurately using archaeological methods, their histories, pre- and post-colonial, are known well enough in Native communities. Kingcome Inlet is a case in point. On the same cliff as Nicolson's pictographic enlargement of a copper, but closer to the water, some much smaller coppers have been painted, and a line of cows.[9] Cows are not traditional denizens of this land, but here they record the status of potlatching chiefs in the 1920s and thus constitute an act of defiance against the prohibitions then being enforced under the terms of the 1886 Indian Act. The cliff face is an object lesson about indigenous knowledge of "land," which is to say that knowledge changes. James Clifford (2001), in a recent account of how the indigenous remains differentiated in certain Pacific islands, makes just this point: "People aren't, of course, always attached to a habitat in the same old ways, consistent over the centuries. Communities change. The land alters. Men and women speak and act differently, in new ways, on behalf of tradition and place." The lesson is still needed as the charged negotiations leading to the Nisga'a Treaty demonstrated. Nicolson's supplement to the cliff at Gwa'yi brings the past into the future, deploying the past as "a continuous, changing base of political and cultural operations" (Thomas 1997). But fluid interpretation of past knowledge may yet come up against specific and local cultural constraints. Not merely in a declarative mode, it has something to declare. The story of the Wolf ancestor figure is the intellectual property of a community. Like the nearby potlatch count, it was made, and made public, with the compliance of that community.

In an entirely different mode, Yuxweluptun also makes powerful representations of belief systems that are stunning to look at but not necessarily

fully explained to their non-Native audience. He has found a way of picturing Native ceremonial—large narrative canvases that combine spirit beings, masked dancers and uncertain recombinant types—with environmental critique. His works show spirit familiars and shamans, power boards and rattles, replacing the Christian saints, with their paraphernalia, that derive from the convention of the figure in a landscape inherited from the European Renaissance. Here, an indigenous knowledge is surely reiterated, but not much more is explained and nothing is given away. His animation of the land literally shows that what in another historical tradition is thought of as inert matter, possesses *anima,* or spirit, and is alive. In paintings like *Red Man Watching White Man Fix Hole in Sky* (1989) and *Scorched Earth Policy: Clear-cut Logging on Native Sovereign Lands, Shaman Coming to Fix* (1991), he has drawn on Coast Salish cosmology to throw light on the devastation of British Columbia that anyone can recognize.

Yuxweluptun, an active participant in Coast Salish ceremonial, including the Sxwaixwe dance, nevertheless takes a bifocal view of his culture, a view he parodies in *Double-headed Serpent* (1995) (figure 32). He is too stern a critic to "celebrate" anything. In works such as *Throwing Their Culture Away* (1988) and *Alcoholics on the Reservation* (1988), any pieties are dispatched by an unforgiving attention to the social and domestic turmoil of reserve life. Part of Yuxweluptun's ongoing project also is to demonstrate that "myth is dead" and that its habitual signifiers—ovoids—have become voids. Ovoids are an essential component of Northwest Coast style, identified and named by Bill Holm, though their nature has been much complicated by recent work by artists and scholars (McLennan and Duffek 2000). Yuxweluptun first worked on "ovoidism," isolating and evacuating the ovoid, in 1998. His paintings of high-contrast but vacuous jostling forms are awkward and rough on purpose (Linsley 1995). He is not, for example, emulating the smooth finish of the somewhat comparable paintings of the American abstract artist Ellsworth Kelly. He is trying to make the disagreeable handling of paint itself eloquent. In this way, a more credible picture emerges of what is actually involved in legitimizing and protecting indigenous knowledge than it does from the pleasingly sinuous formlines associated with the canonical version of Northwest Coast art associated with the restorative work of Bill Reid. A conference and publication orga-

nized by the Union of British Columbia Indian Chiefs (2000) gave an indication of the extent of the need for protection of indigenous knowledges, and the diversity of methods devised to do so.

It is not news that we carry around inadequate and quasi-ignorant pictures of other cultures in our heads. In a move that gets a jump on the travesty of indigenous forms and icons, Brian Jungen indulged in a stereotyping of stereotypes[10] almost revisionist in its elegance. In a series of large paintings, made specifically for an art gallery, he brought all the crude and unselfconscious vitality revivifying the often inert authorized versions of cultural representations, off the streets (figure 33). They ended up not so much travesties as, all over again, a celebration of outsider art: guileless, childlike, primitive—and, simultaneously, a condemnation of ignorance.

A vivid instance of a mask, as an encapsulation of non-static indigenous knowledge having social agency, is Robert Davidson's recovered version of the great salmon head which repeatedly rears up from behind a suspended curtain during the Salmon Coming Back ceremony. The mask is central to a performance that honours and enacts the longed-for return of the salmon to the spawning grounds. The ceremony has been revived, under Davidson's initiative, in Rainbow Creek, the river near his childhood home of Old Massett. Davidson might have had Robert Houle's lucid epigram in mind: "It is not a question of what is left but rather of what is there."[11] Davidson has spoken of the process of recovery: "Many times I feel like I'm putting a puzzle back together, but I don't know what the puzzle is" (1993:7). He found out through a combination of study, intuition and instruction from his elders, until he was free of the constraints of what he came to think of as too-slavish adherence to information collected by anthropologists from the Haida in the late nineteenth and early twentieth centuries (figure 34). This serves to clarify that the limits set on defining Haida art and culture are not, so to speak, carved in cedar. They are always in the process of being worked out by Haida people.

Like Davidson, and as a person of Native ancestry, Jungen's choice to play with masks is exercised in a bounded and prescribed field. But that he is licensed to play with them at all, he says, is only possible because the Dunne-za do not themselves have masks. And, unlike Davidson, he is not therefore part of a revitalization process involving masks. But then again,

perhaps he is. Confections made from deconstructed running shoes, the four masks that are collectively titled *Prototypes for New Understanding* (1998) call upon a system of cultural representations as given. This is a totally different situation from the risky experiments of modernism to *invent* signs that might, somehow, work. Jungen's masks, in a way that is comparable to Nicolson's deployment of the copper, have such criteria, they have access to such inalienable meaning. But their moves with respect to it are curtailed. Although "exploitable knowledge belongs to the creators of it," as Marilyn Strathern puts it (1999: 233), the creators, or those having rights to such knowledge, may not themselves exploit it. The signs that they make their work about are proprietary signs. They mark a kind of knowledge that the language of compromise cannot reach. They mark the connection between inalienable rights and impermeable boundaries.

MATERIAL WORLD

Many Native artists, across North America, deploy beading, quillwork, weaving and basketry technologies that use a vast array of natural materials, with or without reference to ceremonial or domestic uses, past and present. The foregrounding of the *way* in which things are done, as more significant than what might be termed content, was identified by Homi Bhabha (1994) as a culture's defining characteristic. Heiltsuk elder Kendra Newman, in an often reiterated move, sharpened this understanding of the material base to the point of advocacy when she previewed the pieces in the first major exhibition of Heiltsuk work, *Kaxlaya Gvilas: Those Who Uphold the Laws of Our Ancestors,* saying: "You realize how important cedar bark—all our resources—were to us. *And the resources are still a big part of our lives.* That is a message in itself."[12]

In considering these and other valences of aboriginality, a burden of attention is on so-called visual artists because, over the past two hundred years, what has come to be called Northwest Coast Native art has tended to privilege the visual. This tendency is increasingly documented and analysed.[13] A noticeable shift from the hieratic, distanced and predominantly visual is allied to a move towards the more broadly sensuous, where references are embodied rather than iconographic or discursive. Reinstating the sensorium—reprivileging the senses of touch, smell, taste

and hearing—is now central to the promotion of indigenous knowledge. This take on embodiment is frequently linked to the unwritten knowledge carried on in oral traditions, traditions where embodied knowledge is the counterpart of that found in books. These ideas have come up many times in courtrooms and committee hearings, and at treaty tables (Cassidy 1992; Gisday Wa and Delgam Uukw 1992). A recent ethnography attempted to write non-verbal and corporeal knowledge into its verbal depiction of Salish cosmology (Bierwert 1999), while *A Stó:lō–Coast Salish Historical Atlas* (Carlson et al. 2001) reinstates the interplay between perceptions of seasonal change, topography and the life cycles of fish and birds, as central to any understanding of a culture.

In Robert Davidson and Dorothy Grant's *Seven Ravens* (1991),[14] precisely because it is nearly invisible, the fine hand-stitching involved in the appliqué work on the ceremonial blanket draws attention to the techniques of its manufacture and the physical involvement of its maker. In this discussion, this particular work, consisting of two blankets danced and then framed for display, must stand in for the endlessly inventive ways in which the essential components of the public panoply of blankets are sewn. Nicolson has made a series of paintings that take their formal directives as to scale, colour, framing edge, and figure and ground relations, from the 1.8-metre (6-foot) square button blankets of the Kwakwaka'wakw. At a further remove than *Seven Ravens,* here the stitchery and work with cloth are represented in paint. Announcing technique itself as a means of transformation, pointing up stitching as a technology for archiving the rights and responsibilities of crest ownership.

In apparent contradistinction to these pieces, the "masks" of Jungen's *Prototypes for New Understanding* (1998) draw upon, and parody, the implication of aboriginality with technologies. Yet the deconstruction and reconstruction of moulded rubber, webbing and embroidered flashes impose a hand-sewn ingenuity and uniqueness across the mass-produced standardization of running shoes. They also recall, by unpicking, literally undoing them, the sweat-shop labour that went into their standardized manufacture. From millions of identical others, these have been rescued for special treatment. So after all they too are a kind of *hommage* to the significance of making. The attention to making approaches an ethics—

one of the several associations between Native cultural production and the Arts and Crafts movement in the twentieth century. Jungen gives the ethics a global spin.

Pallets serve globalization. They are the crude but strong wooden platforms depended on for shipping goods, but often used and then cast aside, too ordinary to bother with. In a move that allies sensory referents with the iconic referents of art gallery murals, discussed earlier, Jungen transforms the pallets through a double operation. One—the old trick—they have been put into an art gallery (art as a product of volition and context); two, they have been remade and materially altered. A known object-type has been transformed: that is, from its customary manifestation in common pine to redolent cedar; from the cheap and rough to the smooth seduction of finished cedar associated with masks. Jungen's pallets are shaped with the most exacting attention to the functional banality of the original, and, joined with wooden pegs instead of nails, are much better made than the prototype. They are emphatically "well-made objects." Jungen is too adroit to be politically correct: in a gallery, they inevitably also recall masks displayed as trophies of the connoisseur's market. It is an association that can be counted on to carry olfactory, tactile and innumerable other references with it in British Columbia. Cedar is a Native referent, in other words, unmissable, if more attenuated, than is the case with iconographic references—to, say, ravens, canoes or shamans' rattles. Corporeal knowledge diffuses through the senses from the visual focus. The point may appear banal; but, equally, it may be worth reconsidering.[15]

RELATIONAL SPACE

In addition to the presumption and problematization of indigenous knowledge, and in addition to the search for fitting modes in which to perpetuate and adapt it, a third valence in struggling with aboriginality plays out in its relations with audiences and sites. Here there are disputes about the ownership and withholding of knowledge, as well as rights over its representation, and here the tension between having a shared understanding of the world and having an understanding that cannot be shared. In British Columbia, such disputes play out in the argument between Robert Bringhurst and such leaders of Haida thought as Guujaaw and Gwaganad over Bringhurst's work

in *A Story as Sharp as a Knife* (1999) as translator and poetic exegete of early
Haida texts. And they carry the widest possible resonance. All that can be
done here is to indicate briefly some of the ways in which some artists impli-
cate themselves, and are implicated, into networks of social relations
wherein these contentious and politically abrasive issues are enacted.

Each of these artists has benefited from relationships with patrons and
with authenticating institutions such as museums and art galleries. But they
also have initiated the circulation of their work, or have blocked it, in ways
that cut across their institutional classification. Thus, in a work that makes
a sculpture out of two fragments of a Haida house frame, Davidson took
the cosmology of the bighouse and turned it into a metaphor which has
personal significance for the patron—a real estate developer. In his three
poles commissioned by the Pepsico Sculpture Park, in New York State, the
shock of the old is buttressed by their placement, for they create a distur-
bance in relations between the other sculptures on the site. The crests on
the poles, over which Davidson has representation rights, are conceptually
reconfigured as overt cultural signifiers: they mean different things to Haida
and non-Haida viewers. So they shock again by affronting the public's sup-
posed freedom of access with implied claims to exclusive rights. More
recently, Davidson has made several large versions of an Eagle mask flanked
by open hands. One forms the centrepiece of a themed display on Grouse
Mountain, from which the view south over the city of Vancouver conveys
the message of prior presence on the land spread out so spectacularly all
around, as well as inviting everyone to soar above it in imagination "like the
eagle," which by implication is the capacity of the Native artist identified
with the bird. Another, the largest, a double Eagle/Raven mask, hangs as
part of the display of Northwest Coast art in the new international terminal
at Vancouver Airport. One has been widely illustrated in the publicity for a
drive to raise funds, and the patronage relationship between the artist and
the potential purchaser is both acknowledged and deployed to a particular
end: the project to assemble Haida songs and performance protocol, and to
master them electronically for archival and educational purposes.[16] It is
shrewd fundraising and as such comparable with the dinner staged in
Vancouver in 2001 by urban Tsimshian to raise funds to help with the costs
of the Schooner family's memorial potlatch to be held in Bella Coola, 800

kilometres (500 miles) up the coast, to which, as was well understood, most of those present could not be invited.

Three Power Figures (1998) is one of Marianne Nicolson's paintings of button blankets.[17] The artist knows that Kwakwa̲ka'wakw power figures, the central motifs of the work, which are believed to be imbued with the potency of *nawalak* ("sacredness" in Kwak'wala) are little known, and less understood, amongst people accustomed to looking long and hard at painted canvases. Invasive enquiry is not required to respond to their formal compulsions. As cultural representations, they say something, but not everything, about what most audiences do not know. Along with the invitation to discover and, potentially, to own, is the fascination of the no-go sign. Withholding translation carries considerable weight. Power figures and button blankets are amongst those "things" which, cut adrift from their social matrix, have been subject to the classificatory regimes of material culture. Now they are being given a different sort of iconic status in a work of art. At minimum they are icons of indigenous knowledge. Another painting in the series announces the birth of her sister's daughter. In its border, the appearance of the copper attempts to draw on the potency of coppers at Gwa'yi, as does the representation of the blanket formula itself. The question arises as to whether Nicolson is also reproducing some parts of their status and crest performativity. It is impossible for an outsider to know whether this could be the case or whether, in the paintings, the blankets, coppers and *sisiutl* are anything more than motifs. The anxiety of interpretation cannot be easily dispersed.

Nicolson's scaled-up copper on the cliff owes something to the declarative expansiveness of land art and site-specific installations. Contributing as it does to the society of the spectacle, as identified by Guy Debord (1994), the work may seem to be a gain for accessibility, a loss for signification—visible, and therefore comprehensible, to all. In this sense, it might seem to be penetrating the boundary between Native and non-Native. Inasmuch as the work can also be understood to be a declaration of the "inalienable rights" of the Dzawada̲'enux̱w, it is inevitably fraught with conflict. The huge (untitled) pictograph thus has declarations to make about the nature of private knowledge and access to it, as well as making a political statement which has at its root a declaration of irreducible difference. And there is a politics of

reception too. Native claims over their stewardship of the land—"since time immemorial"—are often perceived as making it sacred for everyone (Gelder and Jacobs 1998). This seems to have been successful when non-Natives object to the giant copper as a defacement of the land.

Pursuing the theme of translation offered and translation withheld, in contrast to the exegesis of *The Spirit of Haida Gwaii* offered by Reid himself, and extended in the same terms by Bringhurst in *The Black Canoe* (1992), and by Tully (1995), Yuxweluptun offers no equivalent in *Inherent Visions, Inherent Rights* (1991), his virtual reality installation. The viewer is allowed into the bighouse, but there is no attempt to translate what she will encounter there, no instructions about what to do when surrounded by beings who could be masked dancers, or could be spirits, or...However, world culture throws any number of heavily mediated and partially understood modes and characters into everybody's mix (Hebdige 1996). As a way of defining postmodernism, eclecticism might seem to yield exactly the kind of hybrid soup that I have argued is being resisted. The success of Yuxweluptun's work suggests that he has judged the limits of popular enquiry rather well. On the one hand, he reaffirms indigenous knowledge, for audiences Native and non-Native. But there can be little doubt of an equal tendency to cut off access to that knowledge. It recalls the conclusions of Claude Dennis's assessment in *We Are Not You* (1997) of the outcome of a trial which pitted Canadian and Salish modes of administering social sanctions.

The angry passion of Yuxweluptun's better-known narrative canvases makes an apocalyptic critique while giving oblique endorsement to the potency of Coast Salish healing ceremonials. Oblique, because potency can be lost through disclosure. The popularity and widespread reproduction of paintings like *Red Man Watching White Man Fix Hole in Sky* (1989) and *Scorched Earth Policy: Clear-cut Logging on Native Sovereign Lands, Shaman Coming to Fix* (1991) can be supposed to have furthered the perceived connection between Native people and environmentalism. In them, the Coast Salish world view throws light on the devastation of British Columbia that anyone can recognize. Audiences, typically exercising what they think of as their right of free access, may then be led towards previously much less accessible, more intractable, forms of "evidence" for aboriginality—here is

its inclusiveness. But, monitored by First Nations with sovereign rights, it becomes simultaneously, perhaps ironically, a line of exclusivity, a no-go sign. It is worth recalling here that the disagreement in 1982 between Reid and Fleming was not over *access* to knowledge but over the *need* for it.

Aboriginality is acted out in the ways in which these artists position themselves in relation to their audiences, the ways in which they avail themselves of patronage relationships, and in the unembarrassed ascription of agency to their work. I have also suggested that other valences are unmissable, and active, in their work: indigenous knowledge—that the past exists in the present, that cultural forms and ideas are legitimized through time depth or inheritance, that tradition is not so much a problematic millstone as a prescription, that survival is not at issue so much as continuity—and what I have called the material world, the focus on technologies of making. Implicit too is the need to distinguish aboriginality from the romantic primordialism associated with a reactionary, atavistic politics. Arjun Appadurai is hardly alone in warning of the threat posed by the adoption of a "primordial perspective" in animating today's frequently violent ethnic movements (1996:157). However, aboriginality is evidently deeply implicated in the politics of the liberal humanist and pluralist democracy to which it contributes but which it also confronts. How could it not? Reid might have enjoyed the mythopoetic conceit that *The Spirit of Haida Gwaii* did something to readjust the relative geopolitical significances of Washington and Lyell Island. For his successors, the struggle continues.

ENDNOTES

1 Tape recordings of the proceedings of the symposium are in the UBC Museum of Anthropology archives.

2 "A Non-Haida Upbringing: Conflicts and Resolutions," this volume.

3 I am grateful to James Clifford and Sally Price, who were both present at the 1999 symposium, for independent corroboration of this (personal communications, 2002). In arguing that major art museums were welcoming art objects from other cultures much more willingly than their makers, Price has herself (2001:459) written about the episode, referring to *"L'avidité de l'ancien directeur du Museum of Modern Art à New York d'exposer les chefs-d'oeuvre en bois sculpté et peint créés par les Amérindiens de la côte nord-ouest, contrastant avec l'impatience qu'il s'est permis de montrer devant la tentative d'un des artistes, Bill Reid, d'intervenir dans le contexte d'un colloque que le musée avait organisé dans le cadre de l'exposition."* (The eagerness of the former director of the Museum of Modern Art in New

York to display the masterworks in wood carved and painted by the Indians of the Northwest Coast contrasts with the impatience which he showed before the attempt of one of the artists, Bill Reid, to contribute in the context of a symposium that the museum had organized in the framework of the exhibition.)

4 Both sides of this debate were reported in the two-part series "Land to Stand On" in a CBC Radio *Ideas* program. Robert Bringhurst defended his position in an interview by Thérèse Rigaud (2002:21), published as a pamphlet to accompany the three volumes of the boxed set *Masterworks of the Classical Haida Mythtellers:* "Moving native culture from the junk heap to the pedestal may seem like a great step, but trading one form of cultural apartheid for another is not progress."

5 www.yuxweluptun.net

6 Pinney builds on recent thinking about the "social roles" of objects; see, for example, Lyotard 1971; Appadurai 1986; Gell 1998.

7 For a sophisticated recent development of anthropological functionalism in which art objects are defined by their social agency, see Gell 1998.

8 For a discussion on the history of the current usage, see Kuper 1999.

9 For an accessible account of this rock-face palimpsest, see Williams 2001.

10 Frederic Jameson (1981) has discussed this doubling of the stereotype .

11 Personal communication from Robert Houle, July 1998.

12 This remark, emphasis in the original, was part of a wall text in the exhibition, which opened at the Royal Ontario Museum in Toronto in 2001 and moved to the UBC Museum of Anthropology in 2002.

13 The anti-ocularcentrist critique, recognizing disjunction between the visual and other modes of understanding, is discussed by Ruth Phillips (1999), in "Art History and the Native-Made Object: New Discourses, Old Differences," drawing on Martin Jay's work.

14 This work is illustrated and discussed by the author in Nemiroff, Houle and Townsend-Gault 1992:134–41.

15 Another recent work which accomplishes the same manoeuvre is Eric Robertson's *The Crown's Game*, installed at the entrance to the Museum of Anthropology's *Gathering Strength* exhibit. Twin cedar columns extend both welcoming and resisting hands to the passerby. Tactility is a kind of offence in the context of a history of broken agreements. You can touch, but for that very reason you may think twice before grasping the hands.

16 The Songs of Haida Gwaii "Legacy Project" recognizes that "while Haida art and culture have been studied extensively, traditional Haida music has not received the same attention and effort" and aims to "maintain the integrity of traditional Haida songs and song protocol through developing quality learning resources for Haida singers of future generations." Initiated by members of the Haida Gwaii Singers Society—composed of Robert Davidson, Terri-Lynn Williams Davidson, Reg Davidson, Guujaaw and Marianne Jones—the Legacy Project intends to produce and accurately translate a collection of 250 songs, recorded in the early twentieth century at Skidegate and Massett, that will become part of an education program for younger members of the Haida Nation.

17 Discussed in Townsend-Gault 2000.

A Bringer of Change:
"Through Inadvertence and Accident"

by MARIANNE NICOLSON

> *"I have created the Raven in my own image over the years and insist that mine is the version of this personality that is correct, well, at least it is correct as far as I am concerned. It suits my own attitude toward the world and its people to believe that the Raven is this completely self-centred, uninvolved bringer of change, through inadvertence and accident, and so on. I certainly and deliberately introduced a great deal of variety into the people in the clamshell which I suppose grows out of growing up in an individualistic society we profess to have. It's a version of the Raven myth for today, not for the time when it was created."*
>
> —Bill Reid (in *Artists and the Creative Process* 1983)

I WAS BORN IN 1969. My mother is Dzawada̱'enux̱w, one of the Kwakwa̱ka̱'wakw nations that occupy the upper portion of Vancouver Island and the adjacent mainland. The Dzawada̱'enux̱w live 5 kilometres (3 miles) up from the mouth of Kingcome Inlet. Isolated, with a grand population of just over four hundred, the community of Gwa'yi has given birth to an unusual number of great artists and an unusual amount of great art. Like that of the people of the rest of the Pacific Northwest Coast, its artistic heritage is rich and abundant. Unlike some parts of the coast, its historical legacy is still evident within this small village. This is because the Dzawada̱'enux̱w refused to leave their ancestral home, despite the insistence of the Canadian government. It is also an isolated place, difficult to get into. The Dzawada̱'enux̱w were left to themselves, more so than others,

so it was natural to continue upon this trail of artistic production. I had always wanted to be an artist, and art was everywhere.

When I was an adolescent, spending my summers in Gwa'yi, in Kingcome Inlet, I began to discover our great art. Old poles, not ancient, but certainly older than I, my mother and even perhaps my grandparents, lined our single dirt road, and every trip through the village required us to pass under their ever-present gaze. Two of them were spare human forms with limbs missing, the arms that used to reach outwards toward the river in perpetual greeting. (Later, while studying classical Greek statues at art school in Vancouver, I would be reminded of these amputated companions.) The third pole was a wonderful study in line, form and composition that in presence and stature towered above the other two. At the top, Kulos, younger brother of the Thunderbird, and beneath in descending order, a Whale, a Wolf and a copper. These beings, to me, seemed just as alive as when they had initially emerged from their raw cedar form generations ago. They were animated and infused with spirit.

In 1936, my great-grandparents' generation had decided to build a church in our small community, and within that church they created art-works of such diversity and virtuosity that it was most likely the first "gallery" that influenced my own art. Dzawada̱'enux̱w skills and expressive-ness were embedded within the finely carved bishops' chairs and the lectern, an eagle who turned to view the congregation while shouldering the burden of the Bible. Through the window, I had a clear view of the pole, carved at the same time as the church was built, which recognized the four tribes of the Musga̱magw Dzawada̱'enux̱w: Thunderbird, Wolf, Raven and T'se̱ka̱'me (the Cedar Man), supporting them all.

Years later, while studying art at the Emily Carr Institute of Art and Design, I began to make trips to the Museum of Anthropology. It seemed a middle ground: within the city but offering the familiar objects that reminded me of home. But looking at the poles there, I felt awkward. Something inside me felt that somehow these objects, so familiar, had become diminished, their eloquence curtailed. The glass walls of the museum were a barrier, a box meant to contain objects. Away from their original contexts the poles seemed suspended in time. I would greet them

like old friends, silently whispering to them a few of the Kwak'wala words of greeting that I knew.

Passing on through the museum, I eventually discovered an alcove, and within this darkened alcove, a formidable sculpture—familiar, yet different. This sculpture displayed identifiably Northwest Coast forms, yet it was not completely of a traditional genre. Indeed, it was definitely a sculpture—not a pole, a memorial monument or a ceremonial mask. Within an allocated space and specifically lit was a large clamshell from which human figures were emerging. Perched atop this clamshell was a raven, elegant and animated. And the work changed as I walked around it. Every angle offered up something new. It was, of course, Bill Reid's *The Raven and the First Men.*

This work appealed to me for various reasons. Its scale was large and unusual, not upright and linear like the poles, nor square and boxlike, but rounded and full-bodied. Small humans, both hesitant and curious, emerged from a clamshell; with the all-observing raven, their forms flowed and moved, converged and diverged in a harmonious composition, reminding me of the Kulos-topped pole in my home village of Gwa'yi. Yet it was without the sadness and suspension from time and place of the objects in the Great Hall. This was not a work separated from its original context but a work of art fulfilling its intent within the institution that it was meant to inhabit. Instead of nudging at feelings of loss and of a culture usurped, here was a work which, while recognizing the rich and wonderful past, was making a powerful and very present statement.

This experience, amongst others, made me ask questions about museums, which had collected, preserved and protected objects that were a reflection of the people I was a part of. Why was I uncomfortable with the poles and objects on display: those that had been collected from villages and communities such as Gwa'yi (Kingcome Inlet), Gwa'yasdams (Gilford Island) and 'Yalis (Alert Bay)? Why did they incite such sorrow? They were misplaced friends, old friends, whom I felt somehow missed the winds and the rain and the passing seasons of their home communities, the actions and activities to which they were meant to bear witness. Now, what was their objective? To witness the growth of tourism and the day-by-day rush of curious onlookers, students and professors? What of their own people,

the descendants of their creators? Well, they could come and visit, as I could, gaining something and feeling sad all in the same moment.

It intrigued me that *The Raven and the First Men* did not incite the same depressing reaction. This was not a creation imported from another community but an artwork that seemed to be a part of, and to communicate within, the framework of a Western institution. This work was not created for a potlatch ceremony, nor was it a curio imitating such objects. So I was at ease with it in the museum space. Later on I would incorporate these ideas into my own artistic production. I would be uncomfortable producing ceremonial works for display in a Western context—a museum or a gallery—so I would adapt them. No, I could not, would not, create a blanket for display. Instead, I would build wooden structures to be painted, based on blanket compositions. I would create paintings, not ceremonial objects, for display in Western contexts. To view a painting in a gallery was a Western notion. Ceremonial works would be reserved for their original intent: ceremonies.

Bill Reid had done just this when he created his sculptures *The Raven and the First Men* and *The Spirit of Haida Gwaii*. And while *The Raven and the First Men* was an expression of the creation story of a people, *The Spirit of Haida Gwaii* went further and attempted to express the contemporary mood of a nation. It is the pinnacle of Reid's production, the high point of his formal aesthetic. Here, he has mastered all the techniques of his rich inheritance, and others besides. A variety of creatures are crowded into a canoe, some paddling, others there for the ride. One figure dominates: a chief, with spruce-root hat and speaker's staff. The crest figures are expressive, alive and interacting. The chief is benign, lordly. They are composed in a way that leads the eye around and around, a journey of acute visual satisfaction, so that formally the work is an overwhelming aesthetic accomplishment.

It is within the content of this work that Reid has shifted; a slight shift, but nevertheless a movement away from the traditional subject matter of the Northwest Coast. Present are the animals, always a fixture, but this work moves away from pure depiction and is infused with a commentary that has not been present in earlier works. The canoe is overcrowded and precarious with evidence of animosity amongst the characters, and it is within this expressiveness that *The Spirit of Haida Gwaii* begins to take on a political overtone. This is a depiction of a nation which is struggling in its attempt to move

forward in unison. Is Reid acknowledging that differences and disparities do exist within this Canadian nation? From my perspective as a First Nations person existing in a contemporary Canada that has yet to resolve its "Indian Question," the criticality of the work is mild. It exists nonetheless, and removes the sculpture from the sphere of the strictly traditional.

So *The Raven and the First Men* and *The Spirit of Haida Gwaii* launched Bill Reid onto the national and international scene, not merely as a great First Nations artist but as a great Canadian artist. Why? Because within the Canadian national artistic consciousness, Reid had taken his work beyond the ethnographic and into the artistic. How? Because he had broken away from the norms and created new work with Western sculptural technique and by infusing his most notable work, *The Spirit of Haida Gwaii*, with critical commentary. By doing this, Reid was able to open up the interpretations of his work to a Western audience beyond the merely ethnographic.

The belief that Reid single-handedly revived the Haida art form is perhaps misleading. There were certainly other talented, notable Haida artists who could also be given credit for this, but it was Reid who was able to take it to a point where the Western world could comprehend the work beyond the anthropological. Initially, it was his choice of materials that bridged that gap. He began with gold and silver, which, interestingly enough, were appropriated by the First Nations for their own purposes when introduced to the Northwest Coast by early traders; later, he worked with materials such as plaster and bronze, never before used by the indigenous people of the area.

However, First Nations have been consistent in their ability to adapt materials to their own requirements. For example, when sheet metal was introduced, new coppers (the copper shields used up and down the coast as a symbol of wealth) were produced from this material, as it was easier to acquire than the native copper. When wool and buttons were acquired, cedar blankets were discarded and ceremonial button blankets began to take their place, introducing what was certainly a new and innovative mode of artistic production. These developments were, however, contained within indigenous cultural institutions. Reid took his innovations into Canadian national artistic institutions and became renowned for it.

The Raven and the First Men and *The Spirit of Haida Gwaii* belong in the same continuum as the work of sculptors such as Auguste Rodin and Alberto

Giacometti. These sculptures were not produced for a tribal ceremonial or memorial, but for exhibition. Reid used the formal visual language of his Haida ancestors, which he knew well, and inserted it into this continuum of Western sculpture. This was why the sculpture that I encountered at the Museum of Anthropology in Vancouver did not disturb my sensibilities as the other older, traditional, recontextualized works did. This work had not been taken away from its original context in order to fulfill another culture's mandate.

I believe, and this belief comes from my own experience as an artist in similar circumstances but of a younger generation, that Bill Reid's background enabled him to see things in a cross-cultural manner and to create sculptures that could be visually literate in two cultures. Since the artist needs a comprehensive understanding of both, there are few works that are equally articulate within both indigenous and Western contexts. Both *The Raven and the First Men* and *The Spirit of Haida Gwaii* accomplish this difficult undertaking. They have left the strongest impression on me. They refer to our people today, for these are not historical works, nor works attempting to preserve a time long past. They articulate a vital contemporary existence, and it is of value to all the First Nations of Canada that their expression be registered by the nation's consciousness.

Re: Reading Reid and the "Revival"

by LESLIE DAWN

S CHOLARLY BOOKS such as the one in your hand attest to the growing
recognition that Bill Reid's productions are as conceptually elusive as
they are physically beautiful. Not only does his oeuvre span multiple cultural
heritages and traditions but the diversity of authors appearing herein indi-
cates that its complexities require the resources of more than one
academic discipline to be fully comprehended. Since Reid first emerged as
a leading figure in the so called "revival" of Northwest Coast Native art in
the 1950s, both art history and anthropology have claimed his productions
as their proper objects of study. But it seems he exceeded the borders of each.
This has led to certain disciplinary overlaps and equivocations: art historians
argue about Reid's position within the ethnographic realm, while ethnog-
raphers decipher his place in art history. Reid was well aware of this double
attention and its potentially disruptive discursive consequences. By posi-
tioning himself somewhere in the ambivalent spaces between the two
disciplines, he escaped, if not challenged, the narrow confines of both. His
ironic and punning identification of himself as an "artifaker" speaks to his
delight in playfully resisting singular categorizations, be they linguistic or
academic (Duffek 1986:41). I would even claim that he found a degree of
agency in this provocative ambiguity.

But as much as this ambivalence of identity was generated by the artist,
it also owed something to the specific histories and shifts within the two dis-
ciplines and his relationships with them. Their mutual focus on Reid in the
last fifty years indicates that the two have much in common. From the late

1800s to the 1920s, both ethnology and the art world worked jointly with the government of Canada to produce an image of the Indian that was based on cultural decrepitude if not total disappearance. At the same time, each was engaged in appropriating motifs and principles from the "primitive" to revitalize the Dominion's claims to modernity and a distinct identity different from its colonial parents.[1] The complex network of interdisciplinary assertions on which this construction of the image of the "Indian" was based might be termed the "discourse of disappearance."[2] Its basic assumption, supported by both art history and ethnology, was that the object of their study or representation was rapidly and inexorably vanishing before their gaze. This view prevailed into the 1930s (see Dawn 2001), but in the last few decades, that is from about 1970, both disciplines experienced substantial revisions.[3] Each field underwent a process of questioning its basic assumptions, problematizing its methodologies and redefining its relationships with its objects of study. As modernist paradigms for structuring knowledge into ever more exclusive and specialized areas and fixed singular truths collapsed, and as issues such as colonialism, class, gender, ethnicity, race, identity and so on emerged, radical alterations were inflicted on each.[4] But it was also the inclusion of the voice that was formerly seen as silent: that is, the voice of the object of scrutiny and study, the object which both disciplines attempted to discipline, the unruly indigenous voice which began to speak back, that wrought profound changes. The continuing presence of this voice led to the abandonment of the notion of disappearance.

Before the discourse of disappearance disappeared entirely, however, it first took on a new, and somewhat deceptive, form. Until the 1990s, the concepts of the "revival" or "renaissance" of Native art, culture and identity circulated as stable, given truths. Earlier, throughout the 1950s, 1960s and 1970s, leading scholars from both disciplines, otherwise given to sober reflection and insisting on historical and social grounding, spoke repeatedly of the "miraculous rebirth" of Northwest Coast Indian art, culture and identity in general and Reid's work in particular but seldom offered historical particulars other than vague generalizations. For example, in 1975, art historian Joan Vastokas wrote on "Bill Reid and the Native Renaissance." She dated the total death of all Native culture on the West Coast as occurring between the potlatch ban of 1885 and the 1920s. On the other hand, she saw

a new pole which had recently appeared in Old Massett as "a miraculous sign of rebirth for native culture as a whole. Now, instead of mourning the decline and death of West Coast traditions, writers have begun to proclaim a native renaissance."[5]

As the title of Vastokas's article indicates, Bill Reid occupied a central place within the construction of the "renaissance." The most visible of all Native artists, he and his work were identified with it. He came to serve as a metonym and a cipher for the "revival" of all of Northwest Coast Native art, culture and identity in general, which was seen, at times, as a non-differentiated whole. The archaeologist George MacDonald for example, spoke of Reid in 1983 as "signalling that Northwest Coast native culture was not extinct but was, shamanlike, rising from the ashes."[6]

To the extent that Vastokas and MacDonald's metaphors on Reid could be taken as authoritative, the two terms tacitly assumed, and reinforced, the assumption that all Native culture and identity on the Northwest Coast had suffered extinction and loss at some point in the past, and that any current manifestations were the products of this "revival." In this sense, the terms occluded the specific and complex histories of accommodation, negotiation and resistance of individual peoples. It is now becoming clear, as the unique histories of various groups within the Canadian colonial context are being compiled and written, that these assumptions were anything but the case. Narratives of resistance to the programs of cultural suppression, especially the potlatch ban, as well as the failure of that program, are becoming increasingly well documented.[7] Somewhat paradoxically, just as the term "disappearance" has disappeared, so the term "revival" has gone through a revival. Its usage in the second half of the twentieth century in relationship to the state of post-contact Native cultures in Western Canada is an echo of a previous deployment. Christopher Bracken (1997: 180–82) has recently studied the contradictory meanings attached to the term "potlatch" by non-Native writers wishing to define, and hence control and eradicate, the core of Native cultures. He points out that "revival" was used extensively from just after the beginning of the twentieth century into the 1920s as a means of circumventing the acknowledgment of the persistence of Native traditions and identities in the face of moves to render them extinct. Officials, confronted with the continuity of the potlatch, for example,

"were unable to admit their predictions were wrong... so they suggested that the potlatch had indeed passed away but then returned from the dead" although "there was no reason to conclude that the reviving potlatch had ever died." The questions then arise: why the insistence on an obviously fictitious "revival" to disguise continuity and was there a similar denial going on the 1940s and 1950s, when the term appeared in its second context? Indeed, in the recent past, a discourse has emerged within the new art history and ethnology which might be termed "the discourse of continuity or survival," calling into question those of both disappearance and "revival."[8] In this context, how is one to read the meaning of the post–World War II "revival" for both art history and ethnology and their assessment of Bill Reid and his work, as well as its popular reception?

The meaning of "revival" and the role played by Bill Reid in the post-war period were inextricably linked. Not only were art history and ethnology instrumental in creating an interdisciplinary discursive knowledge of Reid, each participated in ensuring that he and his production were discussed within a historical / cultural / aesthetic construction that became known as the "revival" or the "renaissance" of Native art. These were romantic and appealing terms, which seemed to recognize the continued presence of the Native as replacing the increasingly discredited rhetoric of disappearance. Yet, insofar as one cannot have a rebirth without a preceding death, both loaned their predecessor validity while neither called for a critical reassessment.

The Haida scholar Marcia Crosby has already noted the existence of the "revival" as a construct for defining and knowing what she termed the "Imaginary Indian." She observed that both art history and ethnology placed Reid within "what he calls 'the so-called great revival' of native art": that is, the myth of the death and subsequent miraculous rebirth of Native culture and identity.[9] Although Crosby sketched out something of Reid's role within it and threw it into question, she placed the overall complex historical and social context of the mythic "revival/renaissance" beyond the scope of her inquiry. I would like to take up where she left off and investigate Reid's personal relationship to the "revival," his negotiations and accommodations with it, the identities he constructed from it and the effects he may have had on it. Indeed, I would like to propose that Bill Reid both participated in the construction of the "revival/renaissance" and then

just as purposefully used the voice and identity he was given to undermine and dismantle the terms on which it initially was founded.

In my 1981 master's thesis, which attempted to encompass both art history and ethnology, I suggested the possibility of cultural continuity among the Gitxsan of the Upper Skeena River in opposition to the discourse of disappearance or the narrative of "fatal impact." Focussing on the museum of 'Ksan, I sketched out the specific historical conditions in which the "revival" appeared in the 1940s and noted that the concept "appears fairly malleable and occasionally changes meaning" (Dawn 1981:51). In general, the "revival" emerged as a complex of integrated programs spanning diverse but communicating governments, institutions, corporations, disciplines, audiences and artists, whose primary intent was to foster and control the production, consumption and knowledge of Native culture, and specifically Native arts, by a non-Native consumer culture.[10] Subsequent work has broadened the discursive or institutional complexity of these programs and their historical and cultural meaning, as well as the extent of Native resistance to policies of assimilation.[11]

The programs associated with the "revival" represented a substantial shift, or more precisely, a reversal, in the position of the Canadian government and its agencies in dealing with First Nations peoples, cultures and arts. The change first emerged shortly before World War II, when the federal government took a renewed interest both in the "Indian question" and in forming a new Canadian national identity within the arts. Several factors entered into this radical change, including the increased organization of Native peoples on the west coast. The Native Brotherhood, formed in 1931 to voice common concerns over Native rights and the repressive aspects of the Indian Act, was growing in power by the Second World War.[12] The Brotherhood took an active role in altering the direction of these changes and the course of the "revival" after the program was instituted. The revisions in policy, such as they were, were implemented under "the Special Joint Committee on the Indian Act, which sat until 1949 and ultimately led to the passing of a new Indian Act in 1951" (Hawker 1998:229). In many ways, this allowed for the integration of Native arts into the fabric of a Canadian national identity.

This is not to say that Canada had not previously attempted to incorporate Native arts within its cultural heritage. In fact, it had taken a leading

role in this endeavour in the 1920s. Canada displayed Native art as part of its national artistic heritage in early 1927 at the Jeu de Paume in Paris, and later in the year at the touring *West Coast Art, Native and Modern* exhibition. In both instances, the Native work was presented as belonging to the past, a discontinuous tradition which had been replaced by the "modern" landscape images of the Group of Seven, which were figured as native, indigenous and autochthonous—all terms appropriated from the "Indian."[13] The National Gallery of Canada, however, did not pursue this idea after 1927, and Canada lost its position of leadership in recognizing Native art as art, even if this was viewed retrospectively.

Events had, however, progressed differently in the United States. During the 1920s, there was a growing movement in the Southwest by powerful and influential interest groups to have the arts of the indigenous peoples of this region recognized as continuous and ongoing aspects of their surviving cultures, and as a contribution to the construction of a non-European American culture and identity (see Mullin 1995; Penney and Roberts 1999; Schrader 1983). In the 1930s and 1940s federal government programs and various exhibitions promoted Native arts and crafts, albeit for economic as much for cultural and artistic reasons.[14]

The financial success and economic potential suggested by these programs and exhibitions did not escape the notice of Canadian government officials, who began to consider similar initiatives.[15] Implementation was to take some time, however. Other than the war, there was an important issue to be resolved: how to reconcile the idea of the contemporary production of Native art with the policy of disappearance without undermining and exposing the errors of previous government programs and discursive truths. It was at this point that the rhetoric of "revival" re-emerged. In 1939, Marius Barbeau, ethnologist at the National Museum of Canada and among the foremost proponents of the discourse of disappearance in Canada, announced that he and the federal government had reversed their position on the possibility of a "revival" and that the latter was investigating a program to "restore the lost arts of the British Columbia Indians."[16] Mentioning argillite and silver work particularly, and citing the interest in tourism and economic enhancement of the Native community, he was quoted as saying: "The authorities in Ottawa are satisfied that there is a good future for Indian

craftsmanship."[17] Here, death and revival, along with government programs and a resistance to evidence of continuity, and precisely the arts with which Reid would be linked, that is, those which were marketable to a non-Native audience and would not be seen as evidence of cultural continuity, were closely joined.[18]

As well as Barbeau's expression of intent on behalf of the federal government, that same year the British Columbia Indian Arts and Welfare Society (BCIAWS) was formed under the direction of Alice Ravenhill and the aegis of the British Columbia Provincial Museum (BCPM).[19] The society sponsored educational programs and focussed the public's attention on Native art through various activities and exposure in the news media.[20] Beginning in 1943, these included annual exhibitions at the museum, where Thunderbird Park had just opened two years earlier.[21] Both the museum and the society experimented with various types of artistic production and their marketing potential "that served as the basis of promotion and marketing over the next three decades." As Ron Hawker points out, such control allowed "state officials to define the criteria for what constitutes 'Indian' art" and to establish the parameters of what it meant to be a "Native artist."[22] As will be shown, this control did not go uncontested.

In 1948, the BCIAWS served as the organizing body for a conference at the British Columbia Provincial Museum in Victoria, chaired by Harry Hawthorn from the University of British Columbia (UBC), where he had recently become head of the newly created ethnology department.[23] His wife, Audrey Hawthorn, also an ethnologist, became the assistant curator of the ethnology museum, which opened in 1949. Hawthorn issued a report with far-reaching recommendations on "Arts and Crafts," "Health and Welfare" and "Education."[24] In terms of the arts, which were discussed first, it concluded that "[i]n view of the fact that the B.C. Indian Arts and Welfare [*sic*] has carried out a sustained experiment in the marketing of Indian Arts and Crafts, we recommend that the Society prepare an evaluation of the experiment with suggestions as to the possibilities for future development and expansion, and that these suggestions be submitted to the Indian Affairs Branch, Ottawa."[25]

Over the next two years, events progressed rapidly as the programmatic "revival" entered its second, expanded and more complex, yet also more

focussed, phase. After an initial period of "experimentation," its aims and means were clearly established. It now involved the participation, co-operation and co-ordination of various levels of governments, educational institutions, museums, galleries, corporations and individuals, albeit within a small community. For example, immediately following the conference, one of the participants, Ellen Neel, a Kwakwaka'wakw artist who had learned the art of carving from her grandfather, Charlie James, was given a workshop and salesroom in Stanley Park, in co-operation with the Parks Commission of the City of Vancouver. Despite her insistence on her direct links to a continuing carving tradition, her work was presented to the public as "conscientiously attempt[ing] the resuscitation of the real old native arts."[26]

In the fall of 1949, the University of British Columbia announced a project to restore the poles in its collection and to build a Totem Park.[27] Mungo Martin, a carver from Alert Bay, also related to Charlie James, was engaged to undertake the work, assisted by Ellen Neel.[28] Martin had been carving poles and other objects for fifty years, and was an authority on all aspects of the (continuing) culture of his people. During his stay at UBC, which lasted until 1952, he also carved several new poles for the university. He then moved his operations to the Provincial Museum, where he not only carved new poles to replace the old ones in Thunderbird Park but also built a bighouse, which was opened in 1953 with a three-day potlatch televised nationally.[29]

In the meantime, the Hawthorn report was integrated into the larger national program. It formed one of the background papers for the *Report of the Royal Commission on National Development in the Arts, Letters and Sciences 1949–51*, which was instrumental in reformulating the concept of Canadian national identity as expressed in the arts.[30] Native peoples and productions, addressed in a separate section, were now included as potential contributors, rather than exemplifying a lost heritage. Despite developments in British Columbia, however, the Royal Commission report still equivocated on whether Native cultures and arts were irrevocably dead or whether it was still possible to supply a valid context for their "revival" under government supervision. The concept of continuity was, not surprisingly, absent. Nonetheless, several methods were outlined for creating public interest in Native art and for promoting its production on a wider, national, basis than those indicated by Hawthorn:

11. Several suggestions have been made about the type of assistance that might be given: cooperation from the National Gallery in preserving and publicizing Indian designs; travelling exhibitions of Indian work; special instruction; and a study of marketing problems for the different kinds of products . . . High standards of quality must be maintained . . .

12. It has been suggested that the Indian Affairs Branch be encouraged to look after these matters, and that it be provided with the necessary resources . . .

13. These voluntary groups and individuals . . . seem to agree that the Indian can best be integrated into Canadian life if his fellow Canadians learn to know and understand him through his creative work. They have suggested to us that it is no act of patronizing charity to encourage a revival of the activities of those who throughout our history have maintained craftsmanship at the level of an art.[31]

Such exhibitions of works of "quality" soon followed, in which Native art re-emerged as art within the art world.[32] In 1951 sizeable loans from the collection of the BCPM were shown at various art galleries in Canada and the United States, including the Montreal Museum of Fine Art.[33] In 1954, the Victoria Art Gallery organized a show of Native art, including some pieces never before publicly exhibited, in conjunction with work by Emily Carr and Sophie Pemberton. The following year, the gallery exhibited a show from the Alaska Arts and Crafts Exhibit, sponsored by the BCIAWS.[34]

In 1954, Harry Hawthorn collaborated with Stuart Jamieson and Cyril Belshaw on a broad survey of the Native situation, focussing "on the adjustments of the Indians to the Canadian economy and society."[35] The comprehensive report, commissioned by the Department of Citizenship and Immigration, included a section on "The Economic Role of Arts and Crafts" (Hawthorn, Belshaw and Jamieson 1958:257–67). Despite the breadth of the initial mandate, this section was, as with most of the report, restricted to British Columbia and was detailed in its analysis.[36] The chapter was more specific than either the first Hawthorn report or the Massey Commission. It outlined both the unique problems and possibilities of promoting a craft "revival" in the province and made direct recommendations for future production,

marketing and education programs based on the Alaskan model. With the aims, means and motivations clearly established, the second phase of the "revival" was now complete.

It is then, in the third phase of the "revival," that Bill Reid was integrated into the program, which at that point lacked a central figure with whom the public could identify it. Handsome, urbane, articulate, charming, assimilated but with a important lineage through his mother to the Haida carver Charles Edenshaw, who was cited as both the best and last of the great Haida artists, Reid was the perfect figure for constructing the necessary biographical and cultural narrative upon which the mythic foundations of the "revival / renaissance" were built and communicated to and identified by the public.[37] His first knowledge of the "revival" is difficult to date, as is his decision to position himself within it, but he probably was aware of initial developments in Victoria under the BCIAWS as early as 1939, just as he was leaving high school and beginning his career in public radio.[38] By 1943, when the program was in its first stages, he took his first trip as an adult to Skidegate where, as his biographer Doris Shadbolt tells us, he encountered connections to his Haida past. In 1948, when the "revival" was entering its second phase, he began two years of training as a jeweller at the Ryerson Institute of Technology in Toronto.[39] Here, he immediately used his connections to make a replica of a Haida bracelet and took a sudden interest in poles in the collection of the Royal Ontario Museum. These actions, as well as his readings in Native art at the time, must be seen in the context of the "revival." At the same time, he was rising through the national media network of the Canadian Broadcasting Corporation (CBC), thus answering the need for radio and television coverage identified as early as 1939 by the BCIAWS.[40] In 1951, Reid moved to Vancouver to take up making jewellery and continue his work at the CBC.[41]

Well prepared and positioned for his forthcoming role, Reid seems to have officially joined the "revival" in 1954, when he became part of a totem pole salvage / restoration program undertaken by Wilson Duff of the BCPM, Harry Hawthorn at UBC and the Indian Affairs Branch.[42] The project had its beginnings in the late 1940s, at least in its conception, but in 1952, H.R. MacMillan showed an interest by contacting Hawthorn and offering to underwrite the project.[43] This corporate involvement by a prominent British Columbia lumber company was, at first, largely disguised. MacMillan

"remained a more or less silent partner, contributing major portions of the funding while remaining anonymous in the committee's promotional literature."[44] When MacMillan and others, such as lumber magnate Walter Koerner, did emerge as contributors, their altruistic, humanitarian motives were always stressed. Hawker suggests, however, that other purposes, especially concerned with land claims, may have played a part.[45] Aside from collecting, preserving and restoring poles, the program was designed to draw public attention to the distinctive art form, establish benchmarks of quality, identify poles with the province, create a tourist attraction, and serve as the foundation for developing carving programs.[46] Duff made a preliminary trip to Haida Gwaii in 1953 to assess the situation and raise public interest.[47]

Reid was essential to the program's publicity aims. As Duff reported in 1954, on the second salvage expedition to Haida Gwaii, "Mr. Bill Reid, a C.B.C. announcer of Haida descent, gave his time to take part in the project, and prepared two radio reports and two interviews which were broadcast. Photographs and movies taken by the Anthropologist [Wilson Duff] were widely publicized; the latter were televised on two occasions."[48] The text of one of Reid's talks has been recently published. In it, he stressed his personal relationships with the Haida people in general and the village of T'anuu in particular. He also established his vision of the poles there and at Skedans as art: that is, as monumental sculpture of a "high standard of artistic achievement" (Reid 1954a:41). He characteristically figured himself as just going along for the ride, providing no acknowledgement of his own role in the broader program.

Yet his position was anything but passive. Reid soon began active collaboration with both the ethnographic and art worlds, both of which had already established the basic premises and boundaries of the "revival" and the subject position of "Native artist," which he would come to occupy. In the spring of 1956, the Vancouver Art Gallery launched *People of the Potlatch*, the first of a series of major exhibitions designed to introduce and educate the public on the principles and quality of Native art.[49] The material in this ambitious and important, but often overlooked, exhibition, which included several hundred objects, consisted primarily of historical work drawn from the collections of the new Museum of Anthropology at UBC and the BCPM.[50] The richly illustrated catalogue contained an instructive essay written by

Audrey Hawthorn,[51] who placed the arts within their cultural context: that is, she saw, and instructed her audience to see, the work primarily as ethnographic rather than purely aesthetic. She reported, however, that the potlatch was a discontinuous tradition.[52] Her text mentioned no current artistic production or any possibility of a "revival," nor were there any illustrations of contemporary work.[53]

The actual displays, however, may have conveyed a different message. Archival correspondence indicates that "Haida silver and gold work[s]" were borrowed from Reid, who, by this time, was making copies of Edenshaw's pieces, as well as his own interpretations of the fundamental codes of Northwest Coast design.[54] Thus, while Reid's refined jewellery exemplified the "quality" and authenticity that had become the concern of those in charge of the "revival," its ambiguous role within the exhibition indicates that the principles of current production and pure aesthetic consumption were still not fully in place.

Reid's contribution to the exhibit, however, went further. Despite limited experience and exposure, he was already accepted by this early date as a recognized authority on the traditional forms which define Native art. He supplied the "informative design panels" for the exhibition and gave a series of "evening tours" to help foster a discerning clientele knowledgeable in the art form's principles.[55] Following the directives first laid out by the BCIAWS, the Hawthorns' reports and the Massey Report, and using his connections with the CBC, he also narrated a film on the exhibition in order to promote awareness of Northwest Coast Native art to a wider public. It was unique at the time for the national broadcasting corporation to take an interest in exhibitions on the west coast, indicating the level of support that was in place for disseminating the "revival" and making it visible to the largest possible audiences.

In his film commentary, Reid resisted Audrey Hawthorn's ethnographic position by opposing it with an artistic vision. Countering the catalogue, he stated that the works should be appreciated as autonomous aesthetic objects and that while they might represent crests, the formal, rather than social or iconographic, values were their essential traits. He claimed that the work was "universal," a "great art" of which the Haida produced the privileged exemplars and the "final distillation of the artform." These "had to conform

to certain rigid conventions" (Reid 1956a). Aesthetic appreciation was not contingent on knowledge of the works' cultural contexts but rather on a competence within these restrictions. The two positions seemed to define the discursive limits for the discussion and consumption of Native art at the time. Where Reid agreed with Hawthorn was that this art was of the past. "It is a dead art," he stated. How then to reconcile his own present production, plus that of Mungo Martin, with the discourse of disappearance? Reid accomplished this by placing himself within the tradition as an anomaly and making Martin an exception: "It's true that Mungo Martin in Victoria—a genuine link with the great carvers of the past—and perhaps myself, and maybe a handful more, are still producing a few things in the traditional form, but we're groping behind us toward the great days of the past, out of touch with the impulse and social pattern that produced the art."[56] Although he claimed no role in a "revival," the principle that "authentic masterpieces" of purely formal beauty could be made outside of a traditional context strictly for appreciative non-Native audiences and consumers sensitive to their formal values was an integral part of the "revival" from its beginning.

Thus, almost from his first encounter with it, Reid became closely associated with the "revival" in its third incarnation and soon was its leading public figure, if not its spokesperson. Indeed, the Vancouver exhibition did as much to bring him to public attention as it did Native art. Henceforth, the two became synonymous in the public eye. His role in the "revival" now secure, it only remained to engage him in appropriate projects.

That same summer, Reid was hired for a brief period by the BCPM to work with Mungo Martin on a replica of one of the poles collected from T'anuu.[57] The position was created to "give him training in wood carving techniques," undoubtedly with future "revival" projects of a larger scale in mind.[58] These did not, however, occur in Victoria.[59] After taking part in another salvage expedition in 1957, Reid left the CBC in 1958 and began carving at UBC under the auspices of Harry Hawthorn, with financial support from MacMillan and the new Canada Council.[60] This ambitious project, which included several new poles and a replica of a portion of a Haida village, was supplied with material by "the lumber industry," which maintained an active interest in the "revival" and the directions it was taking (Reid 1974:90). The display was completed by Reid and Doug Cranmer in 1962 and opened in 1963.[61]

In 1958, when British Columbia celebrated its first centenary, the "revival" played a major role. Two centennial poles were carved in Victoria and sent to Queen Elizabeth in England and to the Vancouver Museum. Princess Margaret, who visited the province, witnessed a potlatch at Courtenay.[62] Some of the poles collected in the previous years were arranged on University Boulevard at UBC.[63] At the Vancouver Art Gallery, an exhibition, *One Hundred Years of B.C. Art,* included a significant sampling of Native pieces.[64] Reid wrote "Art of the B.C. Indian" for the introduction to the catalogue, his first published text.[65] Here he again laid claim to the work as "high art" which should be appreciated by contemporary audiences for its distinct formal qualities rather than its initial use, either utilitarian or social. He also discerned various traditional styles and assisted in educating his audiences on their unique properties. But while adopting the vocabulary of aesthetic appreciation and art historical discussion, he made no effort to place himself or his work within these traditions, nor did he make any mention of a programmatic "revival" or his own role in it.

Although the 1960s saw the deaths of Mungo Martin (his son, David, who was to be his successor, had died in 1959) and Ellen Neel, new artists were appearing, and Reid was no longer alone. In 1962, Robert Davidson was already at sixteen being heralded as the youngest carver on the Queen Charlottes.[66] By 1963 Reid was working in a climate sufficiently large to support his independent activity (Shadbolt 1998:36). Given its expansion, in 1964 the "revival" was mooted as a "renaissance."[67]

Up to this point, the definition of the "revival/renaissance" had been primarily ethnographic, with recognition of the works as art achieved largely through their placement in art galleries and Reid's claims for their autonomous aesthetic formal qualities. This changed in 1965, when Bill Holm, an art historian from the University of Washington, published what was to become one of the principal studies of the "revival": *Northwest Coast Indian Art: An Analysis of Form.* The book was heralded as defining what were seen at the time as the fundamental formal elements of a classic "northern" formline tradition, identified with Haida painting and carving.[68] Reid, who had already suggested its possibility, became its exemplar. This brought Reid into the entire apparatus of art history as it was then practised. While he already had staked out his position as the spokesperson for the

work as pure art rather than ethnological artifact, his discursive framework expanded. The discipline was largely occupied at this time with questions of formal integrity, aesthetics, genealogies, attributions, derivations, influences, originality, mastery, genius, masterpieces, taste and so on. The corresponding modernist criticism of the period saw formal attributes divorced from social and political contexts as the primary, if not sole, concern.[69] Given the new interdisciplinary constructions, it could now be said that a true discursive framework for the "revival" had emerged within both ethnography and art history as they were constructed at that time.

All of this found its expression in the *Arts of the Raven* exhibition, held at the Vancouver Art Gallery in the Canadian centennial year of 1967 and financed by both the federal government and a host of lumber companies. A substantial shift had occurred since the *People of the Potlatch* show eleven years earlier. There was now a balance between ethnology and art history, with Reid placed between them. Duff, Holm and Reid all provided essays for the catalogue, with Reid again incorporating the modernist vocabulary of "high art," "expression," "creators," the "classical," "rules and conventions," "distinctive style," embedded in a discussion of "genius," attribution, mastery and derivation within a universal decontextualized art form. He still, however, resisted identifying himself too closely with the "revival" by holding to aspects of the discourse of disappearance and the narrative of cultural decrepitude and discontinuity. Nonetheless, his placement in the "revival" was ensured by the section on "The Art Today," nearly half of which consisted of his work.[70]

Between 1967 and 1973, as Reid was being absorbed into and identified with the now fully defined "revival," he absented himself from the increasingly active scene, going first to London to further study his art and then to Montreal, where a second large exhibition of Northwest Coast material entitled *People of the Potlatch* was held in 1969 and 1970 at the site of Expo 67.[71] Reid, with Robert Davidson, demonstrated carving at the site and also appeared in traditional regalia at the closing ceremonies. The exhibition was a crucial turning point: Audrey Hawthorn wrote a catalogue which reversed her earlier position and now proclaimed the possibility of continuity. It was, however, never published.

During Reid's absence, spaces began to open up within the discursive framework of the "revival" as it was formulated by both art history and

ethnology. In addition, fundamental changes were beginning to enter the practices of each. The *Legacy* exhibition of 1971, organized by the British Columbia Provincial Museum, was the first major sign of a rupture in the discourse of the "revival." This exhibition, which went through several phases over the next ten years, differed from its predecessors by outlining the changing contexts for current artistic production and showing primarily contemporary work by modern artists, including Reid, as part of ongoing traditions.[72] The stated purpose of the exhibition was to provide an "opportunity for both the general public and native Indian people to become aware of the various tribal traditions of the past and their contemporary survival and re-discovery."[73] As has been stated, the notions of continuity and survival tended to destabilize those of both disappearance and "revival." Although ethnologist Peter Macnair did include a brief section on "The Tragedy of Decline" in the catalogue essay, this was mitigated by statements such as his conclusion that "the vigorous traditions of the past remain viable today" (Macnair, Hoover and Neary 1984:24). The catalogue also become more self-conscious of its position within the developing "revival," although its emphasis was primarily stylistic. The publication thus indicated that the "revival" was not as monolithic as it had been presented and that contested areas were opening up.[74]

After Reid returned to Vancouver in 1973,[75] he began writing prolifically. Collectively, these texts indicate the beginning of a transition in his position as he began to "speak back" to the "revival" and to both clarify and redefine his role in it. In 1974, he provided an essay for the catalogue of his retrospective at the Vancouver Art Gallery. Although this may have been the stepping-off point for a reassessment of his own activities, it restated many of his previous positions. In 1975 he collaborated with Bill Holm on the book *Form and Freedom*. The brief essays on individual pieces reaffirmed the primacy of collecting and connoisseurship based on an aristocratic taste and a search for "masterpieces" which could be positioned within an aesthetic hierarchy. In 1976, however, in a lengthy interview published in *Canadian Collector*, Reid began to examine his own history and role within the "revival," though he avoided conceiving of it as a coherent program. Rather, he viewed it as the result of independent individuals operating more or less autonomously. In a eulogy for Wilson Duff, who died in 1976,

Reid (1976:109) began to admit to the possibility of a "renaissance of native Northwest Coast art." In addition, he began his first prolonged stay in Skidegate, his mother's village, where, during the course of two summers, he carved a pole for the band office, rather than non-Native consumers. The pole was raised in 1978 with attendant ceremonies (Shadbolt 1998:54). In Skidegate, he would have encountered not only a different audience and community, one to which he had initially claimed links, but also a different, traditional use for his production and its concurrent ritualistic aspects which were outside of the scope of the "revival."

Further reanalysis of Reid's position within the "revival" occurred during an illness in 1979 when he wrote "Haida Means Human Being." Here, he began exploring the specific social / cultural / political history of the Haida down to the present, though this was largely speculative, idealized, essentialized, subjective and romantic, even when it touched on less pleasant aspects, and still recited the narrative of generalized disappearance. But while again acknowledging the "so-called renaissance," albeit grudgingly, he refused Native agency within it (1979:140–41). Rather, he saw it strictly as a product of non-Native academics: that is, those ethnologists and art historians with whom he had contact, with himself, and presumably all other Native artists, playing a passive, powerless and peripheral role.[76] Nonetheless, he admitted to the possibility of the continuity of certain aspects of the "old ways" and a persistent Haida identity in which he was starting to participate. He even went so far as to call for the recognition of Native human rights, though he tactfully abjured land claims.

But while his own position was changing, Reid insisted on stability within the ethnographic and art historical discourse in which he operated, precisely at the moment when both disciplines were starting to undergo radical change.[77] This came to a head when the *Legacy* exhibition finally reached Vancouver in 1982. Despite the catalogue's dramatic move to narratives of continuity, the exhibition came under criticism from the emerging "new" art history for an excessively formalist approach and for not supplying the entirety of the historical context or what the reviewer, Marnie Fleming, termed the "conditions of production."[78] Reid's lengthy response to these criticisms indicated the importance he placed on these issues. He insisted that Fleming's critique was "superfluous rhetoric": that is, he placed it outside

of the discursive boundaries for knowing and discussing the works.[79] He still advocated a limited, ahistorical, apolitical and asocial reception to the art, focussed solely on aesthetic assessments of its formal properties available to an "essential universal humanity." In short, he demanded a return to the "old" art historical format, clearly separated from ethnology, a position from which he himself was diverging. But more was at stake than just discursive stability. Reid also attacked Fleming for a point she had not raised. Her call for a socio/political analysis of past production would result, he felt, if applied to the present, in seeing the current status enjoyed by Native art as the result of "some cynical public relations program." The problem was that it would have revealed and made transparent his own active participation, and that of his art, within the programmatic "revival," which, until then, he had avoided scrutinizing or even admitting to. He seemed to advocate that, while the products of the "revival" were open to close scrutiny within a limited frame-work, the mechanics and history of the "revival" itself must remain invisible.

Nonetheless, Reid had already begun approaching these issues in a paper entitled "A New Northwest Coast Art: A Dream of the Past or a New Awakening?" (1981), in which he dropped the "so-called" from the "renais-sance" and indicated the changes it had undergone and his own role within it. Although he still saw it as a fragmented rather than coherent program, he did notice one significant alteration:

> The first part of this paper is based on a talk I gave at UBC only a couple of years ago, and it's amazing to see how the scene has changed in that short time. I said then that in talking about the his-torical background of the Northwest Coast Renaissance, what we're really talking about is the transition in Northwest Coast art from the native society, where its function was largely ceremonial, to the present day, when what is made is intended almost exclu-sively for sale to the non-native community.
>
> Well, this has changed, and today increasing numbers of objects are being created by the native artists to be returned as potlatch gifts, sold or traded items, or contributions to community life.[80]

Reid cited his own work in Skidegate as contributing to this end but gave numerous other examples (1981:168). Although he still actively resisted the notion of a "revival," defined, it seems, as a return to a form of unchanging pre-contact culture similar to what is now known as an ethnographic present, his attitude was shifting significantly.[81] The communal production, led by Reid, of a 15-metre (49-foot) canoe named *Loo Taas* for Expo 86, must have confirmed this direction.

By the mid-1980s, Reid was actively engaged in giving his production, and himself, a new role within the "revival" that was at odds with its initial tenets and the old models of art history and ethnology but more in keeping with the revisions then ongoing in each. As he was commissioned by major corporations and governments to create more monumental public sculptures, it seems he realized the power that was attached to them. He also became increasingly aware that his voice carried political as well as aesthetic authority. Furthermore, he began to understand that the "revival," though orchestrated by a variety of non-Native institutions, could be used by Native peoples not only for accommodation and a point of entry into the spaces of the larger institutional framework but also as points of negotiation and resistance for issues outside of its domain. He increasingly identified with his Haida ancestry, applying for Indian status in 1985, and began to abandon the concepts of the discourse of disappearance.[82]

All this ultimately led Reid to an active engagement in promoting Haida authority over Haida Gwaii, and, of course, land claims. He had already publicly protested logging at Windy Bay on Lyell Island in 1980 (Reid 1980b). Despite his tactful attempt to avoid confrontation, this meant turning against the very corporate structures that had initially funded the "revival." The issue came to head, however, during the production of his monumental sculpture for the new Canadian chancery building in Washington, called *The Spirit of Haida Gwaii* but also known as "the black canoe."[83] As Shadbolt summarizes (1998:177): "There has been a significant shift in his viewing of the situation and his relation to it, one in which he not only locates persuasive humanist reasons for supporting native land claims but also finds the clear hard signs of moral regeneration among Haidas he had earlier despaired of ever seeing." She reports his active participation in 1985 and 1986 in support

of the Haida against logging on the Islands and the failed attempt to make South Moresby a park.[84] Here, he appeared at the barricades and used his artwork to raise funds for the protest.[85] But as progress on the issue stalled, Reid went further. In 1987, he publicly announced that he had stopped work on the *The Spirit of Haida Gwaii* and would resume only when the federal government established the South Moresby National Park Reserve and halted logging.[86] Postulating both continuity and sovereignty, as well as the political power of art as an act of resistance, was a sea change in his position, and one that disrupted the discourse of the "revival" in no small way. If Ron Hawker is correct, it was precisely this that the discourse had been attempting to head off from its inception (1998:292).

Declarations of Haida sovereignty and identity became even more apparent when Reid and a Haida crew took *Loo Taas* to Paris in 1989, on the occasion of an exhibition of his work at the Musée de l'homme. They refused to fly the Canadian flags supplied by the Canadian embassy, but instead proceeded up the Seine to Paris under a Haida banner (Jennings and Janssen 1989). This ceremonial entry into Paris to meet the mayor of the city as representatives of an autonomous Haida nation was a complete reversal of Reid's initial assessment of the "revival" and indicates the changes in his roles within it and the identities he established from it. Indeed, his search for identity may have been drawing to a close. Journalist Moira Johnston (1998) tells us, "At a healing potlatch given by Chief Chee Xial, the Raven Chief of the Wolf clan of Tanu, on Thanksgiving weekend, 1996, he had finally been honoured in Skidegate, and fully accepted as he yearned to be, participating as a Raven of Tanu." Reid had become not just Haida through direct links to the "old ways," which he initially claimed had disappeared, but after his death in 1998 was hailed as a "Haida activist."[87]

The transformation in Reid's position in the last decade of his life is remarkable. He had by that time begun to disengage himself from the tenets of the "revival" with which he had not been able to admit an affiliation but in which he played an integral and conscious part. He also began to undermine the terms of the subject position of "Native artist" as it had initially been formulated and started to rearticulate it within a broader context. He abandoned the principle of disappearance, the concept that all Native, and specifically Haida, culture and identity had perished, the idea that Native art

was a solely formal concern devoted to a non-Native consumer culture and that it had no current ceremonial or ritualist possibilities. Most importantly, he abandoned the passive role which he had initially given himself and began to see his work and his position within the constructs of art history and ethnology as being a point for power and agency within relationships between Native and non-Native peoples. Oddly, this change brought him more closely in line with both disciplines as they came to be practised.

Now, continuity, rather than being rejected as outside the framework for knowing Native art, has begun to establish a new discourse. Recent scholarship on Haida carving is currently investigating the continuation of the carving tradition, in which Reid plays a role, but no longer the central, exemplary role he was given in the "revival." Robin Wright, in *Northern Haida Master Carvers* (2001), has begun to establish the links in the chain between the present, the past and the future in a new fashion. In addition, Haida representatives such as Diane Brown acknowledge the importance of Reid within continuous but changing forms of cultural practice.[88] The "revival" may be over, but only in the sense that art history and ethnography have abandoned the term for a new way of knowing and speaking about the art, culture, identity and history of the Haida as well as of other groups of the Northwest Coast.[89]

ENDNOTES

1 See Ryan 1990; Morrison 1991; S. Dyck 1995; Hawker 1998; Dawn 2001. See also Cole 1973; Kulchinsky 1993; Nurse 2001.

2 Dippie 1982 outlines this in the United States.

3 See Phillips 1999:97–112. Of the three shifts that Ruth Phillips proposes, this paper concerns itself primarily with the third: that is, the relationships between art history and ethnology as they played out in one historically specific area.

4 For a critique of evolutionist models, the salvage paradigm and the ethnographic present, see Clifford 1988; see also Marcus and Myers 1995. For an overview of the "new" art history, see Fernie 1995; Preziosi 1998; Edwards 1999; Harris 2001. Harris attributes much of this to the influence of T.J. Clark and feminist scholarship rather than French theoretical concerns.

5 Vastokas 1975. Hawker (1998) has pointed out that Vastokas's historical gloss perpetuates the discourse of "fatal impact," which, as Nicholas Thomas states, has "been detected in European historiography far more frequently than it actually occurred." "Though generally sympathetic to the plight of the colonized, such perceptions frequently exaggerate colonial power, diminishing the extent to which

colonial histories were shaped by indigenous resistance and accommodation" (Thomas 1994:16, cited in Hawker 1998:332). The discourse of disappearance is, then, one such example of "fatal impact."

6 MacDonald 1996:228. In the light of the new art history and the crisis in ethnology, these types of poetic panegyrics, though difficult to resist, have come to be seen as a species of mystification and naturalization where historical, social and cultural facts are simply swept aside, or not discussed, in favour of seductive generalizations and cultural sameness among the various peoples of the Northwest Coast. See also Townsend-Gault 2000–01.

7 It is now recognized that the potlatch ban was largely ineffective until 1920, some thirty-five years after it was passed. Even then, despite a brief period of intense repression in the early 1920s, it was not as deadly as has often been presented. As these cultural histories of resistance are reclaimed, it is becoming apparent that a case for continuity within transition is more appropriate, especially as recent histories of the Haida, Gitxsan, Kwakwaka'wakw, Nisga'a, Nuu-chah-nulth, Coast Salish and others appear. For a scholarly and well researched alternative historical narrative of Haida carving based on the principle of continuity of traditions, see Wright 2001.

8 This is not to say that the Haida did not suffer severe disruption. They did, and probably more so than any other group. But it does lead to questions: how and why did the state of the Haida come to be represented as the norm for all Native cultures on the west coast during this period, when in fact they were statistically the exception? Whose interests did this generalized historical narrative serve?

9 Crosby 1991:280. See also Crosby 1994.

10 For a further discussion of aspects of the "revival" as applied to a specific medium, see Dawn 1984.

11 In terms of the former, I am indebted to Ronald Hawker's close analysis of the production of Native art within the context of these programs and especially his insistence on the active role Native artists took in shaping their development; see especially Chapter Six, "Mathias Joe, Mungo Martin and George Clutesi: 'Art' as Resistance" (1998:209–55).

12 "Both government and industry officials had indeed moved to recognize the Native Brotherhood as a legitimate and powerful bargaining agent from the mid-1940s on" (Hawker 1998:228–29, see also 191–92). Recognition of the depressed economic state of Native communities was also a factor, as was the failure of assimilationist policies. After the war, the contribution of Native soldiers to the defeat of fascism also discredited policies of racial exclusion.

13 Dawn 2001. My dissertation examines the construction of a state-sponsored discursive framework for "knowing" the Indian within the formation of a nascent Canadian national identity, as each of these was formulated, reproduced and distributed through a wide variety of channels in the 1920s. Both were postulated on the proposition that all Native culture and peoples were on the verge of extinction and that their artworks and territories were ripe for appropriation. I also examine the resistance to these programs and how they ran contrary to actual fact and alternative representations, especially in western Canada and in particular among the Gitxsan, and hence failed.

14 See Penney and Roberts 1999. The first major manifestation of this program occurred in 1931 at the *Exposition of Indian Tribal Arts* held in New York City. It developed further during the Depression under President Roosevelt's liberal New Deal policies and his Commissioner of Indian Affairs, John Collier, who was a firm believer in fostering, displaying and creating audiences and markets for these arts. By the late 1930s, under the Indian Arts and Crafts Board, formed in 1935, programs were also being developed in Alaska to foster carving. The report of Virgil Farrell, supervisor of Native

arts and crafts for the United States Bureau of Indian Affairs, on the financial success of the Alaskan program must have had a salutary effect on Canadian officials. So must the success of the 1939 Golden Gate Exhibition in San Francisco and of the 1941 exhibition in New York City, in which displays of Northwest Coast material, including recent productions, played major roles. The catalogue accompanying the latter framed the work under the heading "Living Traditions" in Douglas and d'Harnoncourt 1941. See also Schrader 1983.

15 This is not to say that there had not been some pressure in British Columbia from concerned individuals such as the Rev. George Raley, These, however, met with little or no response until the major successes in the United States demonstrated the potential of such programs, see Hawker 1998. For extracts from the *Annual Reports* of the U.S. Secretary of the Interior, 1936–1941, of the Indian Arts and Crafts Board concerning the promotion and marketing of contemporary Indian art in the United States, see Dawn 1981:Appendix 1, A1–A2. These activities and programs were closely duplicated in Canada.

16 *Vancouver News Herald*, 30 June 1939, 8.

17 *Vancouver News Herald*, 30 June 1939, 8. Speaking earlier at the University of British Columbia in 1926—that is, shortly after the federal government had embarked upon its period of greatest persecution of the potlatch under the regime of Duncan Campbell Scott—Barbeau had unequivocally proclaimed the impossibility of any revival of Native arts: "The possibility of a revival among the Indians of former talent seems out of the question . . . They have long since lost the national pride which makes possible great feats in the field of art. The best we can hope for now is to preserve the remnants within our borders" (Barbeau, quoted in *Vancouver Province*, 22 October 1926, 15, cited in Dawn 1981:32–33). In short, the subject position of "Indian artist" was not available at this time. It is important to note that in 1939 Barbeau returned to his fieldwork in the Upper Skeena among the Gitxsan, whom he had proclaimed earlier had lost all their culture and their lands. He now, however, encountered evidence of continuity in the form of potlatch ceremonies and pole raisings that had gone on during his extended absence during the Depression, when ethnographic work, as well as the Western economy, had gone into "decline." Unable to accept this as evidence of continuity, he continued to rehearse the idea that all Native culture was moribund.

18 Dawn 1981:57. "[T]he 'revival,' at least in its early stages, did not tend to support that art which would reaffirm the continuity of traditional culture."

19 Hawker 1998:171. It was initially called the Society for the Furtherance of British Columbia Indian Arts and Welfare. Other moves had also been made. In 1938 the Canadian government once again included Native pieces within a major exhibition of art representing Canada outside the country for the first time in over a decade. *A Century of Canadian Art*, shown in London at the Tate Gallery, included two Chilkat blankets and a selection of argillite model poles, mounted adjacent to French-Canadian woodcarvings, Barbeau's other area of speciality. In 1939, two large, new poles carved by Mungo Martin were placed outside the Canadian pavilion at the New York World's Fair.

20 See "Objects of the Society" 1939.

21 The production of educational material to develop knowledgeable audiences was also a key component. See, for example, Ravenhill 1938, which served as a textbook for educating schoolchildren on the Native peoples of British Columbia. Hawker (1998:178–79) indicates the paternalistic and evolutionist bias in her text. In 1944, Ravenhill's *A Cornerstone of Canadian Culture: An Outline of the Arts and Crafts of the Indian Tribes of British Columbia* appeared. Originally commissioned by the federal

government, it was published by the British Columbia Provincial Museum (Hawker 1998:188). Hawker points out the connection of this book with Reid, who used the drawings by Charles Edenshaw, done for John Swanton, as sources for designs. Bruce Inverarity's *Art of the Northwest Coast Indians* also appeared around this time, in 1950.

22 Hawker 1998:171. The BCIAWS and other institutions associated with the nascent "revival" were at first uncertain which types of art to promote. As they experimented with the possibilities for opening up the subject position of "Indian artist" within the "revival," they oscillated between encouraging accul- turated works in Western conventions and traditional arts from Native culture. In terms of the former, which had proven successful in the American Southwest since early in the twentieth century, the various agencies worked co-operatively to promote both George Clutesi and a young Gitxsan artist, Judith Morgan. Each painted Native subject matter using Western conventions and media. In the late 1940s Morgan was given several exhibitions, including ones at the B.C. Provincial Museum, the Vancouver Art Gallery, the Art Gallery of Greater Victoria and the National Museum of Canada. Her work also toured the United States. Given the extensive exposure, expectations for both artists were high, but it was soon concluded that this type of work did not sell, except to the sponsoring bodies (*Omineca Herald and Terrace News*, 25 August 1948, 4, cited in Dawn 1981:113): "George Clutesi, British Columbia's noted Indian artist has sold a collection of seven paintings to U.B.C. and they will now hang in the new uni- versity museum, now under construction in the library wing. 'It is curious,' said a professor, 'to note that though Mr. Clutesi has exhibited paintings in all parts of the north west, and has been acclaimed by public and critics alike, this is the first major sale of his works.'" It is significant that the unnamed professor evaluated the work primarily in terms of its sales potential. The Provincial Archives of British Columbia purchased five of Morgan's paintings in 1949 (*Native Voice*, August 1949, 1). After this, she disappeared from the "revival." She currently lives and paints in Kitwanga. See also Baird 1962. The failure of Morgan and Clutesi's paintings to meet market expectations led to an emphasis on "authenticity" based on an adherence to traditional forms, which became the primary critical criteria for evaluation. These, how- ever, had not been fully explicated for non-Native audiences in the 1950s.

23 Shadbolt 1998:29. Harry Hawthorn, who had written his dissertation at Yale and published a mono- graph on the Maori and acculturization, had come from New Zealand where a successful "renaissance" of Maori art had already been orchestrated and noticed in Canada. A three-part article on the subject appeared in *Native Voice* in June, July and August 1948, see especially Sinclair 1948. Given his background, Hawthorn was the ideal candidate for fostering the "revival" of Canadian Native art and co-ordinating its activities in British Columbia.

24 *Report of Conference on Native Indian Affairs at Acadia Camp, University of British Columbia, Vancouver, B.C., April 1, 2 and 3, 1948*.

25 *Report of Conference on Native Indian Affairs 1948*, n.p. The report's recommendations were based on the Alaskan model.

26 *Native Voice*, July 1948, 7. See also K. Phillips 2000 and Nuytten 1982.

27 "In his annual report for 1947–48, University of British Columbia president Norman McKenzie referred to the initiation of plans for constructing a Totem Park on campus and to the collection of some twenty poles which had already been donated or purchased" (Shadbolt 1998:29).

28 Martin was James's stepson. Shadbolt's phrasing on this matter is instructive: "If Duff and Harry Hawthorn are to be given credit for having triggered the resurgence of serious west coast native art

activity of the past thirty-five years, then Mungo Martin, a Kwakiutl carver from Fort Rupert, was the first substantial artist to be reactivated, so to speak, through non-Indian initiative" (1998:29). By giving ethnology the leading and active role in the "revival," Shadbolt downplays Native agency in the program, rendering the Native artists as passive figures. As Hawker (1998) has pointed out, this was anything but the case.

29 BCPM *Annual Report* 1953:B21–B22. Hawker (1998) has noted Martin's use of the "revival" program as a site of resistance to the suppression of Native cultures.

30 *Report of the Royal Commission on National Development in the Arts, Letters and Sciences, 1949–1951*. Known popularly as the Massey Commission.

31 *Report of the Royal Commission on National Development*, 242–43, cited in Dawn 1981:62–63. The oxymoron of "reviving" something that had been historically "maintained" escaped notice.

32 On the manner in which art galleries and museums shape "taste" for a discerning clientele that has privileged access to the codes of artistic production, see Bourdieu 1984.

33 BCPM *Annual Report* 1951:B20.

34 *Native Voice*, October 1955, 4. The presence of the Ministers of Labour and Public Works at the opening indicates the importance of the show as part of the larger government programs.

35 Hawthorn, Belshaw and Jamieson 1958:iii. Types of work were itemized, described and analysed for their potential usage. Problems with the supply of materials were discussed. Methods for educating the buying public were recommended, including the publication, as had occurred in Alaska, of simple but well-written books for the layperson. Museum projects were also called upon to play a role in educating the public on Native culture and arts in order to supply an adequate market base. The rationalization of production was also explored. In short, a broad, co-ordinated and co-operative institutional framework with a single purpose was proposed.

36 The report cited the specialities of those conducting the investigation as the reason for its restricted focus. It may also have been that the unique situation in British Columbia required special attention, especially since Native land claims were different in that province than elsewhere. Hawthorn did produce a larger two-volume report in 1966 entitled *A Survey of the Contemporary Indians of Canada: A Report on Economic, Political, Educational Needs and Policies*, published by the Indian Affairs Branch. By contrast, it included little on art.

37 Shadbolt 1998:13. Shadbolt figures Edenshaw as a "bridge" figure situated historically at the "conspicuous breakdown" of Haida culture. Reciting the narrative of "fatal impact," this subsequently became a period of "helpless demoralization" for Native cultures in general on the west coast (1998:14–15, see also 27, 29 and 40). Hawker (1998:306–7) is more sanguine about Reid: "Reid had the pedigree to legitimize his art and the attitude that endeared him to museum and gallery curators and, through them to the non-Native art-buying public." Crosby (1994:109) is equally sanguine: "Reid could be described as the perfect model for the successful integration of the Indian. The western values for which he was praised—his education, articulate speech, and successful career—signal the possibility of the successful assimilation of other Canadian Indians into the progressive space of modernity."

38 Reid's high school teacher, Ira Dilworth, was well connected with the arts, museum and media communities of Victoria. Dilworth, who later became regional head of the CBC, had also been instrumental in sponsoring George Clutesi and his work during the important early stages of the "revival," see Baird 1962:5.

39 "In 1948, I decided I would like to try to emulate my grandfather and the other Haida silver- and gold-smiths" (Reid 1974:88). Insufficient inquiry has gone into the timing and motivation for Reid's decision to study jewellery at Ryerson. Ryerson Press was also active in the "revival" at this early stage. For example, see Large 1951; this publication, aimed at a popular audience, included colour drawings by Charlie George and pen sketches by the author. It fit the pattern of books promoted during the early stages of the "revival."

40 Shadbolt 1998:25, 27. Reid had begun working in radio as early as 1937.

41 Shadbolt 1998:28 gives the year as 1950, but evidence supports 1951.

42 Hawker 1998:291. Wilson Duff joined the British Columbia Provincial Museum in 1949.

43 The University of British Columbia began collecting poles through Marius Barbeau in 1947 (Hawker 1998:265–66). It is often assumed that collecting Haida poles became the main goal of the restoration program. Despite the fact that this was where media attention was focussed, such was not the case. In fact, the next focus was on Gitxsan poles. This group had been among the most resistant to moves to extinguish their culture. The Gitxsan continued traditional ceremonial activity, raised new poles and adamantly maintained their land claims throughout the twentieth century. Duff and Harry Hawthorn first visited these villages in 1949, see BCPM *Annual Report* 1949:B8. Duff returned there in 1952, see BCPM *Annual Report* 1952:B18. BCPM *Annual Report* 1952:B18 outlines the "totem-pole restoration programme." For MacMillan's letter, see Hawker 1998:292.

44 Hawker (1998:292) points out the extensive connections between the lumber companies and the "revival." MacMillan, for example, both collected and underwrote museum collecting and carving programs, giving $3,000 in 1956 for purchasing poles, as well as supplying logs for new poles (Hawker 1998:297). Walter Koerner soon joined MacMillan in underwriting purchases and further collecting of poles (Hawker 1998:298–300). Koerner also became a major patron of Reid's. Corporate contributions were regularly reported in the BCPM *Annual Reports*, but without commentary.

45 See also Hiller 1991:283 for an outline of the mechanisms by which a national display of Native arts "hides . . . current struggles over land rights and masks a violent colonial past."

46 See BCPM *Annual Reports* for 1953 to 1956. The Totem-pole Preservation Committee was formed in 1954 (BCPM *Annual Report* 1954:B18).

47 "On returning home, the Anthropologist edited the summer's films and made up a twenty-five-minute movie, 'Totem Heritage'. Showings of the movie, lectures, and newspaper and radio publicity have aroused much public interest in these Haida totem-poles, and at the year's end there was some promise that a programme of salvage could be arranged for the near future, drawing support from outside sources" (BCPM *Annual Report* 1953:B18).

48 BCPM *Annual Report* 1954:B18. Robert Bringhurst (Bringhurst and Steltzer 1991:37) gives 1956 as the date of Reid's first trip with the restoration project.

49 *People of the Potlatch: Native Arts and Culture of the Pacific Northwest Coast,* the Vancouver Art Gallery with the University of British Columbia. Smaller exhibitions of Native material had preceded this. For example, the BCPM loaned "certain material" to the Vancouver Art Gallery in 1947 "to stimulate interest in the Indians native to British Columbia" (BCPM *Annual Report* 1947:F14).

50 The BCPM loaned more than 250 items and assisted with the installation (BCPM *Annual Report* 1956:D19–D20). If UBC loaned a similar amount of material, this would be one of the largest exhibitions of its kind ever mounted. No archival records of UBC's contribution have emerged, however.

51 Audrey Hawthorn, "People of the Potlatch" (VAG 1956:n.p.).

52 There is no mention of fact that the ban had been dropped from the Indian Act in 1951, nor of the publicized ceremonies in Victoria at the opening of Mungo Martin's bighouse in 1953 at the BCPM, nor of the carving program going on there.

53 Audrey Hawthorn did notice that argillite was still being carved but mentioned that good pieces were becoming increasingly hard to come by, thus implying the passing of the art form.

54 Letter from the business manager of the Vancouver Art Gallery to Reid (Hume 1956). My thanks to Cheryl Siegel, librarian at the Vancouver Art Gallery, for making this information available. See Shadbolt 1998:127 illus. for an example of his work at this time. No Reid works were illustrated in the exhibition catalogue.

55 R.M. Hume 1956. It is possible that Reid instructed his audiences on the purely formal aspects of the works displayed, thus filling in for what Hawthorn left out of the catalogue.

56 Reid 1956a:45. Reid's conflation of his own position with that of Mungo Martin as "groping" undercuts claims that the latter's work was part of a continuous tradition.

57 Bringhurst gives the date as 1957 (Bringhurst and Steltzer:1991:37; Bringhurst 2000b:238) , but the BCPM *Annual Report* 1956:20 clearly establishes 1956 as the date.

58 BCPM *Annual Report* 1956:20. Hawker (1998:308) indicates that Reid "would replace Mungo Martin as a public metonym for the Northwest Coast."

59 Bringhurst (2000b:238) reports that Reid also took part in a group exhibition at the National Gallery of Canada in 1957, as prescribed earlier by the Massey Report, and also calls this Reid's "[f]irst group show." If *People of the Potlatch* in 1956 is counted, this is at least his second.

60 Shadbolt 1998:31 and Hawker 1998:305. This project had already been conceived and discussed with Reid in 1955: that is, the year before *People of the Potlatch. See* Audrey Hawthorn to Reid, 28 October 1955; 5 exhibitions 53—Temporary exhibits 22-2 People of the Potlatch (1955–56), UBC Museum of Anthropology archives.

61 Shadbolt 1998:32. See also A. Hawthorn 1963. Audrey Hawthorn's account is instructive. Despite the title, she reiterates a narrative of cultural discontinuity, using the Haida as an exemplar for the peoples of the Northwest Coast and dating the end of Haida culture from 1870: that is, before the implementation of the potlatch ban. This historic generalization has the effect of making any assumed termination of Native culture on the west coast appear as the inevitable result of contact, rather than an act of programmatic, legislated cultural suppression. She also ascribes the project to Reid's initiative: "The project was the conception and the work of Bill Reid." She then, however, attributes it to the University of British Columbia and several lumber companies, including those of MacMillan and Koerner, which provided the logs. It seems that Reid's will and those of the university and the lumber corporations were indistinguishable at this time.

62 *Native Voice*, August 1958, 1. The event was organized by the Native Brotherhood.

63 *Native Voice*, August, 1958, 3.

64 BCPM *Annual Report* 1958:C23 and VAG 1958. The catalogue for *One Hundred Years of B.C. Art* lists ninety-six pieces of Native work, largely from the BCPM and UBC collections. It should be noted that the exhibition was funded by the Leon and Thea Koerner Foundation. Despite the title of the exhibition, no current pieces by Reid or any other Native artists were listed or illustrated. Indeed, the Native work was situated in the chronologically organized catalogue before the section on "The Early Settler in

B.C.": that is, placed before colonization and disappearing thereafter. Nonetheless, current work was featured insofar as Reid also provided the formline design for the cover of the catalogue, which, it was claimed, "adheres in all respects to the conventions of traditional Haida art" (VAG 1958:n.p.).

65 See Bringhurst's bibliography in Reid 2000:247.

66 *Native Voice,* April 1962, 1.

67 *Native Voice,* May 1964, 3.

68 Competency within these complex conventions, which had previously been somewhat ambiguous, was now no longer in question and clearly could be appreciated by discerning and critical audiences. The effect this had on the course of the "revival" cannot be underestimated.

69 The possibility that Holm's conventions could harden into a rigid set of academic rules producing a sterile art was commonly countered by deploying the romantic term "genius" which would find a way to "transcend" them while remaining true to their principles. More difficult to deal with was the possibility that formline constructions might not fully encompass all of the aspects of the "northern style" as it had actually been practised historically. This is especially apparent if one examines Gitxsan rather than Haida poles. See Dawn 1981, especially 203 n. 13. See also McLennan and Duffek 2000. The complex relationships between modernism's precepts and the critical reception of the "revival" are only now being studied.

70 Vancouver Art Gallery 1967:n.p. The equivocations within the brief paragraph describing "The Art Today," placed at the back of the catalogue, are indicative of the problems confronting attempts to reconcile the discourse of disappearance and that of "revival." In order to salvage the former but admit to the latter, a distinction was made between the arts and the culture, with the latter dying but the former hanging on. This precarious relationship became increasingly problematic in the next sentence when the possibility of cultural continuity among the Kwakiutl (as they were known at the time) was mooted, while an eclipsed but continuing artistic tradition among the Haida was posed. Conversely, groups like the Gitxsan who clearly represented cultural continuity, were not discussed, while the Nuu-chah-nulth and the Salish, where similar possibilities existed, were excluded from the exhibition, ostensibly for "stylistic reasons."

71 "Moved to London, England, on a fellowship from the Canada Council to study museum collections in Britain and Europe. Worked for a time at the Central School of Design, London," where he further refined his technical abilities (Bringhurst 2000b:239). See also A. Hawthorn 1993:66–74. For Hawthorn's draft and Walter Koerner's oppositional position, see 5-53, People of the Potlatch (drafts) n/d ACC #2002-42, curators, Audrey Hawthorn; and File 5—exhibitions 54—exhibitions loaned elsewhere, Man and His World (1969–1970) 23-4, UBC Museum of Anthropology archives.

72 Macnair, Hoover and Neary 1984:9. The *Legacy* catalogue, which first appeared in 1980 when the exhibition traveled to Edinburgh, was originally subtitled *Continuing Traditions of Canadian Northwest Coast Indian Art.*

73 Macnair, Hoover and Neary 1984:9. The works for the first stage of the exhibition were purchased or commissioned pieces by contemporary artists. More contemporary works were added when the show toured Canada and British Columbia between 1975 and 1980. Historic pieces were added in its final incarnations.

74 What Ruth Phillips noticed as the emerging "turf war" between art history and ethnology may have been evident in the fact that Holm did not provide the discussion for the formal analysis (1999:97).

It was, rather, written by Peter Macnair. Furthermore, the catalogue did not share in the unfettered enthusiasm for Reid's work and tactfully questioned the aesthetic value of his production by deferring final judgement and stating that it was yet to be fully assessed (Hoover and Neary 1984:186).

75 Shadbolt is unclear on the date of Reid's return to Vancouver: she gives 1972 on p. 49 and 1973 on p. 53. Bringhurst (2000b:239) places it in 1973.

76 Reid does not mention the involvement of either the government or the lumber companies, though he would have been well aware of their roles.

77 See Harris 2001 on this shift.

78 Fleming 1982a and 1982b. The irony is that the catalogue, written primarily by ethnographers, was charged with not paying sufficient attention to the "sociocultural circumstances of the objects of the makers" (Fleming 1982a:20).

79 Bill Reid, "The Legacy Review Reviewed: Bill Reid," *Vanguard* 11(8–9):34–35. He again suggested the possibility of the continuity of "old traditions."

80 Reid 1981:160. The paper referred to was given at the University of British Columbia in 1976.

81 Reid 1981:168. "I don't think the culture is being revived."

82 "It was a search for identity which led him to gravitate towards his Haida ancestry, the 'need for some cultural roots and those were the only ones I had'" (Shadbolt 1998:167). She supplies no date for this important statement nor does she mention his application for status. See, however, Bringhurst's comments in Reid 2000:218 n. 1, 224 n. 2 and 240–41. Status was granted in 1988.

83 Significantly, the piece was underwritten by Nabisco, a multinational food corporation, rather than a lumber company. Bringhurst (Bringhurst and Steltzer:1991) omits this fact, but see Godfrey 1992. For further discussion of the work, see Shadbolt 1998:175–79. She also makes no mention of the change in patronage. Yet insofar as the carving of *Loo Taas* in 1985 was underwritten by the Bank of British Columbia, it appears as if the lumber companies may have begun to withdraw financial support for Reid's increasingly politicized and resistant projects. Any firm conclusion awaits, however, a detailed analysis of corporate and other patronage of his work and other projects involving the Haida.

84 Shadbolt 1998:177. Shadbolt mentions Reid's attendance at meetings, the lithographs he made for sale to raise funds and his statement to the Wilderness Advisory Committee in support of land claims. She makes no mention of an arrest, but see Johnston 1998.

85 See Townsend-Gault 1998. Townsend-Gault also reports that Reid turned down the Order of Canada, "saying that he would never accept an honour from a country that would lay waste to a people's home." Johnston (1998) reports that Reid "refused it again several years later."

86 See Bringhurst and Steltzer 1991:45–46. Bringhurst, who devotes only two sentences to Reid's actions, avoids mentioning that he joined the barricades, was possibly arrested and helped finance the protests through the sale of his works. He does, however, cite some of these activities (2000b:240–41).

87 *Globe and Mail*, 16 March 1998, D2.

88 Again, my thanks to Karen Duffek.

89 As I worked on the last paragraph of this essay, the announcement that the Haida had claimed all of the Queen Charlotte Islands was made. It would, of course, be fascinating to hear Reid's position on this claim.

Beyond

by LORETTA TODD

W HY IS HE AS he is? And why are we always speculating? Is he a difficult poem? A lost son gone home? Northrop Frye meets Michelangelo? Is he the Indian that Pierre Trudeau always wanted to be? Maybe he was just a really good jeweller.

I was wondering when he started to sink into the psyche of Canada. Did his voice all those years ago on CBC radio carry a subliminal ancestral message? Was he a fierce warrior using his power to protect the sovereignty of his nation? Or was he a prince of the "New World"—forever making pretty things for the overseers?

And what of the pretty things? He once said that artists always did and still do serve elites. Was he railing against Duchamp? Telling the world to stop pretending that art can be freed from ruling classes and the object? Or was he cozying up to his benefactors—who still, despite their public belief in the democratization of the art, secretly long for the tiara?

And now he's gone, though "every shut eye ain't asleep," and certainly Bill Reid isn't asleep—if for no other reason than we keep him awake with our racket of speculation and our need for him to represent—something, somehow. It would seem Canada needs some art stars, maybe not quite so tragic and complicated as the American master Jackson Pollock, or quite so Marxist and sensual as Diego Rivera, the Mexican master. Sure, there are the elusive yet taciturn Seven and the clutterer Emily Carr, but here in Reid is the gentleman, country-born but with the bearing of a country squire.

So it would seem he's needed.

I look at his piece that stands in Vancouver International Airport and the Canadian Embassy in Washington, D.C., and imagine the pride and sense of purpose it must engender in the Canadian people, despite its kitsch excess or perhaps because of it. It is large but not monumental, daring but not shocking, narrative but not poetic. It holds its space as unmoving as a boulder, even while it holds figures in a canoe obviously en route on the water. It is tragedy and comedy—together in a pea-green sea.

I wonder how many remember or are taught that he was prepared to stop making the piece if the Canadian government didn't relent on its plans for Lyell Island? Tragedy and comedy indeed.

I once interviewed him when I was doing research for a documentary called *Hands of History* (about four women artists). I asked him if Haida women, or Northwest Coast women, ever carved totem poles or masks. He was absolute that they did not—but he later allowed that perhaps they had carved small utility objects. I guess my relative youth stopped me from questioning him further on this.

He did talk about mastering craft as a prelude to greatness, or even as a prelude to being an artist—as if anything before was simply practice. He dismissed some artists' claims that forces worked through them—that any sense of being overtaken by a force was simply the moment when those artists mastered their craft. Then and there an artist no longer had to think about the technique, because the work became, I guess, like breathing.

Again, I didn't ask more questions. Still, my thoughts were given to reflection. I had renewed confidence in how I seek precision at all levels of my film production—if only because he helped me realize it was something I strove for from the beginning. I even vowed to ask questions with more precision.

So, I did learn from our brief meeting. And perhaps I've learned more from Bill Reid's "legacy" and his relationship to Euro-Canadian culture and its dynamics with the concept of "Indian" and its relationship to "man."

> But when classicism says "man," it means reason and feeling. And
> when Romanticism says "man," it means passion and the senses.
> And when modernism says "man," it means the nerve.[1]

What does "man" mean when aboriginality is said? There is a complicated relationship, not only because of the anthropology / art duality but

because ultimately we are about relationships, and this relationship seems fraught with its own risks.

Bill Reid, I think, was perhaps the first "aboriginal" artist who was experienced as a "man"—not just a shaman, or a hunter, or a drunk, or a dreamer, or even a carver—by the Euro-Canadian culture. And though he liked the term "trickster," he wasn't that in the Euro-Canadian estimation—though they expected trickster behaviour. In a way, he was one of them. But wait, this isn't simply a case for Reid as White—no, not at all.

I keep thinking of the film *Notting Hill*, with Hugh Grant and Julia Roberts, where Julia, the movie star, falls in love with Hugh, a nebbish bookstore owner. Julia Roberts stands in front of Hugh Grant and declares, "I'm just a girl, standing in front of a boy, asking him to love her." I see Bill Reid as Julia Roberts and the connoisseur art world as Hugh Grant, and then, of course, sometimes the other way around.

Notting Hill? Bill Reid as Julia Roberts? And no, this isn't satire or even an earnest effort to find simile—it's to illustrate this emotional connection that Reid was afforded. He was forthright, infatuated with himself and at the same time self-deprecating. He liked all the pseudo indicators of what has passed as high-brow culture in Canada, and he even worked for the CBC, once the venerable storehouse of all things pseudo high-brow. He was an on-again, off-again lover of the Canadian ruling classes, but wait—there is more.

What is this "man?" It is a construct of power and knowledge if we are to follow Foucault—which I think is important to do, but not simply to evoke Foucault. Reid understood power and knowledge. If anything he was like Foucault, in that he saw the simple episteme or a discursive formation (I'm not a Foucault devotee, just a simple evoker). He knew that he had to be a "man" in the estimation of the powers-that-be, if he was to be in their purview of power and knowledge.

At first, Reid was complicit—cutting down totem poles and taking them away. Reid was born at a time when there were very few Indians, even fewer Haidas. In this power relation, we were already dead. When we didn't actually die, it became much easier to control the body of the "Indian" as artifact in a museum. He had to be a man—one of them—to take part in that process. He was part of the embalming, but then something changed.

It would seem that Reid also knew that "a subject dies when no longer a useful element of discursive practice." He needed to keep the "Indian" subject alive and he did, starting with his seductive voice, his rakish good looks and his raconteur ways.

"Indian/Native" is always at risk of death. *Le sauvage* is, after all, an invention that predates Europeans wandering onto the shores across the Atlantic. The Green Man, the Wild Man, the Hairy Man—these informed the Europeans' imagining of whom they encountered. A fictional character, sometimes carved into the stone on churches, he represented the cycle of life, Nature, the pleasures, the pagan. We, too, were near to becoming like those frozen, long ago forgotten figures.

Reid, it would seem, had the insight of Frye, Foucault and perhaps Umberto Eco and certainly Vine Deloria—understanding sign and signifier, myth and irony, absence and presence. He knew how to evoke new and fancy ways to mean "Native/Indian" and he did so with style—and great professional benefit. He understood the dynamics at play between the concept "man," which is meant to evoke something wholly related to Judeo-Christian culture and the Enlightenment, and the concept "Native/Indian," which was meant to evoke something quite apart from "man."

Like some aboriginal alchemist, he could pour mercury and other secret potions from one bottle labelled "man" and another labelled "Native/Indian" and mix and match. It wasn't about identity politics—it was beyond that. Alchemist, Hermes, Raven—he worked the proverbial room. He played them like a conductor. Quick—create something "new" became his mantra.

So what does this legacy mean to the "Native/Indian" artist, now "aboriginal/First Nations" artist? The Reid legacy for me is on a few fronts.

For one, I can make pronouncements—and if they are backed up with thought, research, integrity and knowledge, then I needn't shrink from the discussion, or even the argument. So, in keeping with his teachings:

We can't simply put on Indian Happy (or Tragic) face stickers and make it (us) Indian. Well, we can, but with the humour and irony that Reid understood so well.

The *mise en scène* of our images and stories is at risk of being flattened into so many postcards. Like an elaborate *mise en scène*, layering fore-

ground and background, light and shadow, lace curtains and branches of trees, our representations of our worlds should be thick with meaning. It has become too easy for the powers-that-be to take the postcard, or even the scribble, and proclaim it "Native, aboriginal, First Nations, etc." and say they have fulfilled their cultural quota or broadcaster CRTC[2] requirements or whatever. And we've been too quick to deliver the postcard.

That intelligence is our legacy—and our right.

That imagination is our right—and our legacy.

There is discipline and talent to our image making—even if we all want to tell stories.

We can all tell stories—even if we don't all have the talent or the discipline to create art.

There is another lesson that has become apparent as I examine what I know of Bill Reid's influence. In the end, something else happened—and it wasn't just strategic essentialism. The dichotomy between myth and reason that Reid exploited no longer belonged to separate worlds.

I imagine Reid dangling myth and dream like a carrot on the end of a stick for his patrons. But was he a believer? Perhaps, when myth was considered as metaphor—or even as archetype or as lesson. But he was a son of the Enlightenment—even if he was an alchemist of social dynamics. Manufacturing belief is a convenient ruse for some.

But Haidas who had no apparent reason to love him—loved him. Haidas who had no reason to trust him—trusted him. Sure he had, and I imagine still has, his detractors, but there came understanding. It must have been humbling for such an independent man.

You've likely heard it a thousand times—the power of story, the necessity of story. How there is nothing but story, and yes, those Natives are always going on about story.

Bill Reid was part of a story. The *Loo Taas* up the Seine? Part of a story. The *Loo Taas* making the almost 1000-kilometre (620-mile) voyage to Haida Gwaii? Part of a story. You can't escape story.

Everything has to begin—and Bill Reid had to begin somewhere. Iljuwas (one of Bill's Haida names) began before Bill Reid. But both began in the imagination—in the realm of myth and story.

N. Scott Momaday (I'm not giving up the Indian classics) once asked the question, in a book called *The Man Made of Words,* "What is the relationship between what a man is and what he says—or between what he is and what he thinks he is?"

Momaday answered that "the state of human *being* is an idea." Momaday also spoke of a storyteller named Pohd-lohk, who believed a man's life proceeded from his name, like a river proceeds from its source.[3]

Bill Reid had an idea of himself, an idea he realized through the language of his life and his work. But perhaps he came to realize that his idea would be nothing without the language of his life—a language that preceded him. He imagined himself as he was imagined. And in that way, he was no longer alone.

ENDNOTES

1 Hermann Bahr in 1891, quoted in William R. Everdell. 1997. *The First Moderns: Profiles in the Origins of Twentieth-Century Thought.* Chicago: University of Chicago Press.

2 Canadian Radio-Television and Telecommunicaitons Commission.

3 N. Scott Momaday. 1997. *The Man Made of Words: Essays, Stories Passages.* New York: St. Martin's Press.

Bibliography

"Aboriginal Art Is Lost: Belated Efforts Being Made to Save Remaining Indian Totem Poles." 1925. *Vancouver Sun*, 6 December.

Adorno, Theodor. 1997. *Aesthetic Theory*, ed. by Gretel Adorno and Rolf Tiedemann, trans. by Robert Hullot-Kentor. Minneapolis: University of Minneapolis Press.

Alberti, Leon Battista. 1972. *On Painting and on Sculpture: The Latin Texts with Translations, Introduction and Notes*, ed. by C. Grayson. London: Phaidon.

Ames, Michael. 1992. *Cannibal Tours and Glass Boxes: The Anthropology of Museums*. Vancouver: University of British Columbia Press.

Anderson, Margaret, and Marjorie Halpin, eds. 2000. *Potlatch at Gitsegukla: William Beynon's 1945 Field Notebooks*. Vancouver: University of British Columbia Press.

Appadurai, Arjun. 1986. "Introduction: Commodities and the Politics of Value." In *The Social Life of Things: Commodities in Cultural Perspective*, ed. Arjun Appadurai. Cambridge: Cambridge University Press.

———. 1996. *Modernity at Large: Cultural Dimensions of Globalization*. Minneapolis: University of Minnesota Press.

Arnason, Al. 1985. "Bill Reid Puts Focus on Disease. *Vancouver Province*, 30 September, 28.

"Artist Didn't Have Contract." 1987. *Vancouver Sun*, 31 March.

Artists and the Creative Process: Two Worlds. 1983. Videocassette. Produced and directed by Don Thompson. Toronto: Ontario Education Communication Authority.

Artscanada (July/August 1981):33–34.

B.C. Indian Arts Society. 1982. *Mungo Martin: Man of Two Cultures*. Sidney, B.C.: Gray's Publishing.

Baird, Ron. 1962. "Man with a Vision." *Beaver* (Spring):4–10.

Barbeau, Marius. 1929. *Totem Poles of the Gitksan, Upper Skeena River, British Columbia*. Ottawa: National Museum of Canada.

———. 1957. *Haida Carvers in Argillite*. National Museums of Canada Bulletin no. 139, Anthropological Series no. 38, 158. Ottawa: National Museums of Canada.

Barth, Frederik. 1966. *Models of Social Organization*. Occasional Paper no. 23. London: Royal Anthropological Institute of Great Britain and Ireland.

Bataille, Georges. 1985. "The Notion of Expenditure." In *Visions of Excess: Selected Writings of Georges Bataille, 1927–1939*, trans. by Allan Stoekl. Minneapolis: University of Minnesota Press.

BC Bookworld. 1998. Summer:45.

Beech, Dave, and John Roberts. 2002. *The Philistine Controversy.* London: Verso.

Bell, Michael. 1993. "Of Public Concern: The Pensioning of the Visual Arts in Canada Since 1945." In *In the Shadow of the Sun: Perspectives on Contemporary Native Art*, ed. by Canadian Museum of Civilization, 197–212. Hull: Canadian Museum of Civilization.

Bell, Stewart. 1996. "A Celebration in Art." *Vancouver Sun*, 25 April, D3.

Belting, Hans. 1994. *Likeness and Presence: A History of the Image Before the Era of Art*. Chicago: University of Chicago Press.

Berlo, Janet, and Ruth Phillips. 1998. *Native North American Art*. New York/ London: Oxford University Press.

Bernstein, Bruce. 1999. "The Indian Art World in the 1960s and 1970s." In *Native American Art in the Twentieth Century*, ed. by Jackson Rushing, 57–71. New York: Routledge.

Bernstein, J.M. 1991. *The Fate of Art: Aesthetic Alienation from Kant to Derrida and Adorno*. University Park, Pa.: University of Pennsylvania Press.

Bhabha, Homi. 1994. *The Location of Culture*. London: Routledge.

Bierwert, Crisca. 1999. *Brushed by Cedar, Living by the River: Coast Salish Figures of Power*. Tucson: University of Arizona Press.

"Bill Reid Honored: Canadian Native Arts Foundation to Present Haida Artist with Lifetime Achievement Award." 1994. *Kahtou*, 7.

Blackman, Margaret, and Edwin Hall. 1982. "The Afterimage and Image After: Visual Documents and the Renaissance in Northwest Coast Art." *American Indian Art Magazine* 7(2):30–39.

Boddy, Trevor. 1989. "Erickson in Washington." *Canadian Architect* 34(7):24–37.

Bourdieu, Pierre. 1984. *Distinction: A Social Critique of the Judgement of Taste*, trans. by Richard Nice. Cambridge: Harvard University Press.

———. 1995. *Free Exchange*, trans. by Hans Haacke and Randal Johnson. Stanford University Press, Stanford.

Boyd, Robert. *The Coming of the Spirit of Pestilence: Introduced Infectious Diseases and Population Decline Among Northwest Coast Indians, 1774–1874*. Vancouver: University of British Columbia Press, 1999.

Bracken, Christopher. 1997. *The Potlatch Papers: A Colonial Case History*. Chicago: University of Chicago Press.

Brand, Stewart. 1988. "Indians and the Counter-Culture, 1960s–1970s." In *History of Indian-White Relations*, ed. by Wilcomb Washburn, 570–72. Vol. 4 of *Handbook of North American Indians*, ed. by William C. Sturtevant. Washington: Smithsonian Institution Press.

Bringhurst, Robert. 1999. *A Story as Sharp as a Knife: The Classical Haida Mythtellers and Their World*. Vancouver/Toronto: Douglas & McIntyre; Lincoln: University of Nebraska Press.

———. 2000a. Introduction to *Solitary Raven: Selected Writings of Bill Reid*, ed. by Robert Bringhurst, 9–34. Vancouver/Toronto: Douglas & McIntyre; Seattle: University of Washington Press.

———. 2000b. Chronology. In *Solitary Raven: Selected Writings of Bill Reid*, ed. by Robert Bringhurst, 237–41. Vancouver/Toronto: Douglas & McIntyre; Seattle: University of Washington Press.

Bringhurst, Robert, and Ulli Steltzer. 1991. *The Black Canoe: Bill Reid and the Spirit of Haida Gwaii*. Vancouver/Toronto: Douglas & McIntyre; Seattle: University of Washington Press.

———. 1992. *The Black Canoe: Bill Reid and the Spirit of Haida Gwaii.* 2d. ed. Vancouver/Toronto: Douglas & McIntyre; Seattle: University of Washington Press.

British Columbia Provincial Museum (BCPM). *Annual Reports.* Various years. Victoria: British Columbia Provincial Museum.

Brodzky, Anne Trueblood, Rose Danesewich and Nick Johnson, eds. 1977. *Stones, Bones and Skin: Ritual and Shamanic Art.* Toronto: Society for Art Publications.

Brown, Steve. 1998a. "Bill Reid: Haida." *Indian Artist* 4(3):36–41.

———. 1998b. *Native Visions: Evolution in Northwest Coast Art from the Eighteenth through the Twentieth Century.* Seattle: Seattle Art Museum.

Brown, Steve, ed. 1995. *The Spirit Within: Northwest Coast Native Art from the John H. Hauberg Collection.* Seattle: Seattle Art Museum.

Buchloh, Benjamin, Serge Guilbaut and David Solkin, eds. 1983. *Modernism and Modernity: The Vancouver Conference Papers.* Halifax: Press of the Nova Scotia College of Art and Design.

Burkhardt, Jakob. 1958. *The Civilization of the Renaissance in Italy.* 2 vols. New York: Harper & Row.

Canizzo, Jeanne. 1983. "George Hunt and the Invention of Kwakiutl Culture." *Canadian Review of Sociology and Anthropology* 20(1):44–58.

Carlson, Keith Thor, et al., eds. 2001. *A Stó:lō–Coast Salish Historical Atlas.* Vancouver/Toronto; Douglas & McIntyre, Seattle: University of Washington Press; Chilliwack: Stó:lō Heritage Trust.

Cassidy, Frank, ed. 1992. *Aboriginal Title in British Columbia: Delgamuukw v. The Queen.* Lantzville, B.C.: Oolichan Books; Montreal: The Institute for Public Policy.

Cassirer, Ernst. 1963. *The Individual and Cosmos in Renaissance Philosophy.* New York: Harper & Row.

Castiglione, Baldassare. 2002. *The Book of the Courtier,* trans. by. C. Singleton and D. Javitch. New York: W.W. Norton.

Cennini, Cennino. 2001. *Il Libro dell'arte,* ed. by F. Brunello. Vicenza: Neri Pozza.

Cernetig, Miro. 1987. "Haida Artist Abandons Carving for Embassy." *Vancouver Sun,* 10 March, A1.

Clifford, James. 1988. *The Predicament of Culture: Twentieth-Century Ethnography, Literature and Art.* Cambridge: Harvard University Press.

———. 1991. "Four Northwest Coast Museums: Travel Reflections." In *Exhibiting Cultures: The Poetics and Politics of Museum Display,* ed. by Ivan Karp and Steven Lavine, 212–54. Washington: Smithsonian Institution Press.

———. 2001. "Indigenous Articulations." *Contemporary Pacific* 13(2):468–90.

Clifford, James, Virginia Dominguez and Trinh T. Minh-ha. 1987. "Discussion of Other Peoples: Beyond the 'Salvage' Paradigm." In *Discussions in Contemporary Culture,* ed. by Hal Foster. Seattle: Bay Press.

Clifford, James, and George Marcus, eds. 1986. *Writing Culture: The Poetics and Politics of Ethnography.* Berkeley: University of California Press.

Cocking, Clive. 1971. "Indian Renaissance: New Life for a Traditional Art." UBC *Alumni Chronicle* 25(4):16–19.

Coe, Ralph T. 1977. *Sacred Circles: 2000 Years of North American Indian Art.* Kansas City: Nelson Gallery of Art and Atkins Museum of Fine Arts.

Cole, Douglas. 1973. "The Origins of Canadian Anthropology, 1850–1910." *Journal of Canadian Studies* 8(1):33–45.

Cowen, Tyler. 1998. *In Praise of Commercial Culture.* Cambridge: Harvard University Press.

Crosby, Marcia. 1991. "Construction of the Imaginary Indian." In *Vancouver Anthology: The Institutional Politics of Art*, ed. by Stan Douglas, 267–91. Vancouver: Talonbooks.

———. 1994. "Indian Art / Aboriginal Title." Master's thesis, University of British Columbia.

Crosby, Marcia, and Paul Chaat Smith. 1997. *Nations in Urban Landscapes*. Vancouver: Contemporary Art Gallery.

Crow, Thomas. 1996. *The Rise of the Sixties: American and European Art in the Era of Dissent*. New York: Harry N. Abrams.

Dalzell, Kathleen. 1993. *The Queen Charlotte Islands: 1774–1966*. Vol. 1. 3d ed. Madeira Park, B.C.: Harbour Publishing.

Darling, David, and Douglas Cole. 1980. "Totem Pole Restoration on the Skeena, 1925–1930." BC *Studies* 47:29–48.

Davidson, Robert. 1986. "Haida Idea or Haida Ideal?" Paper presented at the symposium "The Legacy of Bill Reid: A Critical Enquiry," 13 November 1999, University of British Columbia. UBC Museum of Anthropology archives.

———. 1993. Transcript of Insight Audio Tour accompanying *Robert Davidson: Eagle of the Dawn* exhibition at Vancouver Art Gallery.

———. 1994. "The *Bear Mother* Pole in Massett, 1969." In *Eagle Transforming: The Art of Robert Davidson*, Robert Davidson and Ulli Steltzer, 21–25. Vancouver / Toronto: Douglas & McIntyre.

Davidson, Robert, and Ulli Steltzer. 1994. *Eagle Transforming: The Art of Robert Davidson*. Vancouver: Douglas & McIntyre; Seattle: University of Washington Press.

Dawn, Leslie. 1981. " 'Ksan: Artistic, Museum and Cultural Activity among the Gitksan Indians of the Upper Skeena River, 1920–1973." Master's thesis, University of Victoria.

———. 1984. *The Northwest Coast Native Silkscreen Print: A Contemporary Tradition Comes of Age*. Victoria: Art Gallery of Greater Victoria.

———. 2001. "How Canada Stole the Idea of Native Art: The Group of Seven and Images of the Indian in the 1920s." Ph.D. diss., University of British Columbia.

Debord, Guy. 1994. *The Society of the Spectacle*, trans. by Donald Nicholson-Smith. New York: Zone Books. Originally published 1967 in French as *La Societé du spectacle*, Paris: Buchet-Chastel; reprinted 1971, 1983, 1987, Paris: Champs Libre; reprinted 1992, Paris: Gallimard; trans. by Fredy Perlman and John Supak into English 1970, 1973, 1977 (rev.), 1983, Detroit: Black & Red.

de Menil, Adelaide, and William [Bill] Reid. 1971. *Out of the Silence*. New York: Outerbridge and Dienstfrey; Toronto: New Press; for Amon Carter Museum, Fort Worth.

DeMott, Barbara. 1989. Introduction to *Beyond the Revival: Contemporary North West Native Art*, by Barbara DeMott and Maureen Milburn, 7–17. Vancouver: Charles H. Scott Gallery, Emily Carr College of Art and Design.

Dennis, Claude. 1997. *We Are Not You: First Nations and Canadian Modernity*. Peterborough, Ont.: Broadview Press.

Dippie, Brian. 1982. *The Vanishing American: White Attitudes and United States Indian Policy*. Middletown, Conn.: Wesleyan University Press.

Douglas, Frederic H., and Rene d'Harnoncourt. 1941. *Indian Art of the United States*. New York: Museum of Modern Art.

Douglas, Stan, ed. 1991. *Vancouver Anthology: The Institutional Politics of Art*. Vancouver: Talonbooks.

Dubin, Margaret. 2001. *Native America Collected: The Culture of an Art World.* Albuquerque: University of New Mexico Press,

Duff, Wilson. 1952. *Gitksan Totem Poles, 1952.* Anthropology in British Columbia Memoir no. 3, 21–30. Victoria: British Columbia Provincial Museum.

———. 1954a. "A Heritage in Decay: The Totem Art of the Haidas." *Canadian Art* 11(2):56–59.

———. 1954b. Letter to Bill Reid, 23 February. British Columbia Provincial Museum correspondence inward 1897–1970, GR-0111, Box 17, file 46. British Columbia Archives.

———. 1959a. *Histories, Territories and Laws of the Kitwancool.* Victoria: British Columbia Provincial Museum.

———. 1959b. "Mungo Martin, Carver of the Century." *Museum News* 1(1):3–8. Reprinted 1981 in *The World Is as Sharp as a Knife: An Anthology in Honour of Wilson Duff,* ed. by Donald Abbott, 37–40. Victoria: British Columbia Provincial Museum.

———. 1962. Letter to Margery Bedinger, 23 August. British Columbia Provincial Museum correspondence inward 1897–1970, GR-0111, Box 17, file 46. British Columbia Archives.

———. 1972. "Levels of Meaning in Haida Art." Manuscript. University of British Columbia Museum of Anthropology library.

———. 1976. "Mute Relics of Haida Tribe's Ghost Villages." *Smithsonian* 7(6)84–91.

———. n.d. *Thunderbird Park.* Victoria: B.C. Government Travel Bureau.

Duff, Wilson, Jane Wallen and Joe Clark. 1969. "Totem Pole Survey of Southeast Alaska: Report of Field Work and Follow-up Activities, June–October 1969." Manuscript. Alaska State Museum archives.

Duffek, Karen. 1983a. *A Guide to Buying Contemporary Northwest Coast Indian Arts.* Museum Note no. 10. Vancouver: University of British Columbia Museum of Anthropology.

———. 1983b. "The Contemporary Northwest Coast Indian Art Market." Master's thesis, University of British Columbia.

———. 1986. *Bill Reid: Beyond the Essential Form.* Museum Note no. 19. Vancouver: University of British Columbia Press.

Duffy, Dennis. 1986. *Camera West: British Columbia on Film, 1941–1965.* Victoria: Provincial Archives of British Columbia.

Dyck, Lloyd. 1983. "Arts and the Man." *Vancouver Sun,* 6 August, H1.

Dyck, Noel. 1991. *What Is the Indian "Problem"? Tutelage and Resistance in Canadian Indian Administration.* St. John's: Institute of Social and Economic Research, Memorial University of Newfoundland.

Dyck, Sandra. 1995. " 'These Things Are Our Totems': Marius Barbeau and the Indigenization of Canadian Art and Culture in the 1920s." Master's thesis, Carleton University.

Edwards, Steve, ed. 1999. *Art and Its Histories: A Reader.* New Haven: Yale University Press.

Farrow, Moira. 1973. "Indian Village to Rise at UBC." *Vancouver Sun,* 16 January, 1–2.

———. 1980. "Raven Carving Due to Move to Museum for Final Touches." *Vancouver Sun,* 12 January.

Feder, Norman. 1971. *Two Hundred Years of American Indian Art.* New York: Praeger.

Fernie, Eric, ed. 1995. *Art History and Its Methods.* London: Phaidon.

Fleming, Marnie. 1982a. "Patrimony and Patronage: The Legacy Reviewed." *Vanguard* 11(5–6):18–21.

———. 1982b. "Ms. Fleming Responds." *Vanguard* 11(8–9):35.

Forrest, Linn. 1971. Interview by Aldona Jonaitis. Manuscript. Alaska State Museum archives.

Foster, Hal. 1985. "The 'Primitive' Unconscious of Modern Art, or White Skin Black Masks." In *Recodings: Art, Spectacle, Cultural Politics,* 181–210. Seattle: Bay Press.

Francis, Daniel. 1992. *The Imaginary Indian: The Image of the Indian in Canadian Culture.* Vancouver: Arsenal Pulp.

Frascina, Francis. 1993. "The Politics of Representation." In *Modernism in Dispute: Art Since the Forties,* by Jonathan Harris, Francis Frascina, Charles Harrison and Paul Wood, 77–169. New Haven: Yale University Press.

Gainor, Chris. 1982. "Renowned Haida Carver Helping Disease Research." *Vancouver Sun,* 17 December.

Galois, Robert M. 1997–98. "Colonial Encounters: The Worlds of Arthur Wellington Clah, 1855–1881." *BC Studies* 115/116:105–47.

Gelder, Ken, and Jane R. Jacobs. 1998. *Uncanny Australia: Sacredness and Identity in a Postcolonial Nation.* Victoria: Melbourne University Press.

Gell, Alfred. 1998. *Art and Agency: An Anthropological Theory.* Oxford: Oxford University Press.

Gisday Wa and Delgam Uukw. 1992. *The Spirit in the Land: Statements of the Gitksan and Wet'suwet'en Hereditary Chiefs in the Supreme Court of British Columbia, 1987–1990.* 2d ed. Gabriola, B.C.: Reflections. Originally published 1989 as *The Spirit in the Land: The Opening Statement of the Gitksan and Wet'suwet'en Hereditary Chiefs in the Supreme Court of British Columbia.* Gabriola, B.C.: Reflections.

Glass, Aaron. 2001. "Interrogating the Northwest Coast Renaissance: Birth, Rebirth and the Politics of Metaphor." Typescript.

———. In press. "Cultural Salvage or Brokerage?: The Emergence of Northwest Coast Art and the Mythologization of Mungo Martin." In *Otsego Institute Papers on Native American Art,* vol. 1, ed. by Aldona Jonaitis. Cooperstown, N.Y.: New York State Historical Society.

Globe and Mail. 1998. 16 March, D2.

Godfrey, Stephen. 1992. "Bill Reid and the Washington Embassy Project: The True Story of the Little Canoe That Grew." *Canadian Art* 9(1):11–13.

Gombrich, Ernst. 1972. *The Story of Art.* London: Phaidon.

———. 1979. "In Search of Cultural History." In *Ideals and Idols: Essays on Values in History and in Art.* London: Phaidon.

———. 1984. " 'The Father of Art History': A Reading of the Lectures on Aesthetics of G.W.F. Hegel (1770–1831)." In *Tributes: Interpreters of Our Cultural Tradition.* Ithaca: Cornell University Press.

Graburn, Nelson. 1993. "Ethnic Arts of the Fourth World: The View from Canada." In *Imagery and Creativity: Ethnoaesthetics and Art Worlds in the Americas,* ed. by Dorothea and Norman Whitten. Tucson: University of Arizona Press.

Gray, Viviane. 1993. "Indian Artists' Statements Through Time." In *In the Shadow of the Sun: Perspectives on Contemporary Native Art,* ed. by Canadian Museum of Civilization. Hull: Canadian Museum of Civilization.

Gritton, Joy. 2000. *The Institute of American Indian Arts.* Albuquerque: University of New Mexico Press.

Guilbaut, Serge. 1983. "Preface: The Relevance of Modernism." In *Modernism and Modernity,* ed. by Benjamin Buchloh, Serge Guilbaut and David Solkin. Halifax: Press of the Nova Scotia College of Art and Design.

Gustafson, Paula. 1999. "A Good, Hard Look at Reid." *Vancouver Sun,* 15 November, B6.

Gwaganad (Diane Brown). Paper presented at the symposium "The Legacy of Bill Reid: A Critical Enquiry," 13 November 1999. Tape recording in University of British Columbia. Museum of Anthropology archives.

Hall, Edwin, Margaret Blackman and Vincent Rickard. 1981. *Northwest Coast Indian Graphics*. Seattle: University of Washington Press; Vancouver/Toronto: Douglas & McIntyre.

Halpin, Marjorie. 1975. "The Uses of Collections." In *Northwest Coast Indian Artifacts from the H.R. MacMillan Collections*, 41–45. Vancouver: University of British Columbia Press.

———. 1976. "William Beynon, Ethnographer." In *American Indian Intellectuals*, ed. by Margot Liberty. St. Paul: West Publishing Co.

———. 1979. *The Graphic Art of Robert Davidson, Haida*. Museum Note no. 7. Vancouver: University of British Columbia Museum of Anthropology.

———. 1981. *Totem Poles: An Illustrated Guide*. Vancouver: University of British Columbia Press in association with University of British Columbia Museum of Anthropology.

———. 1999. Paper presented at the symposium "The Legacy of Bill Reid: A Critical Enquiry," 13 November 1999, University of British Columbia. Tape recording. University of British Columbia Museum of Anthropology archives.

Harris, Cole. 1997. *The Resettlement of British Columbia: Essays on Colonialism and Geographic Change*. Vancouver: University of British Columbia Press.

Harris, Jonathon. 2001. *The New Art History: A Critical Introduction*. London: Routledge.

Hawker, Ronald. 1998. "Accumulated Labours: First Nations Art in British Columbia, 1922–1961." Ph.D. diss., University of British Columbia.

———. 2002. *Tales of Ghosts: First Nations Art in British Columbia, 1922–61*. Vancouver: University of British Columbia Press.

Hawthorn, Audrey. 1963. "A Living Haida Craft: Some Traditional Carvings for Our Times." *Beaver* (summer):4–12.

———. 1975. "The Walter and Marianne Koerner Collection." In *Indian Masterpieces from the Walter and Marianne Koerner Collection*, 10–15. Vancouver: University of British Columbia Press.

———. 1993. *A Labour of Love: The Making of the Museum of Anthropology, UBC, the First Three Decades, 1947-1976*. Museum Note no. 33. Vancouver: University of British Columbia Museum of Anthropology.

Hawthorn, Harry. 1966. *A Survey of the Contemporary Indians of Canada: A Report on Economic, Political, Educational Needs and Policies*. Ottawa: Indian Affairs Branch.

Hawthorn, Harry, C. Belshaw and S. Jamieson. 1958. *The Indians of British Columbia*. Toronto: University of Toronto Press. Originally published 1955 in 2 vols. Vancouver: University of British Columbia Press.

Hebdige, Dick. 1996. "A Report on the Western Front." In *The "Block" Reader in Visual Culture*, ed. by George Robertson et al. London: Routledge.

Henderson, R.W. 1985. *These Hundred Years: The United Church of Canada in the Queen Charlotte Islands: 1884–1984*. Queen Charlotte City: Official Board of the Queen Charlotte Church.

Herem, Barry. 1998. "Bill Reid: Making the Northwest Coast Famous." *American Indian Art Magazine* 24(1):42–51

———. N.d. "Remembering Bill Reid." www.mvnf.civilisations.ca/aborig/ reid/reid08e.html. Originally published in *Seattle Art Museum Ethnic Art Newsletter*.

Hiller, Susan, ed. 1991. *The Myth of Primitivism: Perspectives on Art*. London: Routledge.

Hodgins, Jack. 2001. *A Passion for Narrative: A Guide for Writing Fiction*. Toronto: McClelland & Stewart.

Holm, Bill. 1965. *Northwest Coast Indian Art: An Analysis of Form*. Seattle: University of Washington Press; Vancouver/Toronto: Douglas & McIntyre.

Holm, Bill, and William [Bill] Reid. 1975. *Form and Freedom: A Dialogue on Northwest Coast Indian Art.* Houston: Institute for the Arts, Rice University. Reprinted 1978 as *Indian Art of the Northwest Coast: A Dialogue on Craftsmanship and Aesthetics.* Seattle: University of Washington Press; Vancouver / Toronto: Douglas & McIntyre.

Hoover, Alan. 1983. "Charles Edenshaw and the Creation of Human Beings." *American Indian Art Magazine* 8(3):62–67, 80.

———. 1993. "Bill Reid and Robert Davidson: Innovations in Contemporary Haida Art." *American Indian Art* 18(4):48–55

Hoover, Alan, and Kevin Neary. 1984. Appendix II. In *The Legacy: Tradition and Innovation in Northwest Coast Indian Art*, 179–88. Vancouver / Toronto: Douglas & McIntyre; Seattle: University of Washington Press. Originally published 1980 as *The Legacy: Continuing Traditions of Canadian Northwest Coast Indian Art*, by Peter Macnair, Alan Hoover and Kevin Neary. Victoria: British Columbia Provincial Museum.

Hopkins, David. 2000. *After Modern Art: 1945–2000.* Oxford: Oxford University Press.

Houle, Robert. 1992. "Ancestral Connections." In *Land, Spirit, Power: First Nations at the National Gallery of Canada*, ed. by Diana Nemiroff, Robert Houle and Charlotte Townsend-Gault. Ottawa: National Gallery of Canada.

Hume, Christopher. 1991. "Reviving a Heritage." *Toronto Star,* 24 November, C1–2.

Hume, Mark. 1989. "Haida Artist, Paddlers, War Canoe Bound for Paris Art Exhibition." Vancouver Sun, 23 September, A1–2.

Hume, R.M. 1956. Letter to Bill Reid, 16 May. Vancouver Art Gallery archives.

Huyssen, Andreas. 1995. *Twilight Memories: Marking Time in a Culture of Amnesia.* New York: Routledge.

Iglauer, Edith. 1982. "The Myth Maker." *Saturday Night* (February):13–24.

Inverarity, Bruce. 1950. *Art of the Northwest Coast Indians.* Berkeley: University of California Press, 1950.

Ivory, Carol. 1999. "Art, Tourism, and Cultural Revival in the Marquesas Islands." In *Unpacking Culture,* ed. by Ruth Phillips and Christopher Steiner. Berkeley: University of California Press.

Jameson, Fredric. 1981. *The Political Unconscious: Narrative as a Socially Symbolic Act.* Ithaca: Cornell University Press.

Jennings, Nicholas, and Brigid Janssen. 1989. "Haidas on the Seine: The City of Light Toasts Artist Bill Reid." *Maclean's* (16 October):68.

Johnson, Eve. 1982. "A Whale of a Tale." *Vancouver Sun,* 2 June, D12.

Johnston, Moira. 1998. "The Raven's Last Journey: Bill Reid's Final Work of Haida Art Was His Own Funeral." *Saturday Night* 113(9):72–84.

Jonaitis, Aldona. 1981. "The White Man's Perception of Northwest Coast Indian Art from the 1930s to the Present." *American Indian Culture and Research Journal* 5:1–45.

———. 1989. "Totem Poles and the 'Indian New Deal.'" *Canadian Journal of Native Studies* 9(2):237–52.

———. 1993. "Traders of Tradition: The History of Haida Art." In *Robert Davidson: Eagle of the Dawn,* ed. by Ian M. Thom, 3–23. Vancouver / Toronto: Douglas & McIntyre and Vancouver Art Gallery.

———. 1999. "Northwest Coast Totem Poles." In *Unpacking Culture,* ed. by Ruth Phillips and Christopher Steiner, 104–21. Berkeley: University of California Press.

Kahtou: The Voice of B.C. First Nations. 1994. 28 February.

Kew, Michael. 1958. Letter to Bill Reid, 30 June. British Columbia Provincial Museum correspondence inward 1897–1970, GR-0111, Box 17, file 46. British Columbia Archives.

———. 1993–94. "Anthropology and First Nations in British Columbia." *BC Studies* no. 100 (winter):78–105.

Knight, Rolf. 1978. *Indians at Work: An Informal History of Native Indian Labour in British Columbia.* Vancouver: New Star.

Kowinski, William. 1995. "Giving New Life to Haida Art and the Culture It Expresses." *Smithsonian* 25(10):38–46.

Kubler, George. 1962. *The Shape of Time: Remarks on the History of Things.* New Haven and London: Yale University Press.

Kulchinsky, Peter. 1993. "Anthropology in the Service of the State: Diamond Jenness and Canadian Indian Policy." *Journal of Canadian Studies* 28(2):21–50.

Kuper, Adam. 1999. *Culture: The Anthropologists' Account.* Cambridge, Ma.: Harvard University Press.

Large, Geddes. 1951. *Soogwillis: A Collection of Kwakiutl Indian Design & Legends.* Toronto: Ryerson Press.

"The Legacy of Bill Reid: A Critical Enquiry." 1999. 13–14 November, Vancouver, British Columbia. Tape recordings in UBC Museum of Anthropology archives.

Lévi-Strauss, Claude. 1943. "The Art of the Northwest Coast at the American Museum of Natural History." *Gazette des Beaux-Arts* 24:175–88.

———. 1963. *Structural Anthropology,* vol. 1. New York: Basic Books; 1976, vol. 2. Chicago: University of Chicago Press.

———. 1974. "Bill Reid." In *Bill Reid: A Retrospective Exhibition,* Vancouver Art Gallery, 7–8. Vancouver: Vancouver Art Gallery.

———. 1989. *Des symboles et leur doubles.* Paris: Plon.

Lewis, Robert. 1999. "The Art World Goes on the Attack: The *Maclean's* Cover Story on Haida artist Bill Reid Brings a Storm of Protest." *Maclean's* 112(43):10.

Linsley, Robert. 1995. "Yuxweluptun and the West Coast Landscape." In *Yuxweluptun: Born to Live and Die on Your Colonialist Reservations,* ed. by Charlotte Townsend-Gault and Scott Watson. Vancouver: Morris and Helen Belkin Art Gallery.

Lowndes, Joan. 1982. "Child of the Raven: Bill Reid." *Vanguard* 11(1):20–25.

Lush, Pat. 1985. "A Transformer of Existing Things." *Ryerson Rambler* 28:9-13.

Lyotard, Jean-François. 1971. *Discours, figure.* Paris: Editions Klincksieck.

MacDonald, George. 1996. *Haida Art.* Vancouver/Toronto: Douglas & McIntyre; Hull: Canadian Museum of Civilization; Seattle: University of Washington Press.

McLennan, Bill, and Karen Duffek. 2000. *The Transforming Image: Painted Arts of Northwest Coast First Nations.* Vancouver: University of British Columbia Press.

McMartin, Pete. 1996. "To the Future." *Vancouver Sun,* 25 April, D1, D7.

McMaster, Gerald. 1999. "Towards an Aboriginal Art History." In *Native American Art in the Twentieth Century,* ed. by Jackson Rushing. London/New York: Routledge.

McMaster, Gerald, ed. 1998. *Reservation X: The Power of Place in Contemporary Aboriginal Art.* Hull: Canadian Museum of Civilization; Fredericton: Goose Lane Editions; Seattle: University of Washington Press, 1999.

Macnair, Peter. 1993. "Trends in Northwest Coast Art, 1880–1959." In *In the Shadow of the Sun: Perspectives on Contemporary Native Art,* ed. by Canadian Museum of Civilization, 47–70. Hull: Canadian Museum of Civilization.

Macnair, Peter, and Alan Hoover. 1984. *The Magic Leaves: A History of Haida Argillite Carving*. Victoria: British Columbia Provincial Museum.

Macnair, Peter, Alan Hoover, and Kevin Neary. 1984. *The Legacy: Tradition and Innovation in Northwest Coast Indian Art*. Vancouver/Toronto: Douglas & McIntyre; Seattle: University of Washington Press. Originally published 1980 as *The Legacy: Continuing Traditions of Canadian Northwest Coast Indian Art*, Victoria: British Columbia Provincial Museum.

Maranda, Lynn, and Robert Watt. 1976. "An Interview with Bill Reid." *Canadian Collector* 11(3):34–37.

Marcus, George, and Fred Myers, eds. 1995. *The Traffic in Culture: Refiguring Art and Anthropology*. Berkeley: University of California Press.

Maurer, Evan. 1977. *The Native American Heritage: A Survey of North American Indian Art*. Chicago: Art Institute of Chicago.

Mauss, Marcel. 1990. *The Gift: The Form and Reason for Exchange in Archaic Societies*, trans. by W.D. Halls. London: Routledge; New York: W.W. Norton. Originally published 1950 in French as "Essai sur le don" in *Sociologie et anthropologie*, by Marcel Mauss, Paris: Presses Universitaire de France. Trans. 1954 by Ian Cunnison, London: Cohen and West; Glenco, IL: Free Press; reprinted 1967, New York: W.W. Norton.

Mead, Sidney M. 1976. "The Production of Native Art and Craft Objects in Contemporary New Zealand Society." In *Ethnic and Tourist Arts: Cultural Expressions from the Fourth World*, ed. by Nelson Graburn, 285–98. Berkeley: University of California Press.

Mercredi, Ovide, and Mary Ellen Turpel. 1993. *In the Rapids: Navigating the Future of First Nations*. Toronto: Viking, Penguin

Mertens, Susan. 1974. "Haida Art Alive Again." *Vancouver Sun*, 8 November, 6a.

Michelet, Jules. 1855. *Renaissance*. Paris: Chamerot.

Miller, Daniel. 1991. "Primitive Art and the Necessity of Primitivism to Art." In *The Myth of Primitivism: Perspectives on Art*, ed. by Susan Hiller, 50–71. London: Routledge.

Milroy, Sarah. 1999. "Carved Up." *Globe and Mail*, 15 October, A18.

Mohr, Merilyn. 1990. "The Bestiary of Bill Reid." *Equinox* 53 (September–October): 78–90.

Morrison, Ann Katherine. 1991. "Canadian Art and Cultural Appropriation: Emily Carr and the 1927 Exhibition of *Canadian West Coast Art—Native and Modern*." Master's thesis, University of British Columbia.

Mullin, Molly. 1995. "The Patronage of Difference: Making Indian Art 'Art, not Ethnology.'" In *The Traffic in Culture: Refiguring Art and Anthropology*, ed. by George Marcus and Fred Myers, 166–98. Berkeley: University of California Press.

Native Voice. 1947, November, 11; 1948, June; 1948, July, 7; 1948, August; 1949 August, 1; 1950, January; 1955, October, 4; 1958, August, 1, 3; 1962, April, 1; 1964, May, 3.

Nemiroff, Diana, Robert Houle and Charlotte Townsend-Gault. 1992. *Land, Spirit, Power: First Nations at the National Gallery of Canada*. Ottawa: National Gallery of Canada

Nurse, Andrew. 2001. " 'But Now Things Have Changed': Marius Barbeau and the Politics of Amerindian Identity." *Ethnohistory* 48(3): 433–72.

Nuytten, Phil. 1982. *The Totem Carvers: Charlie James, Ellen Neel, Mungo Martin*. Vancouver: Panorama Publications.

"Objects of the Society." 1939. Society for the Furtherance of British Columbia Indian Arts and Welfare. December. British Columbia Indian Arts and Welfare Society Papers Add. Mss 2720. British Columbia Archives.

O'Hara, Jane. 1999. "Trade Secrets." *Maclean's* (18 October):20–30.

Omineca Herald and Terrace News. 1948. 25 August, 4.

Ostrowitz, Judith. 1999. *Privileging the Past: Reconstructing History in Northwest Coast Art.* Seattle: University of Washington Press.

Paalen, Wolfgang. 1943. "Totem Art." *Dyn: The Journal of the Durham University Anthropological Society* 4–5:7–39.

———. 1945. *Form and Sense.* Problems of Contemporary Art, no. 1. New York: Wittenborn and Company.

Paine, Robert, ed. 1971. *Patrons and Brokers in the East Arctic.* Memorial University of Newfoundland Social and Economic Papers no. 2. Toronto: University of Toronto Press.

Panofsky, Erwin. 1969. *Renaissance and Renascences in Western Art.* New York: Harper Torchbooks.

Pater, Walter. 1986. *The Renaissance: Studies in Art and Poetry,* ed. by A. Phillips. Oxford: Oxford University Press.

Penney, David, and Lisa Roberts. 1999. "America's Pueblo Artists: Encounters on the Borderlands." In *Native American Art in the Twentieth Century: Makers, Meanings, Histories,* ed. by Jackson Rushing, 21–38. London/New York: Routledge.

"Philanthropists Bail Out Famed Architect." 1988. Canadian Press newswire, 24 January.

Phillips, Kimberly. 2000. "Making Meaning in Totemland: Investigating a Vancouver Commission." Master's thesis, University of British Columbia.

Phillips, Ruth. 1999. "Art History and the Native-made Object: New Discourses, Old Differences?" In *Native American Art in the Twentieth Century,* ed. by Jackson Rushing, 97–112. London/New York: Routledge.

Phillips, Ruth, and Christopher Steiner, eds. 1999. *Unpacking Culture: Art and Commodity in Colonial and Postcolonial Worlds.* Berkeley: University of California Press.

Pinney, Christopher. 2002. "Creole Europe: Or 'the Implacable Demands of Objects.'" Typescript.

Preziosi, Donald, ed. 1998. *The Art of Art History: A Critical Anthology.* Oxford/New York: Oxford University Press.

Price, Sally. 2001. "Le Musée: lieu de représentation d'une identité." In *L'avenir des musées: actes du colloque organisé au musée du Louvre par le Service culturel les 23, 24 et 25 mars 2000,* ed. by Jean Galard, 455–71. Paris: Réunion des musées nationaux.

Rammell, George. 1999. "Authentic Master, Bill Reid." *Vancouver Sun,* 30 October, A19.

Ravenhill, Alice. 1938. *The Native Tribes of British Columbia.* Victoria: King's Printer.

———. 1944. *A Cornerstone of Canadian Culture: An Outline of the Arts and Crafts of the Indian Tribes of British Columbia.* Occasional Paper no. 5. Victoria: British Columbia Provincial Museum.

Reid, Bill. 1954a. Transcript of CBC radio talk. Published 2000 as "Journey to Tanu" in *Solitary Raven: The Selected Writings of Bill Reid,* ed. by Robert Bringhurst, 37–44. Vancouver/Toronto: Douglas & McIntyre; Seattle: University of Washington Press.

———. 1954b. Letter to Wilson Duff, 22 February. British Columbia Provincial Museum correspondence inward 1897–1970, GR-0111, Box 17, file 46. British Columbia Archives.

————. 1956a. Transcript of CBC radio talk. Published 2000 as "People of the Potlatch" in *Solitary Raven: The Selected Writings of Bill Reid*, ed. by Robert Bringhurst, 45–52. Vancouver/Toronto: Douglas & McIntyre; Seattle: University of Washington Press.

————. 1956b. Letter to Wilson Duff, 21 May. British Columbia Provincial Museum correspondence inward 1897–1970, GR-0111, Box 17, file 46. British Columbia Archives.

————. 1959a. Transcript of voicetrack of CBC documentary film. Published 2000 as "Totem" in *Solitary Raven: The Selected Writings of Bill Reid*, ed. by Robert Bringhurst, 56–65. Vancouver/Toronto: Douglas & McIntyre; Seattle: University of Washington Press.

————. 1959b. Letter to Harry Hawthorn. Hawthorn Papers, Box 12, Series 5, File 5–11. University of British Columbia Museum of Anthropology archives.

————. 1969. Resumé in Canada Council grant application. National Archives of Canada.

————. 1971. "Out of the Silence." Reprinted 2000 in *Solitary Raven: The Selected Writings of Bill Reid*, ed. by Robert Bringhurst, 71–84. Vancouver/Toronto: Douglas & McIntyre; Seattle: University of Washington Press.

————. 1974. Autobiographical note. *Bill Reid: A Retrospective Exhibition*. Vancouver: Vancouver Art Gallery. Reprinted 2000 as "Curriculum Vitae 1" in *Solitary Raven: The Selected Writings of Bill Reid*, ed. by Robert Bringhurst, 85–93. Vancouver/Toronto: Douglas & McIntyre; Seattle: University of Washington Press.

————. 1976. "Wilson Duff: 1925–76." Vanguard 5(8):17. Reprinted 2000 in *Solitary Raven: The Selected Writings of Bill Reid*, ed. by Robert Bringhurst, 109–12. Vancouver/Toronto: Douglas & McIntyre; Seattle: University of Washington Press.

————. 1979. "Haida Means Human Being." Reprinted 2000 in revised form in *Solitary Raven: The Selected Writings of Bill Reid*, ed. by Robert Bringhurst, 131–45. Vancouver/Toronto: Douglas & McIntyre; Seattle: University of Washington Press.

————. 1979a. "The Classical artist on the Northwest Coast." Reprinted 2000 in *Solitary Raven: The Selected Writings of Bill Reid*, ed. by Robert Bringhurst, 115–30. Vancouver/Toronto: Douglas & McIntyre; Seattle: University of Washington Press.

————. 1980a. Untitled statement. In *Bill Koochin*. Burnaby, B.C.: Burnaby Art Gallery. Reprinted 2000 as "Bill Koochin" in *Solitary Raven: The Selected Writings of Bill Reid*, ed. by Robert Bringhurst, 147–50. Vancouver/Toronto: Douglas & McIntyre; Seattle: University of Washington Press.

————. 1980b. "The Enchanted Forest," *Vancouver Sun*, 24 October. Reprinted 2000 in *Solitary Raven: The Selected Writings of Bill Reid*, ed. by Robert Bringhurst, 151–54. Vancouver/Toronto: Douglas & McIntyre; Seattle: University of Washington Press, 2000.

————. 1981. "A New Northwest Coast Art: A Dream of the Past or a New Awakening?" Paper delivered at the conference "Issues and Images: New Directions in Native American Art History," Arizona State University. Reprinted 2000 in *Solitary Raven: The Selected Writings of Bill Reid*, ed. by Robert Bringhurst, 160–72. Vancouver/Toronto: Douglas & McIntyre; Seattle: University of Washington Press.

————. 1982. "The Legacy Review Reviewed: Bill Reid." Vanguard 11(8–9):34–35. Reprinted 2000 in abridged form in *Solitary Raven: The Selected Writings of Bill Reid*, ed. by Robert Bringhurst, 109–12. Vancouver/Toronto: Douglas & McIntyre; Seattle: University of Washington Press.

———. 1983. Transcript of a talk delivered at a panel discussion at the British Columbia Provincial Museum. Published 2000 as "Curriculum Vitae 2" in *Solitary Raven: Selected Writings of Bill Reid,* by Bill Reid, ed. by Robert Bringhurst, 188–99. Vancouver/Toronto: Douglas & McIntyre; Seattle: University of Washington Press.

———. 1991. "The Spirit of Haida Gwaii." Broadside published by the Canadian embassy, Washington, D.C. Reprinted 2000 in *Solitary Raven: The Selected Writings of Bill Reid,* ed. by Robert Bringhurst, 228–30. Vancouver/Toronto: Douglas & McIntyre; Seattle: University of Washington Press.

———. 2000. *Solitary Raven: Selected Writings of Bill Reid,* ed. by Robert Bringhurst. Vancouver/Toronto: Douglas & McIntyre; Seattle: University of Washington Press.

Reid, Bill, and Robert Bringhurst. 1984. *The Raven Steals the Light.* Vancouver/Toronto: Douglas & McIntyre; Seattle: University of Washington Press.

Reid, Martine. 1993. "In Search of Things Past, Remembered, Retraced and Reinvented." In *In the Shadow of the Sun: Perspectives on Contemporary Native Art,* ed. by Canadian Museum of Civilization, 71–92. Hull: Canadian Museum of Civilization.

"Relics of British Columbia To Be Preserved." 1926. *Vancouver Sun,* 15 January.

"Renowned Haida Sculptor Passes Away at 78." 1998. *Vancouver Sun,* Canadian Press newswire, 13 March.

Report of Conference on Native Indian Affairs at Acadia Camp, University of British Columbia, Vancouver, B.C., April 1, 2 and 3, 1948. 1948. Victoria: B.C. Indian Arts and Welfare Society

Report of the Royal Commission on National Development in the Arts, Letters and Sciences, 1949–1951. 1951. Vincent Massey, Chairman. Ottawa: King's Printer.

"Revivalist Reid and the Indian Image." 1986. *Vancouver Sun,* 9 August.

Rigaud, Thérèse. 2002. "Translating Haida Poetry: An Interview with Robert Bringhurst." Pamphlet. Vancouver/Toronto: Douglas & McIntyre.

Rubin, William, ed. 1984. *Primitivism in Modern Art: Affinity of the Tribal and Modern.* New York: Museum of Modern Art.

Rushing, Jackson. 1995. *Native American Art and the New York Avant-garde: A History of Cultural Primitivism.* Austin: University of Texas Press.

Rushing, Jackson, ed. 1999. *Native American Art in the Twentieth Century.* London/New York: Routledge.

———. 2002. *After the Storm: The Eiteljorg Fellowship for Native American Fine Art, 2001.* Seattle: University of Washington Press.

Ryan, Maureen. 1990. "Picturing Canada's Native Landscape: Colonial Expansion, National Identity, and the Image of a 'Dying Race.'" *RACAR* 17(2):138–49.

Sandler, Irving. 1996. *Art of the Postmodern Era: From the Late 1960s to the Early 1990s.* Boulder: Westview Press.

Schrader, Robert. 1983. *The Indian Arts and Crafts Board: An Aspect of New Deal Indian Policy.* Albuquerque: University of New Mexico Press.

Scott, Michael. 1998. "A Tribute: Bill Reid 1920–1998." *Vancouver Sun,* 14 March, B5.

Shadbolt, Doris. 1983. Interview. In *Vancouver, Art and Artists, 1931–1983.* Vancouver: Vancouver Art Gallery.

———. 1986. *Bill Reid.* Vancouver/Toronto: Douglas & McIntyre; Seattle: University of Washington Press.

———. 1998. *Bill Reid,* 2d ed. Vancouver/Toronto: Douglas & McIntyre; Seattle: University of Washington Press.

Sheehan, Carol. 1981. *Pipes That Won't Smoke, Coal That Won't Burn.* Calgary: Glenbow Museum.

Sinclair, John. 1948. "The Renaissance." *Native Voice* (July):1–10.

Sparrow, Kathy. 1998. "Correcting the Record: Haida Oral Tradition in Anthropological Narratives." *Anthropologica* XL: 215–22.

Spivak, Gayatri. 1988. *In Other Worlds: Essays in Cultural Politics.* London / New York: Routledge Kegan & Paul.

Steiner, Christopher. 1994. *African Art in Transit.* Cambridge: Cambridge University Press.

Steltzer, Ulli. 1984. *A Haida Potlatch.* Vancouver / Toronto: Douglas & McIntyre.

Stewart, Hilary. 1990. *Totem Poles.* Vancouver / Toronto: Douglas & McIntyre; Seattle: University of Washington Press.

Stewart, Susan. 1993. *On Longing: Narratives of the Miniature, the Gigantic, the Souvenir, the Collection.* Durham / London: Duke University Press. Originally published 1984, Baltimore: John Hopkins University Press.

Strathern, Marilyn. 1999. *Property, Substance and Effect: Anthropological Essays on Persons and Things.* London: Athlone.

Summers, David. 1981. *Michelangelo and the Language of Art.* Princeton: Princeton University Press.

———. 2002. "E.H. Gombrich and the Tradition of Hegel." In *A Companion to Art Theory,* ed. Paul Smith and Carolyn Wilde, 139–49. Oxford: Blackwell.

Swanton, John R. 1905. *Contributions to the Ethnology of the Haida. Jesup North Pacific Expedition, Memoir of the American Museum of Natural History,* vol. 5, part 1, ed. by Franz Boas. Leiden: E.J. Brill; New York: G.E. Stechert. Reprint 1975, New York: AMS Press.

Thom, Ian, ed. 1993. *Robert Davidson: Eagle of the Dawn.* Vancouver / Toronto: Douglas & McIntyre; Vancouver: Vancouver Art Gallery

Thomas, Nicholas. 1991. *Entangled Objects: Exchange, Material Culture and Colonialism in the Pacific.* Cambridge, Ma.: Harvard University Press.

———. 1994. *Colonialism's Culture: Anthropology, Travel and Government.* Princeton: Princeton University Press.

———. 1997. *In Oceania: Visions, Artifacts, Histories.* Durham: Duke University Press.

———. 2000. "Technologies of Conversion: Cloth and Christianity in Polynesia." In *Hybridity and Its Discontents: Politics, Science, Culture,* ed. by Annie Coombes and Avtar Brah. London / New York: Routledge.

Tippett, Maria. 2003. *Bill Reid: The Making of an Indian.* Toronto: Random House.

Townsend-Gault, Charlotte. 1994. "Northwest Coast Art: The Culture of the Land Claims." *American Indian Quarterly* 18(4):445–67.

———. 1998. "The Raven and Bill Reid, Appreciation." *Globe and Mail,* 21 March, C10.

———. 2000. *The Entrance to Heaven.* Campbell River, B.C.: Campbell River Public Arts Museum.

———. 2000–01. "*Haida Art* review." *University of Toronto Quarterly* 70:1 (Winter):319–22.

Trachtenberg, M. 1997. *Dominion of the Eye: Urbanism, Art, and Power in Early Modern Florence.* Cambridge / New York: Cambridge University Press.

Tully, James. 1995. *Strange Multiplicity: Constitutionalism in an Age of Diversity.* New York: Cambridge University Press.

Union of British Columbia Indian Chiefs. 2000. *Protecting Knowledge: Traditional Resource Rights in the New Millennium,* kit for "Conference on Protecting Knowledge," 24–26 February, First Nations House of Learning and Museum of Anthropology, University of British Columbia.

Vancouver Art Gallery (VAG). 1956. *People of the Potlatch: Native Arts and Culture of the Pacific Northwest Coast.* Vancouver: Vancouver Art Gallery with the University of British Columbia.

———. 1958. *One Hundred Years of B.C. Art.* Vancouver: Vancouver Art Gallery.

———. 1967. *Arts of the Raven: Masterworks by the Northwest Coast Indian.* Vancouver: Vancouver Art Gallery.

———. 1974. *Bill Reid: A Retrospective Exhibition.* Vancouver: Vancouver Art Gallery.

Vancouver News Herald. 1939. 30 June, 8.

Vancouver Province. 1926, 22 October, 15; 1949, 10 November.

Vancouver Sun. 1926, 15 January.

Vasari, Giorgio. 1906. *Le vite de'pui eccellenti pittori, scultori ed architettori,* ed. by G. Milanesi. Florence: Sansoni.

Vastokas, Joan. 1975. "Bill Reid and the Native Renaissance." *Artscanada* 32 (June):12–21. Reprinted 1977 in *Stones, Bones and Skin: Ritual and Shamanic Art,* ed. by Anne Trueblood Brodzky, Rose Danesewich and Nick Johnson, 158–67. Toronto: Society for Art Publications.

Walker Art Center. 1972. *American Indian Art: Form and Tradition.* Baltimore: Walker Art Center.

Walsh, Anthony. 1948. Introduction to *Native Designs of British Columbia.* Victoria: B.C. Indian Arts and Welfare Society.

Warburg, Aby. 1999. *The Revival of Pagan Antiquity.* Los Angeles: Getty Institute.

Warnke, Martin. 1993. *The Court Artist: On the Ancestry of the Modern Artist.* Cambridge: Cambridge University Press.

Webster, Gloria Cranmer. 1991. "The Contemporary Potlatch." In *Chiefly Feasts: The Enduring Kwakiutl Potlatch,* ed. by Aldona Jonaitis, 227–50. Seattle: University of Washington Press; New York: American Museum of Natural History; Vancouver/Toronto: Douglas & McIntyre.

Wesley, Oriana. 1998. "Acclaimed Artist Reid leaves on Final Trip." *Vancouver Province.* 5 July, A14.

Westman, Marja de Jong. 1984. "Bill Reid's Killer Whale." *Waters: Journal of the Vancouver Aquarium* 7:21–28.

White, Brenda. 1980. "Raven: How Two Cultures Came Together Under One Wing." *Vancouver Sun,* 26 April, D1.

Williams, Judith. 2001. *Two Wolves at the Dawn of Time: Kingcome Inlet Pictographs 1893–1998.* Vancouver: New Star Books.

Wittkower, Rudolf. 1949. *Architectural Principles in the Age of Humanism.* London: Warburg Institute / University of London.

Wright, Robin. 1999. Commentary read at the symposium "The Legacy of Bill Reid: A Critical Inquiry," 13 November, University of British Columbia. Transcript. University of British Columbia Museum of Anthropology archives.

———. 2001. *Northern Haida Master Carvers.* Seattle: University of Washington Press; Vancouver/Toronto: Douglas & McIntyre.

Wyman, Max. 1990. "Modest Artist Wins $100,000 Award." *Vancouver Province,* 16 September.

———. 1999. "Art, the Media and Bill Reid." *Vancouver Sun,* 16 October, A21.

Biographical Notes on the Contributors

DIANE BROWN, whose Haida name is GWA͟GANAD, belongs to the Ts'aahl Eagle clan. She worked in the health field for twenty-eight years, and as a school board trustee for ten years, in her home community of Skidegate. Currently, she is teaching the Haida language at the Skidegate Haida Immersion Program. She enjoys gathering and preparing seafood as well as traditional Haida herbal medicines. She describes herself as a spiritual person in her day to day life, and with her husband, Dull, is proud of their children, Judson and Lauren. She continues to devote much of her time to protecting the beauty and bounty of Haida Gwaii.

NIKA COLLISON (JISGUNG), of the Ts'aahl Eagle clan, is a curator at the Haida Gwaii Museum in Skidegate. She works actively with her community on a range of cultural initiatives: developing the Qay'llnagaay Heritage Centre; co-ordinating the Skidegate Repatriation and Cultural Committee, which is dedicated to bringing home and reburying the remains of Haida ancestors from museums around the world; and singing and drumming with the Skidegate-based dance group, Hl Taa͟xuulang Guud ad K'aaju. In 2000, she assisted Jim Hart in carving and painting the *Respect to Bill Reid* pole raised at the UBC Museum of Anthropology.

DOUG CRANMER, a 'Namgis artist, received his first formal instruction in carving from the Kwakwa͟ka'wakw artist and chief Mungo Martin, during the 1950s. Later that decade, he joined Bill Reid in constructing the Haida-style

houses and poles at the University of British Columbia. He has created numerous other monumental works, including a memorial pole in honour of his father, Dan Cranmer (1978), and the painted front of the bighouse at his home community of Alert Bay (1999). In the mid-1970s, Cranmer began a series of innovative paintings to which he brought elements of northern and Kwakwaka'wakw styles, and which remain pivotal works in twentieth-century Northwest Coast art.

MARCIA CROSBY has been an instructor in the First Nations Studies Department at Malaspina University in Nanaimo, B.C, since 1996. She has a B.A. in Fine Art Studio and completed her master's thesis "Indian Art/ Aboriginal Title" in the Art History Department at the University of British Columbia. In 1994, she curated the exhibition *Nations in Urban Landscapes*. She has given public lectures and published essays on issues that explore the social and political contexts for the production of art by artists of aboriginal ancestry. A historian of Tsimshian and Haida ancestry, her maternal lineage is Tsimshian, originating from Maxxtakxaata (Metlakatla) and Gisbutwaada (Killer Whale clan), House of Gitlan.

LESLIE DAWN teaches art history at the University of Lethbridge, where he also serves as chair of the Department of Fine Arts. His research focuses on issues in national identity, colonial landscapes and critical theory. He did his doctoral thesis at the University of British Columbia on the image of the "Indian" in the construction of Canadian identity in the 1920s. He has also written art criticism for numerous journals and galleries. He lives in Victoria when he can.

KAREN DUFFEK is the Curator of Art at the UBC Museum of Anthropology. She has organized numerous exhibitions of contemporary First Nations art, including the Vancouver Art Gallery's *Beyond History* (co-curated with Tom Hill), and *The Abstract Edge: Recent Work by Robert Davidson*, at the Museum of Anthropology. Among her publications are the books *Bill Reid: Beyond the Essential Form* and (co-authored with Bill McLennan) *The Transforming Image: Painted Arts of Northwest Coast First Nations*.

AARON GLASS works primarily with Kwakwaka'wakw communities, exploring issues surrounding the local and global politics of contemporary art and cultural performance. In addition, he has conducted research on the circulation of totem poles (for a planned publication with Aldona Jonaitis), the social history of the Northwest Coast art world, repatriation in a comparative perspective, and the role of indigenous artists and anthropologists as culture brokers. He has an M.A. in anthropology from the University of British Columbia and is currently a Ph.D candidate at New York University, working on the representational history of the Hamat'sa Dance.

HAAWISDII GUUJAAW is a traditional carver, canoe-maker, dancer, singer, hunter and gatherer who is a long standing advocate for cultural and environmental sustainability. Elected president of the Haida Nation, Guujaaw is a member of the *gak'yaals kiigawaay* Raven clan from Skedans. He was instrumental in the protection and creation of Gwaii Haanas National Park Reserve in Haida Gwaii (the Queen Charlotte Islands) and previously served as a member of Gwaii Haanas Archipelago Management Board (a Canada-Haida association).

ALAN HOOVER was formerly Manager of Anthropology at the Royal British Columbia Museum. He is a co-author of *The Legacy: Continuing Traditions of Canadian Northwest Coast Indian Art* (1980) and *The Magic Leaves: A History of Haida Argillite Carving* (1984), and editor of the anthology *Nuu-chah-nulth Voices, Histories, Objects and Journeys* (2000). He also has published articles in *American Indian Art* magazine on the work of Charles Edenshaw, Bill Reid and Robert Davidson.

ALDONA JONAITIS, Director of the University of Alaska Museum, has a Ph.D. in art history from Columbia University. Previously, she was Vice President for Public Programs at the American Museum of Natural History. Her publications on Northwest Coast Native art include *The Yuquot Whaler's Shrine*; *A Wealth of Thought: Franz Boas on Native American Art*; *Chiefly Feasts: The Enduring Kwakiutl Potlatch*; *From the Land of the Totem Poles: The Northwest Coast Indian Art Collection at the American Museum of Natural History*; and *Art*

of the Northern Tlingit. She is currently collaborating with Aaron Glass on a study of the Northwest Coast totem pole.

KI-KE-IN (RON HAMILTON) is a Nuu-chah-nulth carver, painter, print-maker, jeweller and poet who prefers to be known as a creator rather than an artist. A nephew of George Clutesi, he apprenticed as a carver to the Kwakwaka'wakw master Henry Hunt, and has a B.A. in anthropology from the University of British Columbia. His work was represented in such important exhibitions as *The Legacy, In the Shadow of the Sun* and *Topographies.* He has had one-person exhibitions at the British Museum and the UBC Museum of Anthropology (1996). He works as a counselor and has acted as consultant in cases concerning survivors of residential schools.

BILL MCLENNAN is a Project Manager and Curator for the University of British Columbia Museum of Anthropology. Some of his external projects include: registrar for Expo '86, production of First Nations houses for the Canadian Museum of Civilization's Grand Hall, and a consultant to the Vancouver International Airport for First Nations art exhibits. He has won a number of awards including, "Certificate of Design excellence" from *Print* magazine, "President's Service Award for Excellence" from UBC, and, as co-author of *The Transforming Image,* the Award for Outstanding Achievement from the Canadian Museums Association, as well as the Certificate of Merit from the British Columbia Historical Federation.

MARIANNE NICOLSON is an artist whose practice includes both traditional and contemporary production. She is of the Dzawada'enuxw tribe from Kingcome Inlet, one of the many Kwakwaka'wakw nations that occupy the central coast of British Columbia. In 1996, she completed a B.F.A. degree at the Emily Carr Institute of Art and Design, and three years later received her master's degree in Fine Arts from the University of Victoria. She has also been trained, from a young age, in the traditional artistic forms of the Kwakwaka'wakw through her family and other relatives. Since 1992, she has been exhibiting her work locally, nationally and inter-nationally.

RUTH B. PHILLIPS is the Canada Research Chair in Modern Culture and Professor of Art History at Carleton University. From 1997 to 2003, she was the Director of the UBC Museum of Anthropology. Among her recent publications are the books *Unpacking Culture: Arts and Commodities in Colonial and Postcolonial Worlds,* edited with Christopher B. Steiner, and *Trading Identities: The Souvenir in Native American Art from the Northeast, 1700–1900.* Her current research interests include visuality and art in the Great Lakes region, as well as recent and historical exhibitions of Native art in Canadian museums.

GEORGE RAMMELL studied at the Vancouver School of Art. A sculptor since 1976, he worked as a studio sculptor for Bill Reid (1979–1990). He taught at the Emily Carr Institute of Art and Design and is a part-time faculty member in the Studio Art Department at Capilano College. Rammell's public sculpture is in collections in Sweden and France; he has had solo exhibitions at the Burnaby Art Gallery and the Charles H. Scott Gallery, and been in fourteen group shows. He is working on *Ursus Arctos / The Persistence of Instinct,* a large sculptural project that examines animal instinct as instrumental to the development of culture.

MILES RICHARDSON is a citizen of the Haida Nation and has served as Chief Commissioner of the British Columbia Treaty Commission since 1998. Prior to that, he was involved in several key initiatives directly related to settling the land question in British Columbia. He was a member of the First Nations Summit Task Group and the B.C. Claims Task Force, whose report and recommendations are the blueprint for the treaty negotiation process. He was also President of the Council of the Haida Nation and played a leadership role in protecting the Gwaii Haanas area of Haida Gwaii. He holds a B.A. degree in Economics from the University of Victoria.

DORIS SHADBOLT, who died in December 2003, was one of Canada's most respected and influential art critics and curators. Her long association with the museum world included positions at the Art Gallery of Toronto (now the Art Gallery of Ontario), the National Gallery of Canada in Ottawa, the Metropolitan Museum in New York and particularly the Vancouver Art

Gallery. At the VAG, she was the energy behind many major exhibitions, and worked together with Bill Reid, Wilson Duff and Bill Holm to produce *Arts of the Raven* (1967). Her books include *The Art of Emily Carr* and *Bill Reid*, the first major study of Reid's work (1986, revised 1998).

DAVID SUMMERS is the William R. Kenan Jr. Professor of the History of Art at the University of Virginia. The recipient of two fellowships from the National Endowment for the Humanities, he has written and lectured extensively on subjects ranging from the work of Michelangelo to Renaissance aesthetics and optics, theories of world art and Western modernism. A painter himself, Summers also regularly exhibits his work in group and solo exhibitions. His most recent publication is the book *Real Spaces: World Art History and the Rise of Western Modernism*, which offers a new framework for a global and intercultural art history.

LORETTA TODD is an internationally acclaimed director and writer. Her films have been screened around the world, including the Sundance Festival, American Indian Film Festival, Yamagata Documentary Festival and the Museum of Modern Art. Among her credits are the recently released *Kainayssini Imanistaisiwa: The People Go On* (a National Film Board of Canada production), the documentary *Today Is a Good Day: Remembering Chief Dan George*, and numerous other productions, such as *Forgotten Warriors*, which have reached wide audiences. Of Métis/Cree descent, she is also known for her critical writing on art and media issues.

CHARLOTTE TOWNSEND-GAULT's has worked for many years with Native artists in North America, published extensively on contemporary cross-cultural exchange and curated several important exhibitions, including *Land, Spirit, Power: First Nations at the National Gallery of Canada* (1992), *Yuxweluptun: Born to Live and Die on Your Colonialist Reservations* (1995) and *Rebecca Belmore: The Named and the Un-named* (2002). She is an Associate Professor in the Department of Art History, Visual Art and Theory, at the University of British Columbia, and is at work on a book titled *Masked Relations: Display and Disguise on the Northwest Coast.*

SCOTT WATSON is a Professor in the Department of Art History, Visual Art, and Theory, in addition to his position as Director/Curator of the Morris and Helen Belkin Art Gallery, both at the University of British Columbia. His 1991 book, *Jack Shadbolt*, received the Hubert Evans Non-fiction Prize. He has written extensively on contemporary Canadian and international art.